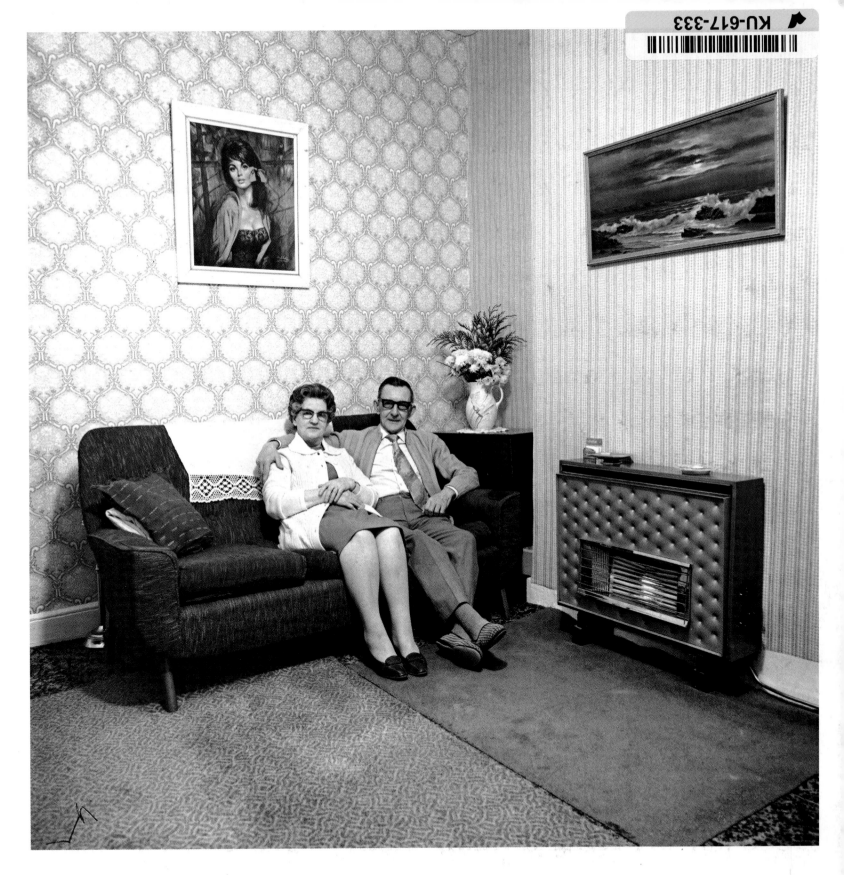

From 'June Street', a collaboration with Daniel Meadows, 1972

State to confront a legacy of bad post-war social engineering and poor-quality building. Victorian Manchester was disappearing fast when Parr arrived; whole streets had been levelled and majestic nineteenth-century buildings had been condemned. Bare stretches of land that had once accommodated communities of industrial workers were marked only by a solitary pub here and there, left untouched through some historic by-law, but bereft of custom and identity.

In the early 1970s Parr's engagement with photography might have seemed foolhardy. Still seen either as trade, fashion or photojournalism, the medium offered few opportunities in Britain for the serious documentarist. The two major London shows of the period, 'Henri Cartier-Bresson' at the Victoria and Albert Museum (1968) and 'Bill Brandt' at the newly opened Hayward Gallery (1970), were anomalies in an art world in which photography was marginalized and

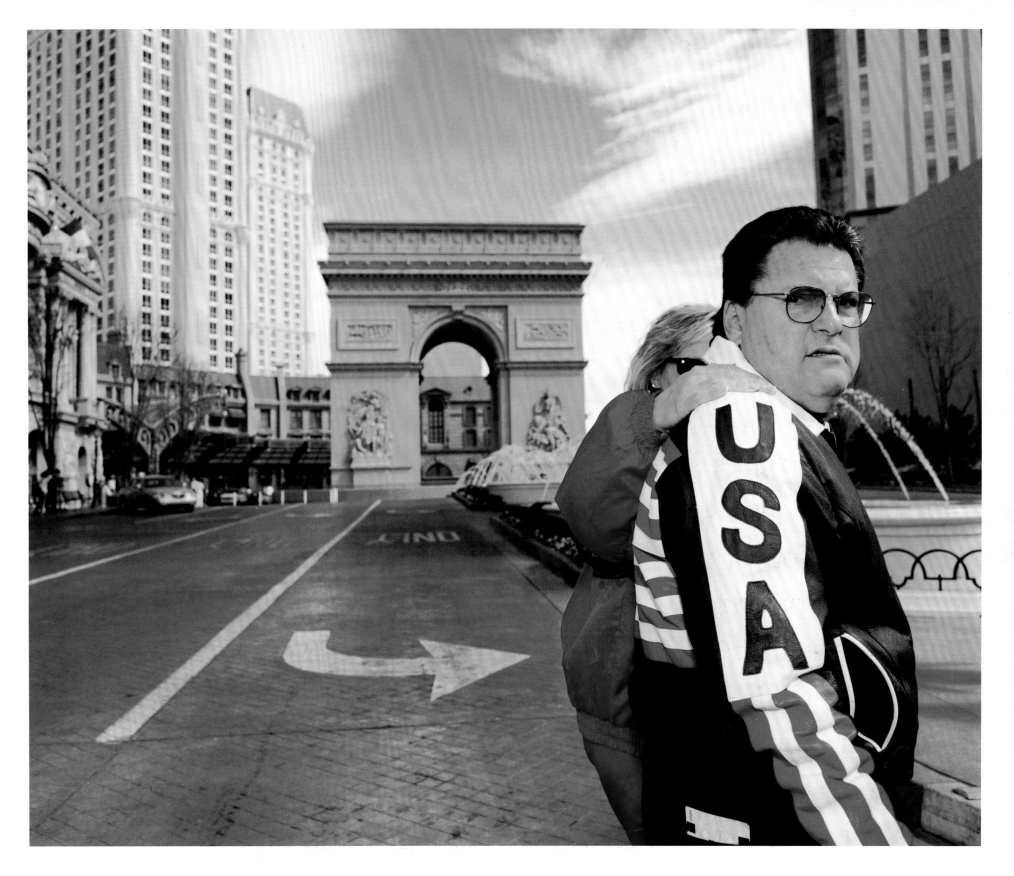

Las Vegas, 2000

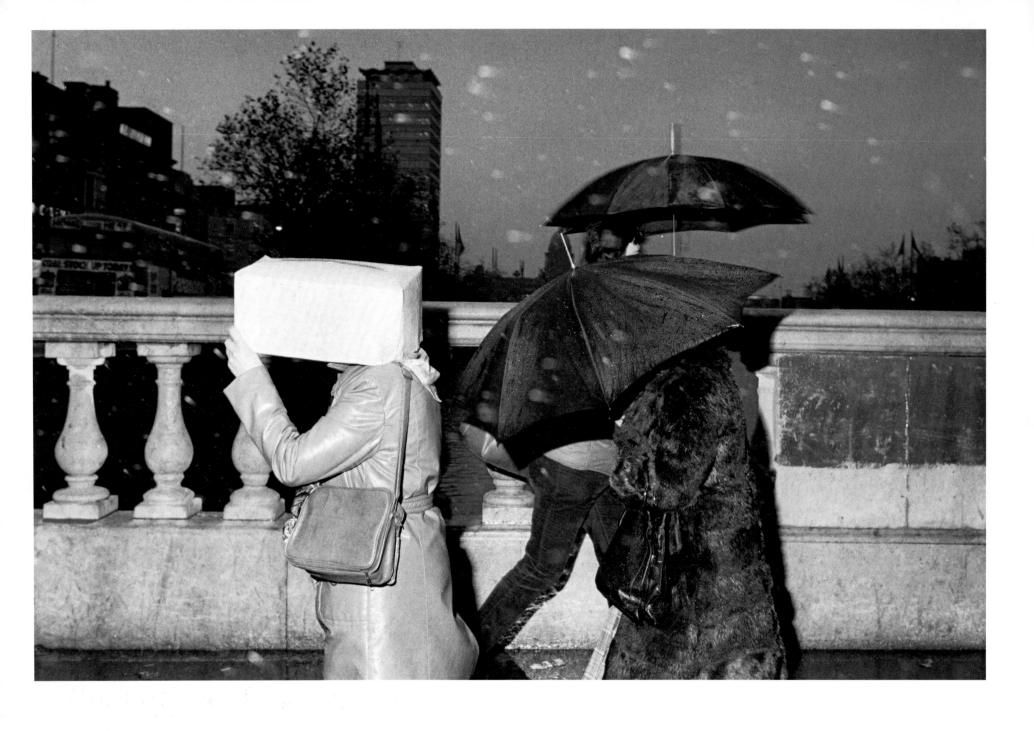

Dublin, 1981, from 'Bad Weather'

excluded from the mainstream. Though it had been a subject of serious scholarship and curation in the United States for many years (the department of photography was established at the Museum of Modern Art in New York in the 1930s), the art and museum establishment in the UK saw it as an unwelcome populist presence in its elitist midst.

In 2001, when every other exhibition is a photography show, and painting and sculpture have become the exception to the rule, it is difficult to imagine a time when small photography galleries, often in makeshift accommodation – a corridor in a university building, a theatre foyer, the reception area of a photographic company – were the only institutions that would show such photographers as Helmut Newton, Don McCullin and David Bailey, or would look at portfolios by such young hopefuls as Martin Parr. Parr's first exhibition was held in a corridor at the Kendall Milne department

store in Manchester and he was one of the first young British photographers of the early 1970s to take advantage of the opportunities to exhibit on the emerging photo-gallery circuit, showing his work at Impressions in York, the Half Moon in the East End of London and at the Photographers' Gallery in Covent Garden.

Martin Parr has always been attracted to the territory which change marks out, he is fascinated by people's choices and tastes and his work is indicative of collapse and a kind of social hysteria. In 1972, Parr made a board game in the flat he shared with three friends from the Polytechnic. An unusual occupation, one might say, for a young man enrolled on an entirely conventional photography course in a city still awaiting a reversal in the cycle of dereliction and neglect that had dogged it since the collapse of the cotton industry. But Parr, like so many of his contemporaries, was himself a product of a cultural revolution, in which the opportunities of

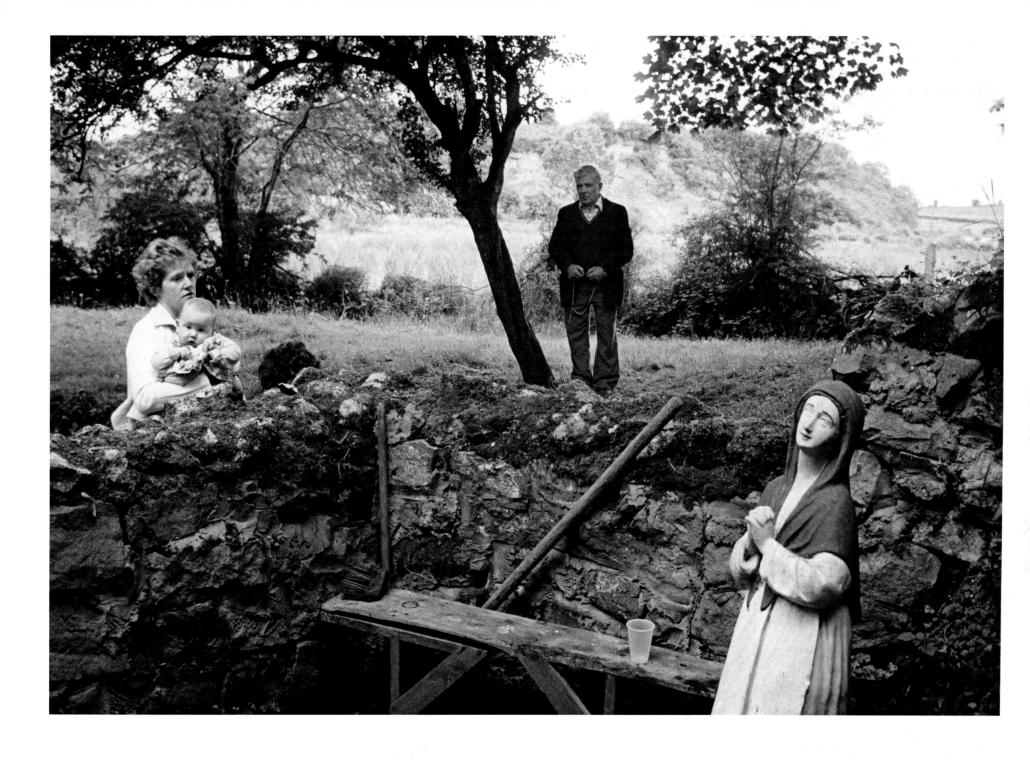

St Mary's Holy Well, Killargue, County Leitrim, from 'A Fair Day' 1980–3

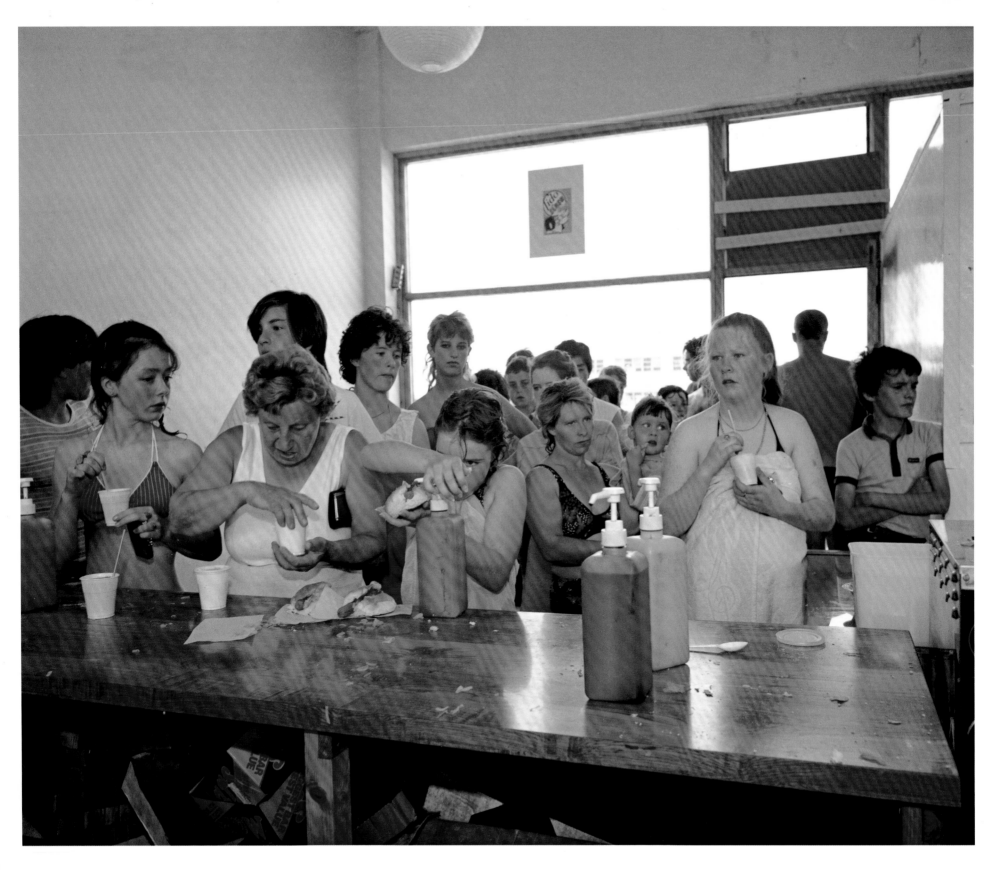

New Brighton, Merseyside, from 'The Last Resort', 1983–6

further education became available to a far wider range of the British population than ever before, and in which enlightened attitudes to art began to encompass the 'democratic' arts: photography, film-making and video. The game was called 'Love Cubes'. It consisted of a set of wooden blocks, on each of which was pasted a black-and-white photograph of a young man or woman. The idea of the game was to make pairs, to work out which people went together and match them to the blocks with photographs of the couples together. 'Love Cubes' was a strange link between the new documentarists of the 1970s, of which Parr was to be a leading member, and the conceptualists of the 1950s and 1960s, a group including people like Keith Arnatt and Richard Long, who were using photography to express ideas about art and culture rather than to create a record of the world around them. In 'Love Cubes', Parr married his urge to document with a bemusement about social behaviour

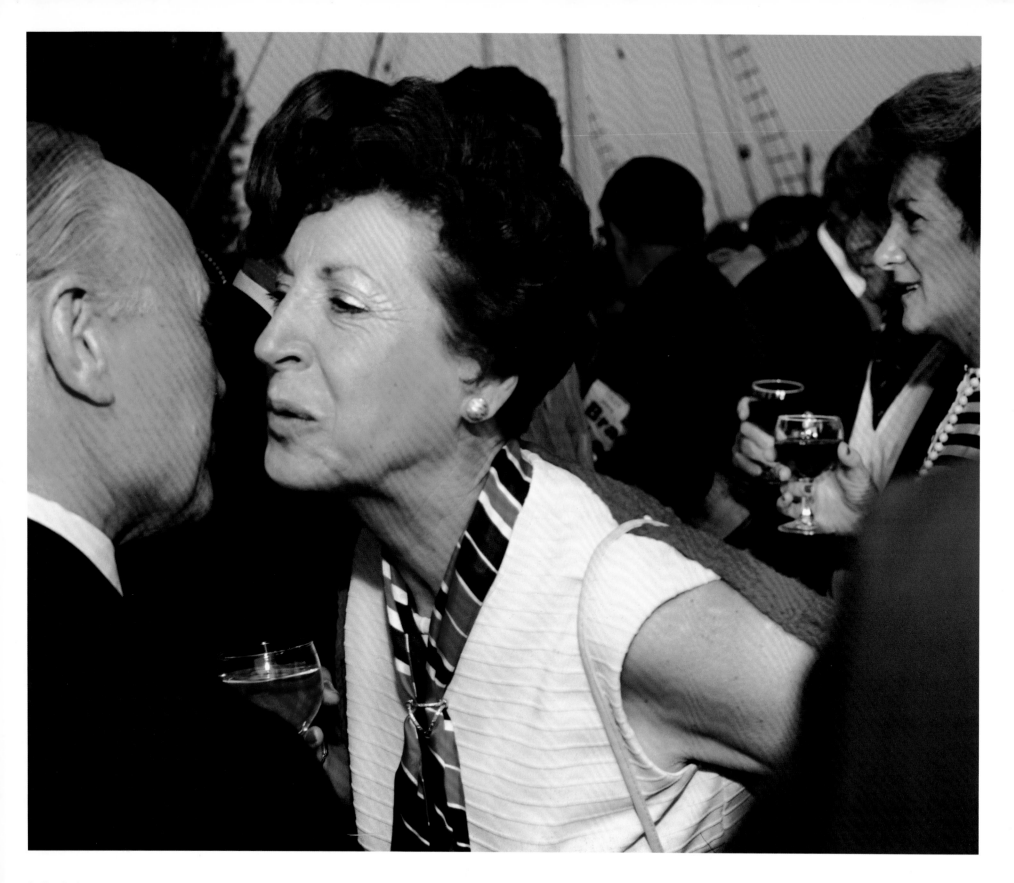

Conservative victory party aboard the SS *Great Britain*, Bristol, from 'The Cost of Living', 1986–9

that still inhabits his work today. He was fascinated by the idea of preference and taste – what makes people choose each other, the idiosyncratic way in which domestic interiors are created, why we follow traditions when their original rationale has long since disappeared.

Twenty-seven years later, when he travelled around Britain in 1998 making a documentary film, he was like a stranger in a foreign land. A gang of girls in Newcastle, skittering along the street in a gale, accused him of being a trainspotter; a holidaymaker gave him a lecture about the evils of immigration and a homeowner expressed his sense of alienation from his birthplace. Perhaps the Newcastle girls were essentially right: he is always watching, taking in the detail, wandering around places where no one knows him, a collector of faces, gestures and social indiscretions.

Parr's photography is essentially a reflection of intense curiosity, deriving much from the American photography

that so influenced him throughout the 1970s and 1980s – William Eggleston, Bill Owens, Joel Meyerowitz, Garry Winogrand. But he was also inspired by an English and international vernacular – the picture-postcard photographs of John Hinde and other anonymous photographers, the studio portraits of the developing world and eastern and southern Europe, the seaside souvenir. Though Parr's photography was, particularly in the mid-1980s, seen as socially transgressive – in projects such as 'The Last Resort' (1983–6) and 'The Cost of Living' (1986–9) – it has a robustness and a variability that transcends a crude theoretical or political opposition. Parr's photography is, above all, a visual extravaganza; a large and skilfully honed collection of aesthetic devices that are used not just to define a social point or to underline a cultural statement, but for their own sake, in celebration of photography's singularity as a still, two-dimensional image acting as a mirror to the way we live.

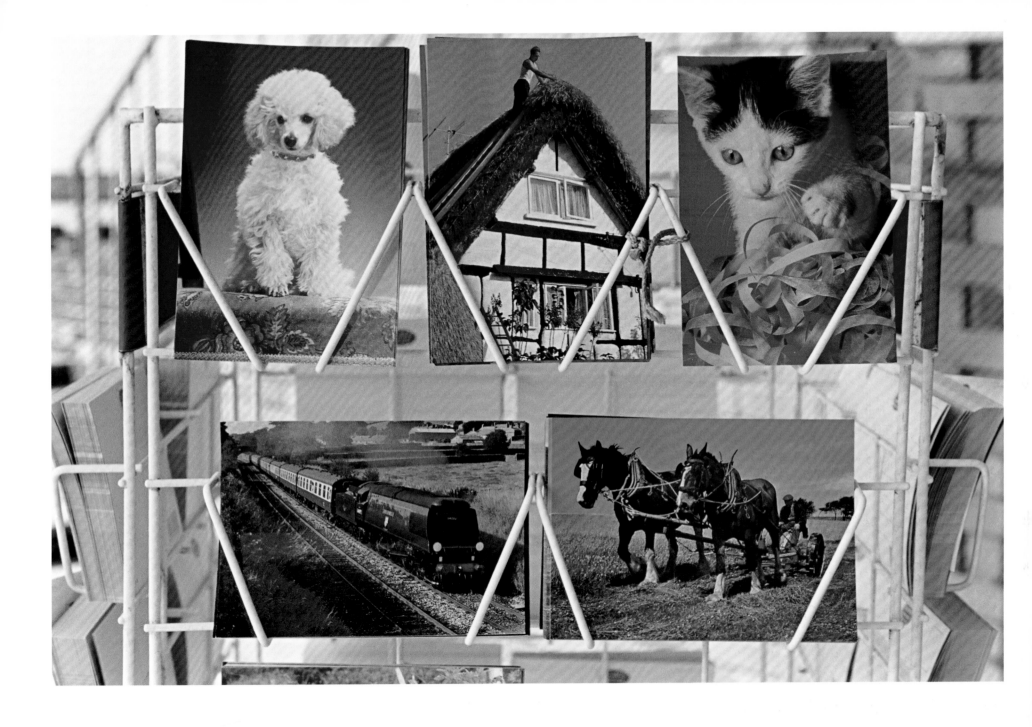

Martin Parr

Martin Parr

Val Williams

Phaidon Press Limited
Regent's Wharf
All Saints Street
London N1 9PA

Phaidon Press Inc.
180 Varick Street
New York, NY 10014

www.phaidon.com

First published 2002
Reprinted in paperback 2004,
2005, 2006
© 2002 Phaidon Press Limited

ISBN 0 7148 4389 X

A CIP catalogue record for this book
is available from the British Library.

Designed by UNA (London)
Printed in China

In addition to the standard edition, there also exist four Collector's Editions. Each Collector's Edition is specially bound and limited to 100 copies and five artist's proofs, and contains one of the following original photographic prints signed and numbered by the photographer: *Jubilee Street Party, Elland, Yorkshire, 1977* (p. 130); *Steep Lane Baptist Chapel, Yorkshire, 1978* (p. 112); *Badminton Horse Trials, Gloucestershire* (p. 231); and *Pink Pig Cakes* (p. 294). For more information, please contact Phaidon Press.

Contents

From Grandad
to
Martin

hoping he will
cultivate a seeing
eye for all beauty
of line, form & colour

Trainspotting

the early years

What makes a photographer? More specifically, what would propel an English schoolboy of the early 1960s towards this career, inhabiting as he did a culture in which the photographer was perceived as either a theatrical maverick (Cecil Beaton, John French) or young fashion cultist (David Bailey, Terence Donovan, Helmut Newton), old fogey (camera club enthusiasts, latter-day pictorialists) or glamour fetishist (amateur photographers, lonely men, entrepreneurs)? The artist was a different figure altogether: distinguished, bohemian, revered, outrageous. Francis Bacon, Lucien Freud, Duncan Grant – all inhabitors of chaotic studios with fascinating sex lives, members of the Colony Club, raconteurs, chameleons – gave colour to a British society that was as dank, drab and colourless as could be.

Across the Channel in France, photographers were as well respected as they had ever been, with Robert Doisneau arranging tableaux of beautiful young Parisians, Henri Cartier-Bresson travelling the world and producing dense *gravure* volumes of real life, choreographed and finely crafted. In the USA, Robert Frank and William Klein were already

working for *Vogue*, bringing street photography with an irreverent bang into the pages of the fashion bible. In Britain, however, there was very little to suggest that photography might be either inspirational or aspirational for the new youth.

In the 1950s, advised by his friend Beaumont Newhall (a New York-based curator and collector of photographs and author of one of the first substantial history books of the medium in English), the German collector Helmut Gernsheim began to assemble a collection of British photography. In junk shops and second-hand book shops, in family attics and institutions, he searched for and found the history of British photography. Julia Margaret Cameron, Lewis Carroll, Winifred Casson, Lady Hawarden, Fox Talbot, Hill and Adamson, Henry Peach Robinson and Roger Fenton all lay waiting for him as the establishment continued to turn a blind eye to the medium. Gernsheim's *History of Photography*, first published in 1969, provided the earliest indication that there was a real, fascinating and substantial British photographic history. Although the Gernsheim collection was even-

tually sold to the University of Texas for want of a British institutional buyer, the *History of Photography* remained an essential handbook for many years.

But it is unlikely that Parr would have encountered Gernsheim's book as a teenager; unlikely too that he would have seen the books of Cartier-Bresson and Brassaï, not widely available in Britain and known mainly to those few who travelled Europe, or whose careers and lifestyles gave them access to such publications. The two giant exhibitions of the work of Bill Brandt and Henri Cartier-Bresson, which finally opened up photography to a wider British public, were yet to come. The pioneering magazine *Camera Owner* (later *Creative Camera*) had begun to develop into an art photography magazine with the editorship of Bill Jay in 1965 but the great 1970s proselytizers of photography (including Peter Turner, editor of *Creative Camera* in the 1970s and 1980s, Mark Haworth-Booth, curator of photography at the Victoria and Albert Museum and Sue Davies, first director of the Photographers' Gallery) were not active in British photography until the early seventies.

SURBITON COUNTY GRAMMAR SCHOOL

REPORT for First Half-year, 1968-69

NAME Martin PARR Form LVIA

SUBJECT	Effort	Standard	Exam. Mark Present	Supplementary Remarks	Master's Initials
ART				Very little work achieved – very lackadaisical considering the amount of work he needs to do	C.M.W.
ENGLISH LITERATURE	C	C-	I 13/32	Shows hardly any interest in class and written work submitted makes it only too clear that he has made no effort to revise his text. He must take stock of his position or he risks... the course is a waste of time	
	C	C	15/		
History English European	C	C	23 25	He started the course with determination and understanding but has gone down very badly since. The exam. was a failure and he really will have to get to grips with the subject	
ART	B	B-	40 17	Main paper in exam. was well done, but term work as a whole disappointing. I had hoped for much more. O level syllabus A taken.	
CRAFTS / PHOTOGRAPHY	B-	B		He will need to work a lot harder at all subjects if he hopes to succeed in this field.	
Pure Maths (O'level)	B	B	OL Taken	He has worked hard recently + I hope he has passed.	
R.I.	B				

EFFORT SYMBOLS:
Very Good A
Satisfactory B
Inadequate C
Very Poor D

STANDARD SYMBOLS:
Very Good A
Satisfactory B
Rather Weak C
Very Weak D

He has a considerable flair for photography and a certain amount of ability in the art field, but there seems to be little chance of realizing his potential if his attitude to his general work continues to be so poor.

J. Turner Tutor

SPECIAL COMMENT

I wish I could understand his temperamental difficulties.

E. Wall M.A., Head Master

FRENCH	D	D	21	29	Utterly lazy & inattentive
MATHEMATICS	B-	B-	28	27	Has ability but makes little effort.
PHYSICS / GENERAL SCIENCE	B-	C+	21	26	Too easily satisfied.
CHEMISTRY	B	B	55	6=	Steady progress
BIOLOGY	B+	B+	52	8=	Pleasing result
ART	B	B	–	–	

Parr was a child of suburbia. He spent his early childhood in Chessington, Surrey, moving as a teenager to Ashtead, near Epsom. The seemingly unpromising hinterland of outer London, forming a ring around the centre encompassing Middlesex, Hertfordshire, parts of Essex, Kent and Surrey, may seem an unlikely origin. But many of the photographers and key players of the new photographic circle that emerged in the late 1960s and early 1970s and who were to have a huge influence on the developing recognition of photography as a fine art in the UK, share roots in this London suburbia. Peter Turner, Sue Davies, Derek Ridgers (a photographer of new style cultures in late 1970s and early 1980s), the artist Helen Chadwick, Jo Spence (who developed Photo Therapy), Barry Lane (the first Photography Officer at the Arts Council of Great Britain), none of these individuals had any kind of allegiance, either through family or education, with an arts elite or with the London bohemia that, in its eccentricity and excess, had dominated British high culture for so long. There were no links with the Sitwells or the Bloomsburyites or with the Beaton circle or even with the rising pop culture of the

1960s. There were no ties with the art school meritocracy of either London or the influential art schools of the North and Midlands: Leeds, Hull, Newcastle or Coventry. Seen from the outside, these worlds were eminently worthy of rejection: dissolute, elitist, upper class or culturally masonic, they were not attractive prospects for the young suburbanites. The systems that existed at leading British art schools, usually dominated by artist-professors and their disciples, were often based on sexism, intimidation and favouritism, where the survival of the fittest was the prevailing norm.

Within this world, photography occupied a peculiar place – it had been practised by conceptualists and pop artists (who occupied high positions in British art schools) but, out-side this narrow range, there were no well-informed people able to teach the medium. At the other end of the scale were the polytechnics, still clinging to their trade and technical status. Few teaching in British art schools were aware of the great European tradition of photography or, even more cru-cially, of the huge wave of photographic energy racing across the Atlantic from the United States. When this finally hit

Britain, it was the Parr generation that saw its value and its vitality, not the increasingly moribund art establishment. This was a group of people who would, by and large, be self taught, who had to impose their own rules and their own standards.

Parr would probably see himself as a true child of suburbia. Listening to him talking about his childhood and teenage years in Chessington and Ashtead is to hear a story of boredom and dullness, of church-going and a childhood dominated by his parents' passionate interest in ornithology. What Parr did become accustomed to during his Surrey childhood, was the idea of watching, very quietly:

'My earliest memories were of going out with my father, in particular on bird-watching trips, day trips, half-day trips and, indeed, bird-watching holidays … Probably, over five years, every Saturday I'd go to Hersham Sewage Works. When I go past it now on the train, I think, "Christ, how many days I spent at this place!" My father used to ring the birds; you had to catch them, these particular migrating birds, and then you caught them again a year later, and he

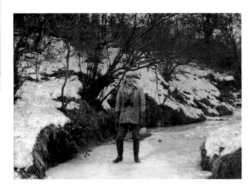

could work out that they'd been from Hersham Sewage Farm to Africa and back. So, I spent many Saturdays at Hersham Sewage Farm – unbelievable isn't it?'

It may seem clichéd to make connections between photography and ornithology, but the correlations are clear. Birds are ordinary wild creatures, but among their mass are special ones, members of a rare species, infrequent visitors to a particular area. To spot them, you must be patient and determined, obsessed enough to believe that what you are doing matters. In many ways, this is exactly how Parr has behaved in relation to documentary photography. Although ostensibly looking at 'the ordinary and the banal' within the great mass of society, he has found the extraordinary within the normal, seen through a gesture or a movement of the body, some strange human interaction. He has also honed in on types within society, just as his parents focused on species within the world of birds – the middle-aged woman with lipstick very bright or a little smudged, leaning forward for a kiss, is a familiar character in Parr's documentary cast list, as is the tourist burdened with guide books, equipment and expecta-

tions. People reading and eating in cars have particularly engaged Parr, as have shoppers, making small decisions, looking, wondering, searching. 'When I went on these trips, and my parents were leading the bird-watchers, I would of course be watching the bird-watchers.'

Parr's interest in typology mirrors the obsession he observed in his youth, displayed by collectors of species. His interest in such people has diminished little, although it was at its height during his early work as a black-and-white documentarist in Yorkshire and the North of England. The Ancient Order of Hen-Pecked Husbands, the Hebden Bridge Camera Club and the obsessive, pious world of the disintegrating chapel at Crimsworth Dean would all become part of a catalogue of British oddity accumulated over the decades. While his vision of the English would grow more raw as the years went on, his preoccupation with the obsessive and the absurd would remain undiminished.

But when he was released from the family ornithological outings, Parr developed an obsessive activity of his own: trainspotting.

'As the trainspotting took off, I insisted on going on my own trips. I'd get a Red Rover ticket, which meant that you could go on London buses for a whole day, and then we'd go off and visit assorted engine sheds. I got interested in trains, steam trains in particular, which are very different from the diesels you get now. I was interested in collecting and numbers, and the romance of steam, I suppose. And all these elements came together in trainspotting. There was this publication called *The Ian Allen Combo*: it's the trainspotter's bible, the list of all the current rolling stock or engines in the country. I would underline all the ones I'd "copped" in it. If you put "c" by the side, it meant that you'd "cabbed" it, meaning that you'd actually got up into the engine cabin. I was interested in it from about the age of thirteen, but by the time I was about to go to college, I'd dropped it.'

Parr is still a collector, of postcards, of souvenirs and ephemera, of wallpaper and of photographic books. His collections are large, disciplined and, you might even say, obsessive. The collections, some of which are displayed in

this book, mirror in many ways the development of Parr's photography: an intense interest in the ordinary coupled with an appreciation of how quickly, through the act of representation, the ordinary can become absurd and remarkable. Parr was, and is, fascinated by the idea of boredom, or what he perceives to be boredom: couples staring into space with nothing to say; a 1960s postcard of a motorway; an aimless stroll through the Hampton Court maze. His perspective on this most complicated and opaque human emotion perhaps sums up all that is both strong and weak about his photographic work. Parr's photography is based on our willingness to judge by surface impressions, to inhabit a visual world where things are what they seem to be, rather than what they might be.

Though Parr's life in suburban Surrey may have failed to provide the stimuli that he would have welcomed, from within his wider family the catalyst emerged that would propel him towards photography. His grandfather, George Parr, was one of a group of photographers, spread throughout Britain and the former British Empire, who were neither professionals nor amateurs, but rather, serious artist-photographers. They were allied to the camera clubs (which themselves had a well-established and relatively powerful national infrastructure) and to the Royal Photographic Society with its traditions of nineteenth-century exhibition and debate.

The nineteenth-century pioneers of photography, often aristocratic (and sometimes royal) were part of a photographic community that included scientists, inventors and critics. By the early twentieth century, photography had become more of a middle-class pursuit, coinciding with the rise of suburbia, the increasing prosperity of the business classes, and the ascendancy of hobbyism. Professional photography, often based around portrait studios, spread throughout Britain as a result of increasing prosperity (which led in turn to a greater demand for family portraits, records of weddings christenings, etc.) and started to become separated from photography as a hobby. The Royal Photographic Society was important in creating a legitimacy for professionals and amateurs alike. With the connotations of academicism, the

various distinctions that could be applied for, and the 'Oxbridge-style' fellowships, otherwise 'unqualified' British men and women were able to feel that they belonged to some kind of an academy, a brotherhood of like-minded souls, sharing information, improving, competing.

Photography did not have the elitism of the fine-art world (which hardly recognized its existence) nor was it a 'profession'. Like building a model boat or growing flowers and vegetables for competition, breeding prize cats or belonging to the Women's Institute, it was an occupation that entirely circumvented the British class system, in which accent and education were of no account. That George Parr was part of this widespread and loosely linked system of photography was significant. He was a Fellow of the Royal Photographic Society, specializing in bromoil (a photographic process in which the image is bleached out and then re-inked, giving a deep-toned rich effect). In the 1970s, Martin Parr would himself become part of a similar group (albeit more contemporary and iconoclastic) of highly individualistic personalities, emerging from a wide range of backgrounds, all having

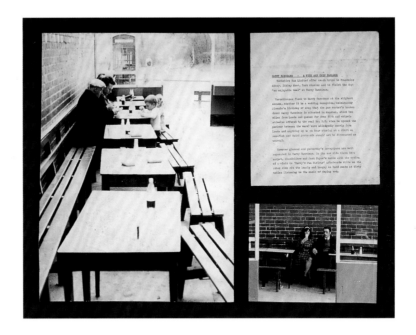

rejected, to varying extents, a conventional educational
or career path.

It was on his holiday visits to his grandparents, George
and Florence Parr, in Calverley, West Yorkshire, that Parr
gained a measure of liberation from the bird-watching trips,
even from the self-imposed discipline of trainspotting, from
the South of England suburbia where life ran to a pattern
dictated by commuting, regular employment and social
conformity.

'The people were very friendly [in Yorkshire]. The houses
were terraced and it felt old. It was hilly there, so it had
much more character [than Ashtead]. Everything about it
felt more engaging to me. When I went to see my grand-
father, first of all I'd go with him to his allotment, and then
I'd go into the darkroom and we'd do some printing together
and watch the picture emerging out of the chemicals, and
then we'd go out on assorted trips to Scarborough and the
Dales and York, all the classic places around Yorkshire. He
would take his camera with him and encourage me to take
mine. I can't remember if he gave me my first camera, but

he certainly gave me my first book about photography.
It was called, I think, *Instructions to Young Photographers*.'

George also took Martin to Harry Ramsden's fish and
chip shop in Guisely, near Leeds, where he made his first
photo-essay.

'I think I was about sixteen when I did it. There were
about four photographs, which I mounted on to a piece of
card … My photographs make it look bleaker than it was.
Despite the fact that I'm identifying with it, I'm actually
projecting it as being quite a sad place.'

Harry Ramsden's was a nationally famous institution
that took the British tradition of eating fish and chips to
a new level. With its checked tablecloths and (for the time)
up-market atmosphere, it broke the divide between the
cramped 'greasy spoon' café, the genteel tea room and the
fancy restaurant. In many ways, it heralded the beginning
of a catering revolution, during which ordinary British
people began to demand higher standards in catering, and
along with the arrival of the package holiday, realized that,
as in continental Europe, eating out could be an affordable,

relatively classless part of everyday life. Photographing
there, Parr learnt some important cultural and photographic
lessons. He learnt that people in restaurants have a certain
vulnerability. They are choosing, waiting, expecting. They are
performing a private function in a public space. Throughout
his photographic career, Parr has returned to the portrayal
of the British eating in public, creating a comedy of manners
and social exposure. From the finger food at the Conserva-
tive Party fête, to the consumption of fast food on the move,
from an elderly couple staring past each other in a drab tea
shop, to a crowd of raucous girls in a New Brighton chip
shop, Parr has produced photographs that form a direct link
to that first photo-essay at Harry Ramsden's. He has become
fascinated by the preparation and consumption of food,
whether a Queen's Jubilee tea laid out in the rain in West
Yorkshire, or the carefully prepared cakes and jam of the
Chew Stoke Women's Institute. He has sensed and exploited
the British uneasiness with food, just as he has sensed their
discomfiture with travel, leisure and each other.

The most common criticism of Parr's photographic work

over the last three decades is that he exhibits a sense of superiority towards those he photographs, that he ridicules them, makes fun of their vulgarity, their unease. But of course, it is more complex than this. Parr delights in a particular vernacular, a Britishness that places the nation far away from its European counterparts. He has photographed the British awkwardness about themselves (which he shares), the hankering for private eating, and for eating as an accompaniment to other activities rather than as an end in itself (Britain is probably the only nation in Europe where many families do not own a dining table).

The problem with Parr's photography, one might suggest, is not with the pictures themselves, but with its crucial core audience, a raft of critics, art directors and commissioning editors who see (like Charles Ryder in Evelyn Waugh's *Brideshead Revisited*) in Parr's photography something that both delights and terrifies them: the greasy-fingered, tabloid-reading people who eat in their cars, who shout and brawl, and who are apart from European culture. Parr has shown, both gently and violently, that the British are the most fasci-

nating of cultural barbarians. Perhaps innocently, perhaps not, Parr has pandered to people's fear of themselves, their wish to be anything but British.

Travelling around Yorkshire with his grandfather, Parr was simply curious. West Yorkshire in the 1960s still clung uncertainly to traditional pre-war values. Untouched by the pop revolution, it was an area where traditions would die hard. Small clubs flourished everywhere, terraced streets were still immaculate, and women still cleaned the pavements in front of their houses. For Parr, it was an idyll, seen through the filter of his grandfather's Yorkshireness. Like many of the young photographers who were to find their inspiration in the North throughout the 1970s, Parr was developing a highly selective vision that enabled him to focus on the quaintness and traditional essence of the North of England, without seeing the concurrent features of decay and inequity that pervaded as manufacturing industries began to close and social problems emerged with astonishing rapidity. If there is fault to be found in Parr and the young photographers who briefly colonized the North, it is that their view,

although gauntly portrayed in black and white, was so rosy. Other photographers (such as Don McCullin, Nick Hedges and, in the 1970s, Chris Steele-Perkins and Paul Trevor) were to produce a portrait of another Britain, another North that belied the myth of the long-running Manchester-set television soap *Coronation Street*, showing a population that was succumbing to severe economic pressures, had as yet failed to break free of Britain's claustrophobic class system and which, behind the facade of the immaculate terraced house, the conviviality of the camera club and the allotment, lived extremely badly.

It is ironic that Parr and his contemporaries (influenced by the British documentarist Tony Ray-Jones) had such reverence for the antiquated and dying customs of the North, but severely critiqued the growth of consumerism and mass tourism that emerged in the 1980s – the first time in the twentieth century that the ordinary people of Britain had any kind of choice about where to shop or where to go on holiday. It was a strange morality that ruled in those days, and one of which Parr and his contemporaries, during

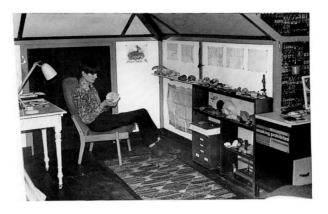

the 1970s and 1980s, would become the major visual theorists.

Yorkshire was also where Parr discovered the English seaside in the resorts of the Northeast of England: Bridlington, Scarborough, Filey, decaying even then as more and more people began to take their holidays abroad, but still a magnet for predominantly working-class families from the North of England and Scotland. This was a time when British industry would virtually close down during the 'holiday weeks', when families would converge on the English seaside for seven days of chips, ice cream, beer and sea bathing. There would always be a fun fair and donkey rides, boarding houses with strict rules and sandy sandwiches.

But Parr only visited Yorkshire for brief holidays during the 1960s. His reality was suburbia and school in Surrey:

'My status at school was very low … People took the piss out of me, and generally I felt that most of the school activities passed me by. I didn't flourish socially there. I didn't enjoy school. I only just scraped through my eleven-plus and got into Surbiton Grammar School where I didn't do well in

many subjects. I wasn't interested in gaining a strong academic background, so I inevitably got interested in art.'

But like most young people, however alienated they may feel, Parr found places in which he could develop his own interests and begin to form a social group of his own.

'I had a room upstairs in our house in Ashtead. I decorated it myself, like a den, and I could go up there with my friends. I got to know people through the Methodist Youth Club. My friend Noel and I were both collectors: he collected stamps and I collected coins. In Ashtead I had a whole group of friends who had nothing to do with school. There were all kinds of people; people like Mandy Kleboe, who was the daughter of Raymond Kleboe, the *Picture Post* photographer. There was also this amazing guy called Max Moldo, and his parents had one of these houses where it was like "open door". Everyone used to go there all the time; it was a very open family. It was somewhere that you could spend hours and hours, and they'd feed you and entertain you. I'm sure that's where I met Noel. I was really impressed by this place, this family.'

Like so many teenagers growing up in the 1960s, not fitting into the conventional academic mould, perhaps a little introspective, or with interests that lay outside (or beyond) the traditional interests of young males, Parr found sanctuary in the school art room. While the grammar schools of the 1960s retained much of the regimentation that had so defined their history, even they had to make way for the looser, essentially more sociable and creative subjects that were assuming an increasingly important place in the nationwide curriculum. Art, drama and music, for so long the peripherals of the English education system, were rapidly becoming part of the mainstream.

The cultural revolution of the 1960s had made these subjects fashionable; writers such as John Osborne, Joe Orton, Arnold Wesker and Shelagh Delany, with their real-life dramas and controversial subject matter, appealed to the young in a way that Terence Rattigan and Noel Coward did not. This was drama that looked at real life, ordinary people, presented in a style that was almost documentary. Parr became an enthusiastic amateur actor and director,

Cover and spread from the Surbiton
Grammar School magazine, 'Surbitonian',
with photographs by Martin Parr, 1969

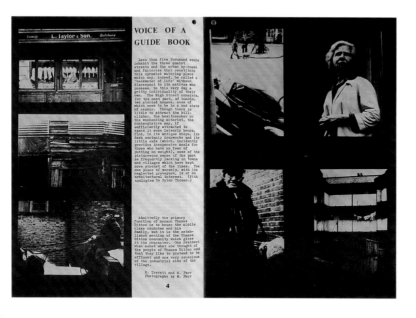

developing an appreciation of the dramatic arena that would, in time, feed into his photography. Photography was the perfect art form for the new cultural revolution. It was firmly part of pop culture, linked as it was to the conceptual artists of the 1950s and 1960s, to fashion (where its chief practitioners became established as pop icons) and to new realism. British photographers such as Roger Mayne, Don McCullin and Nick Hedges began to document Britain in a way that, although following the time-honoured tradition of British documentary photography, was picturing the nation at a crossroads between the old and the new.

Parr was introduced to contemporary photography by Phil Read, craft teacher at the grammar school. Read subscribed to *Creative Camera*, a magazine whose editors and associates would do more to reinstate British photography as an art form than any other group. Run on a tiny budget from a succession of small offices in London, photographer Bill Jay and later Peter Turner, backed by publisher Colin Osman, published portfolios of photographs by practitioners who included Lee Friedlander, Eugène Atget, Walker Evans,

Edward Weston, Garry Winogrand, Bill Brandt, Cartier-Bresson, in fact the whole lexicon of contemporary photographers. *Creative Camera* turned its back on the past (though not on photographic history) and embraced the contemporary. Impatient with the clubiness and hidebound 'professionalism' of the British photographic community, and equally intolerant of the British museums and galleries who did not care to show photography, and the newspapers and art magazines that did not care to cover it, *Creative Camera* and those around it (including the photographers Tony Ray-Jones and David Hurn) looked to American and continental models for inspiration. The magazine espoused and supported a particular kind of photography, much of it inspired by American documentary models. In the early 1970s, independent photo-galleries began to open, usually founded and directed by enthusiasts for the new wave, but otherwise trained in a different field (Sue Davies of the Photographers' Gallery in London had been a secretary at the Institute of Contemporary Arts, Leo Stable of the photographic gallery in Southampton was a university adminis-

trator). However, the art photography that had emerged strongly in the 1960s, but was seen as firmly part of the fine arts, was largely ignored by these new pioneers, who instead gravitated towards photojournalism, landscape and fashion photography. Sue Davies' links with influential picture editors in London, and with the Magnum photo agency, ensured that the brand leader of the British photo-galleries would champion reportage and documentary during the first decade of the renaissance of contemporary photography. It was inevitable, given the status of the London gallery and the prevailing thrust of *Creative Camera*, that the others would, to a greater or lesser extent, follow suit.

Much of Parr's later career would be determined by the emergence of this new photography culture and the systems that developed to support it. But it was the showing of two major exhibitions in London that were the catalyst for Parr's growing interest in photography: the Bill Brandt exhibition, organized by the Museum of Modern Art in New York and touring to the Hayward Gallery in 1970, and the Cartier-Bresson exhibition at the Victoria and Albert Museum.

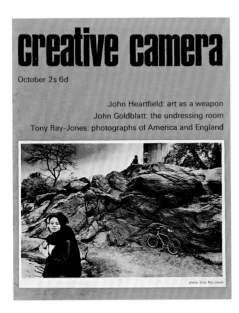

Not only did they enthuse Parr with their content, but
also perhaps because of the importance of the venues in
which they were shown, and the attendant press coverage.
Parr's subsequent career would be powered in part by
his wish to see his own photography elevated to such high
status.

'The Brandt show was immediate, accessible, all those
things. I got the [photography] bug then and I've had it ever
since … I was probably ultimately more impressed by the
Cartier-Bresson show than I was by the Brandt. I liked the
way Bresson juxtaposed people, and the relationships he
made between the people and their immediate environment.
That was very engaging.'

The emerging photo-galleries justified their presence (and
their funding) by insisting on the marginalization of photo-
graphy since the 1950s, and while Parr became part of this
agenda, showing repeatedly in the new photography galleries,
there was always a sense of expediency in his strategy, of
utilizing these new institutions until such time that the art
world might again embrace photography.

Always seeing himself as a communicator, Parr contri-
buted photo-stories to the school magazine and worked on
his photographic skills in the school darkroom. He even
set up his own private museum in an outhouse of the family
home, showing yet again the interest in collecting that would
become such a dominant force as his career progressed.
He applied to full-time photography courses in the UK,
was turned down by Derby but accepted by Manchester
Polytechnic, where the course, though still fairly traditional,
had some members of staff who were aware of new move-
ments in photography. Manchester was an exciting prospect
– it was in the North, where Parr had always felt at home;
it was gritty and industrial and so presented an immediate
and welcome contrast with suburban Surrey; it was far
away from London, which was still dominated by the 1960s
culture of fashion and style with which Parr had never felt
an affinity. It was also the home of *Coronation Street* and a
working-class culture that attracted Parr, both photographi-
cally and emotionally. In October 1970 he took the train
north and entered a new and exciting arena.

Wallpaper

serious beginnings

'I went for interview at colleges in Manchester and Derby and I was enormously impressed by people doing these creative photography courses. I was impressed by people smoking in the darkroom – the idea of having your own darkroom and being able to smoke in it, I just thought was absolutely fantastic. And I remember very distinctly a project that had been set where someone ended up photographing a donkey and putting a carrot in front of it and me thinking that this was, like, the height of creative achievement.'

The year that Parr joined Manchester Polytechnic was an interesting one. Fellow students included Daniel Meadows, who after leaving college would take a double-decker bus around England making portraits and documentaries (the story of which is told in the books *National Portraits*, 1997 and *The Bus*, 2001), and Brian Griffin, who, during the 1980s, was to become a highly respected editorial photographer. Parr and Meadows formed a particular bond. Meadows came from rural Gloucestershire, where his father was an estate manager. Like Parr, he

had disliked school, was not particularly academic and came from a family in which emotions were not easily expressed, where social patterns were quite rigid. 'It was the first time', Parr remembers, 'that I was genuinely enjoying myself, having escaped from the constraints of suburbia. It was the classic sort of student life: debauchery, drinking, smoking pot, eating curries. It was like landing in heaven.'

Together, Parr, Meadows, Griffin and Jackie Ward established their own informal and fairly exclusive photographic salon. They would set themselves assignments and award prizes for the most successful.

'We'd go to different events on a Saturday. I remember very clearly going to the National Brass Band Competition at Bellevue, and Daniel and Jackie went to Knutsford Festival. Then we would come back and process the pictures and John Greenwood and a few other people would act as judges, and then they made a trophy. Another competition Brian and I used to do was that you would have a Polaroid camera and you'd have something like

two minutes, and you were allowed to move one thing in the room if you wanted to, and you'd have to see if you could take a good photograph within a given time, and then these too would be judged. There weren't any prizes for that one. In a way, we created our own educational projects, which we enjoyed and which we did just because we liked doing them.'

The years at Manchester Polytechnic were highly significant ones for Parr. In Griffin and Meadows he had met two people whose interest in photography was every bit as obsessive as his own. He began to look even more closely at the photographic culture that he had glimpsed in Phil Read's copies of *Creative Camera*:

'The really significant photographs I saw were by the Americans, Robert Frank, Lee Friedlander, Garry Winogrand, Diane Arbus – the people who were shown in Szarkowski's 'New Documents' show at MOMA in New York (1967). This was such a pivotal exhibition. They were so fresh and exciting. They took the kind of photographs you really hadn't seen before. The first book I bought was

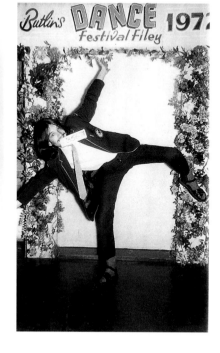

Robert Frank's *The Americans*. And I've still got that copy. I remember Brian and me looking at *The Americans* almost as if it was a dirty magazine, you know, as if it was something naughty. The staff at the Poly, at this particular point in time, just didn't know what was going on in contemporary photography. Within six months, I was more knowledgeable than they were. They would be much more interested in the sort of top-rung advertising people who had come out of the 1960s: Bailey, Donovan etc. They were the people they aspired to. There was just one lecturer, a guy called Alan Murgatroyd, who was a photographer-cum-filmmaker and was interested in the photographers who fascinated us, and I suppose I owe my photographic career to him, because he would show us good work and he knew about this different kind of photography.'

It was Murgatroyd's intervention that prevented Parr from being expelled from the Polytechnic after he failed his theory examination at the end of the first year, and who also supported Parr's decision to photograph the

inmates and surroundings of Prestwich Mental Hospital, which was to be his first cohesive documentary project:

'I'd visited the brother of a friend at the Poly, who had been admitted to the hospital. I was so taken with the place that I decided to do some work and sort out permission to photograph there, then got stuck in for the next three months, photographing constantly. Visually it was very striking. The whole atmosphere … you just knew there was scope there. When you're a nineteen-year-old photographer, you have aspirations, but it's difficult to know actually what to say. But suddenly I found something I wanted to articulate. That's when [my photography] really took off. I spent a lot of time there. The lecturers at the Poly tried to discourage me from spending so much time there; they thought it was taking too long. The whole idea of doing something thoroughly didn't really have currency in those days. At the end of my first year, I had pictures from Blackpool and assorted projects like one about fish and chip shops, but nothing substantial, so they weren't really convinced.'

It was to Griffin that Parr gravitated for those obsessional photographers' conversations about detail and composition, and with Meadows that Parr developed his fascination with subject matter. Parr and Meadows were equally interested in the notion of Northern vernacular and they set out to find the 'real' Coronation Street. This popular TV series, set around a local pub, The Rovers Return, and peopled by characters such as its landlady Annie Walker, Ena Sharples, a plain-speaking pensioner in a hair net, and Ken Barlow, a local teacher, had seized the imagination of the British people from the 1960s onwards. It explored life in a close-knit street of small terraced houses, full of gossip, small dramas and larger-than-life characters. It could not have been more different from Surrey or Gloucestershire. It was as if Parr and Meadows wanted to reclaim something that they had never owned: a heritage, a history far removed from their own childhoods. So they searched for the real Coronation Street, in Salford, near Manchester. They didn't find the actual street on which the series was

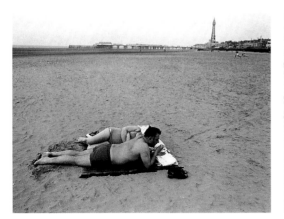
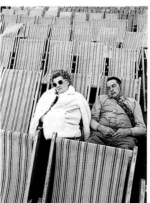
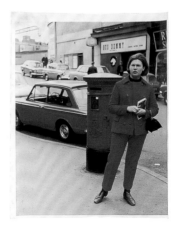
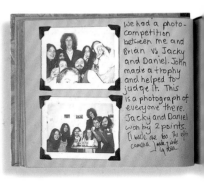

based, as it had already been demolished, but they found a neighbouring street, and began to photograph the residents in their sitting rooms. The pictures were simple studies of people, no drama, no movement. But they were carefully observed, and the photographers' fascination with the artifacts and furniture assembled by their subjects was obvious. 'These', the photographs seemed to shout, 'are real people'. It was a time when the only real people, the only real subjects were the working classes, and Parr and Meadows were as fascinated by them as if they were survivors of a lost tribe:

'I think the street was going to be demolished fairly soon, and one of the ideas was that we should photo-graph it as it was. It had been used in some of the early shooting of *Coronation Street*, because it was a very classic street to look at – a wonderful Salford terraced row. Of course, now it's disappeared.'

The partnership between Parr and Meadows continued throughout their time at Manchester Polytechnic, and together they decided to apply for jobs as photographers

at Butlin's holiday camp. They were sent to Filey, on the bleak east coast of Yorkshire, a place that Parr remem-bered well from his visits to his grandfather. At Filey, they found a capsule of working-class life as unspoiled as if it had been buried in the 1950s. And it was working-class life writ large, where entertainment was laid on, and included a whole collection of competitions (Glamorous Grandmother, Knobbly Knees), which occupied that uneasy territory between the music hall and the freak show. All the guests ate together on long wooden tables in huge dining halls. Families slept in wooden chalets and were woken up each morning by a cheery voice shouting 'Good morning campers!' There were indoor swimming pools, bowls, organized games, crazy golf and, at night, singers, dancers and comedians. And it was very very cheap, its prices geared exactly to the disposable income of the average working man at a time when wives rarely worked and holiday pay had only just been introduced. You didn't need a car to be at Butlin's, and few people had them. You didn't even need to go outside the camp,

for everything was provided and, bar the extras, paid for in advance. Many children who grew up in the 1950s have memories of a Butlin's week, though not all are fond ones. Rules were strict in the camp and there was no real room for individualism, or for the kind of man, woman or child who had higher expectations of what a holiday should be. But for Parr and Meadows it was perfect. They were paid to be photographers and after they had made the portraits that Butlin's sold on to the customers, they were free to make their own work:

'We had to take more photographs than I had ever taken before in my life. We had to photograph people in the dining room during the day, first in black and white, then later with half-frame colour transparencies, which we put into these things called "mini viewers". Then we had to go round and sell them. We put them on people's tables and would then go round again and say, "Would you like to buy your mini viewer?" And people would say, "What happens if we don't buy it?" "Oh, we just throw them out." And this sold more photographs than anything

else. As well as doing that at dinner time, the main work was photographing in the evening round the bars and people getting tanked up. I did this for two years, Daniel did it for one. In the first year I was a "black-and-white walkie", and in the second year I was promoted to being a "colour walkie", and that meant I was able to photograph in the Beachcomber Bar, which was this wonderful kitsch bar with a "thunderstorm" that came on every thirty minutes.'

It was while working at Butlin's that Parr became interested in collecting postcards, particularly those made by the John Hinde company. There was an air of unreality, of high colour and sometimes incongruous elements in the Hinde cards that fascinated him. His collection has since developed into a major interest. For Meadows, the Butlin's experience was more troubling than it was to Parr. He saw it as a darker, more violent place. Unlike Meadows, Parr was steadily narrowing his focus so that he concentrated on seeing what he wanted to see in any given situation. While both photographers made much the same

kind of photographs during their time at Butlin's, it would be fair to say that Meadows' were the most socially concerned. Parr was looking for interesting visual combinations, for evidence of kitsch, while Meadows looked more closely at people. It was the beginning of a tendency in Parr's work for which he would attract growing criticism over the years: that he exploited poverty and poor taste, that he laughed at people less fortunate than himself, that his photography was evidence of class superiority. This debate would come to the fore in the mid 1980s, when Parr began to work in colour and started to receive wide exposure, but it could be said that the seeds of a particular type of social and class comment in Parr's photography began at the holiday camp in Filey. Looking back at the Butlin's work and at subsequent projects, he remarks:

'I don't have a problem with the fact that I'm middle class going to photograph the working class. I think there's this rather precious approach that if you're middle class you can't go and criticize the working class, and

certainly my photographs have a critical bite to them. In those days, we were all blissfully unaware of those issues. I knew I was middle class … when I went to Manchester. I was aware that I was from the middle classes, and I was going to live in a place that is predominantly more working class. But I didn't have a problem with that; in fact I found the general behaviour within the working class to be much more friendly and conducive … I accept that everyone has a point of view, but it's not going to stop me either photographing working-class situations or upper-class situations. I just accept that that's one of the things that comes with photography. Photography is full of guilt; much more so than film or theatre, where you get cutting works, but the same kind of questioning doesn't seem to be so apparent. Mike Leigh is a very good example of that, though of course he's using actors. And I accept that all photography is voyeuristic and exploitative, and obviously I live with my own guilt and conscience. It's part of the test and I don't have a problem with it … When people say to me on the street "You don't

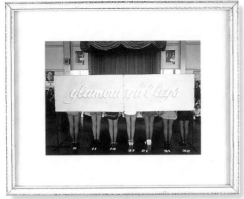

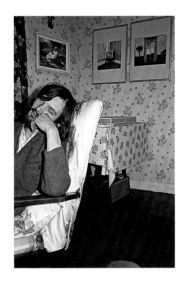

have the right to take my photograph", sometimes I feel
they want me to take photographs of them, because
they know I have the right to do it. It's a very complicated
issue, and I know photographers find it difficult to
talk about.'

What is perhaps interesting about Parr's reflections
on his photographs is that he was so aware of the class
base of his work, even as a twenty-year-old at Butlin's.
It's interesting that he has clung on so firmly to his
'middle-classness' throughout his photographic career,
through the decades of enormous social change in
Britain, through the disintegration of the class system
that occurred during the Thatcher years and the expan-
sion of the British economy. Interesting too that in more
recent works (for example 'Common Sense', 1995–9
and 'West Bay' in 1997) he has focused even more
sharply on junk food, mass tourism, mass-produced
kitsch. In this, he stands apart from other photographers,
both of his own generation and the generations to
follow.

It could be said that when Parr was a student in
Manchester, his young career was at the crossroads.
He showed a real interest in conceptual art, making the
board game 'Love Cubes' in 1972 and the remarkable
installation 'Home Sweet Home' in 1974. For Parr, 'Home
Sweet Home' was a combination of all his interests:
documentary photography, kitsch, collecting, the domestic
interior, and an expression of his deep frustration with
the traditionalism of the Manchester photography
course. It was a challenge thrown out to the studio
photographers, the technicians, the old guard of British
photography:

'"Home Sweet Home" was the vehicle where all
those different ideas and experiments finally found
a sort of resting place … I did it as my diploma show in
Manchester, where I actually built a freestanding room-set
in the middle of the hall, and I put a window in that was
my own window in Manchester, which I photographed
and then blew up to life size and stuck on the wall so you
actually got the same view that I got from my house in

Moss Side. And then I decorated this with rose wallpaper
and put all these different objects around, many of which
I put into kitsch frames that I got from Woolworths. And
I had a tape recorder going of *The Sound of Music* and
South Pacific, and cheap perfume. So it became a whole
photographic environment, which was actually quite
unpleasant to be in. I liked the kitschiness of the frames,
the fact that they would be very much against the whole
sort of preciousness of photography that I've never been
particularly into. And I just like the fact that photography
is this popular, democratic sort of art form, and that these
frames are a good way of expressing that whole idea.
I also glued cake decorations on to the frames just as
a sort of send-up of the type of picture.'

But in the 1970s photography and fine art did not cross
over in the way they do today. Whereas some of Britain's
most radical fine artists were teaching at British art
schools in the 1960s and 1970s, that level of established
photographic talent was not attracted to teaching. So
photography students like Parr, Meadows and Griffin

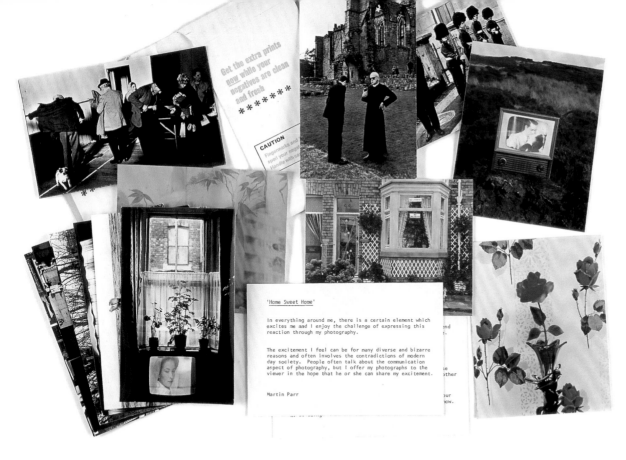

'Home Sweet Home'

In everything around me, there is a certain element which excites me and I enjoy the challenge of expressing this reaction through my photography.

The excitement I feel can be for many diverse and bizarre reasons and often involves the contradictions of modern day society. People often talk about the communication aspect of photography, but I offer my photographs to the viewer in the hope that he or she can share my excitement.

Martin Parr

HOME SWEET HOME

* YOUR

PHOTOGRAPHS

found their own way in photography by looking at books, by subscribing to *Creative Camera* and Bill Jay's *Album* magazine, by visiting exhibitions, attending talks and supporting each other. Very little of photography's history was taught, and certainly no theory. It was not until David Mellor began teaching the cultural history of photography at Sussex University that students (importantly, not photography students) who were conversant with the social and intellectual ramifications of the photographic image began to emerge. Bill Jay, whose lecture tour around Britain in the early 1970s has now become a legend, taught photography through passion and constant reference to the image. It was inspirational, but not enough to give young British photographers a context for the work they were doing.

Later in the 1970s, with the introduction of theory to British photography courses, a huge confusion arose between photographers who had absorbed the theories of Victor Burgin, Michel Foucault and the like, and photographers who understood the medium primarily through the work of a canon of other photographers. The confusion arose not just because the two kinds of photographers and their supporters in academia and the media became embattled, but because both ways of thinking were so speculative and poorly applied. Photography wanted to be art, photographers wanted to be artists, but at the same time, they wanted to be separate and special. Venues such as the Photographers' Gallery in London felt that they had to cater for all tastes within photography, from the war photography of Don McCullin to the beauty shots of Barry Lategan. And because of the hunger for publicity and funding, the lack of clients or substantial patrons, photography, until the late 1980s, kept its halfway status between commerce and art; it developed its somewhat flawed theoretical base yet clung to its pragmatism.

Parr is a product of this and perhaps (in cultural terms) a victim of it too. Many of his photographs from the late 1970s and 1980s are like great pop songs: everyone knows the tune and they become part of the cultural currency, but not many people stop to wonder what they might mean. They were critiqued, from the 1970s through to the 1980s and 1990s, by writers who either supported Parr because of the power and strength of his work, or opposed him because of what they saw as his dubious politics. Looking back through the many reviews that Parr's exhibitions have attracted over the last thirty years, it is almost impossible to find any coherent and substantial arguments around his work. It would seem that he has attracted primarily apologists or attackers, some of whom have been exceptionally vehement. You could say, because of this, that he has never been taken entirely seriously (in the way, for instance, that the colour documentarists Tina Barney, Stephen Shore, William Eggleston and Nan Goldin have been seriously critiqued in the United States). If Parr had become the conceptual artist he might well have been had he not been seduced by the power of the documentary image, the reaction to his work would, undeniably, have been quite different.

In Manchester, Parr lived in Moss Side, a crumbling

Poster for the 'Home Sweet Home'
installation at Impressions Gallery,
York, 1974

Martin Parr at Butlin's, Filey, 1972

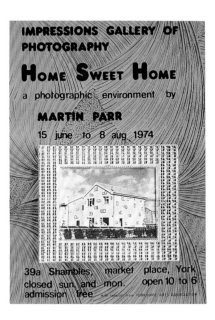

area of terraced streets, corner shops and curry houses.
He liked living there: people were friendly, his surround-
ings were intriguing, there were all kinds of objects to
collect, there were like minds to communicate with, it
was cheap to live and so far away from London that there
were few cultural pressures. At the Poly, the Photographic
Society was active and ambitious. Fashion photographer
Terence Donovan and art director David Hillman, then at
the height of fashionability, came to lecture, as did young
photojournalist Chris Steele-Perkins. During one session,
Meadows put a free picture on each of the chairs, to
demonstrate that photography should be 'throw-away'.
They were an anarchic crowd of students with a particular
distance that set them aside from their contemporaries
at British universities. They did rather than talked, went
on expeditions, organized competitions. In a way, they
were strangely old-fashioned, and part of their fascination
with working-class life was the fact that they could do
old-fashioned working-class things: visiting Blackpool,
hanging around fish and chip shops, going to ballroom

dancing competitions. They liked 'ordinary' things and
'ordinary' people. When Parr and his contemporaries left
Manchester, all but a few stayed in the North, to continue
their quest for 'the real'.

For Parr, the decision to move to the small Yorkshire
town of Hebden Bridge was a highly significant one. With
Meadows, he had made 'Butlin's by the Sea', which was
shown at Impressions Gallery in York and then toured.
He had made the astonishing and controversial room-set
installation 'Home Sweet Home' (which almost caused
a split in the teaching staff at the Polytechnic), also rebuilt
for Impressions and then shown at the Arnolfini Gallery
in Bristol. But a career as a gallery artist was not available
to Parr then as it might be to a similar talent now. He
wanted to publish his work (some of it had already
appeared in *Creative Camera*); he wanted to earn a living
through his photography, and, always a pragmatist, he
began to develop strategies for developing as a photogra-
pher in a number of arenas. The first of these strategies
was his decision, in 1974, to move to Hebden Bridge.

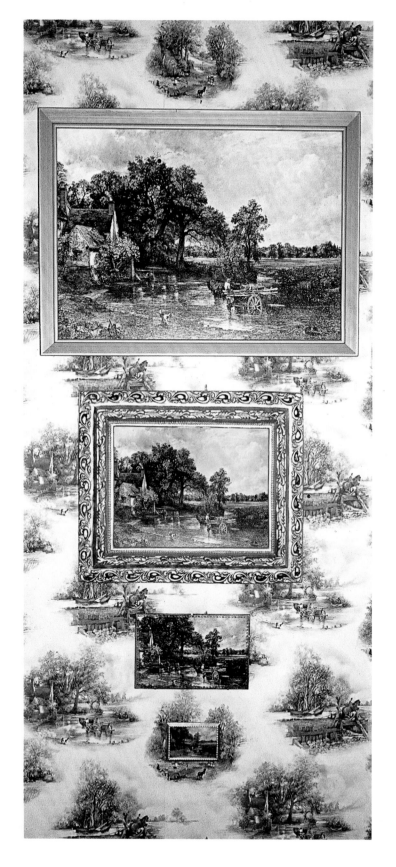

'Diminishing Hay Wains' from the 'Home Sweet Home' installation at the Arnolfini Gallery, Bristol, 1975

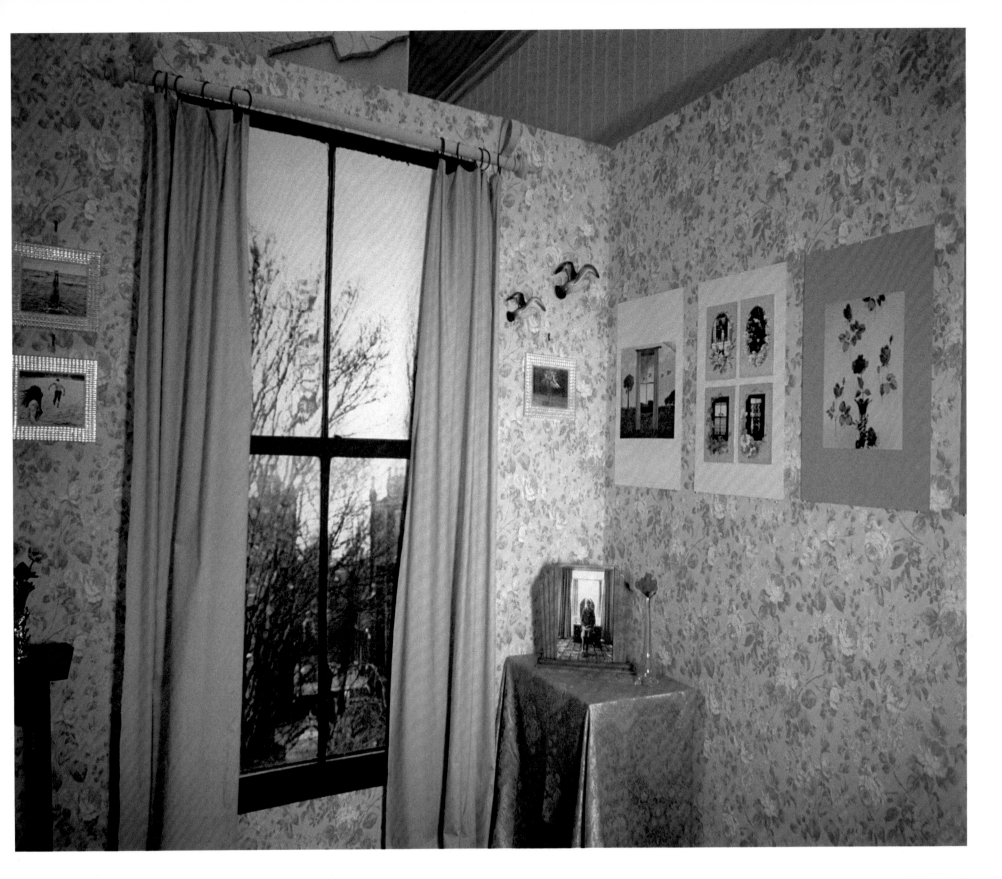

'Home Sweet Home' installation, Manchester Polytechnic, 1973

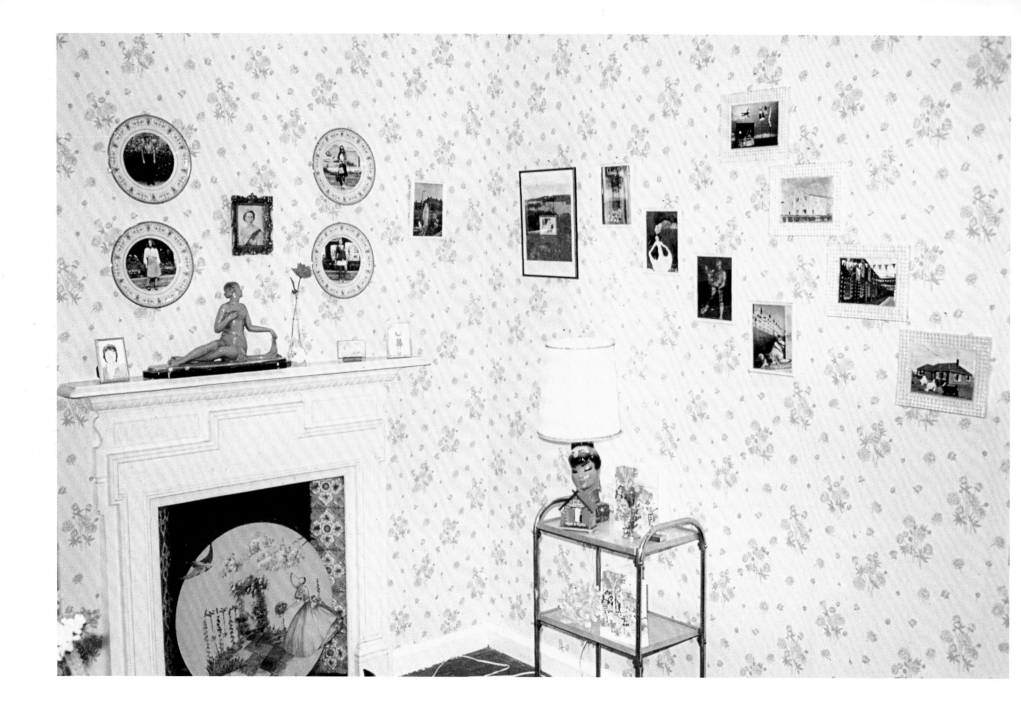

'Home Sweet Home' installation, Impressions Gallery, York, 1974

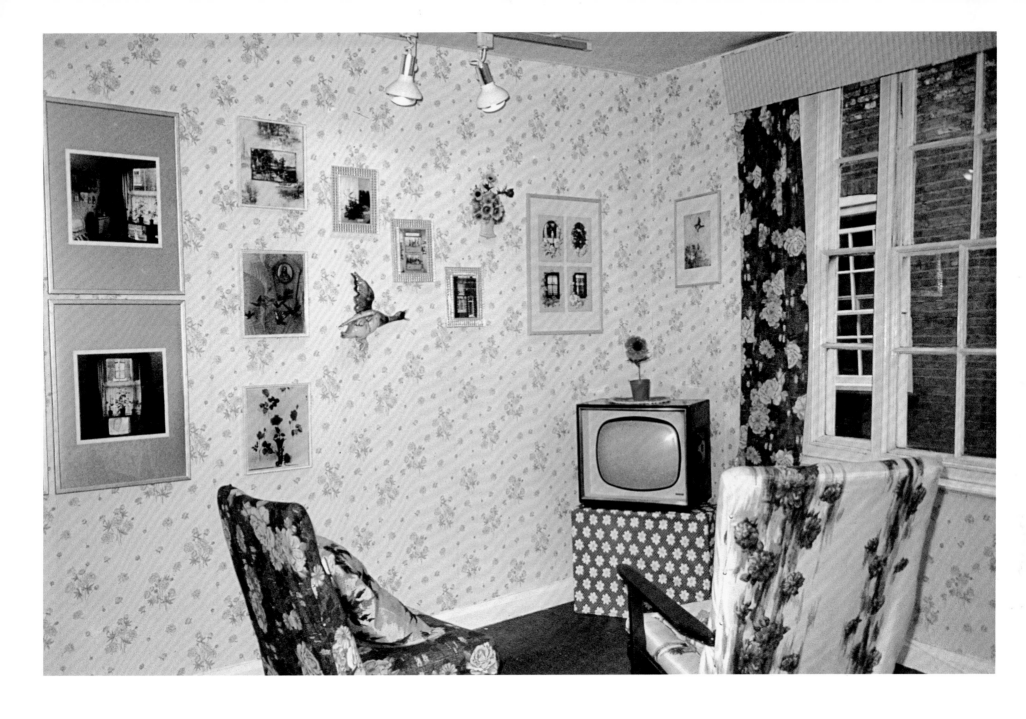

'Home Sweet Home' installation, Impressions Gallery, York, 1974

From the 'Home Sweet Home' installation, 1974

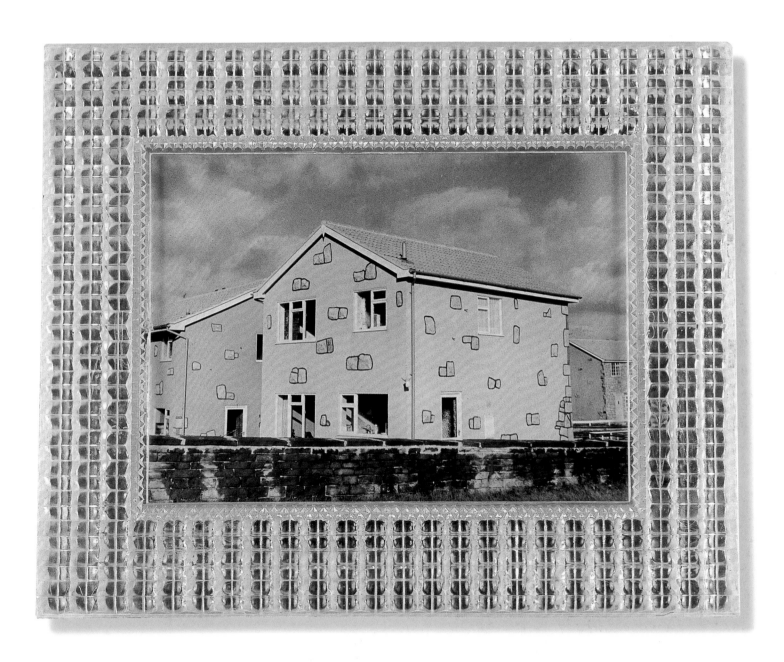

From the 'Home Sweet Home' installation, 1974

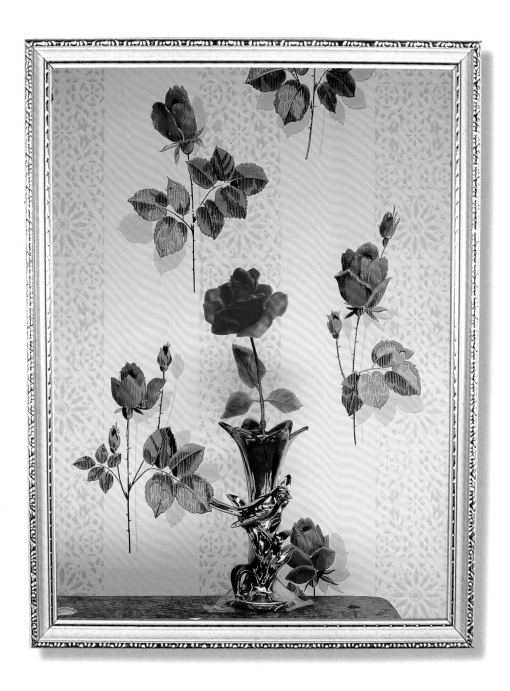

From the 'Home Sweet Home' installation, 1974

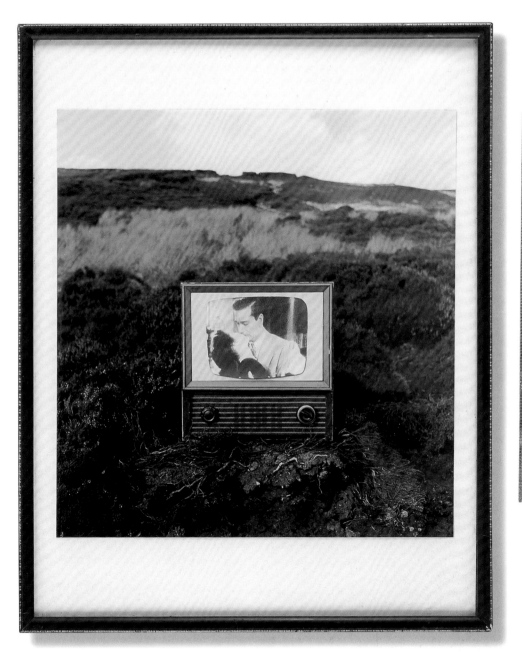

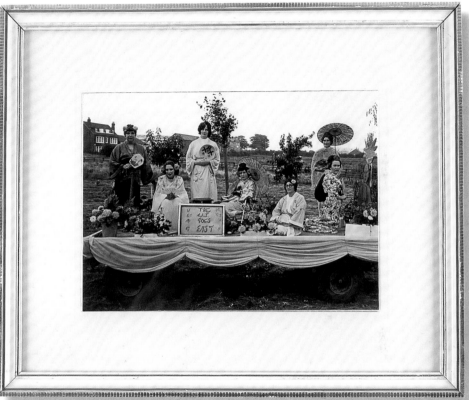

From the 'Home Sweet Home' installation, 1974

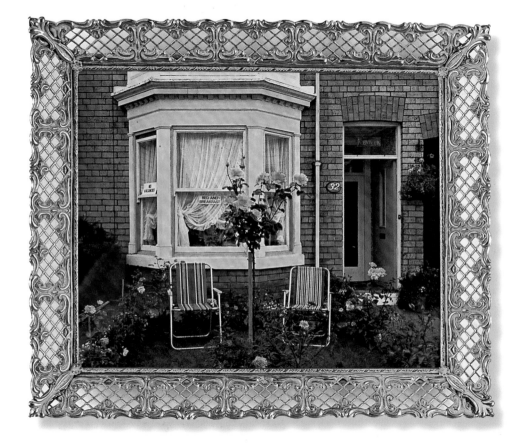

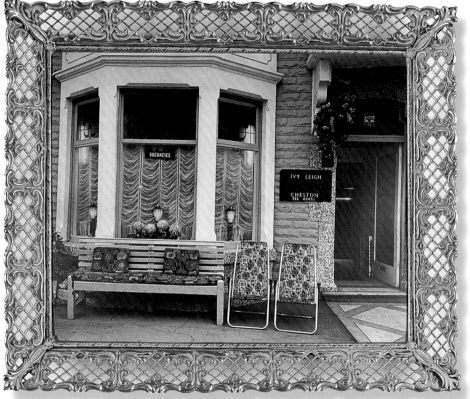

'No Vacancies', from the 'Home Sweet Home' installation, 1974

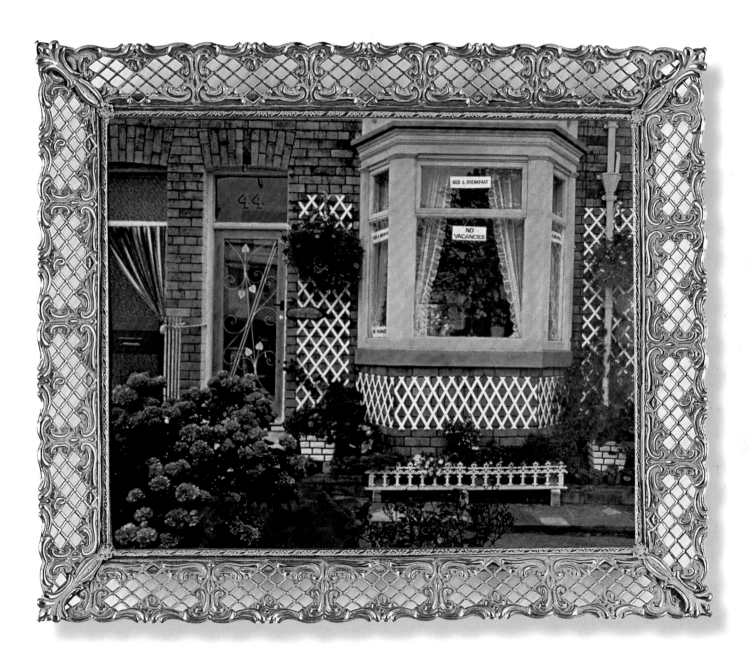

'No Vacancies', from the 'Home Sweet Home' installation, 1974

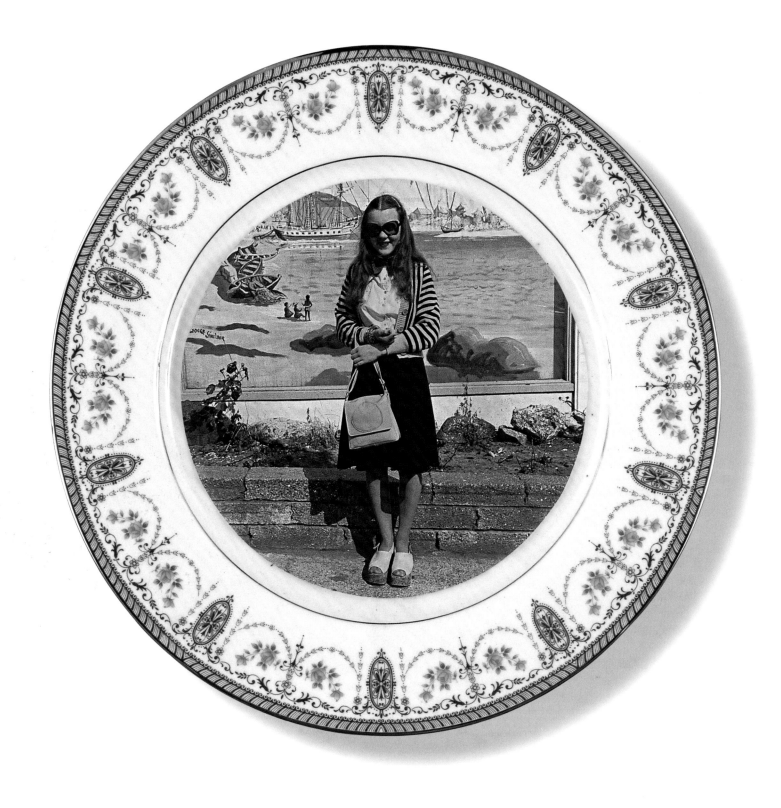

'Bopper plate', from the 'Home Sweet Home' installation, 1974

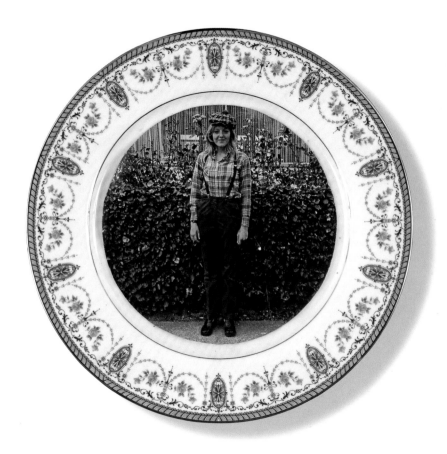

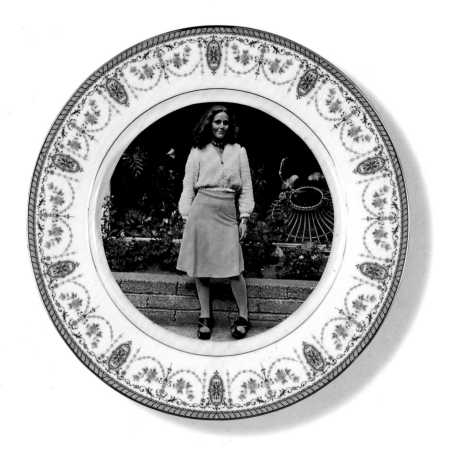

'Bopper plates', from the 'Home Sweet Home' installation, 1974

From the 'Home Sweet Home' installation, 1974

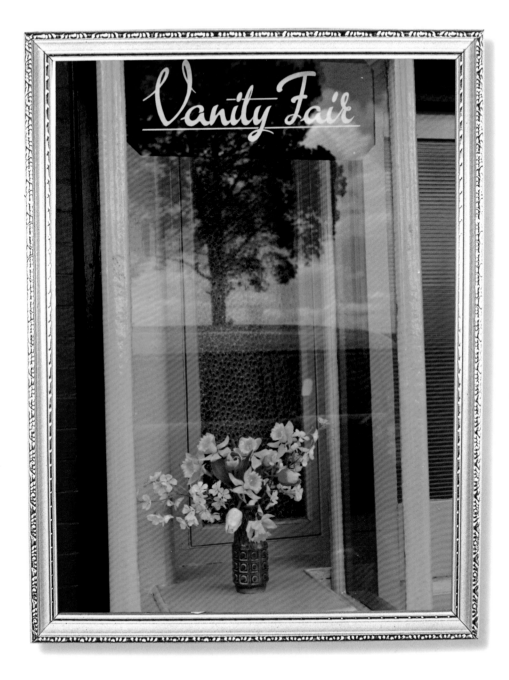
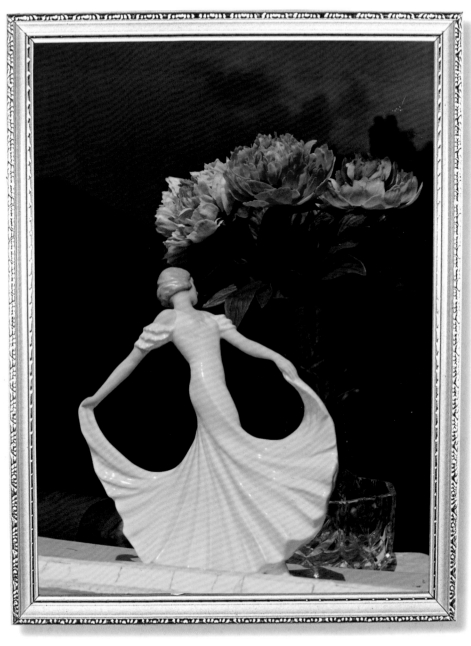

From the 'Home Sweet Home' installation, 1974

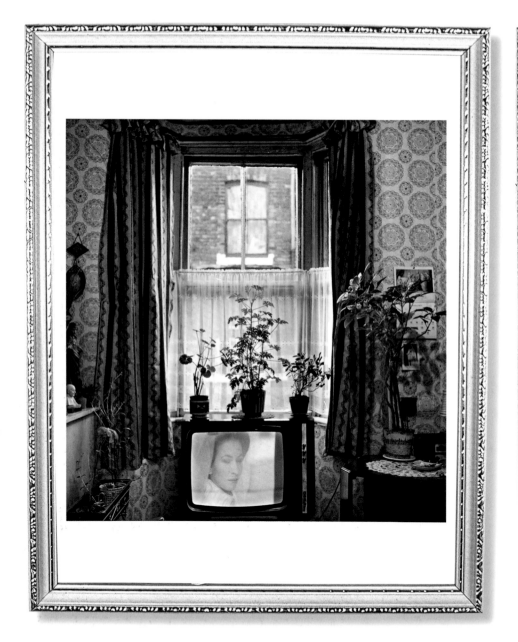
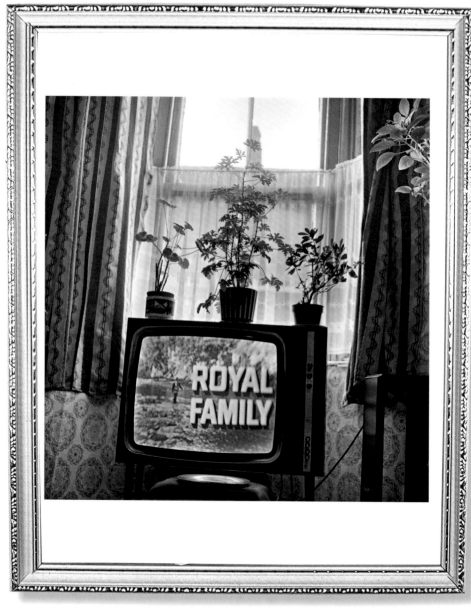

Princess Anne's wedding, from the 'Home Sweet Home' installation, 1974

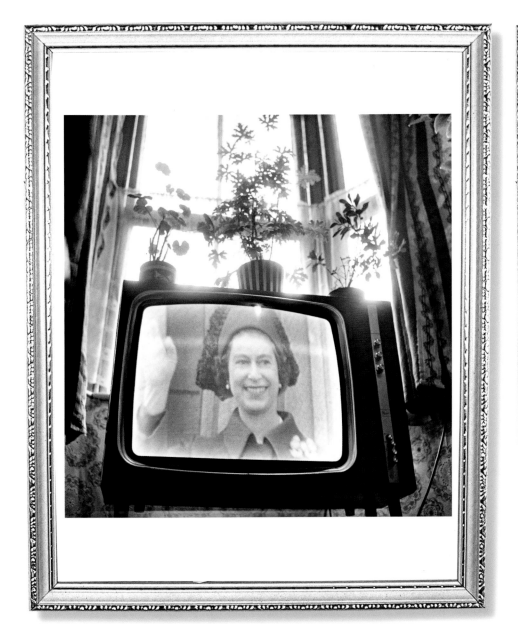

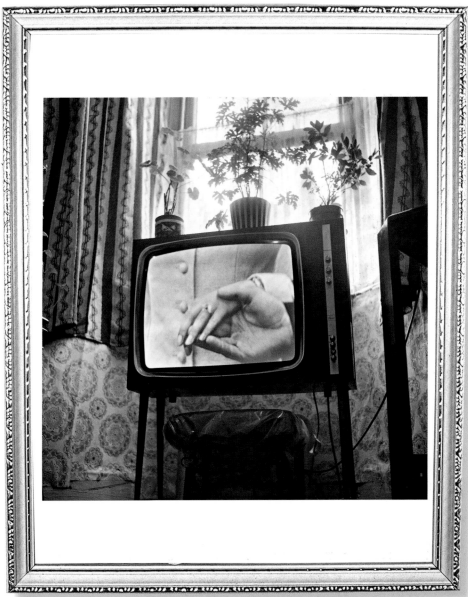

Princess Anne's wedding, from the 'Home Sweet Home' installation, 1974

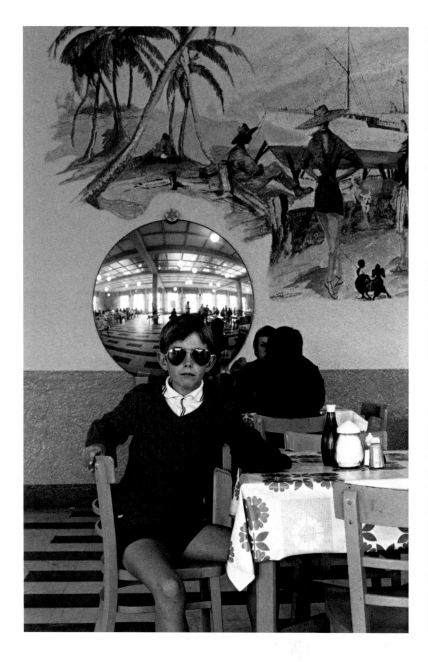

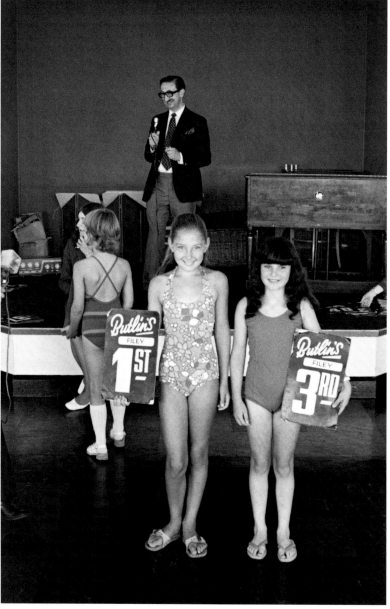

From 'Butlin's by the Sea', 1972 (left photograph by Daniel Meadows)

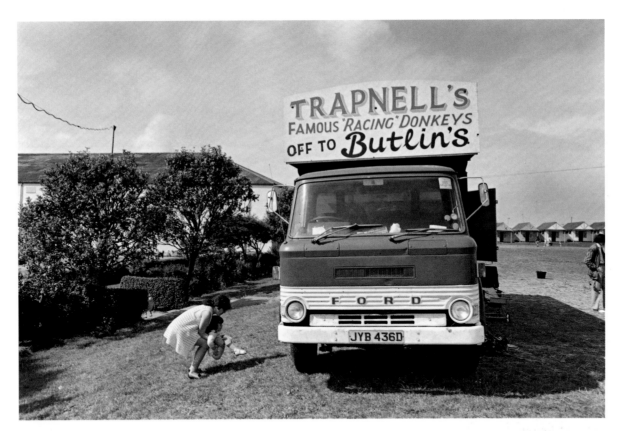

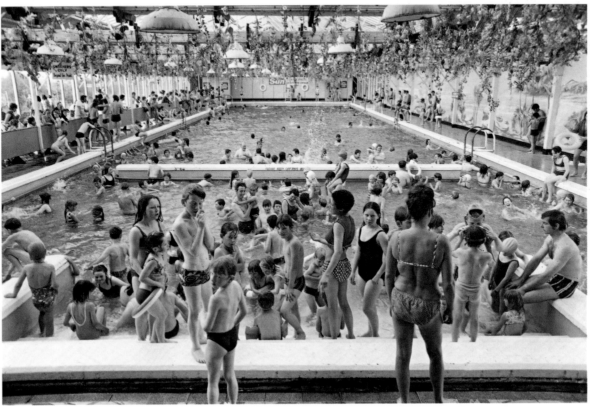

From 'Butlin's by the Sea', 1972

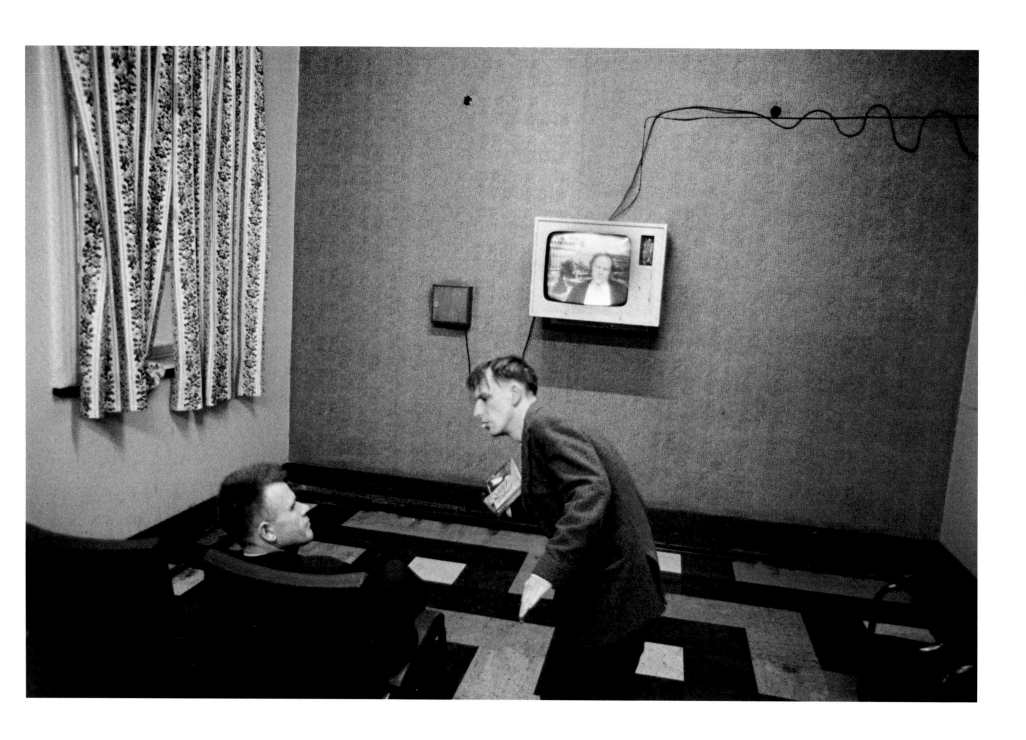

Prestwich Mental Hospital, Greater Manchester, 1971

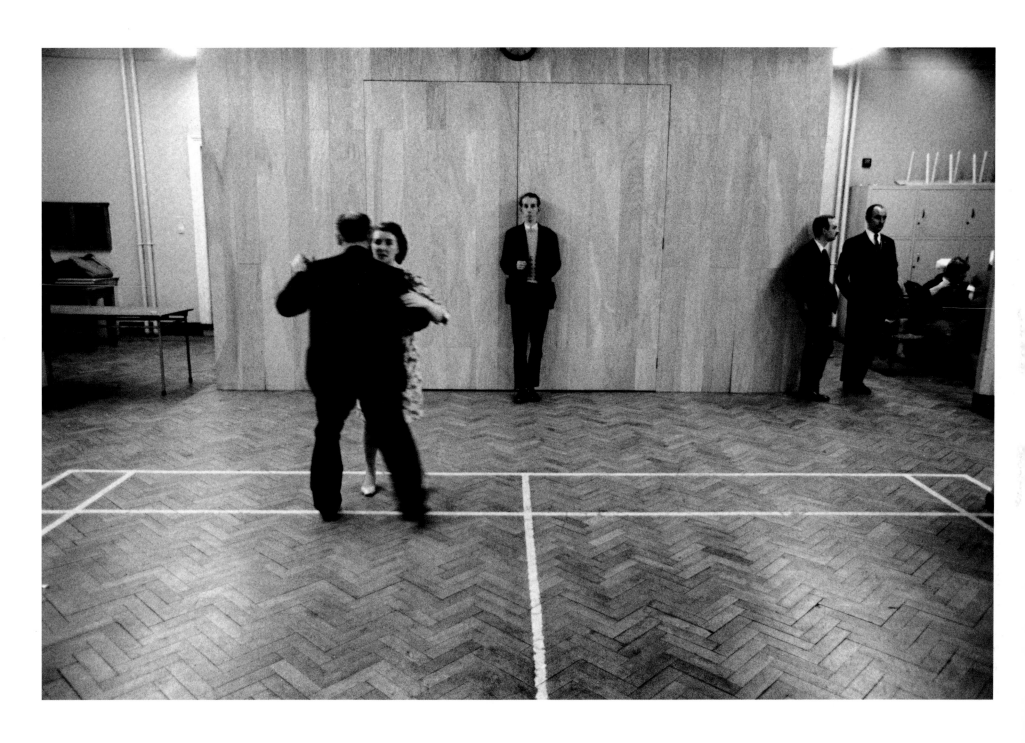

Prestwich Mental Hospital, Greater Manchester, 1971

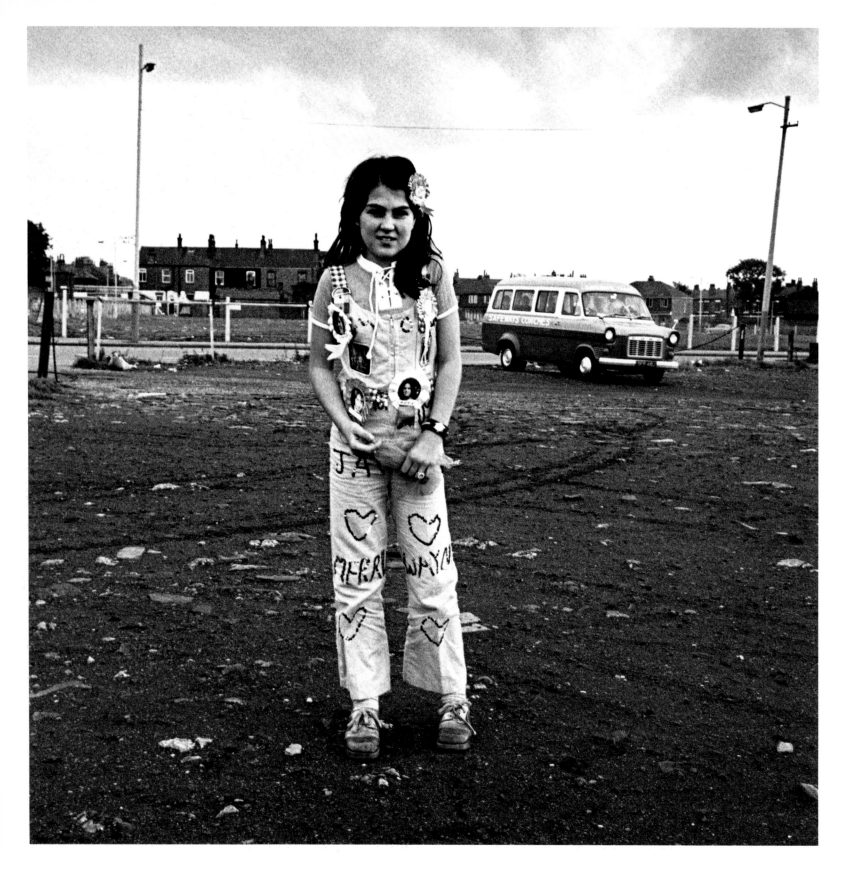

Osmonds fans, Manchester, 1973

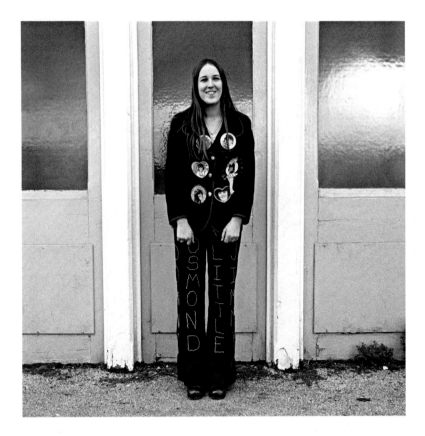

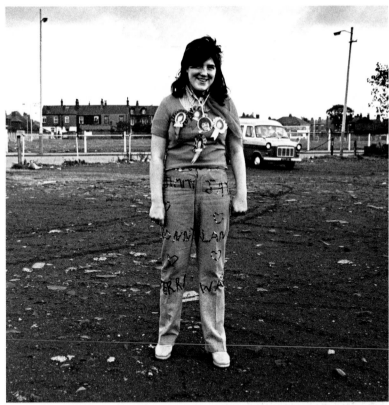

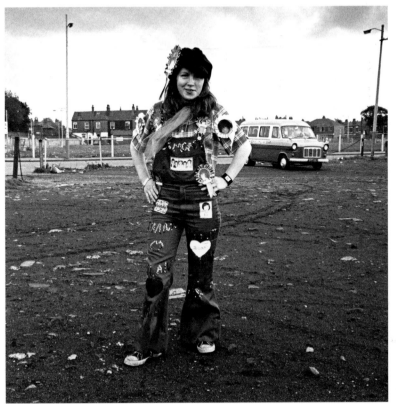

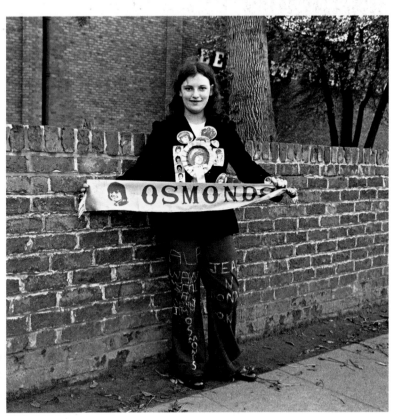

Osmonds fans, Manchester, 1973

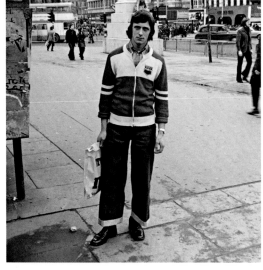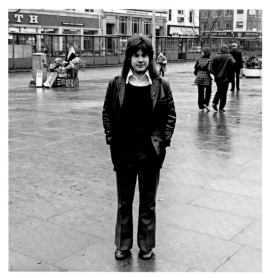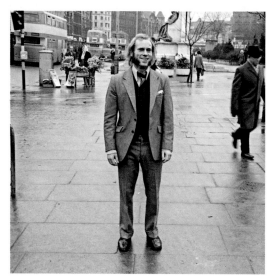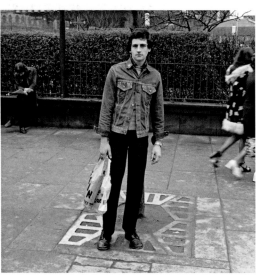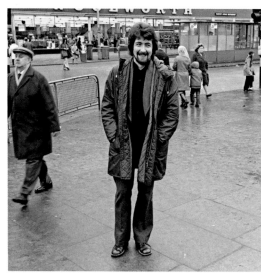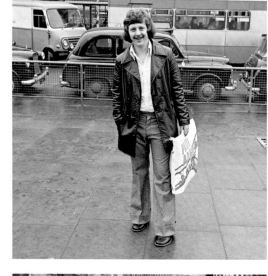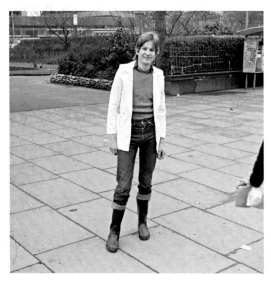

'Love Cubes' board game, 1972

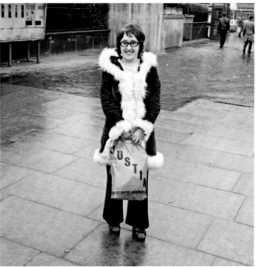
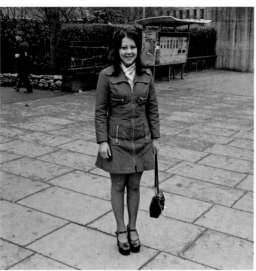
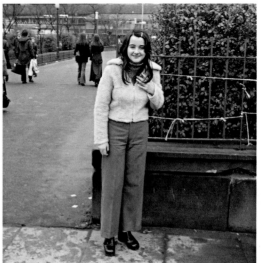

'Love Cubes' board game, 1972

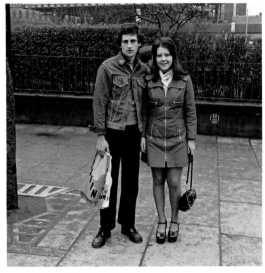

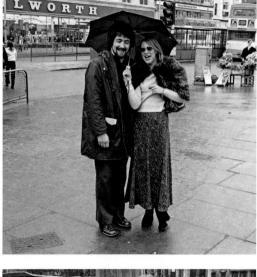
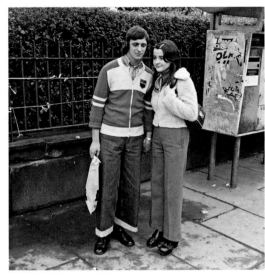
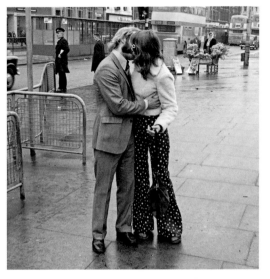
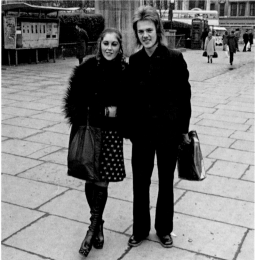

'Love Cubes' board game, 1972

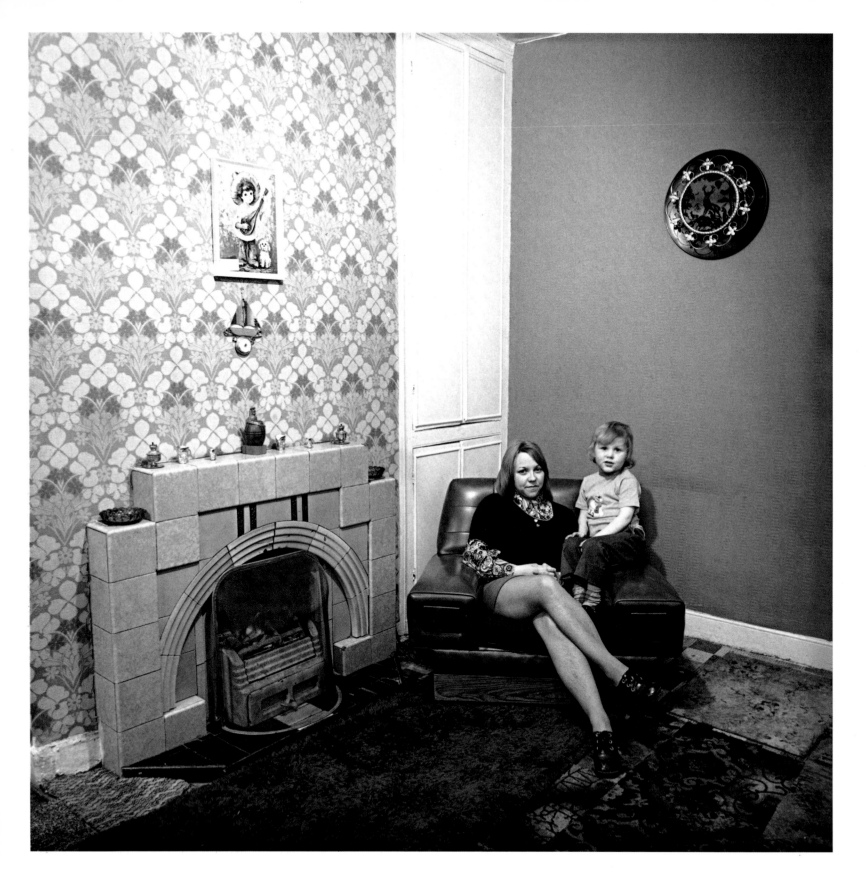

From 'June Street', a collaboration with Daniel Meadows, 1972

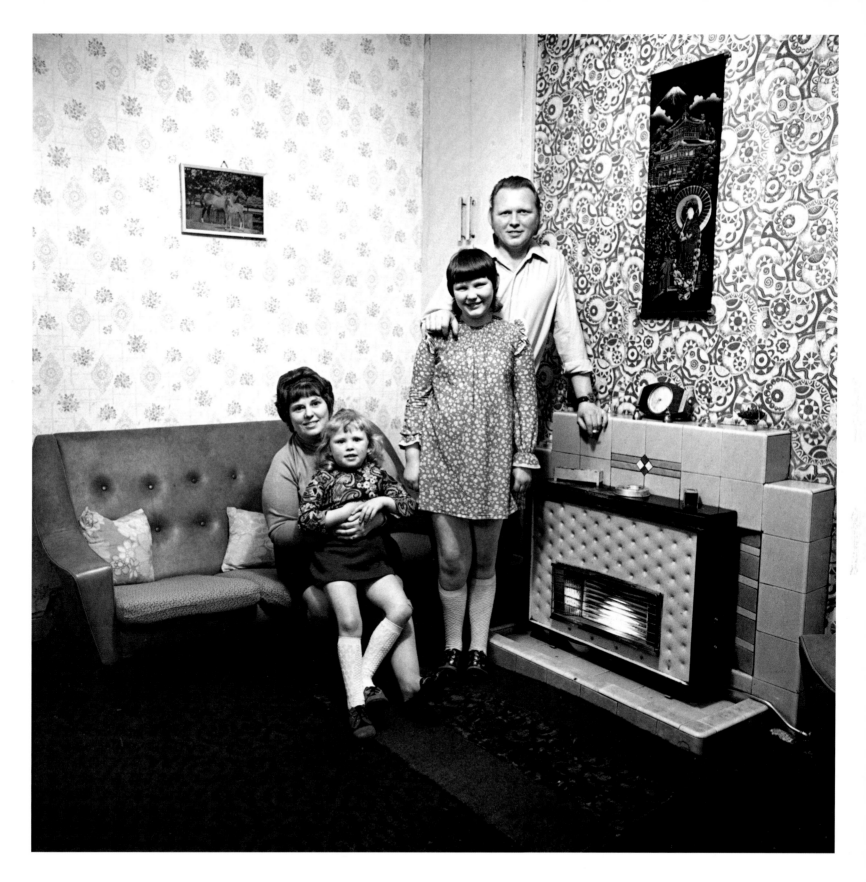

From 'June Street', a collaboration with Daniel Meadows, 1972

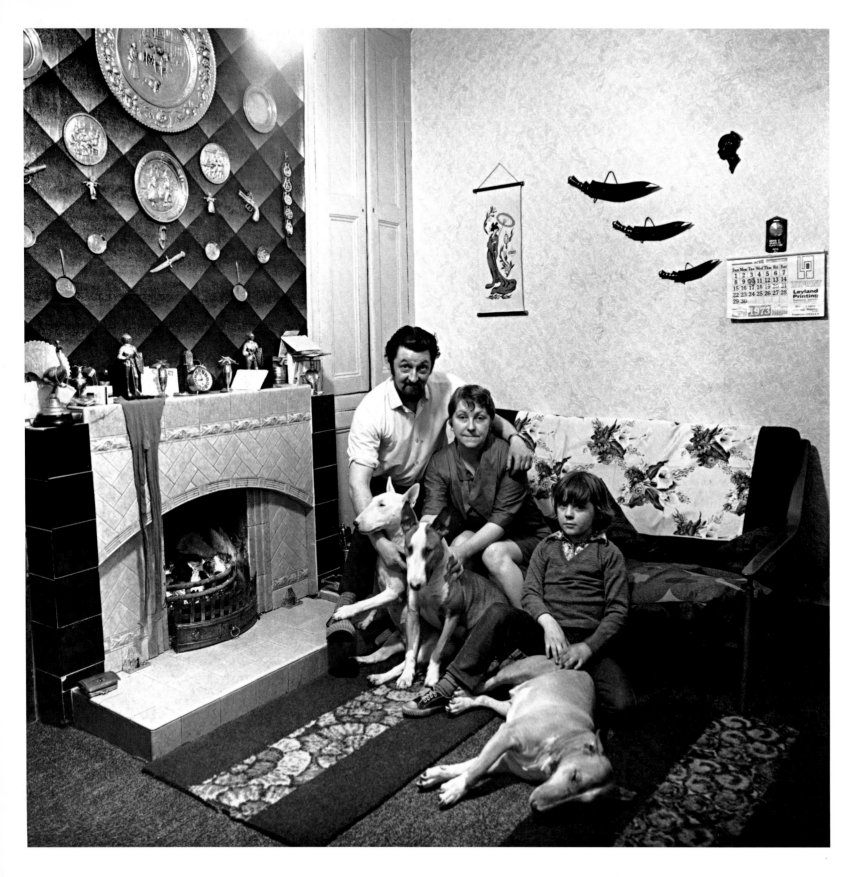

From 'June Street', a collaboration with Daniel Meadows, 1972

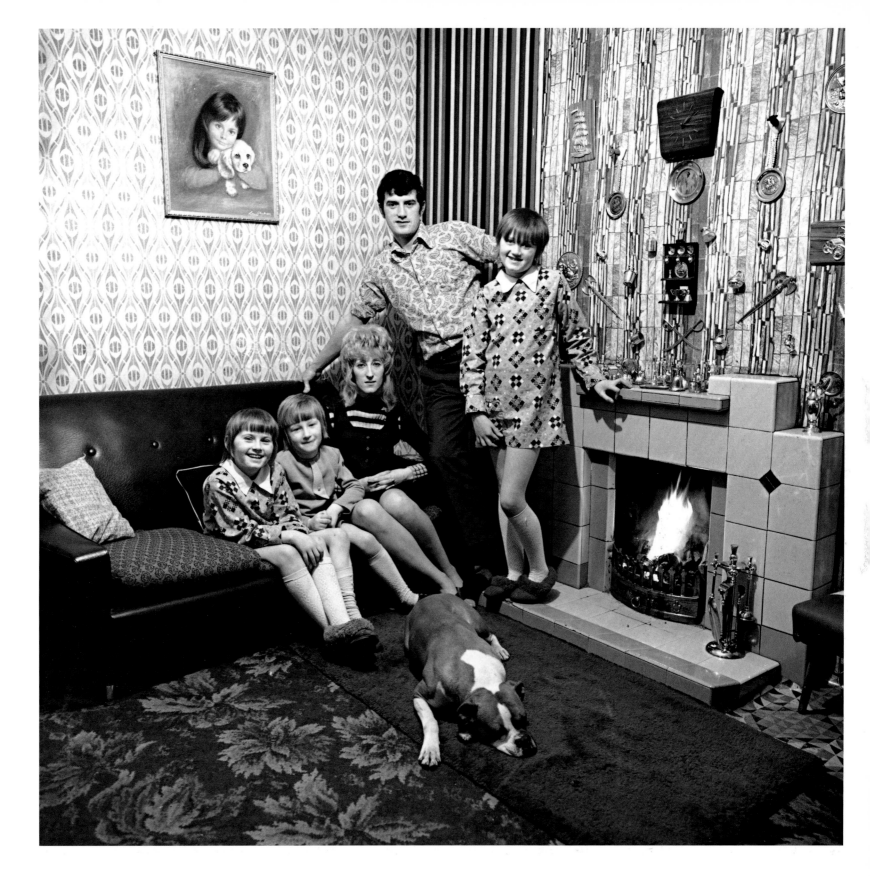

From 'June Street', a collaboration with Daniel Meadows, 1972

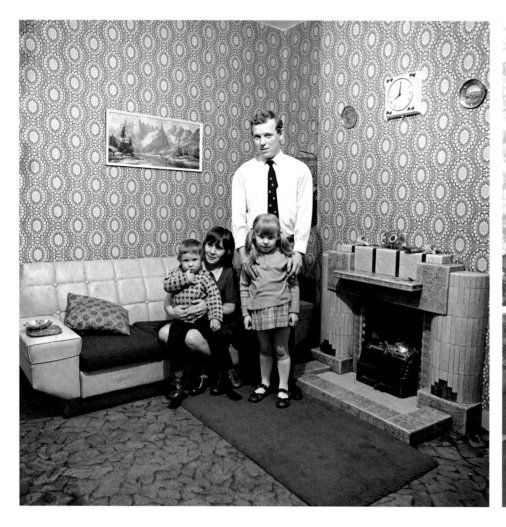
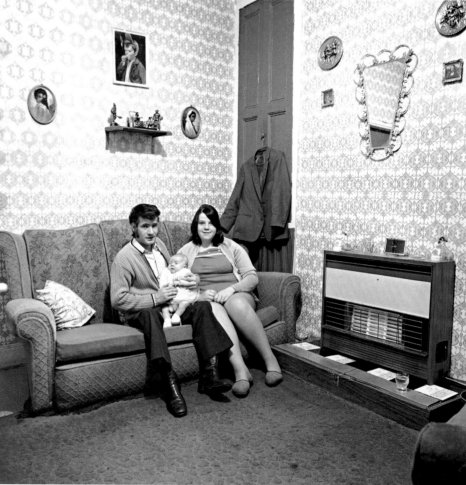

From 'June Street', a collaboration with Daniel Meadows, 1972

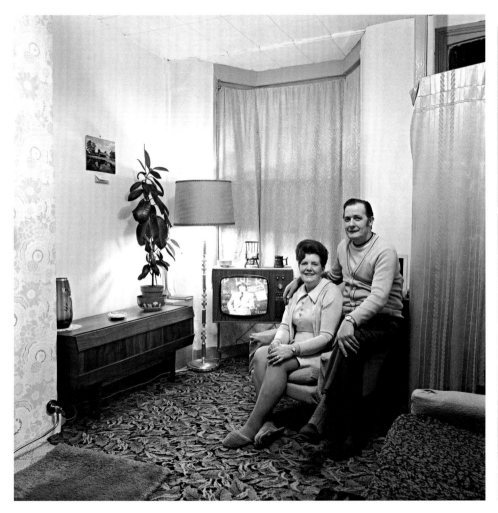

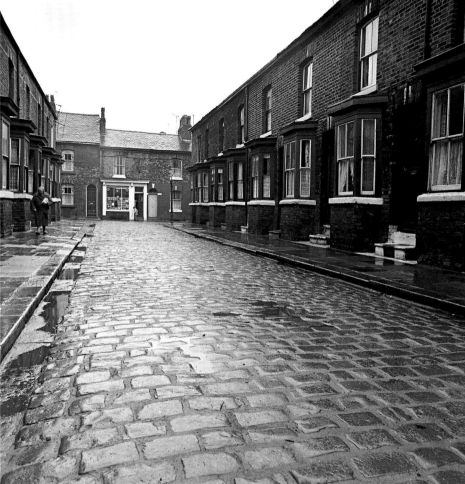

From 'June Street', a collaboration with Daniel Meadows, 1972

Alison Slaters
prize jam tarts
Mytholmroyd Gala 1975

*Mrs Whiteheads prize
decorative fancy cakes
Mytholmroyd Gala 1975*

*Mr Calverts prize shallots
Sowerby Bridge Horticultural
Show 1975*

*Mr Calvert's prize onions
(with fresh green tips, untrimmed)
Sowerby Bridge
Horticultural Show 1975.*

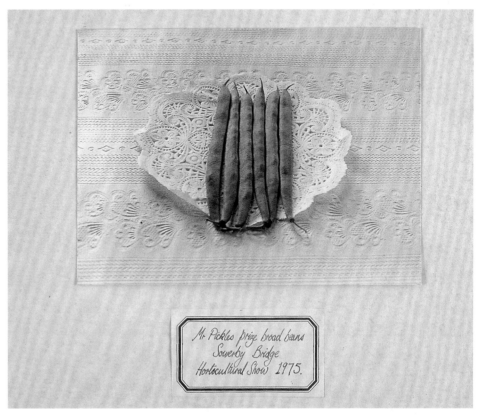

*Mr Pickles prize broad beans
Sowerby Bridge
Horticultural Show 1975.*

From 'Prizewinners', 1975

Vernacular

Northern life and ideals

When Parr moved to Hebden Bridge, he was part of a group of ex-Manchester Polytechnic students who, not long after they had graduated, decided to move out of the city and form a loose community of artists in the hills and moorlands of the industrial Pennines. Hebden Bridge had been a thriving mill town and its terraces of back-to-back houses had been built in the nineteenth century to accommodate the mill workers. Though it has become fashionable now, back in 1974 there was much empty property to let and for sale. With close friends from college, potter Jenny Beavan and painter Ray Elliot, Parr rented 8 Albert Street, which had been a jeweller's shop. The Albert Street Workshop opened in 1975 and at the inaugural party, the group displayed and sold their work. Looking back at the Workshop years, Parr remembers:

'It was very good, because people would drop in for coffee and it was very sociable. I had one wall on the right-hand side as you went in where I displayed my photographs, and as I took new ones, I replaced them, so it was a constantly changing exhibition of my photographs. They were all 10 x 8 prints that I just pinned up with captions on. We had a lot of visitors from outside. I was becoming a part of the photography circuit, and [the Workshop] was one of the places that people passed through often.'

As Peter Inch has written on the occasion of a recent celebration of the Albert Street Workshop:

'In the ten years before 1965, thirty-three mills had been closed in Hebden Bridge, and this decline continued into the 1970s. The town had this nice setting, but it was fairly shabby and depressed and its population was a good deal smaller than it had been in 1900. Efforts had started to be made to turn things round; a local civic trust had been founded in 1965 and a few individuals ... were working to revive the town, organizing clean-up jobs, planting trees, and trying to start local initiatives. But many mills, workshops and other buildings were empty and in the mid 1970s, you could still buy a house here for as little as £50.'

The Albert Street Workshop became known well beyond the somewhat insular world of the Hebden Bridge art community, for by 1975 a number of key people and institutions were becoming interested in Parr's photographs. He was already working on the 'Beauty Spots' series, which was again premiered at Impressions, in York, in 1976. He received one of the first Arts Council of Great Britain bursaries for photography in 1976 and attracted the support of the Arts Council's powerful photography officer, Barry Lane. His work was bought for the Arts Council Collection and also for the Victoria and Albert Museum, where the curator of photographs was a young Cambridge graduate, Mark Haworth-Booth, who had developed a passion for photography while working at the museum. With the group of independent photographers, Co-optic, Parr exhibited at the Jordan Gallery in London, his first appearance in the capital. But progress for a young photographer in the 1970s was much slower than it would be today. A trip to London from the Northwest was a major undertaking:

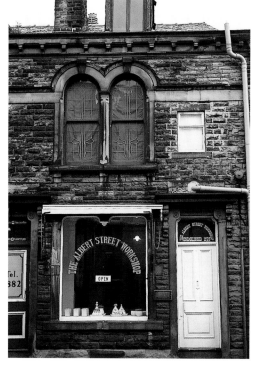

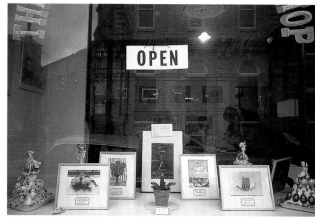

trains were slow and hotels were out of the question. Friends who had moved to the capital provided mattresses on the floor for those travelling from out of town, and trips were planned carefully to encompass as many meetings and exhibition visits as possible. In these pre-electronic, pre-fax, even pre-answering machine days, everything was done by letter and telephone. And even though the more well-funded British curators had visited the USA and the photography festival in Arles, foreign travel was an impossibility for most of those involved with the new wave of photography. London itself seemed foreign and aloof. Picture editors like Bruce Bernard at the *Sunday Times Magazine* were surrounded by their own group of photographers and designers; gallery directors like Sue Davies at the Photographers' Gallery mixed with and supported an older generation of photographers, especially those who worked as photojournalists or in fashion. Everyone seemed older, more self-assured and infinitely more cynical than the Northern groupings of artists and curators.

But there were havens – the cluttered and hectic corner of the *Racing Pigeon* magazine office in Doughty Street where Peter Turner edited *Creative Camera*, the *Creative Camera* book room, run by Grace Osman and the Photographers' Gallery in Covent Garden where Parr had his first London show in 1977. However, Parr still turned to the Impressions Gallery in York to launch most of his new bodies of work in the 1970s, 'Beauty Spots', 'Home Sweet Home' and 'Butlin's by the Sea' all receiving their premieres there.

As well as Parr, Beavan and Elliot, other photographers and artists moved to Hebden Bridge from Manchester: photographers Charlie Meecham, John Greenwood and Kate Mellor all set up home there. Daniel Meadows lived in Heptonstall, just a mile or so away from Hebden Bridge, and Susie Mitchell (later to become Parr's wife), who had studied English at Manchester, lived in a cottage a little way out of the town at Pecket Well. The Manchester students were delighted by Hebden Bridge, and the atmosphere they

created around themselves was clubby and quirky. Parr joined the Hebden Bridge Camera Club and even became a member of its committee. He gravitated to everything in Hebden Bridge that he saw as quirky and old-fashioned, photographing at the Ancient Order of Hen-Pecked Husbands, at bird shows and flower shows. With the other Albert Street Workshop members he took on an allotment. He also began the relationship with Susie Mitchell that was to become so important to him.

But more than the other members, he preserved a life outside the somewhat insular and gossipy world of Hebden Bridge. He promoted his photography constantly, working for magazines such as *New Society* and the *Radio Times* and becoming the official photographer for Northern Ballet. Already astute in business matters, he made sure that photography gave him an income. He found a New York dealer in Marge Neikrug and began to sell his work to collectors and museums in the USA. At the opening of the Albert Street Workshop, he even

The Albert Street Workshop – Parr had
a constantly changing display of images
on one wall

Portrait of Martin Parr taken by a
member of the Hebden Bridge Camera
Club, 1976, and a prize certificate
awarded to Parr by the club in 1977

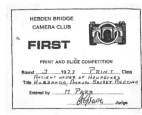

produced two price lists: one for locals, and one for 'arty people' – the arty people paid more.

The Albert Street Workshop was an important venture for Parr. It gave him the companionship and sense of community that he had valued in Manchester, and extended the life of the friendships he had made there way beyond the normal span of college relationships. By choosing not to move to London (as Griffin had done as soon as college finished) he had, in some ways, isolated himself from the centres of photographic activity, but had remained close to his subject matter – working-class life in the North of England. He had applied to the MA course at the Royal College of Art, but was rejected, reinforcing his already established opinion that his kind of photography was marginalized and out of step with the establishment. Many of his contemporaries were equally unattracted by London. Chris Killip and Graham Smith had set up their own documentary practice in Newcastle; landscape photographers Paul Hill and John Blakemore were based in the north

Midlands; Daniel Meadows took a post in Nelson in Lancashire.

In Hebden Bridge, Parr's output was prodigious. He photographed street parties and weddings, the staple subject matter of the young British photographers. He also took pains to find out the dates of traditional celebrations and events, so that he could photograph customs disappearing before his eyes. Like so many of his generation, Parr was deeply impressed by the great photography survey projects that had taken place in Britain, but particularly in the USA: the Farm Security Administration survey of life in the impoverished rural areas of America, undertaken in the 1930s by photographers of the calibre of Walker Evans, Dorothea Lange, Marion Post Wolcott and Russell Lee, and the Mass Observation project in 1930s Britain, which included the work of Nigel Henderson and Humphrey Spender. When Mark Haworth-Booth was employed by the Circulation Department of the V&A (the now defunct travelling exhibitions section of the museum), one of the first

shows he put together was of work from the FSA. In the mid-1970s (when cultural interest in the 1930s was at its height), David Mellor and Ian Jeffrey (art historians who had become active in curatorship) did much to revive the reputations of documentarists such as James Jarche, Edwin Smith, Spender and Henderson.

In this strange hiatus of a decade, a bridge between post-war consciousness and the thrusting modern world, many of the more radical photographers and curators were fascinated by the documentarists of the interwar years. The photographers' collective, Camerawork, set up in the East End of London, was as interested in the working-class past of the 1930s and 1940s (perhaps more interested) as in the society that surrounded them in the East End. And, for these predominantly middle-class young men and women, this working-class past (where roles were clearly defined, religion was still a national force and the vernacular was more visually interesting) was perhaps more comfortable than the working-class present that they could see around them.

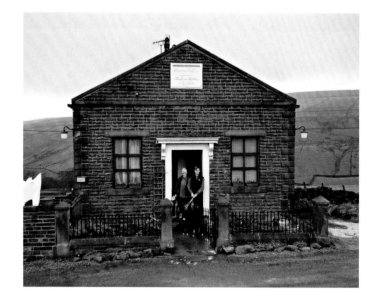

Some young photographers undertook their own survey projects – Meadows' 'Free Photographic Omnibus' (1974); 'Survival Programmes', made by Chris Steele-Perkins, Paul Trevor and Nicholas Battye in the late 1970s; Nick Hedges' study of poverty in Britain for Shelter (1969–72); even Parr's 'Beauty Spots', which, though essentially a study of quirky English life in the style of the much-admired documentarist Tony Ray-Jones, was also a wide-ranging study of English leisure activities. But there was an important difference between the work that Parr produced in the 1970s and that of his documentarist contemporaries. While they were producing work that in different ways illustrated their unease with the poverty and social inequity in Britain, Parr's work was essentially nostalgic for a society that operated within a well-defined code of behaviour, a society that was amusing, even comic, in its old-fashioned ways, its gentle tourism, its love of order and routine. Just as he had never seen the raw side of the Butlin's holiday camps that Meadows

remembered so well, he was equally oblivious to the darker, more ominous aspects of English life.

In the Hebden Bridge years, Parr looked for dignity combined with oddity, an old-fashioned comedy glimpsed in the 1960s episodes of *Coronation Street*, or in an equally well-known (and equally unreal) weekly drama series of life in the Metropolitan Police Force: *Dixon of Dock Green*, which featured genial and wise coppers, foolish villains and a sub-Brandtian urban landscape. Parr's search for this quintessential working-class dignity, this nostalgia for a perhaps imagined past, ended when he discovered the Crimsworth Dean Methodist Chapel, high up on the moors above Hebden Bridge. Discussing the photographic subjects that attracted him in Hebden Bridge, Parr singles out the nonconformist chapels:

'Of course I was able to pick up on my own Methodist background again and feed this back in. The chapels seemed to encapsulate everything that I was interested in in terms of the traditional aspect of life in Yorkshire:

decaying and declining, hanging on with great verve and principle and great belief in the significance of what they were doing. All these elements came together to be the ideal sort of project for me to explore these traditional values and the decline of these values. It was taken for granted that it was quite OK to photograph declining things. I like the idea of Britain in decline – I mean, this once great country slowly going down the plug hole. So I would look for any situation where that would be demonstrated. At this point, I was associating myself with these relatively newly discovered old values, or traditional values, which I'd discovered, in opposition to my childhood. Settling down in Hebden Bridge and having the opportunity to photograph in an intimate way was very appealing. So I got to know people [whom I photographed] very well, something I hadn't done before. Chapel people are very warm and welcoming; they invited you into their flock. They were very taken with the idea of people from outside being interested in their lives, so it was easy to do.'

Sarah Hannah Greenwood at Thurrish
Farm, 1979

Sarah Hannah Greenwood at Crimsworth
Dean Methodist Chapel Anniversary
Service, 1979

Parr's work on the Methodist chapels in
Yorkshire was collected under the title
'The Nonconformists' and exhibited at
the Half Moon in East London in 1981

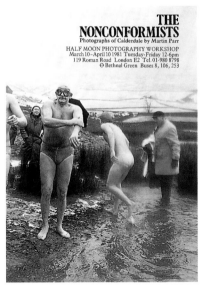

THE
NONCONFORMISTS
Photographs of Calderdale by Martin Parr
HALF MOON PHOTOGRAPHY WORKSHOP
March 10 – April 10 1981 Tuesday-Friday 12-6pm
119 Roman Road London. E2 Tel. 01-980 8798
⊖ Bethnal Green Buses 8, 106, 253

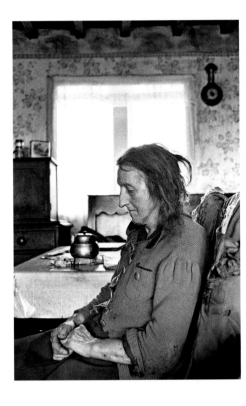

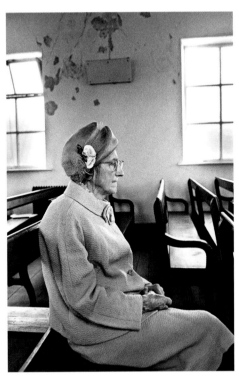

Parr's relationship with Crimsworth Dean Chapel, both photographic and social, was the most crucial in his career. It was important because it cemented his relationship with Susie Mitchell, who had graduated with a degree in English at the same time as Parr and his circle were leaving the Polytechnic. Like them, she decided to rent a house in Hebden Bridge, not in the back-to-backs, but on the moors, at Pecket Well:

'When I was a student living in Manchester, I felt very cut off from any kind of social connection. I'd written my thesis about pastoralism and the rural, the celebration of rural life and fantasy and mythology, the Garden of Eden type of idea. These ideas were pushing me towards country living. I knew that Martin and a few other people were moving out to Hebden Bridge and I went to stay with them a few times, and suddenly it all seemed to be happening in Hebden Bridge; it was where the potential was, where we could actually achieve it.'

Together they began a photography/interviewing project based around the Crimsworth Dean Chapel, which

became a consuming passion. Susie taught at the Sunday school and Martin organized slide shows to raise funds. The congregation of Crimsworth Dean was elderly and diminishing, and Parr and Mitchell became particularly friendly with Charlie Greenwood, his sister Sarah Hannah and Stanley Greenwood. Apart from his later involvement with TV director Nicholas Barker (on the 1992 documentary *Signs of the Times*) this was to be Parr's most successful creative partnership. Susie's personality, warm and outgoing, smoothed the path for Parr, whose social awkwardness was still a dominant part of his persona. She sums up her interest in the chapel thus:

'I think, looking back, that it was some kind of anthropological urge, which I didn't recognize at the time: partly a need to connect but partly also a need to observe and record. What was interesting about our collaboration was that I tended to get much more involved than Martin did, and so, at the chapel, I got involved with teaching the Sunday school and always

kind of lubricated things a lot more than Martin did … It was a partnership, an uneasy partnership. I was interested in trying to write, and this seemed like an opportunity. We looked at lots of other things as well: a chimney pot factory, a coal mine, a butcher's shop. We felt that it needed some kind of exploration beyond images. So I would go and do that and try to be totally neutral. I suppose I had an interest in anthropology. I hadn't read anything about it, I just had a very strong urge towards it. It would be the anonymity of a suburban childhood, frustration with urban living, lack of connection, and suddenly it felt that you could really immerse yourself in a journalistic sense into what people are actually about or what they were doing and just try to recount the details. I wouldn't have done it if I hadn't met Martin. He was the catalyst. He would say "Try this out."'

Parr and Mitchell were introduced to Sarah Hannah and Charlie Greenwood by Ted Maktovicz, an Australian Methodist minister. To Parr, they were 'the icon of

THIS IS YOUR LIFE

Photographs in Calderdale
by Martin Parr

WEST YORKSHIRE
Metropolitan County Council

Daily at the South Pennine Information
Centre, Hebden Bridge. 6 Jan.-17 March.

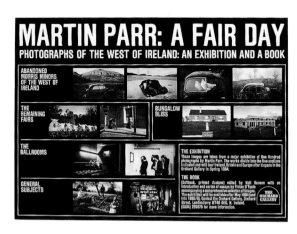

MARTIN PARR: A FAIR DAY
PHOTOGRAPHS OF THE WEST OF IRELAND: AN EXHIBITION AND A BOOK

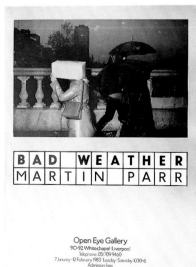

BAD WEATHER
MARTIN PARR

Open Eye Gallery
90-92 Whitechapel·Liverpool
Telephone: 051 709 9460
7 January · 12 February 1983 · Tuesday-Saturday 10.30-6
Admission free
With the assistance of Merseyside Arts

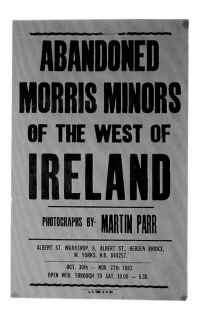

ABANDONED MORRIS MINORS OF THE WEST OF IRELAND

PHOTOGRAPHS BY· MARTIN PARR

ALBERT ST. WORKSHOP, 8, ALBERT ST., HEBDEN BRIDGE,
W. YORKS. H.B. 844257.
OCT. 30th — NOV. 27th 1982.
OPEN WED. THROUGH TO SAT. 10.00 — 5.30.

Hebden Bridge's dark and gloomy, rather miserable past', but Susie saw them more as positive and dignified:

'Extraordinary, eccentric, living in the most extreme discomfort and poverty, yet so open and innocent. They lived in this completely barren, bare, freezing farmhouse. They were in their seventies and on Anniversary day, every year, they would put up these curtains, net curtains, just for the one evening. They were totally ragged, just torn bits of lace, and they would get these bits of rag out and put them up. Crimsworth Dean was ritual and humility and involvement and eccentricity; it was just a real mishmash. On the Anniversary, that one day of the year [Sarah] would turn out with this straw hat with a beautiful white rose in it, and a little summer coat, completely different from how she would usually be. The rest of the year she was dressed in an old woolly shapeless woollen hat and a raggy old coat.'

For Mitchell, the relationship with the Greenwoods was problematic. She saw the danger signals long before the crisis in the friendship finally came:

'I started to feel very uneasy about this … observational … feeding off other people's lives. They were very innocent and very open. But it was certainly one of the things I backed off from, this journalistic way, and I still feel that – I don't particularly like that now … My movement was towards being more involved and a sort of therapeutic relationship, whereas [Martin] went in a different direction. I did feel that it was exploitative. I got to feel very uneasy with the chapel and the people in the valley. I don't think you can go neutrally into something like that for such a long period of time without something being expected of you. And I can see that Stanley [Greenwood] had expectations of us that we didn't live up to.'

Oral history, as those who practise it know, is a potent tool. It unlocks memories and brings the past screaming into the present. For four years, Parr and Mitchell recorded, in photography and on tape, the intimate lives of an isolated group of elderly rural people. The photographs that Parr made are still among

his most powerful. They are lyrical yet painstakingly observed, elegiac yet unsentimental. They are pictures from another world – a lost Eden perhaps – with all the promise that such a concept conveys. For Parr, they were the consolidation of all his developing photographic talents, and, even in his current (and very different) photographs, one can see the legacy of Crimsworth Dean – the fascination with the rituals of eating and drinking, the presence of an elaborate hat, the minutest gesture of a hand. In his project 'Bored Couples' (1993) one may glimpse the still serenity of the Methodist worshippers, or in 'Japonais Endormis' (1998) the fascination with the face in repose. In 'The Cost of Living' (1986–9), the third of Parr's major 1980s documentary projects, we can see him moving in on the brim of a hat, or on a weary man carrying shopping like a penitent. In 'The Last Resort', Parr's most powerful series of photographs to date, made shortly after his return from Ireland, we may see, most significantly, Parr's bitter and sardonic riposte to the things that both he and Susie

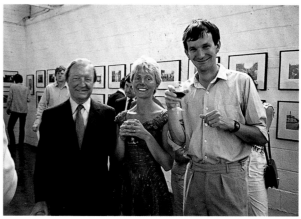

had treasured at Crimsworth Dean: piety, silence and a mannered ritual.

After four years of working with the Crimsworth Dean congregation, the relationship faltered when one of the chapel elders realized that Parr and Mitchell's interest in the chapel was aesthetic and journalistic rather than spiritual. In Parr's words:

'You realize that however close and intimately you feel that you can work with people, ultimately, you're never part of the thing; you're always entirely separate, and your different background, your different cultures, separate you out, however close you try to get. There's always that distance. I mean [we] shared their lives. You understood … how the chapel worked and you knew the details. You felt you were a confidant, you had their ear. I was probably working under an illusion that I was actually closer than I really was, and that sentiment was finally pricked. Since then, I've never attempted to have that kind of intimacy with the people who I've been working with – it's one of the significant factors that keeps me separate from the people I photograph.'

For Mitchell, the end of the Crimsworth Dean project was also a signal for change:

'It drove me into a therapeutic type of relationship with people that is intimate, but it actually contributes in some way, a kind of formal contribution. So although I retain a great interest in the way that people construe their own lives, I've chosen a different kind of path: of involvement. Whereas Martin, in a way, stepped back. It pushed us both in separate directions.'

The direction that Mitchell decided to follow was intimately connected with language. She enrolled on the Irish Health Authority's scheme to recruit British graduates to train as speech therapists. In return for the training, the recruits entered into an agreement to spend two years working in Ireland. For Parr, it was both an opportunity and a setback. He had been included in the Hayward Gallery's groundbreaking exhibition 'Three Perspectives on Photography', an initiative powered by Barry Lane and the influential Photography Committee at the Arts Council. The show was to be the first exploration of contemporary British photography in a major London venue, and Parr was rapidly becoming established as one of the key figures in the contemporary medium. The Hebden Bridge series was about to be shown in London, at the Half Moon, and the sales of his photographs were beginning to take off in New York. Though he kept up his connections as much as possible, the move to Ireland cut him off from the centres of photographic power. Moving between Britain and Ireland was difficult and expensive; it was impossible to be connected to the telephone system, so most of his communication in the years 1980 to 1982 was made by letter. The teaching jobs and magazine assignments on which he had relied in the UK were almost non-existent in Ireland and, perhaps most important of all, the strong network of friends, photographers and artists on whom he had depended in Hebden Bridge was gone. Though he became involved in the fledgling

Irish photographic scene, meeting enthusiasts like photographer and future Director of the Gallery of Photography Christine Redmond, and the photographer Tony Murray, there was no substitute in Dublin for the flourishing British scene. Parr became completely absorbed in photography, always working alone, completely avoiding the involvement with his subjects that had become so problematic in Hebden Bridge:

'My whole idea in Ireland was that I wouldn't personalize it. I got interested in photographing the fairs, and then to try to balance that, I wanted to photograph the bungalows, to show a much more modern aspect of life in the West of Ireland. Then I stumbled across these dance halls and that became another project, as did abandoned Morris Minors.'

Although in some ways, it was an unfortunate time to leave England, it was in Ireland that Parr completed his remarkable series 'Bad Weather' (1982). In this set of photographs Parr used flash and an underwater camera to create eerie scenarios of snowflakes and driving rain, deserted parks and rainswept promenades. It was the perfect antidote to the Crimsworth Dean project and the feeling of claustrophobia experienced towards the end of it. And Parr's conceptual drive, which had faltered during the intense Hebden Bridge project, was reasserted. 'Bad Weather' was a subversion of 'good photography', of documentary and the idea of community. It was comic and melancholy and very very lonely. In many ways, it was a reassertion of independence and a declaration that, from now on, photography was to be a solitary occupation.

When Martin and Susie Parr (they married in 1980) returned to England in 1982, they found a different country from the one they had left. Margaret Thatcher had been Prime Minister since 1979 and the radical policies that would become known as 'Thatcherism' were transforming the country. Society had polarized and fragmented. Parr saw England in a very different way. From that moment, his photography became brightly coloured, raucous and dissonant.

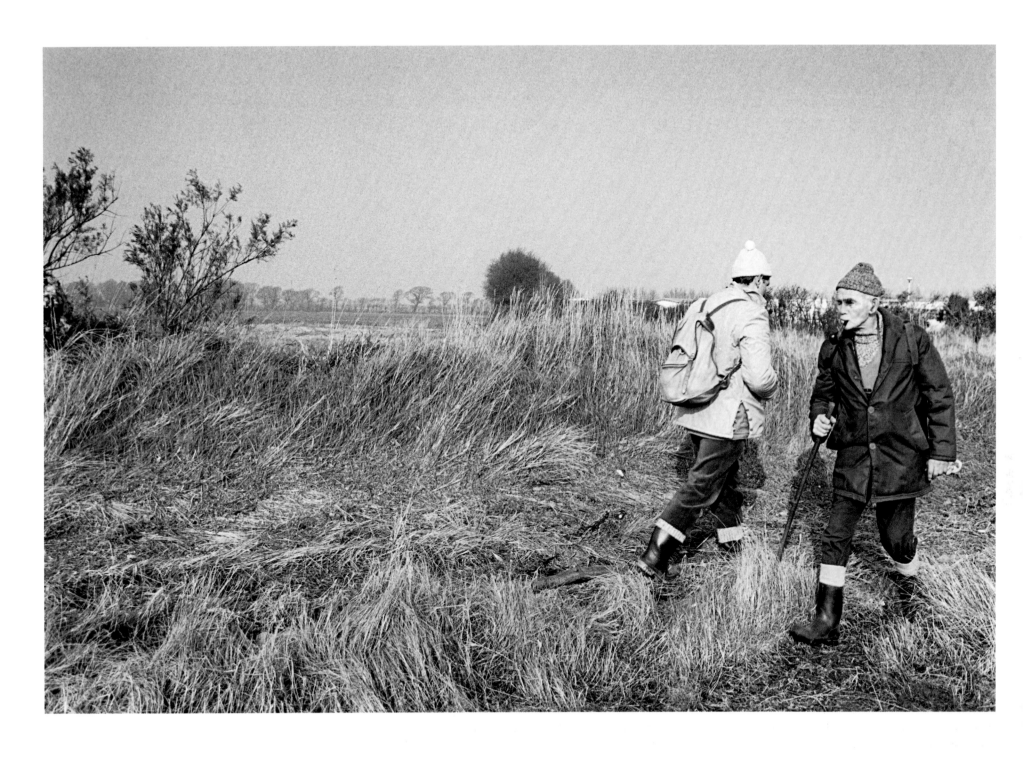

Passing Naturalists, Pagham Harbour, Sussex, 1974

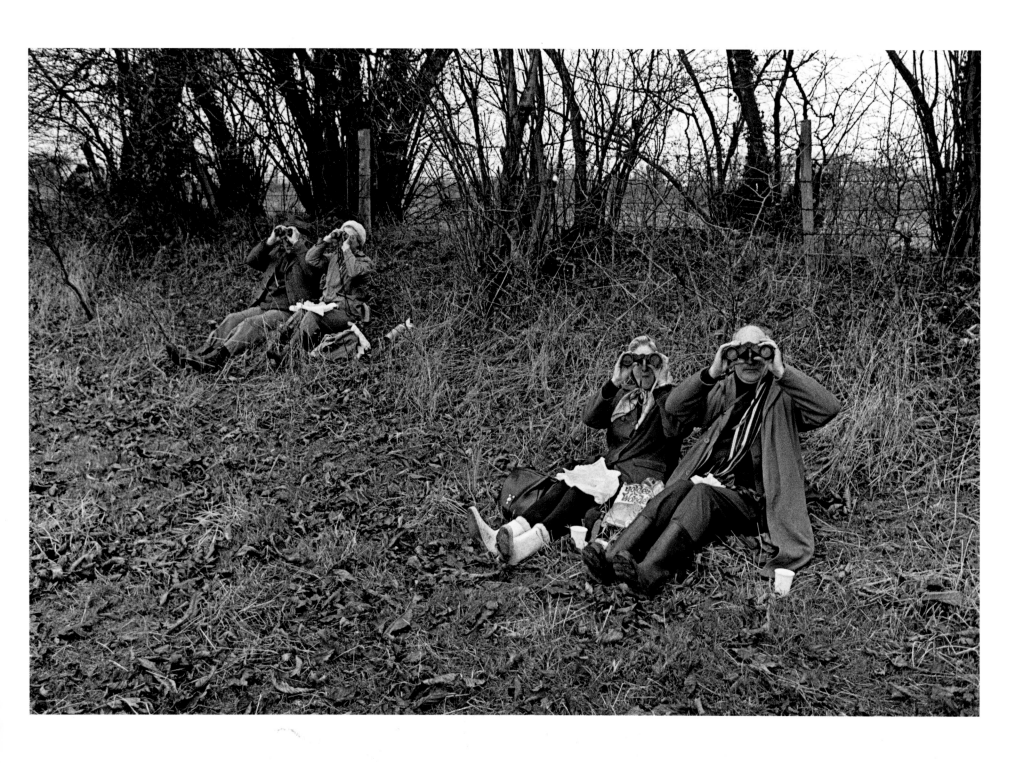

Surrey Bird Club, 1972

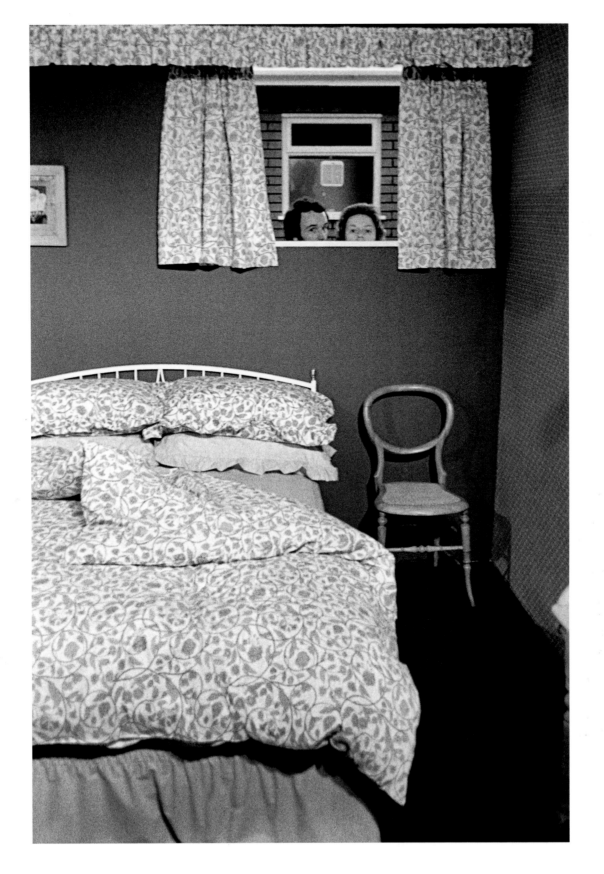

Ideal Home Exhibition, London, 1976

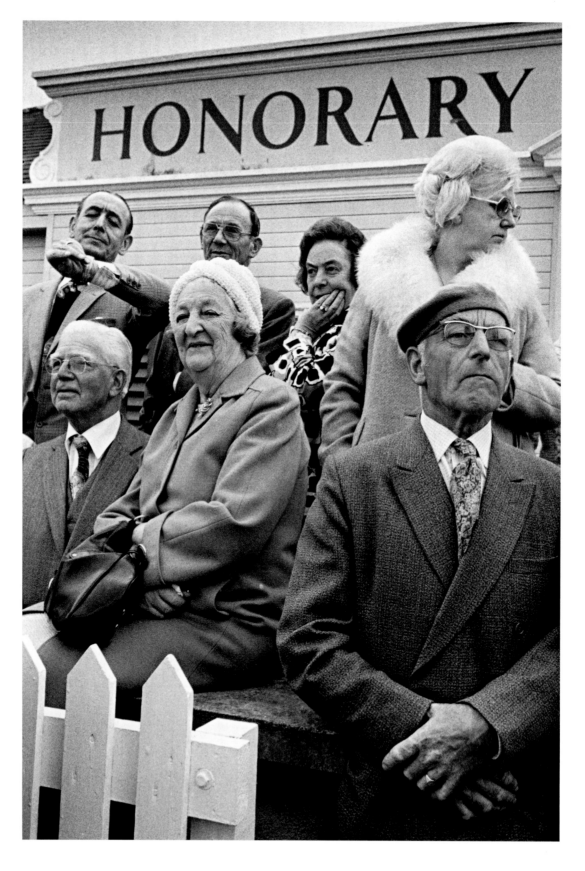

Yorkshire Show, Harrogate, 1977

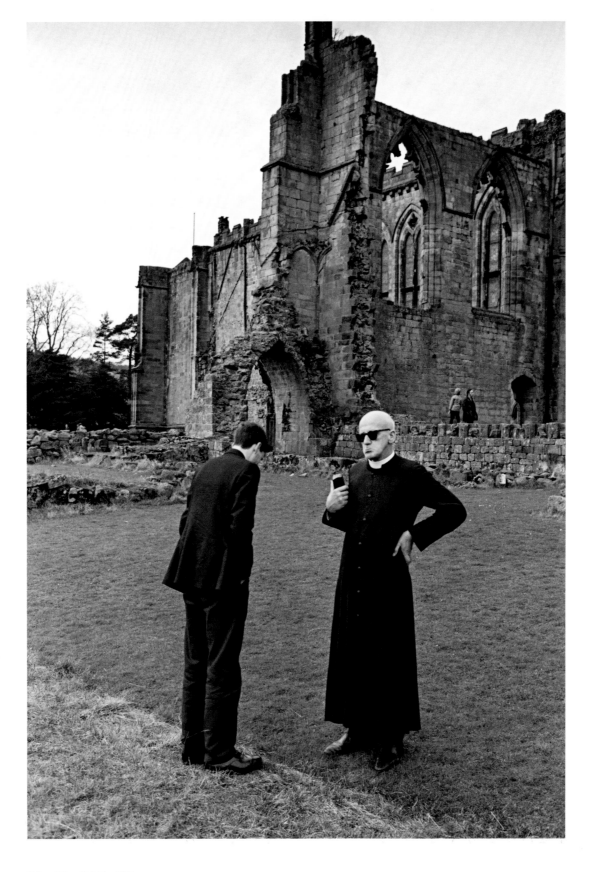

Bolton Abbey, Yorkshire, 1971

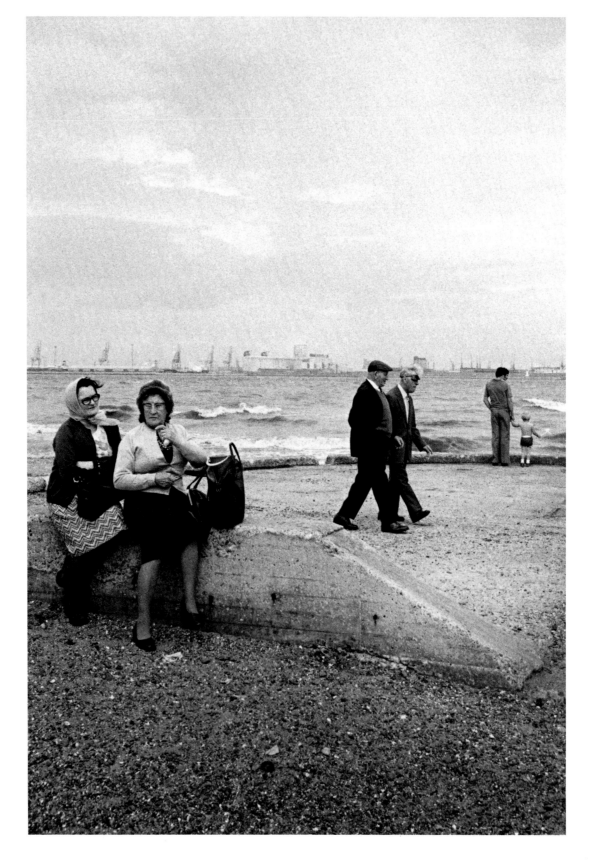

New Brighton, Merseyside, 1976

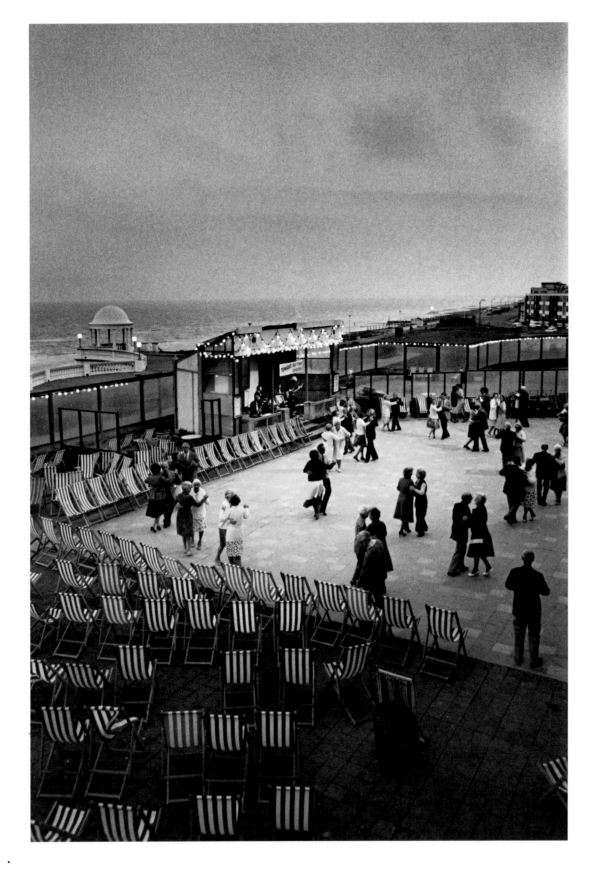

De La Warr Pavilion, Bexhill-on-Sea, East Sussex, 1978

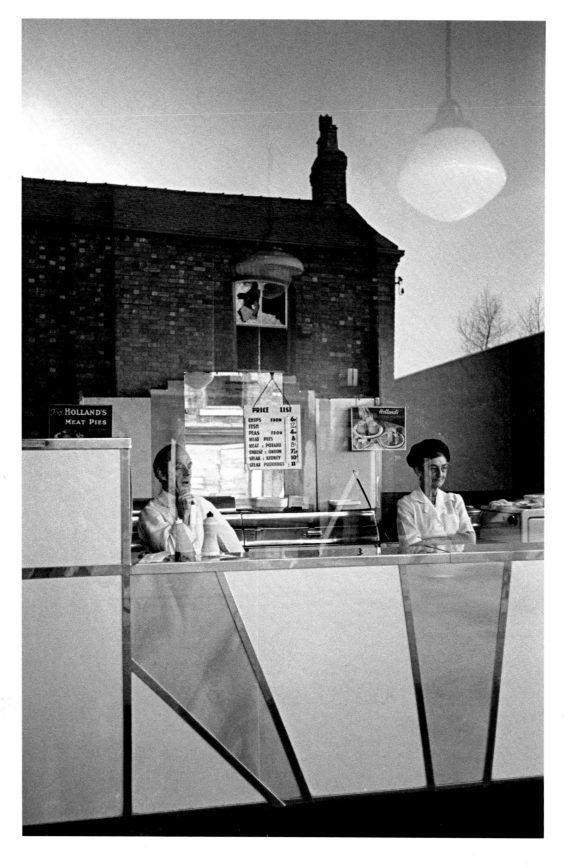

Manchester, 1972

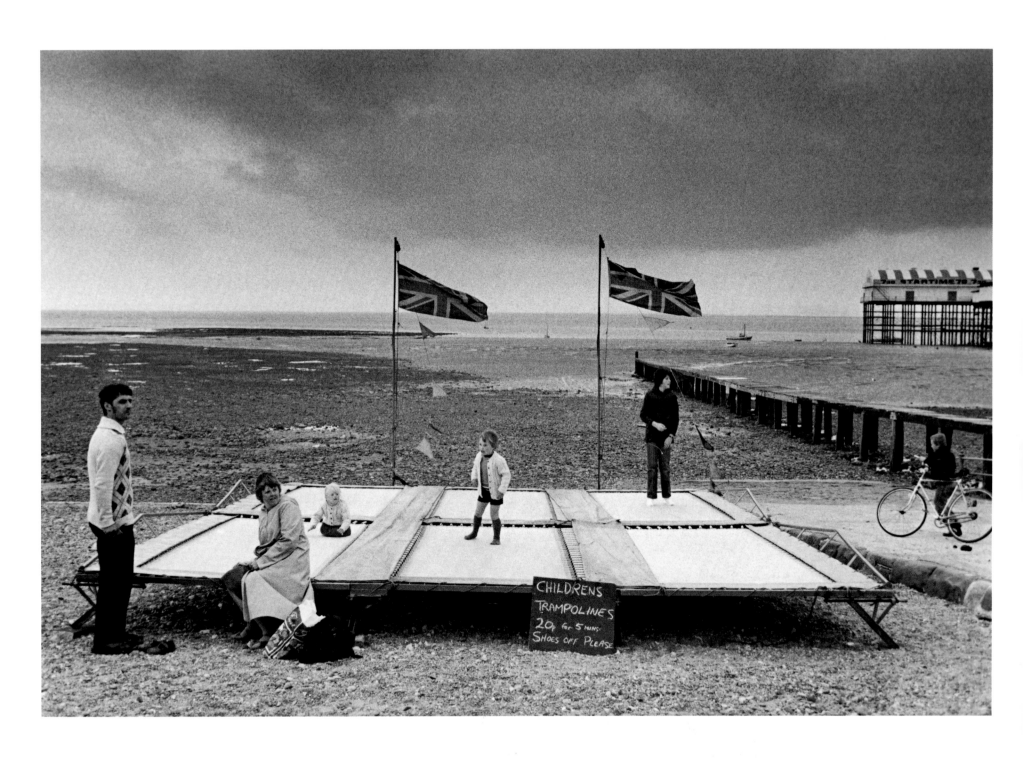

Morecombe, Lancashire, 1976

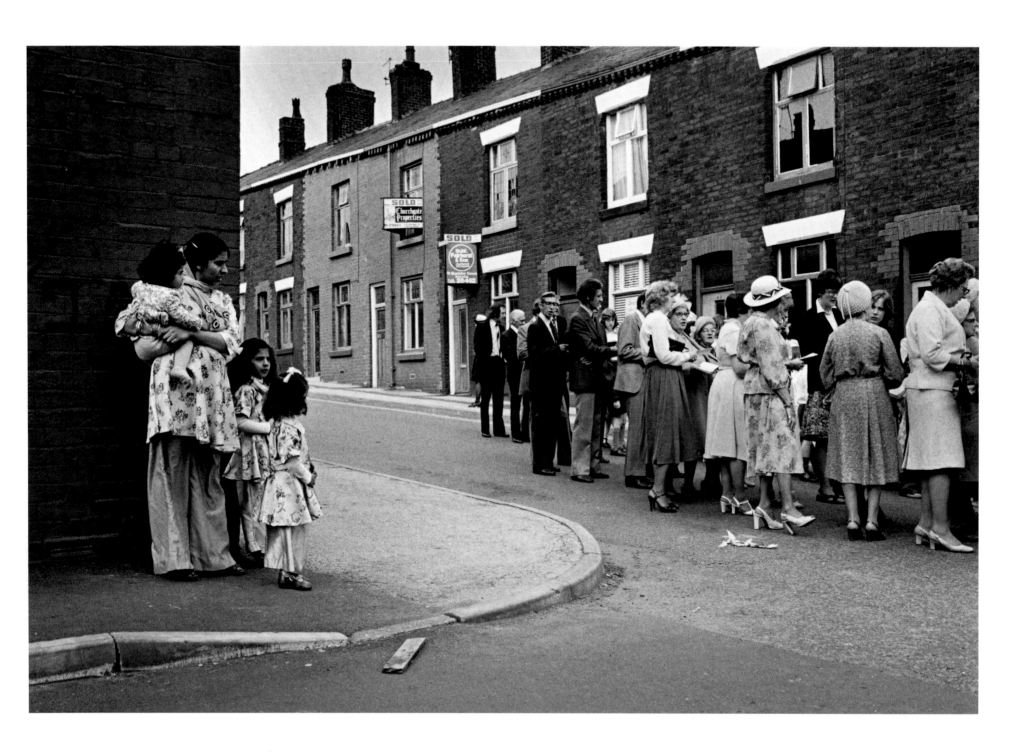

Whitsunday Walk, Bolton, Lancashire, 1979

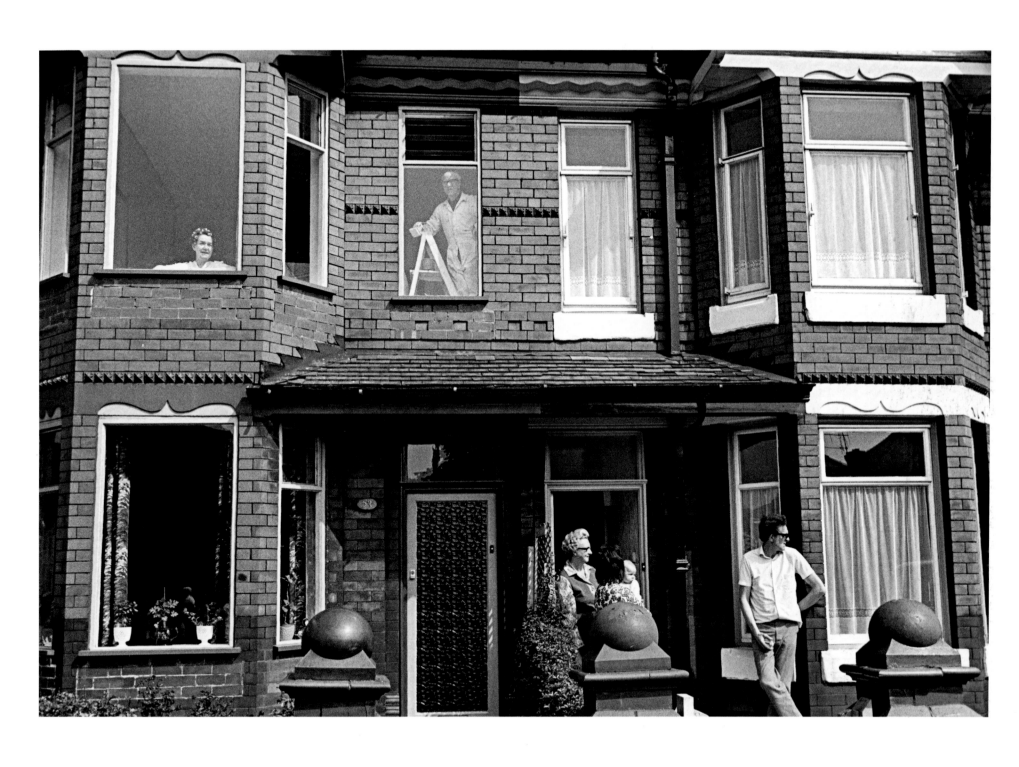

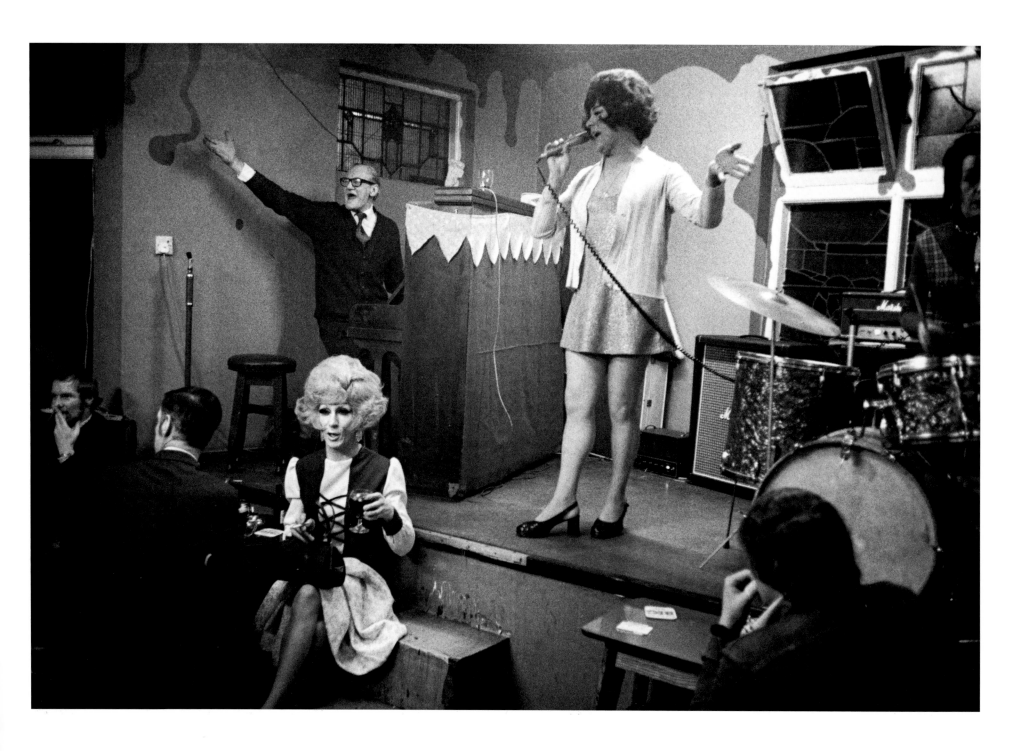

Union Hotel, Manchester, 1974

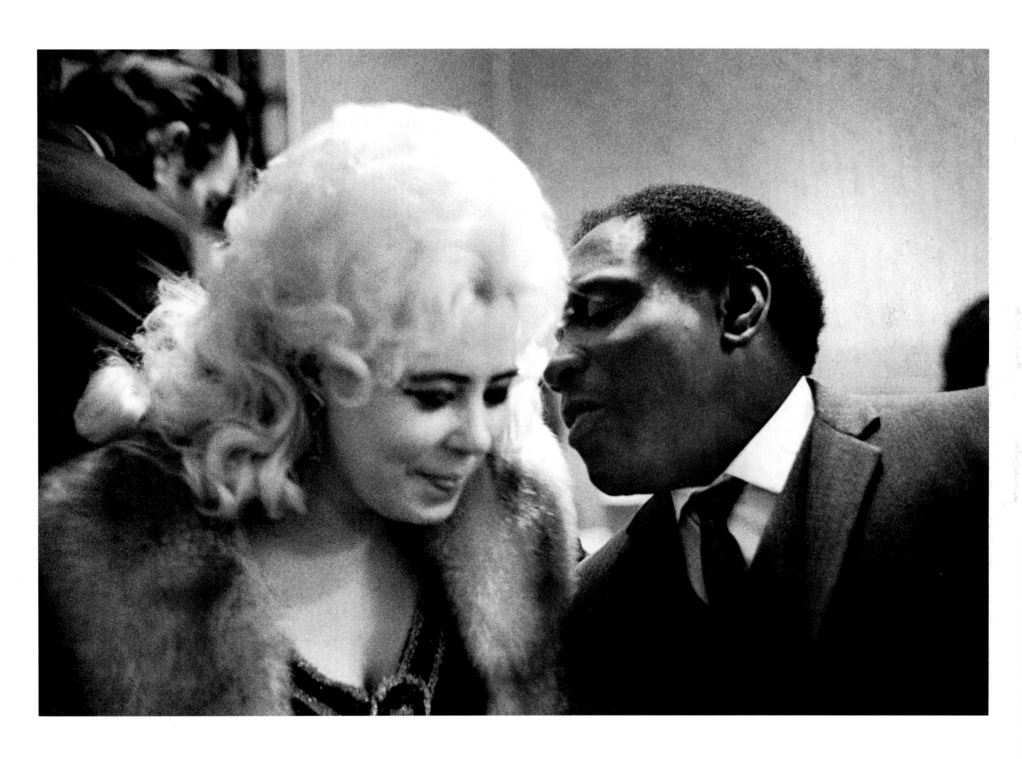

Moss Side, Manchester, 1973

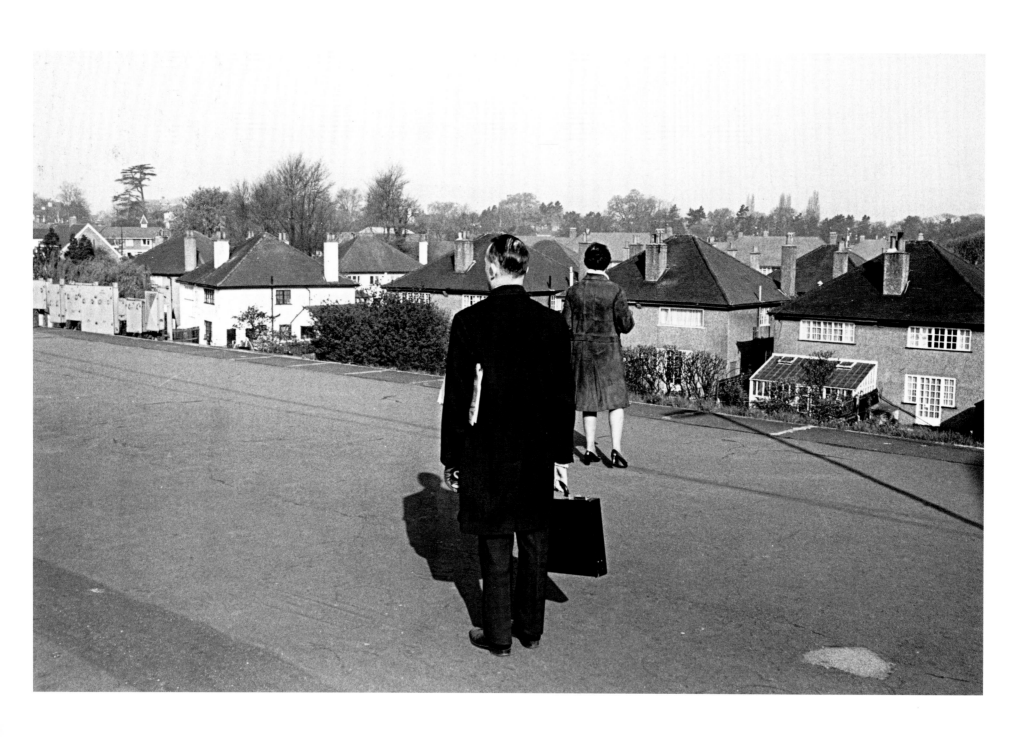

Epsom, Surrey, 1972

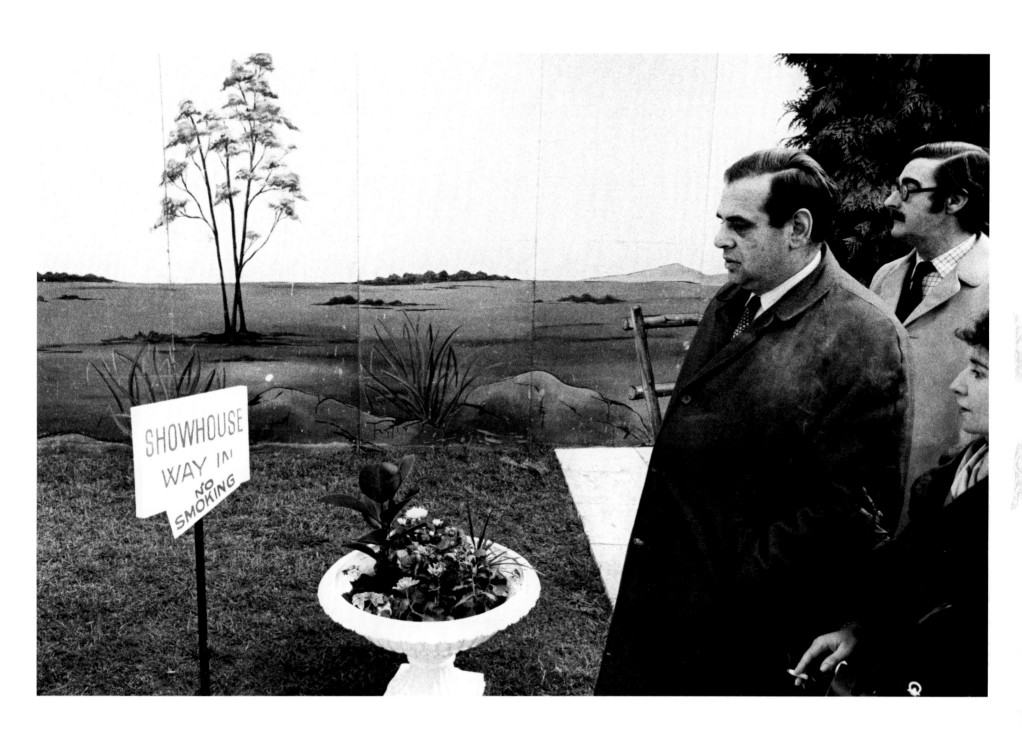

Brighter Homes Exhibition, Manchester, 1971

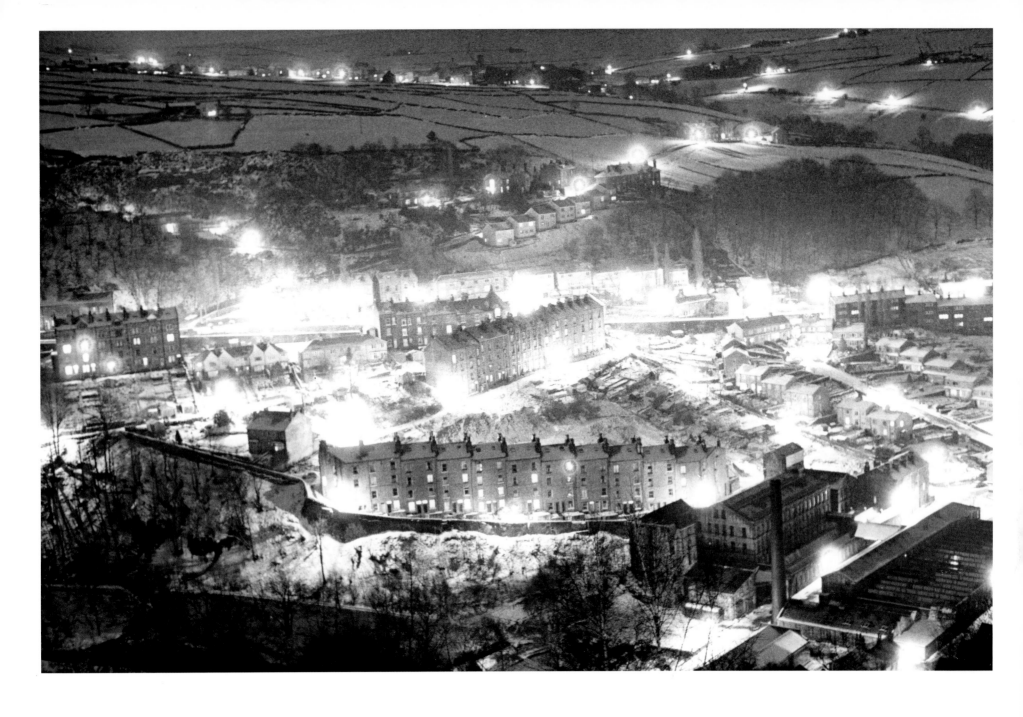

Hebden Bridge, Yorkshire, 1976

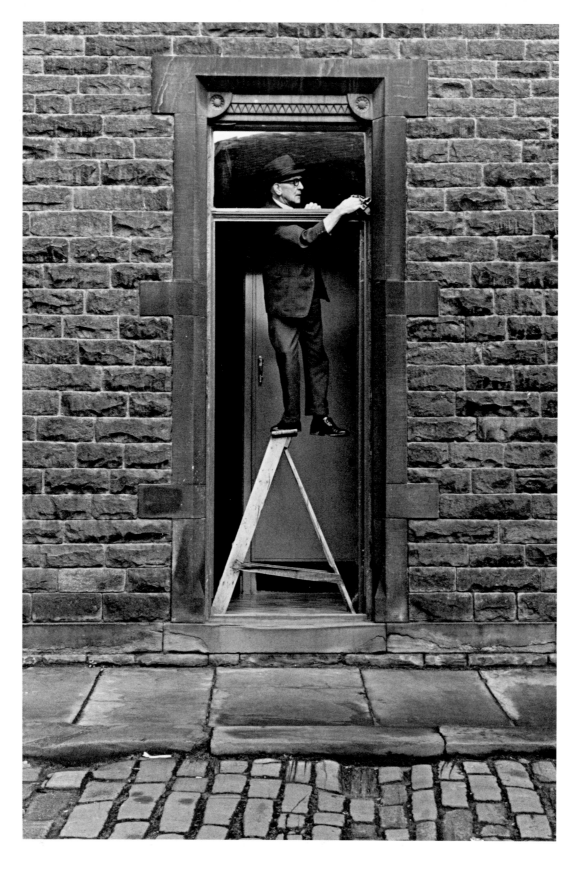

Hebden Bridge, Yorkshire, 1976

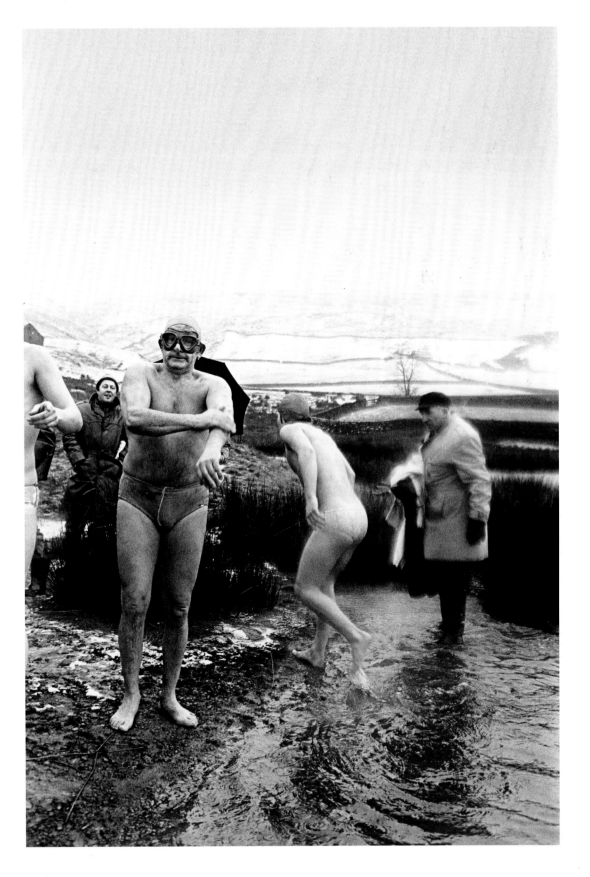

Lee Dam Swim, Todmorden, Yorkshire, 1977

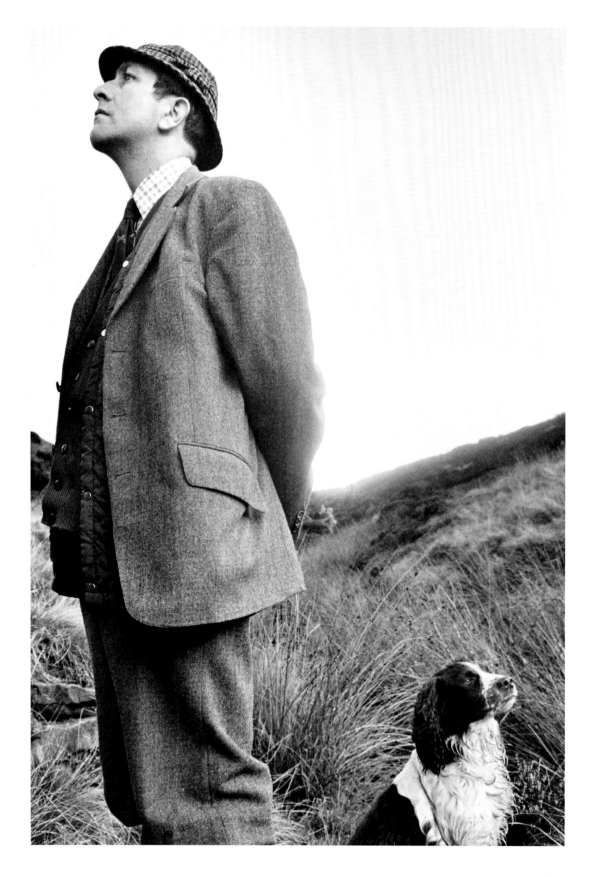

Lord Saville's gamekeeper, Hebden Bridge, Yorkshire, 1976

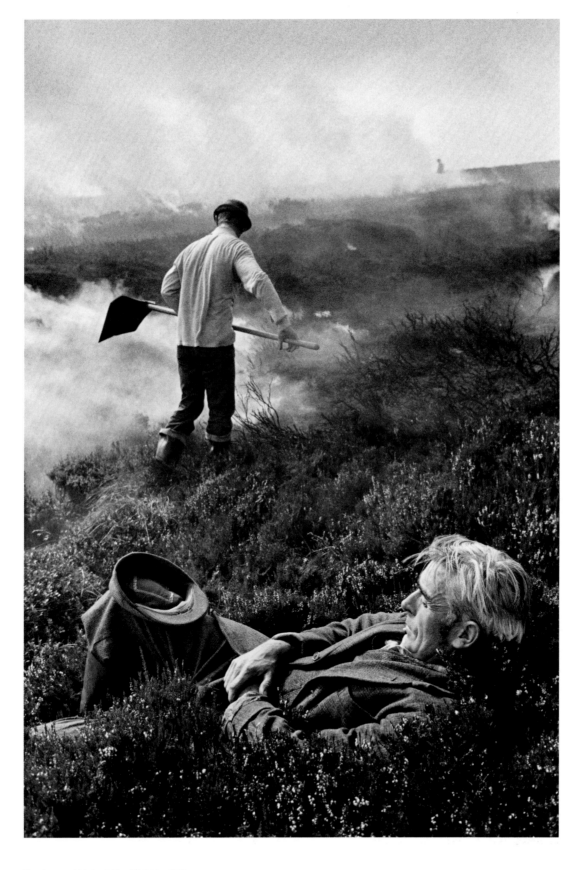

Gamekeepers, Hebden Bridge, Yorkshire, 1976

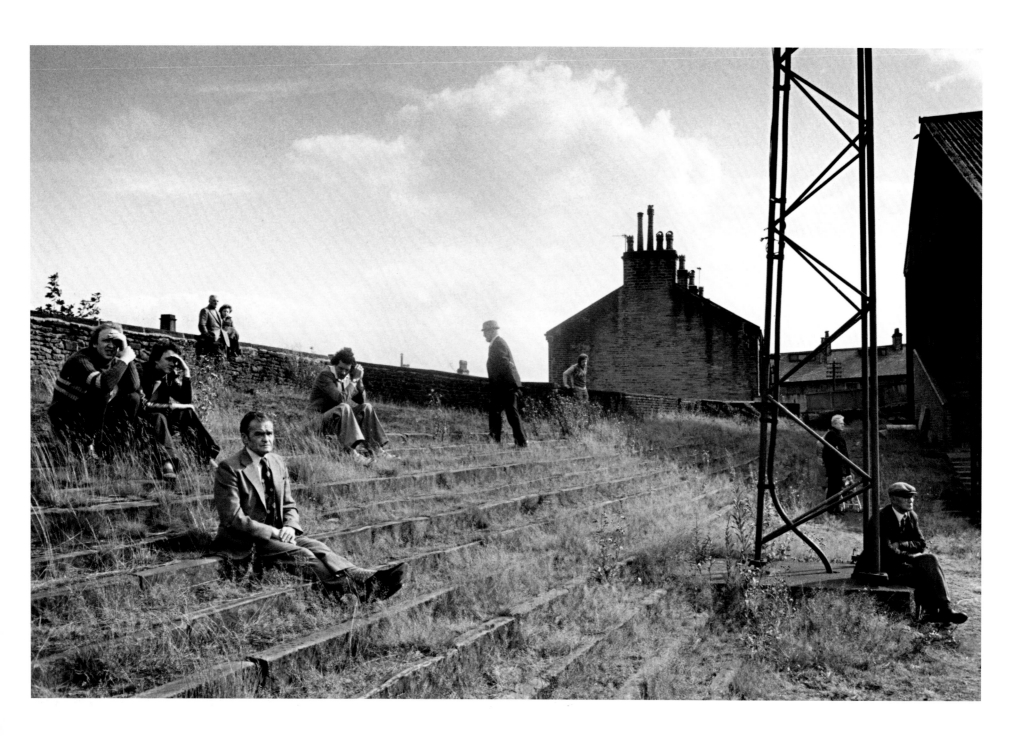

Halifax Rugby League Club ground, Yorkshire, 1977

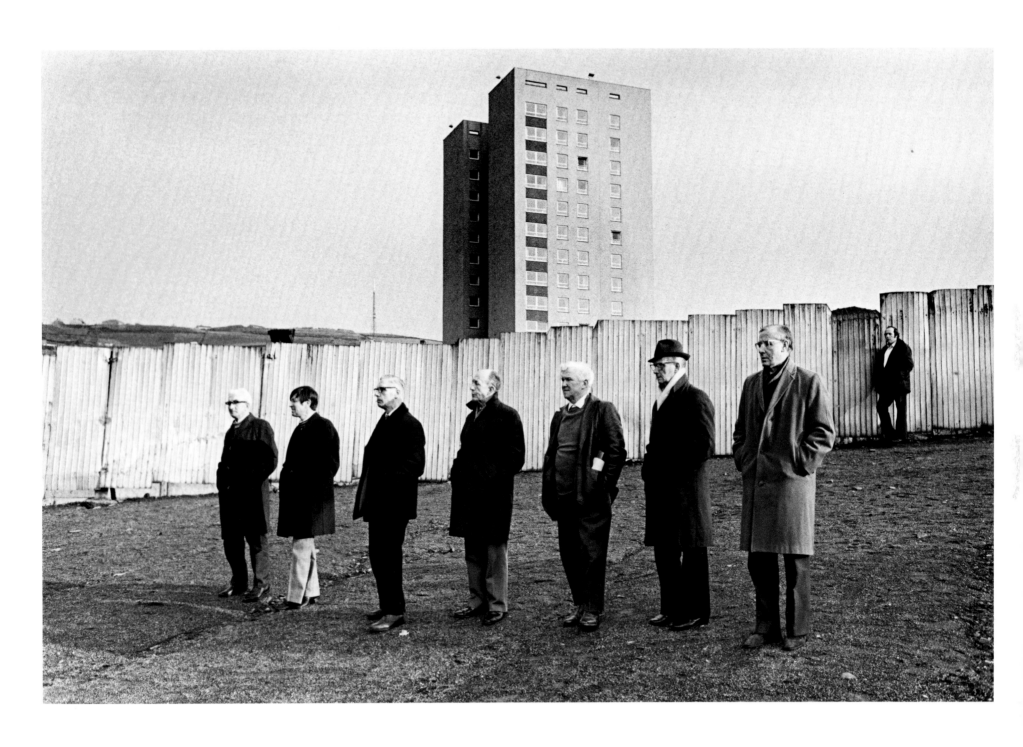

Halifax Town football ground, Yorkshire, 1977

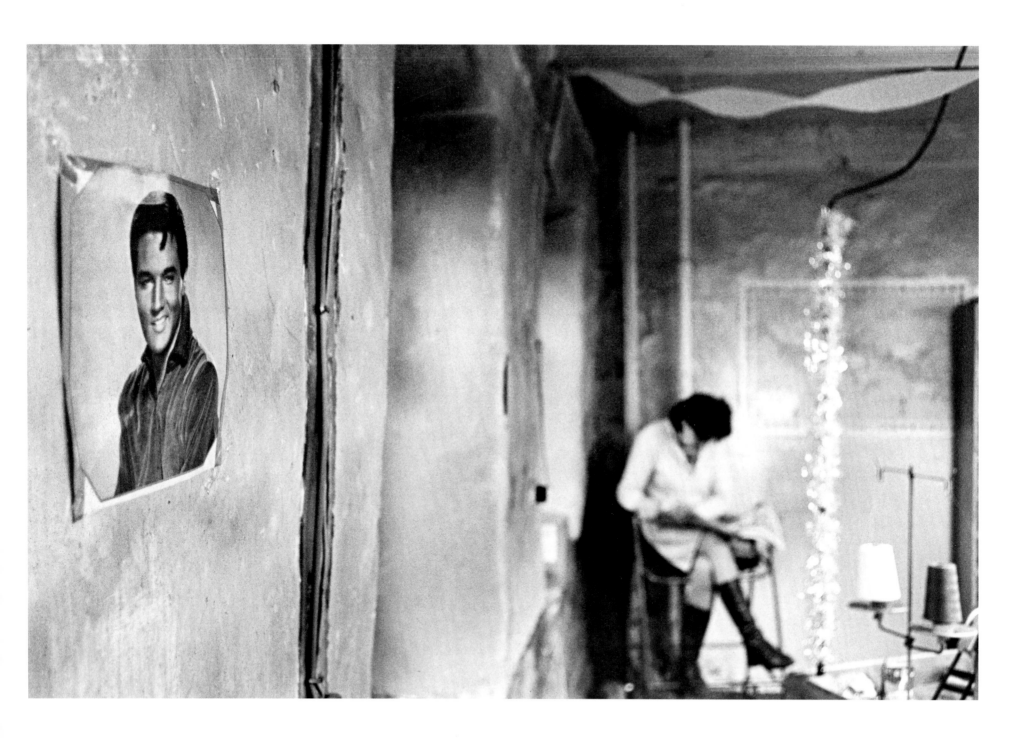

Scarbottom sewing shop, Mytholmroyd, Yorkshire, 1976

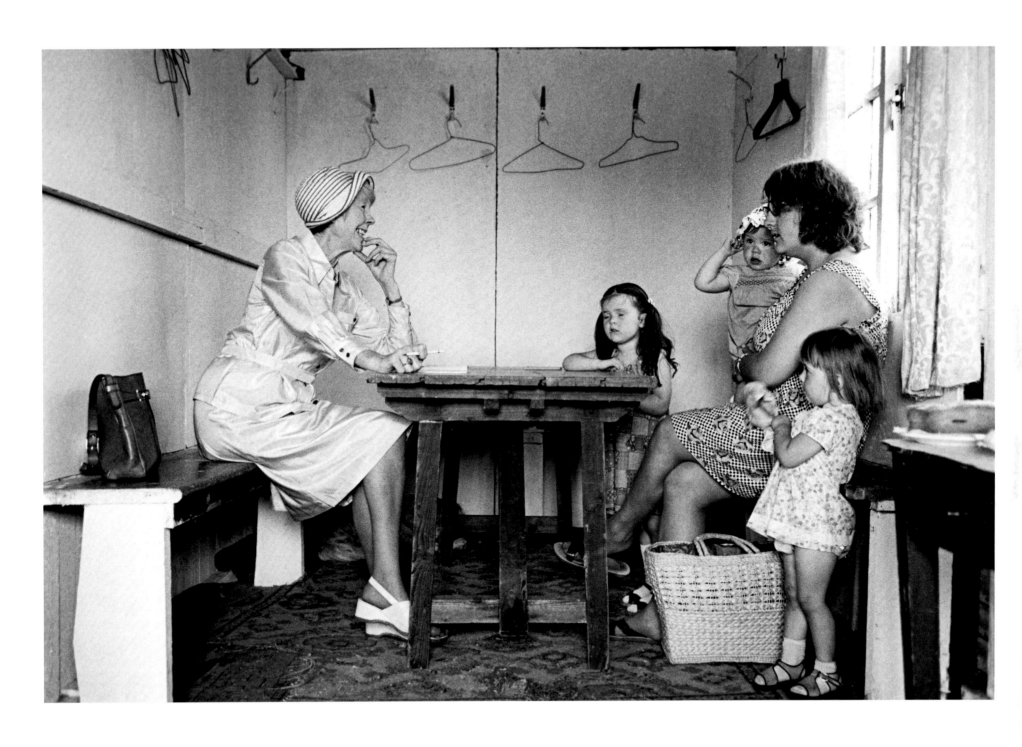

Old Town Fête, Hebden Bridge, Yorkshire, 1977

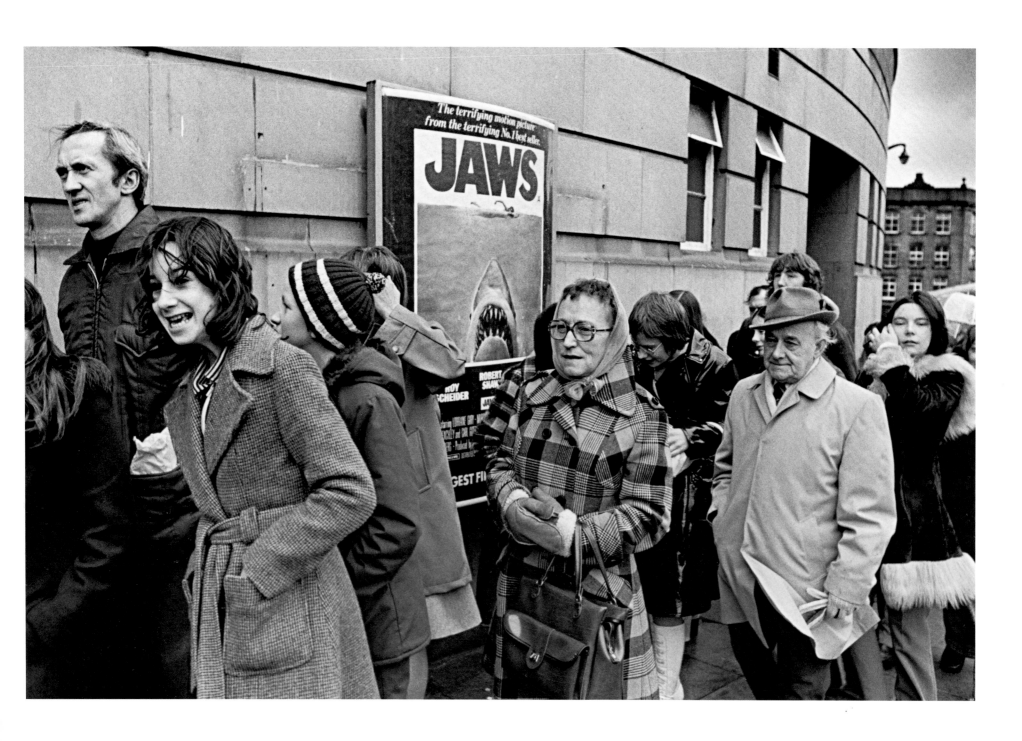

Cinema queue, Halifax, Yorkshire, 1977

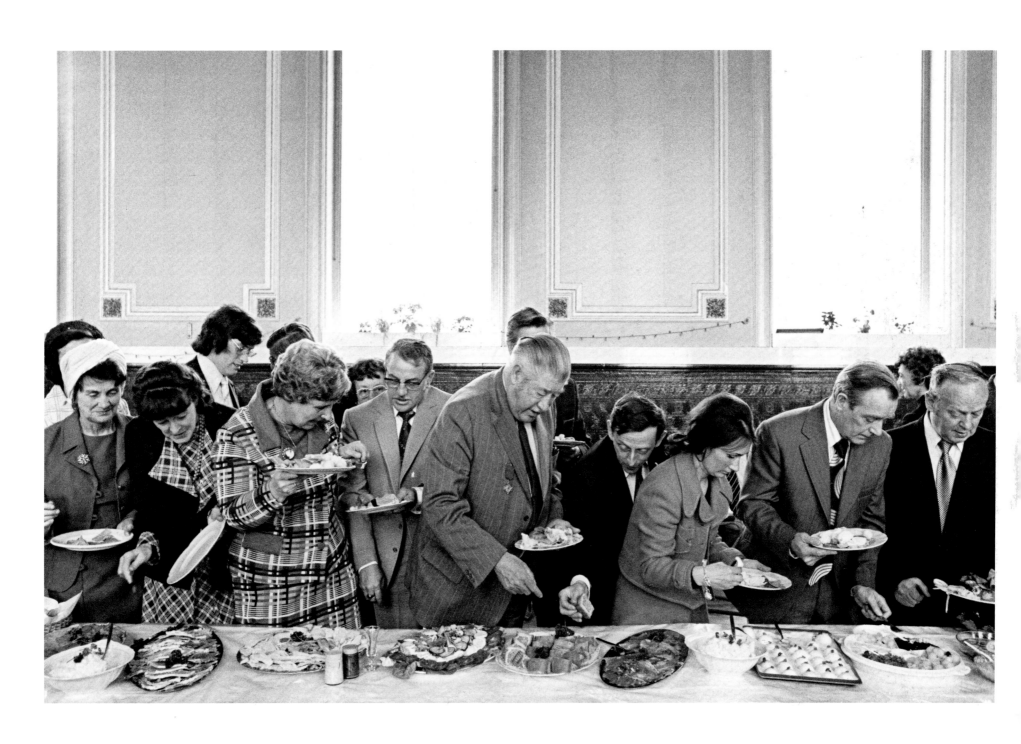

Mayor of Todmorden's inaugural banquet, Todmorden, Yorkshire, 1977

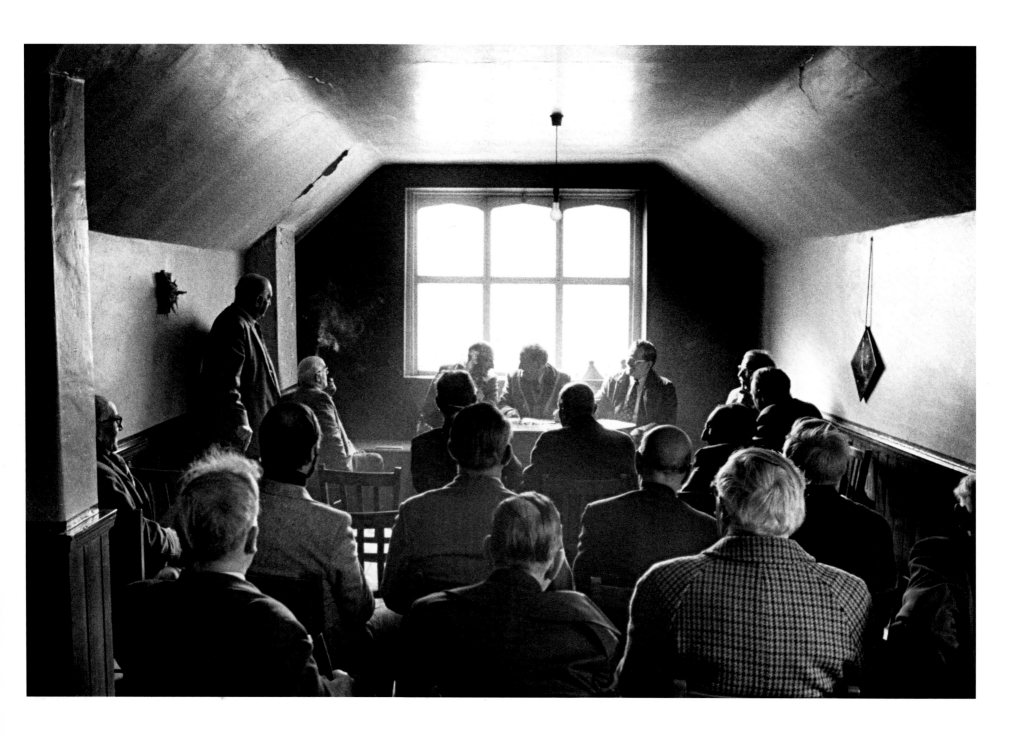

The Ancient Order of Hen-Pecked Husbands Annual General Meeting, Easter Monday, Nasebottom, Hebden Bridge, Yorkshire, 1977

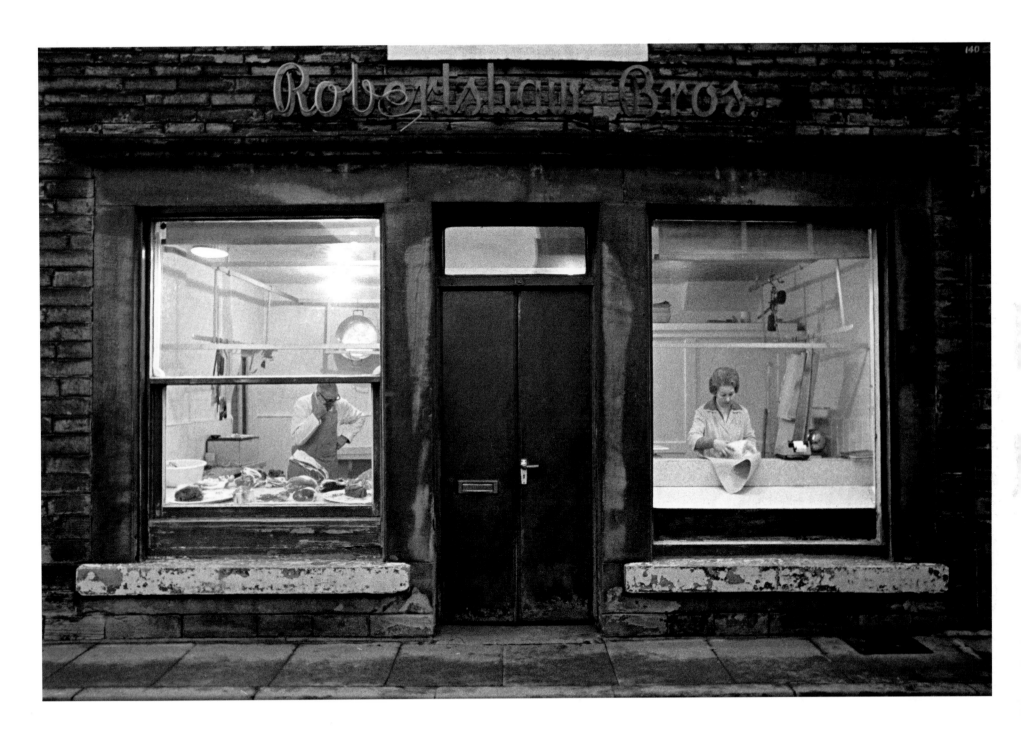

Mytholmroyd, Yorkshire, 1977

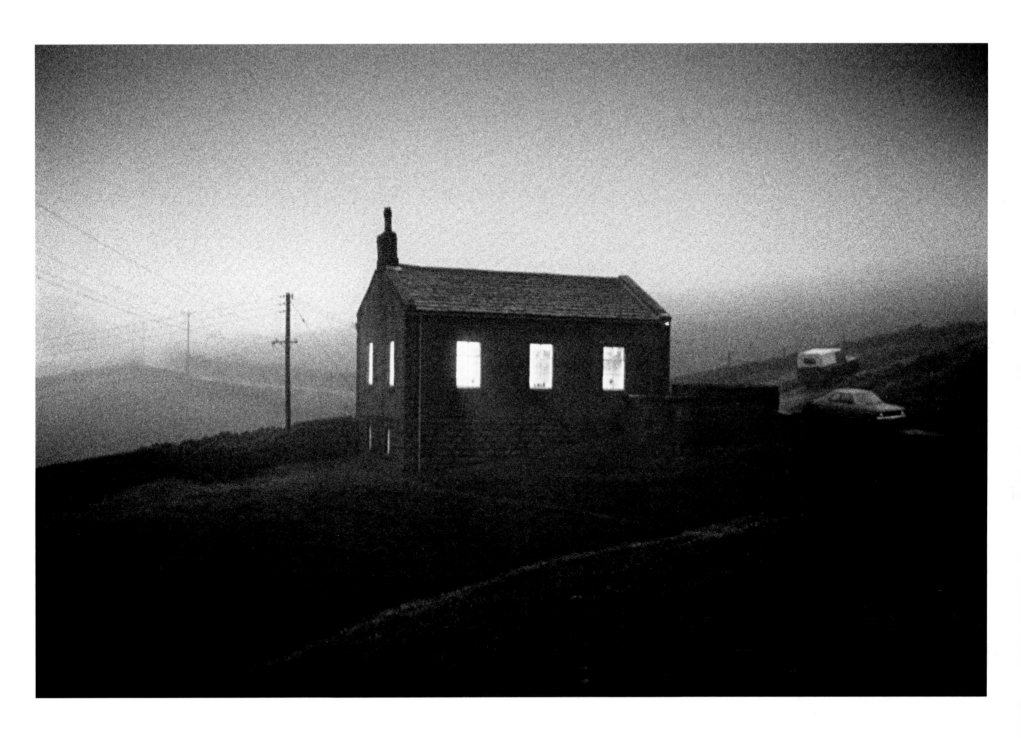

Crimsworth Dean Methodist Chapel, Yorkshire, 1977

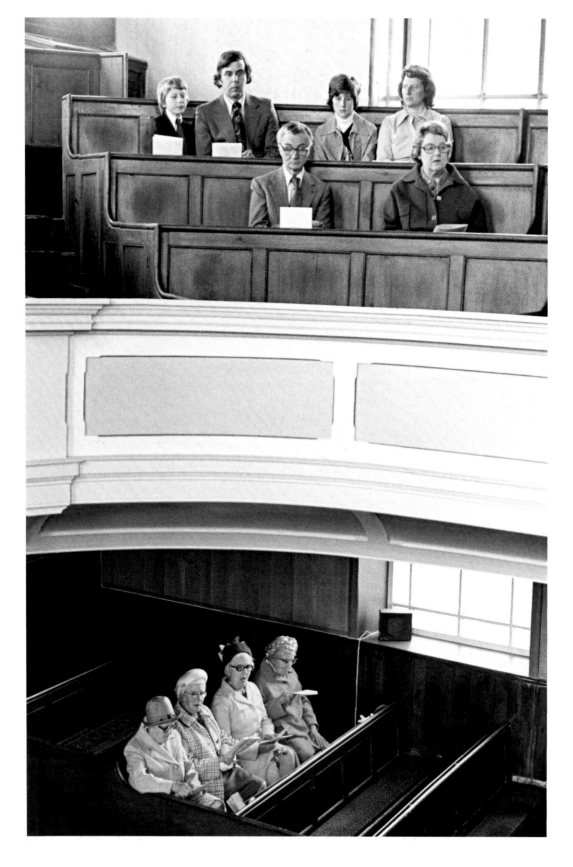

Steep Lane Baptist Chapel, Yorkshire, 1978

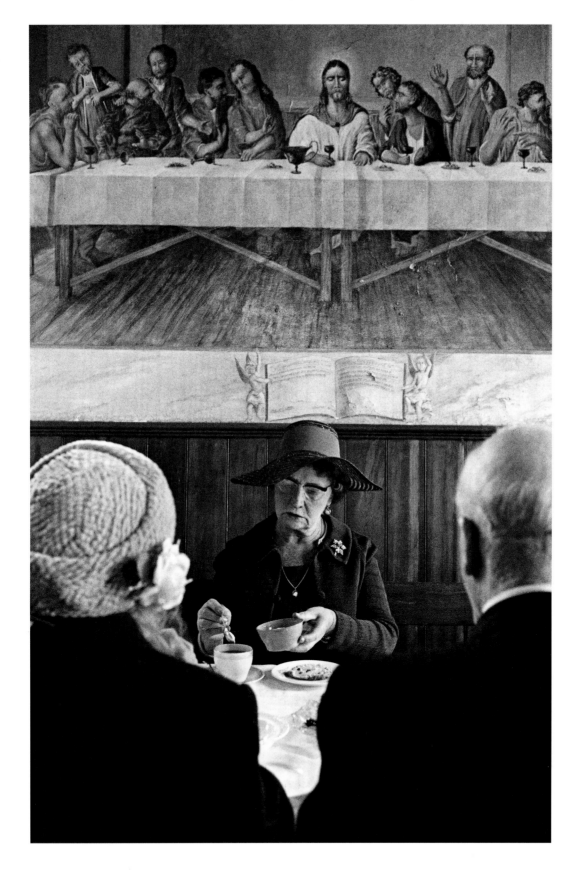

Steep Lane Baptist Chapel, Yorkshire, 1976

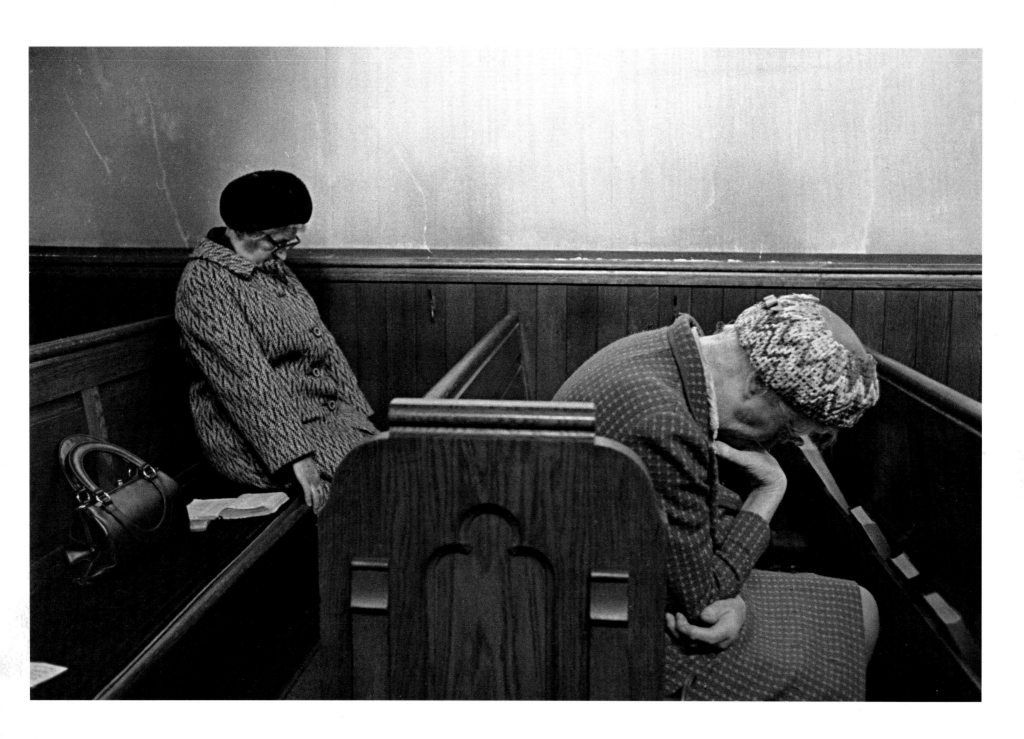

Monkinhole Methodist Chapel, Todmorden, Yorkshire, 1977

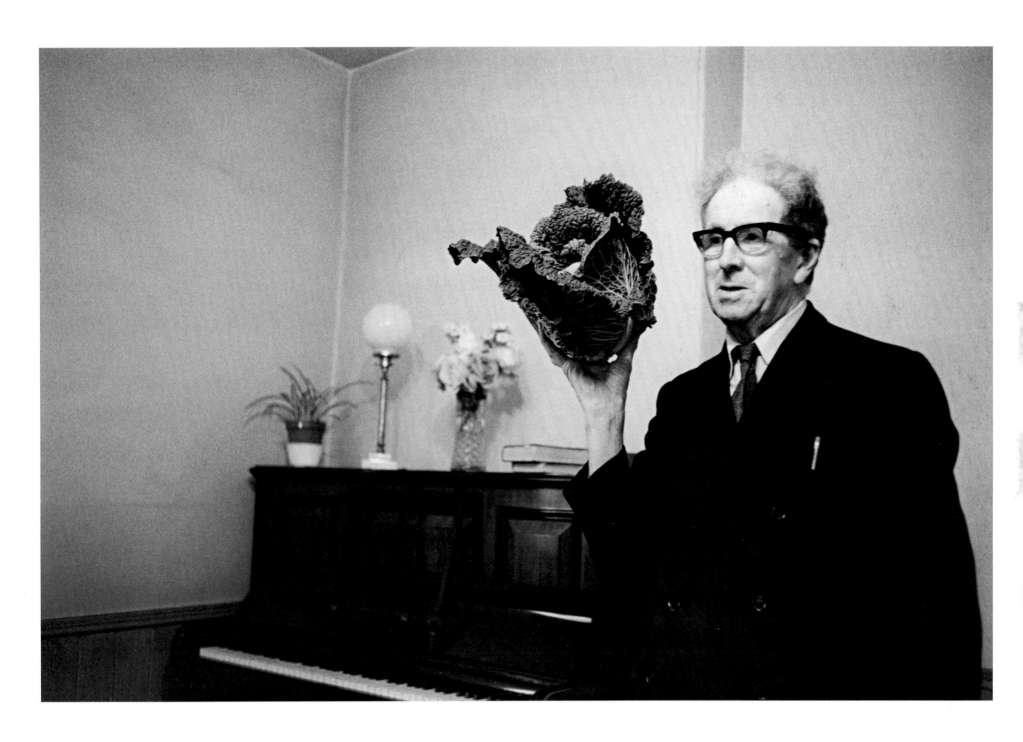

Auction of Harvest Festival goods, Pecket Well Methodist Chapel, Yorkshire, 1978

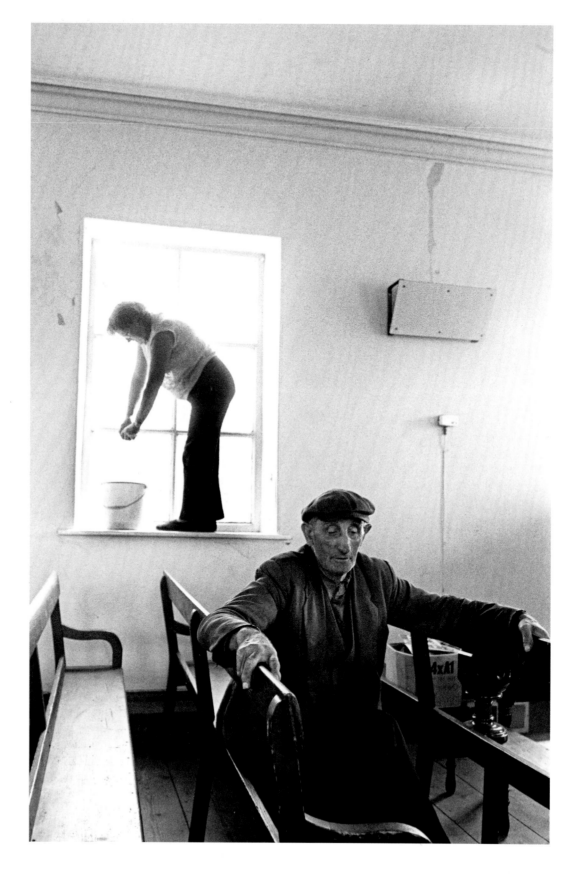

Annual spring clean in preparation for the Anniversary Service, Crimsworth Dean Methodist Chapel, Yorkshire, 1977

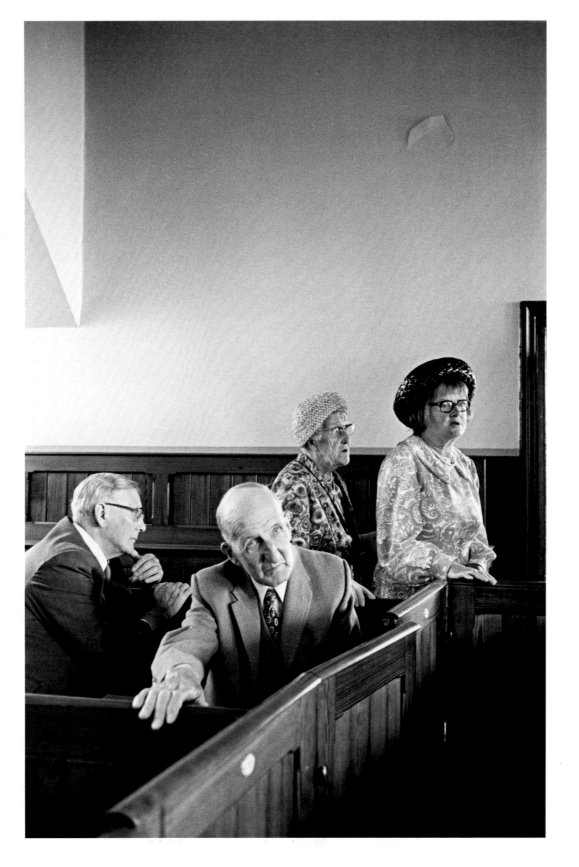

Pecket Well Methodist Chapel, Yorkshire, 1978

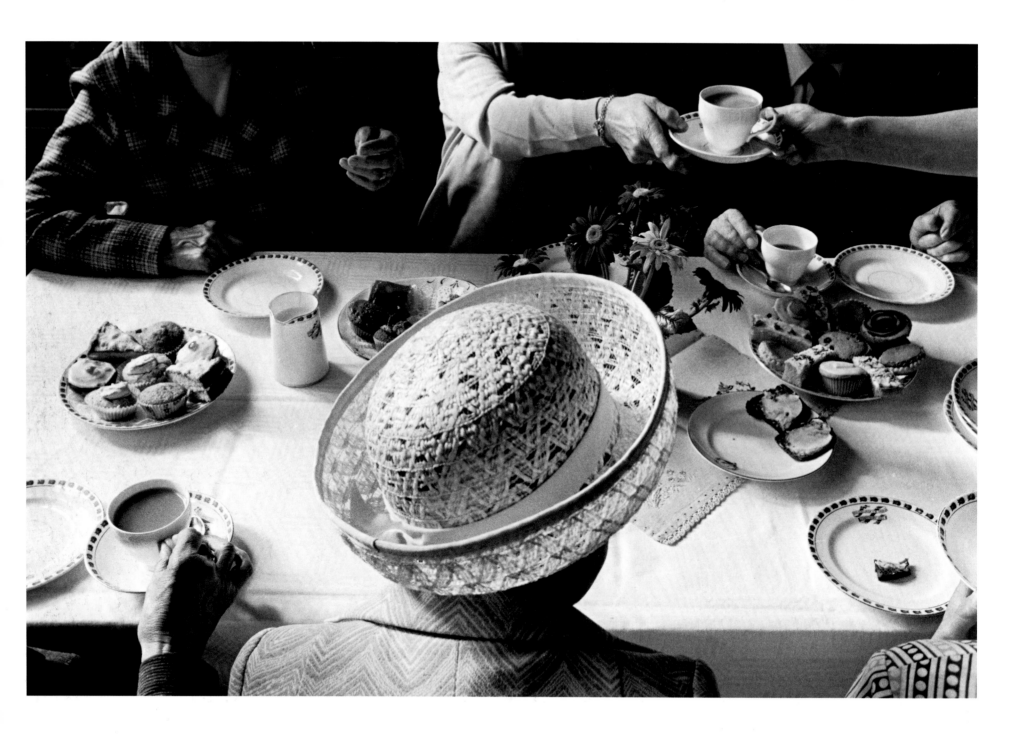

Anniversary Tea, Boulderclough Methodist Chapel, Yorkshire, 1978

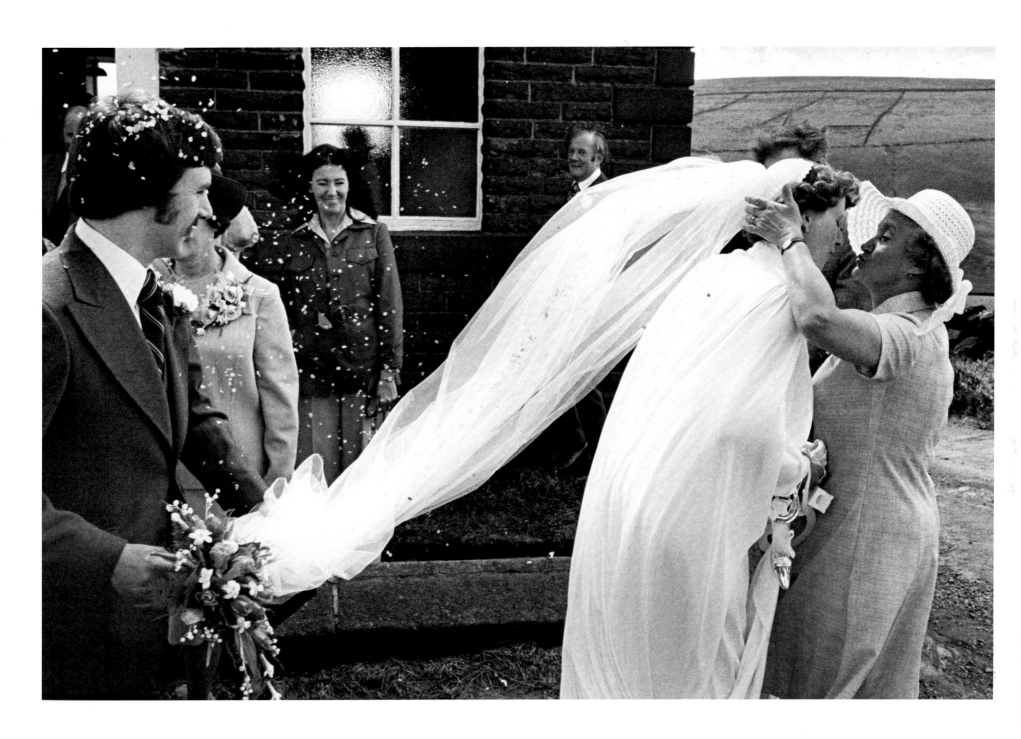

Wedding at Crimsworth Dean Methodist Chapel, Yorkshire, 1977

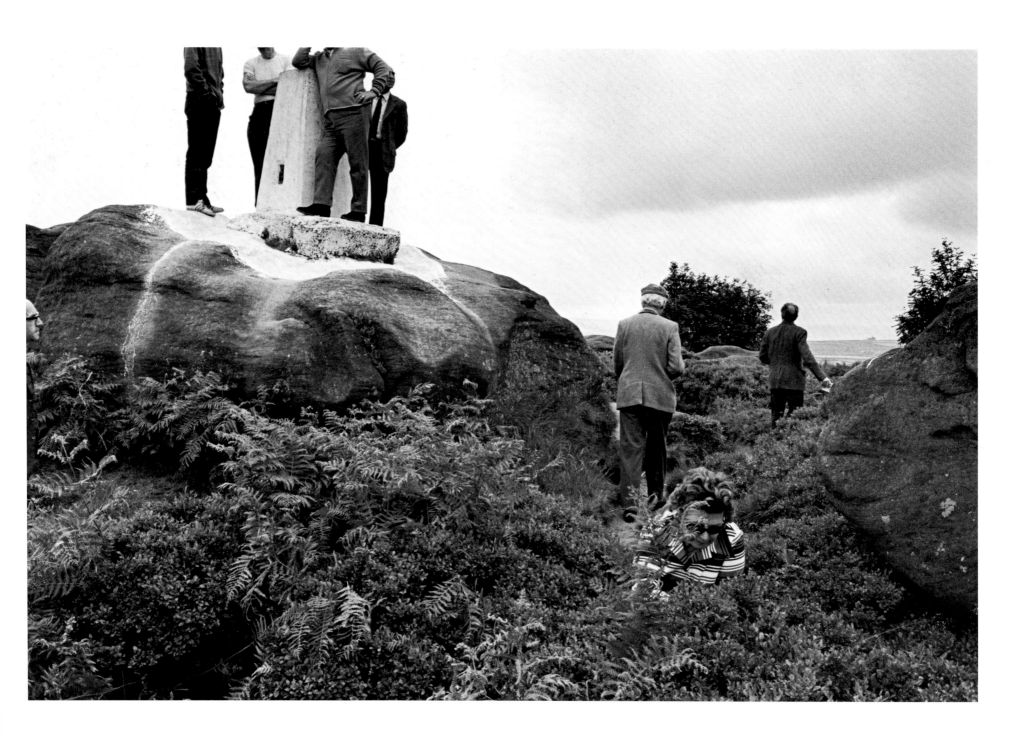

Brimham Rocks, Yorkshire, 1976, from 'Beauty Spots'

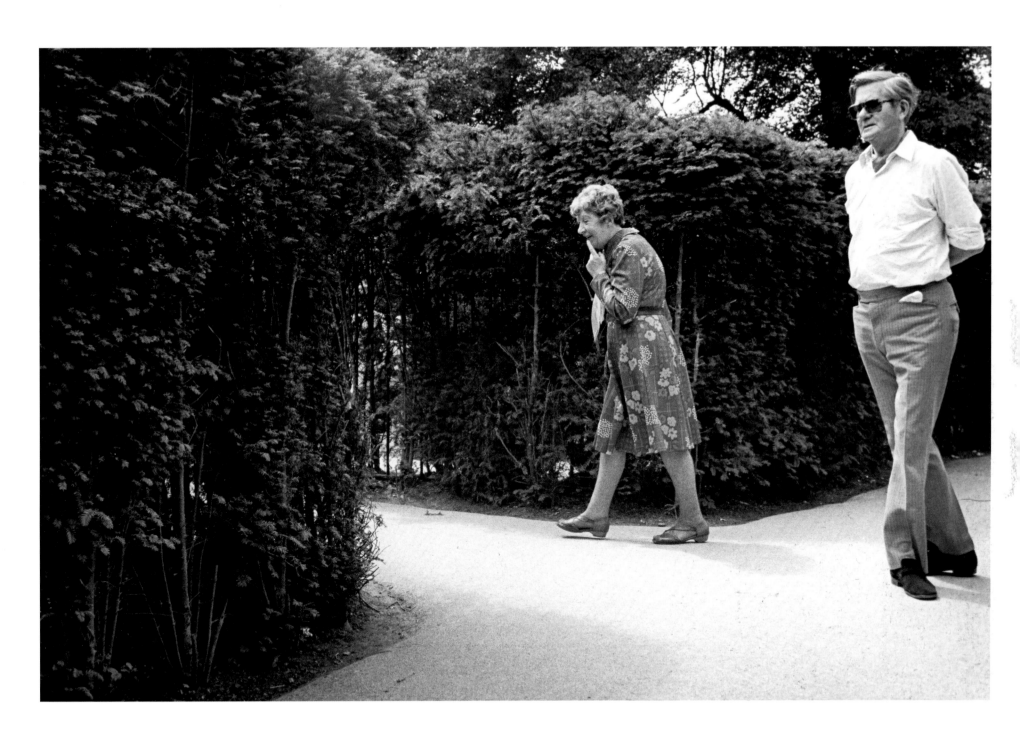

Centre of Hampton Court Maze, Surrey, 1976, from 'Beauty Spots'

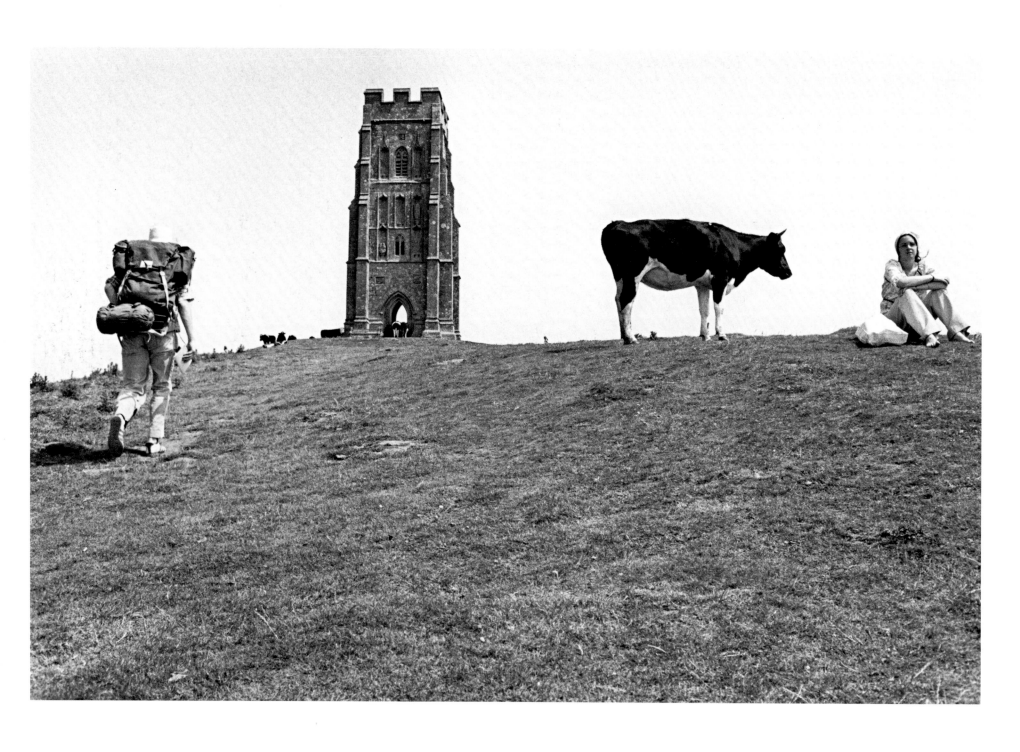

Glastonbury Tor, Somerset, 1977, from 'Beauty Spots'

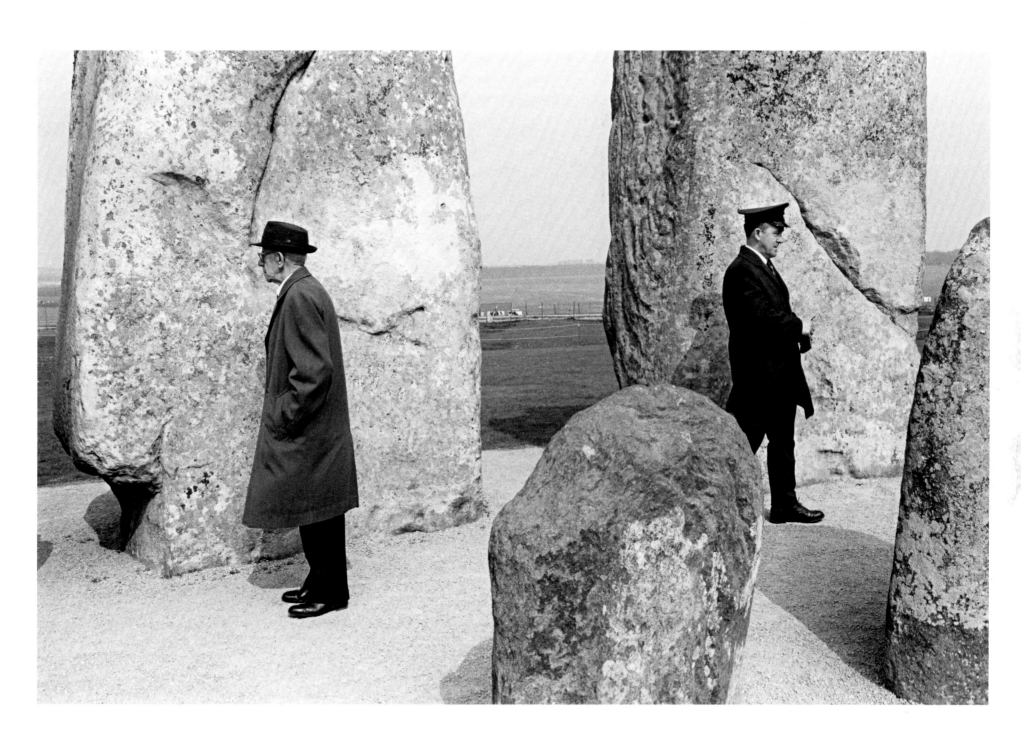

Stonehenge, Wiltshire, 1976, from 'Beauty Spots'

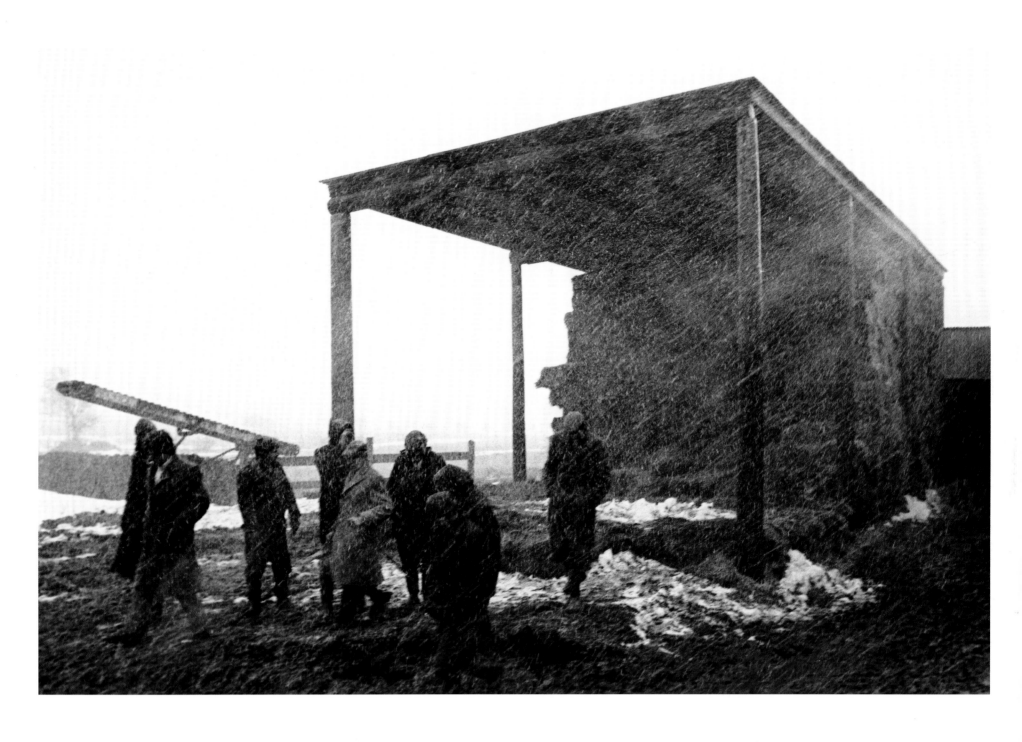

Checkheaton, Yorkshire, 1979, from 'Bad Weather'

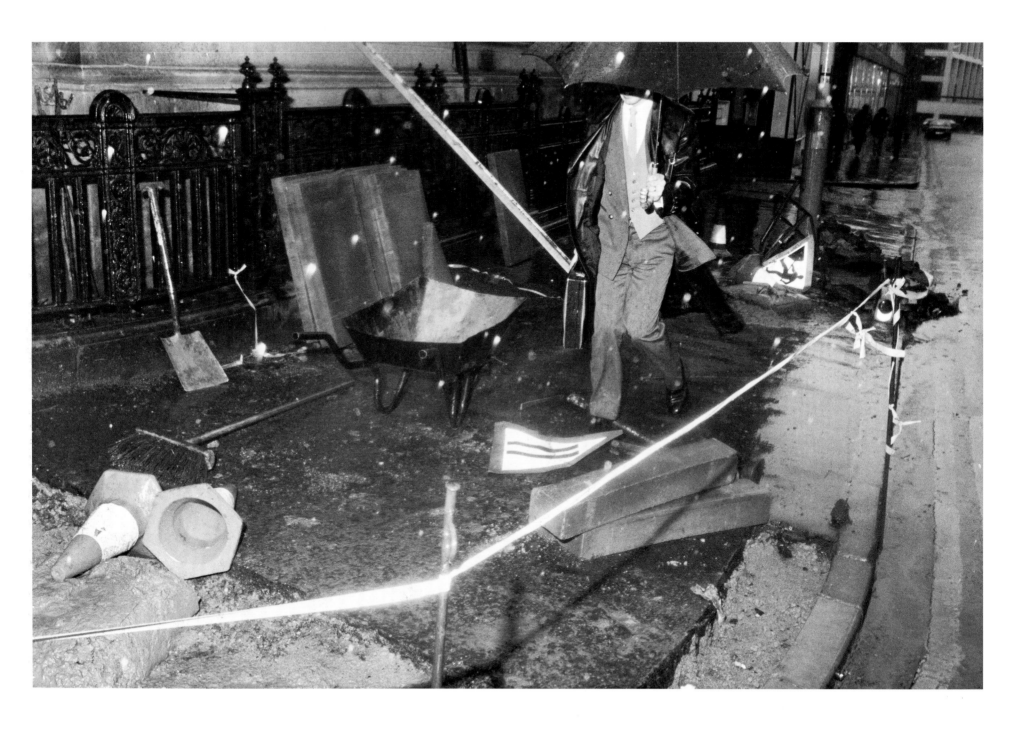

Manchester, 1981, from 'Bad Weather'

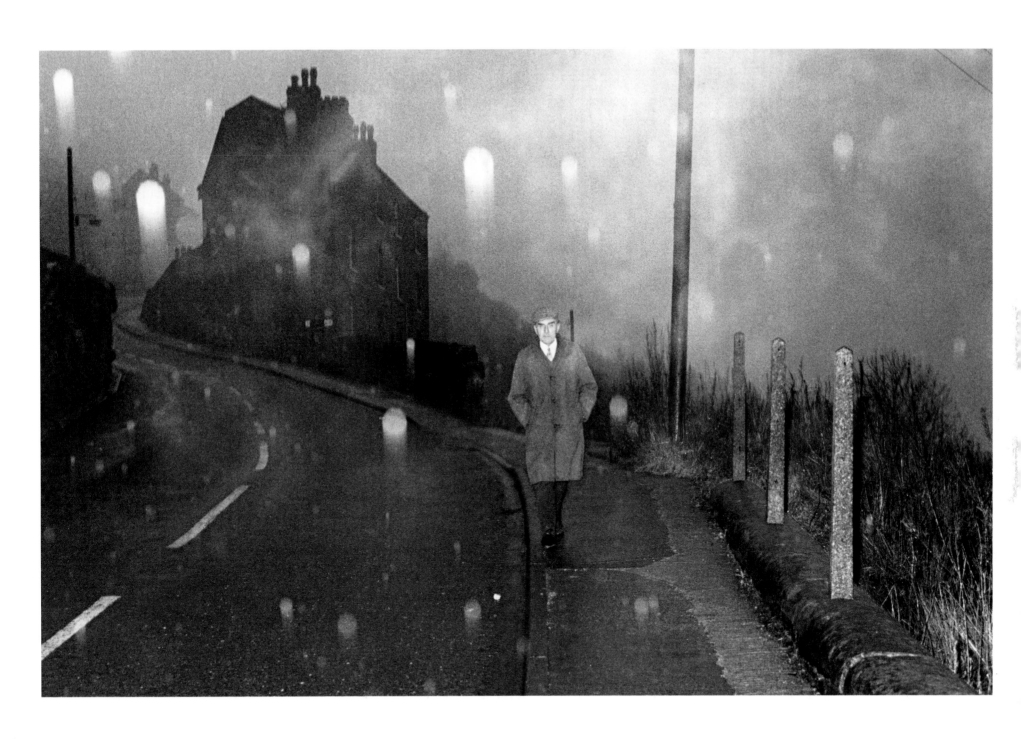

Halifax, Yorkshire, 1978, from 'Bad Weather'

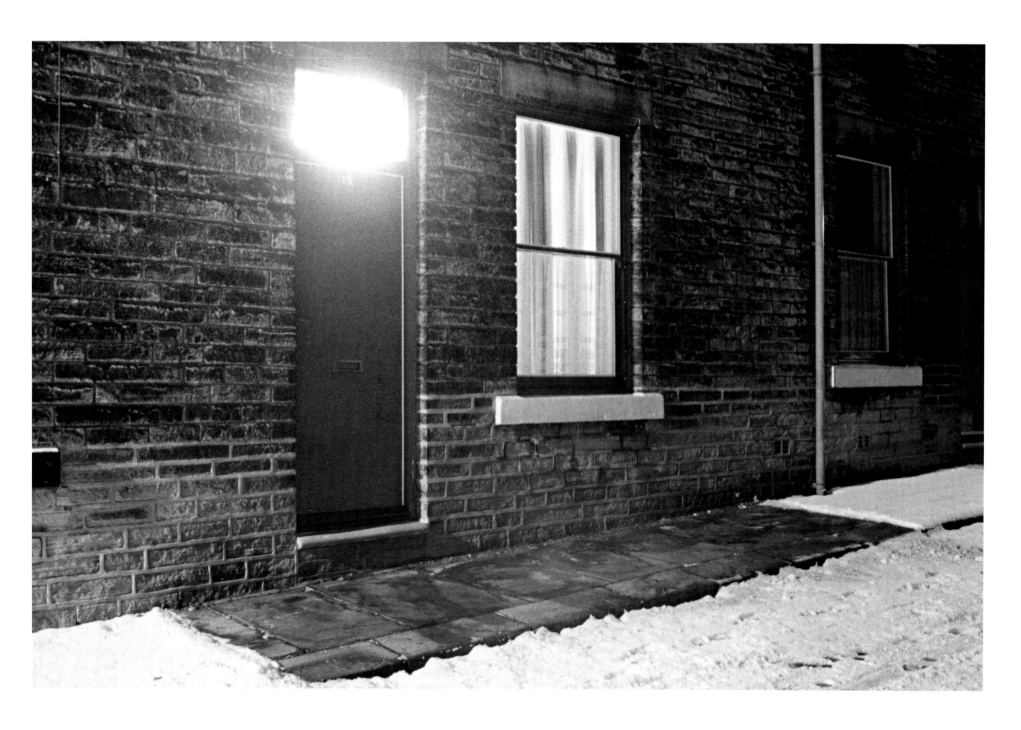

Hebden Bridge, Yorkshire, 1978, from 'Bad Weather'

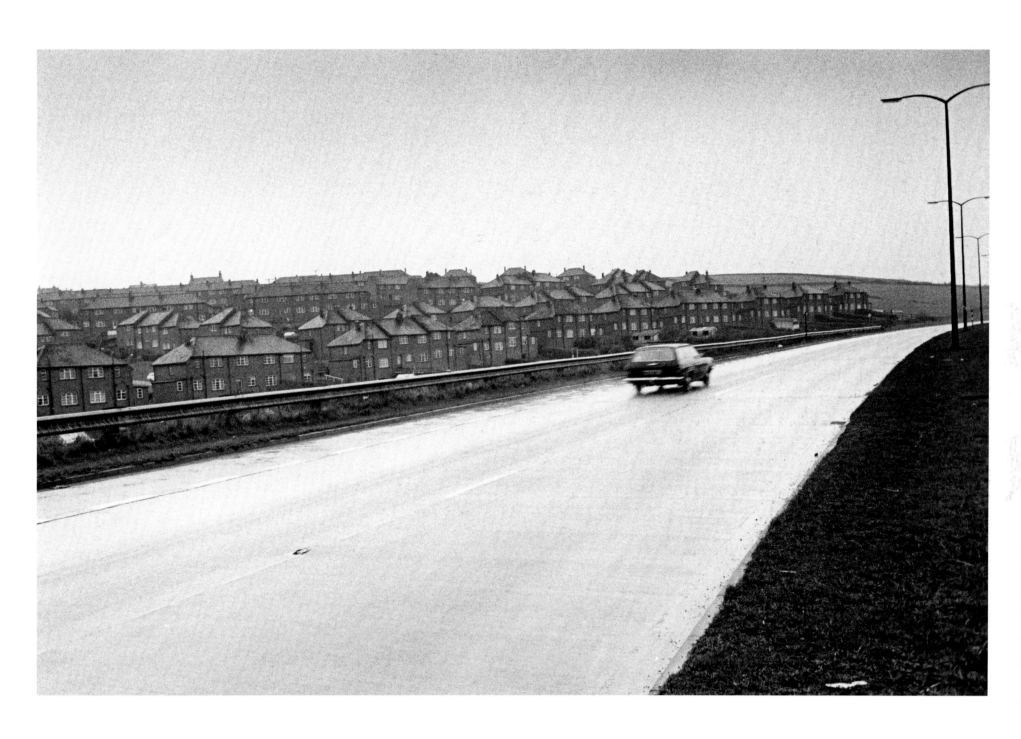

Bradford, Yorkshire, 1978, from 'Bad Weather'

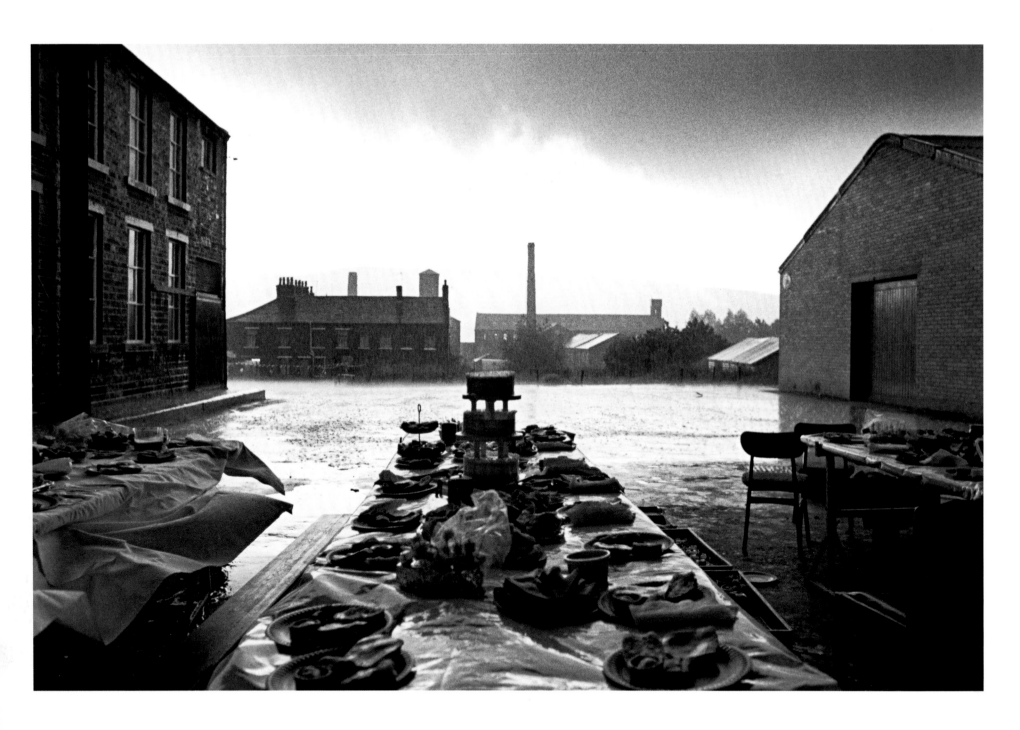

Jubilee street party, Elland, Yorkshire, 1977, from 'Bad Weather'

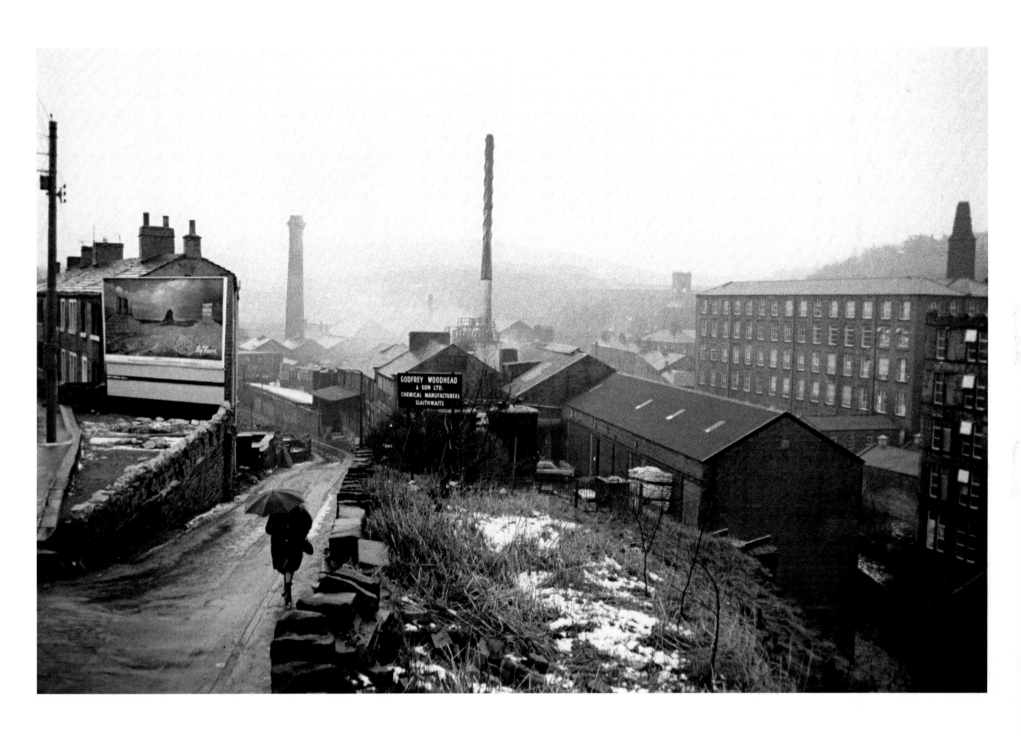

Slaithwaite, Yorkshire, 1980, from 'Bad Weather'

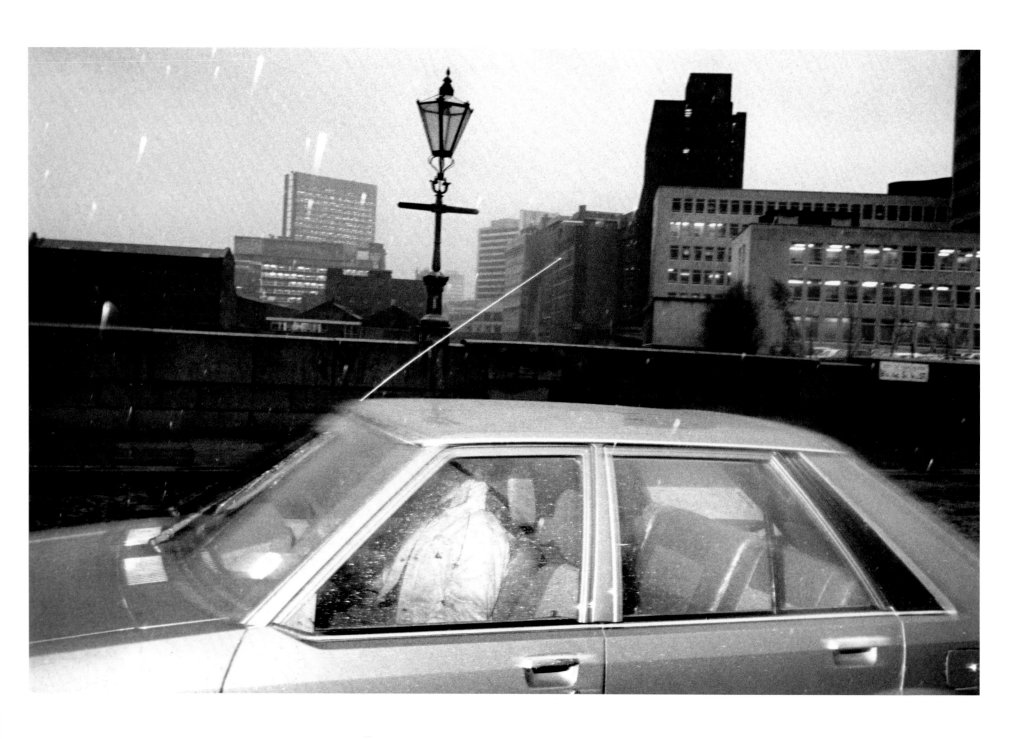

Manchester, 1981, from 'Bad Weather'

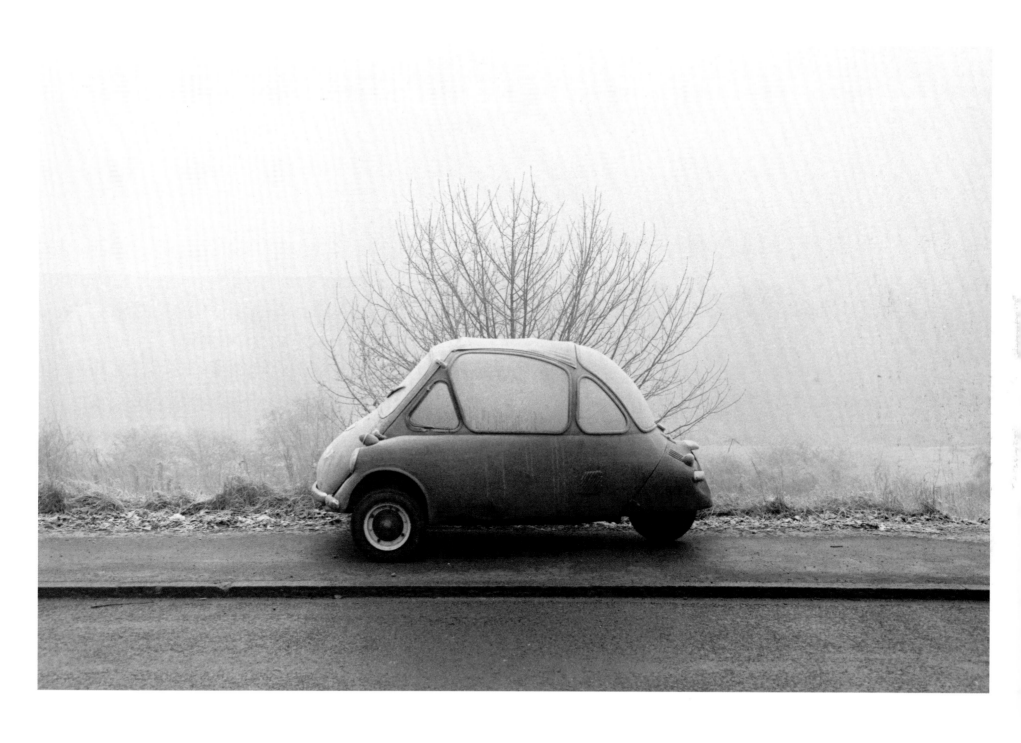

Elland, Yorkshire, 1978, from 'Bad Weather'

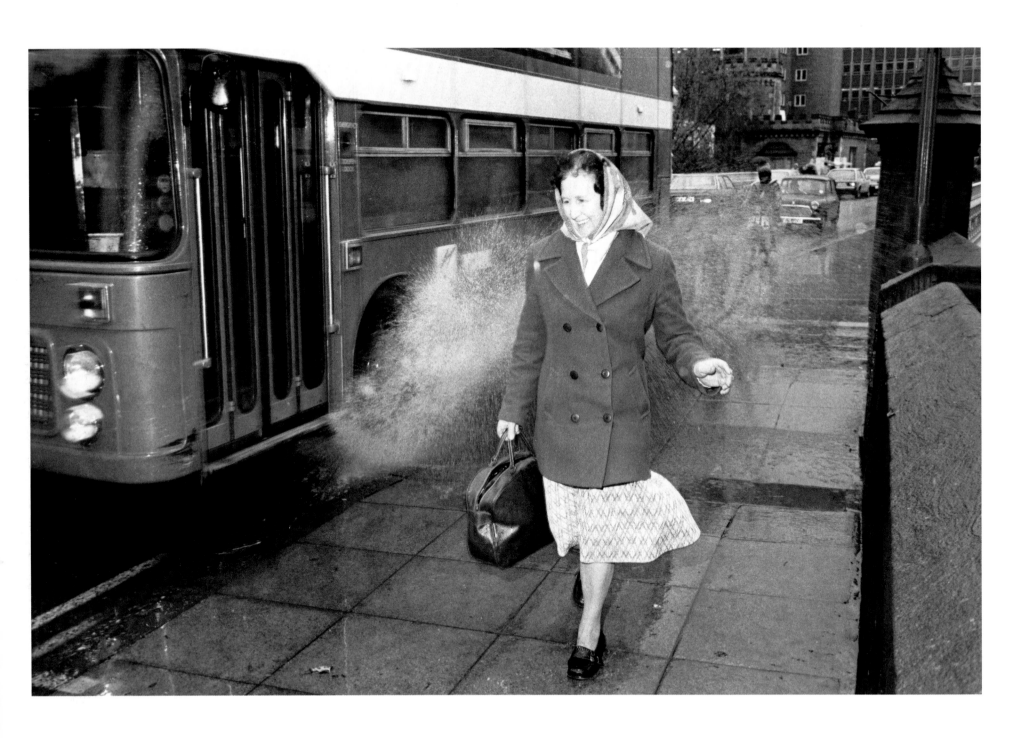

York, 1981, from 'Bad Weather'

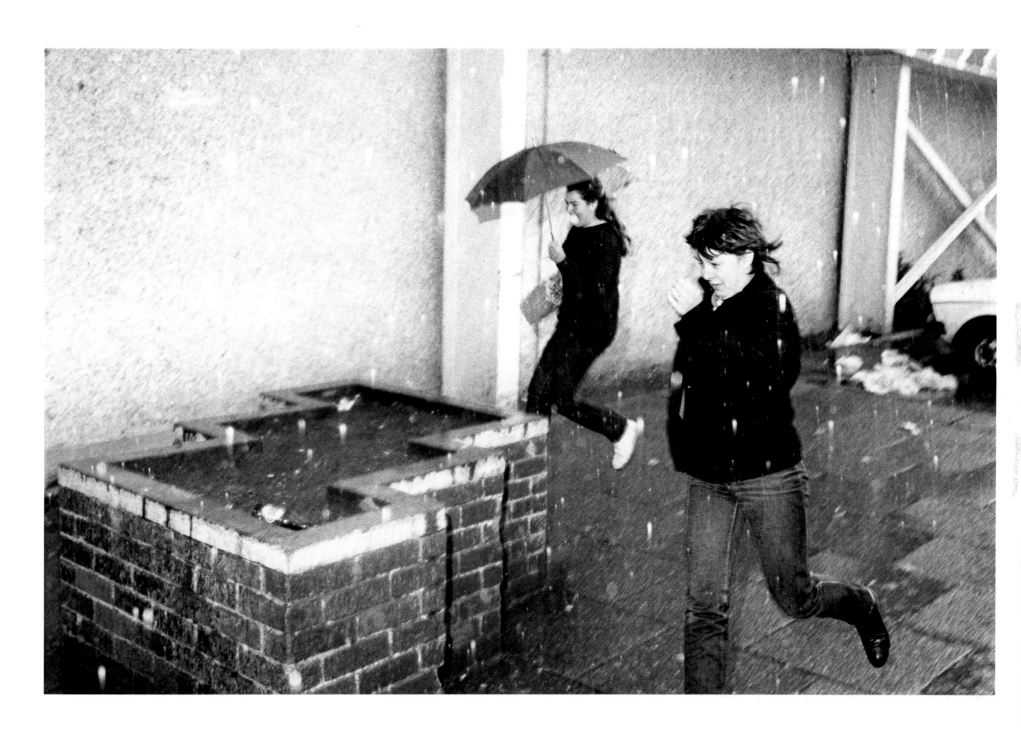

Sligo, Ireland, 1982, from 'Bad Weather'

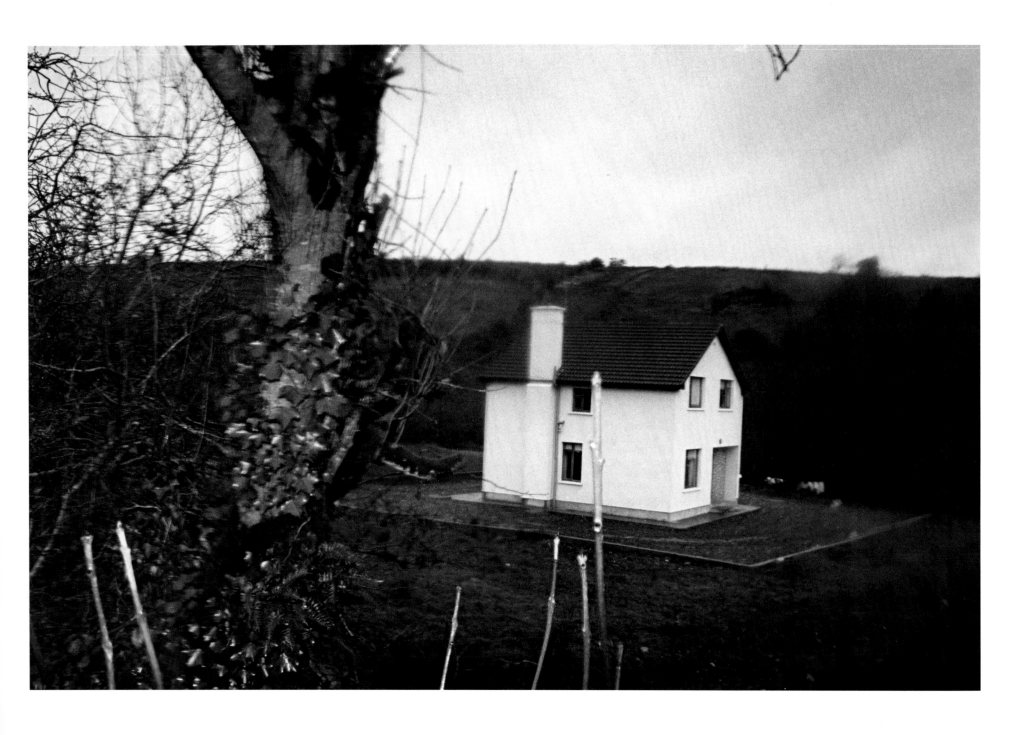

County Roscommon, Ireland, 1982, from 'Bad Weather'

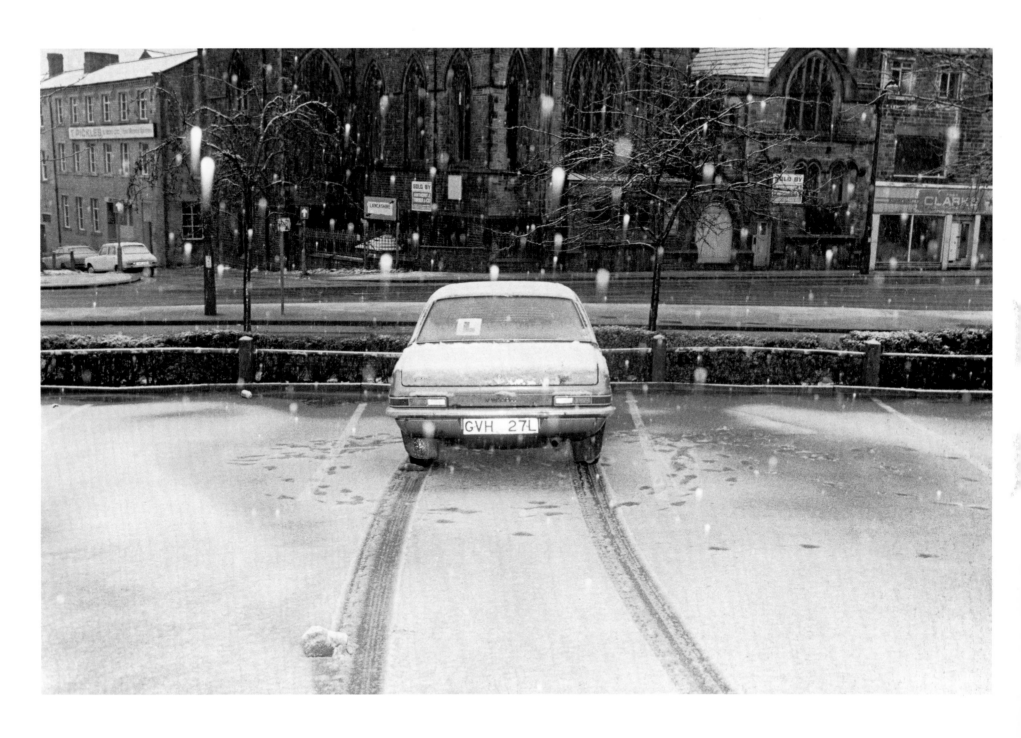

Halifax, Yorkshire, 1980, from 'Bad Weather'

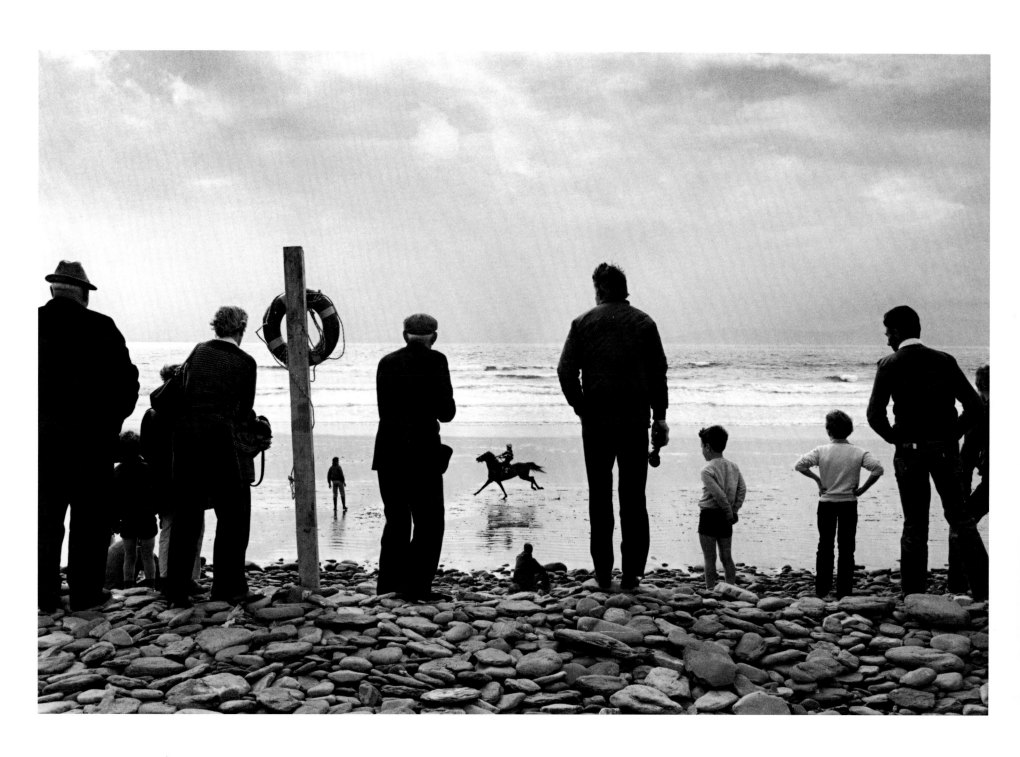

Glenbeigh Races, County Kerry, from 'A Fair Day', 1980–3

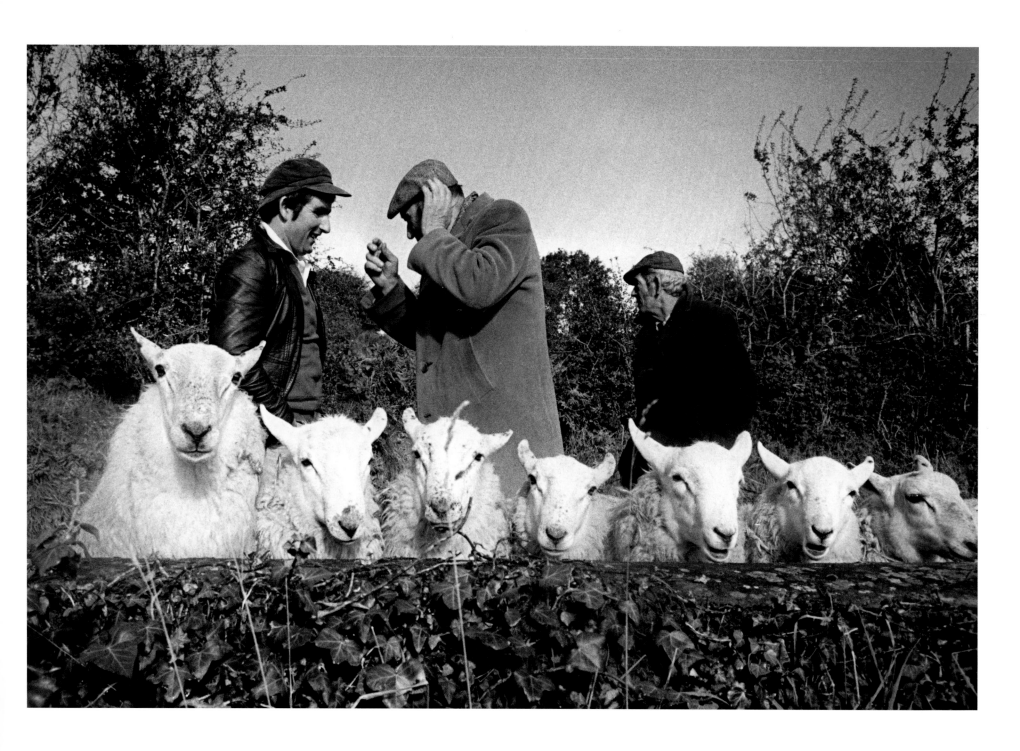

Manor Hamilton Sheep Fair, County Leitrim, Ireland, from 'A Fair Day', 1980–3

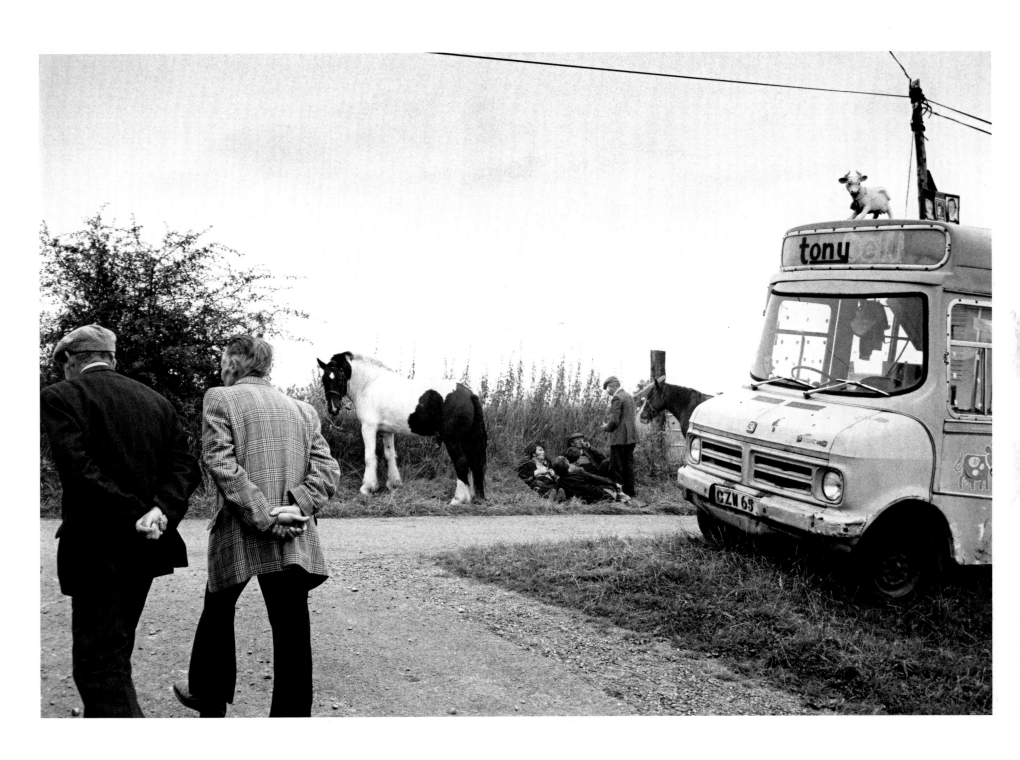

Muff Fair, County Cavan, Ireland, from 'A Fair Day', 1980–3

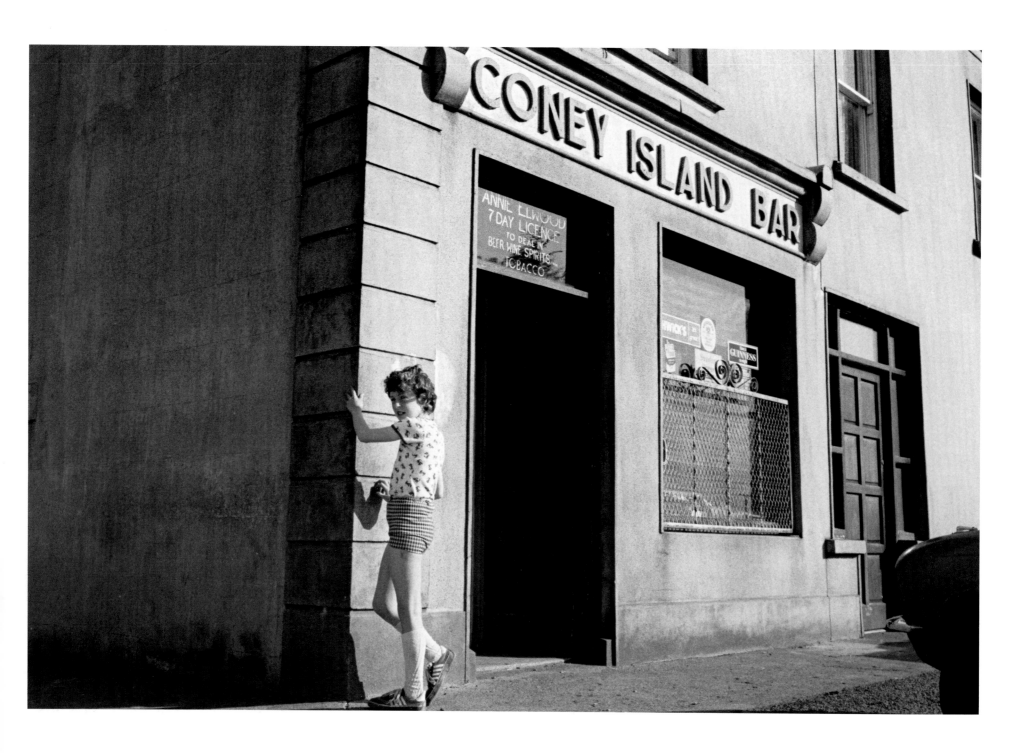

Errit, County Roscommon, Ireland, from 'A Fair Day', 1980–3

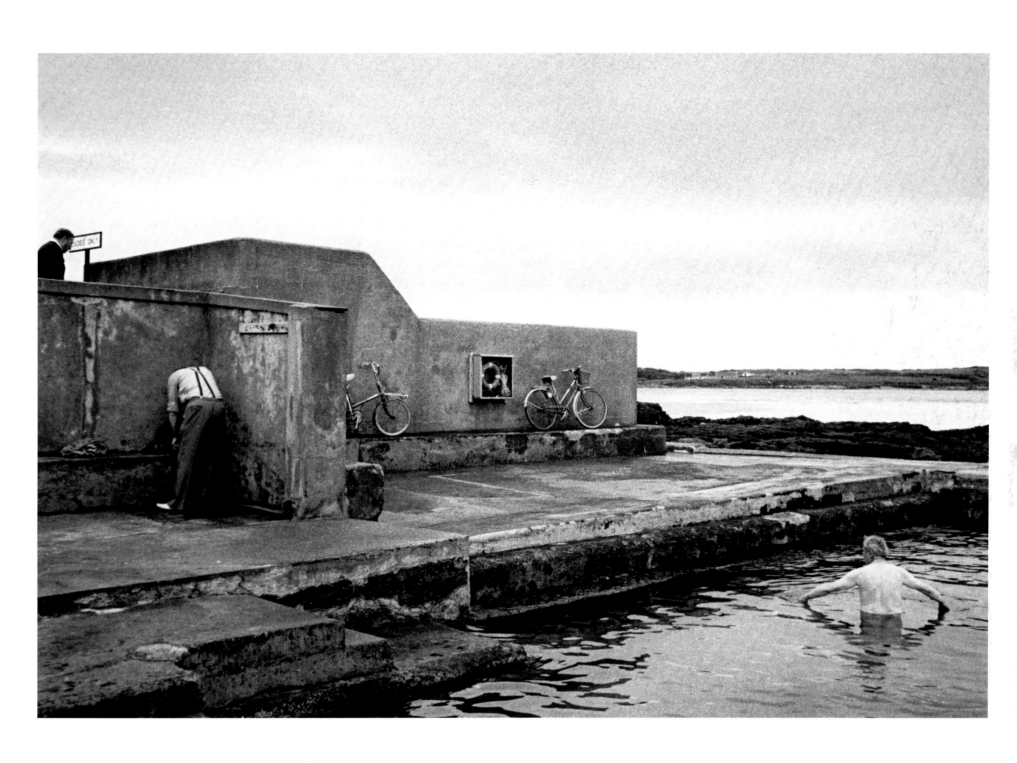

Rosses Point, County Sligo, Ireland, from 'A Fair Day', 1980–3

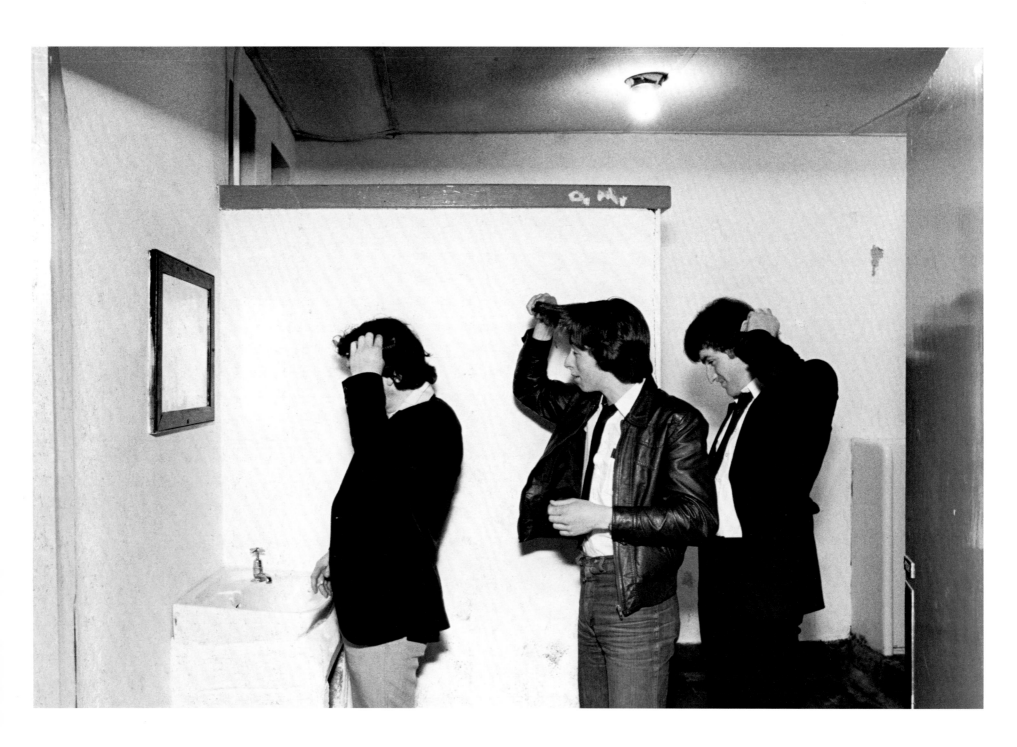

Amethyst Ballroom, Elfin, County Roscommon, Ireland, from 'A Fair Day', 1980–3

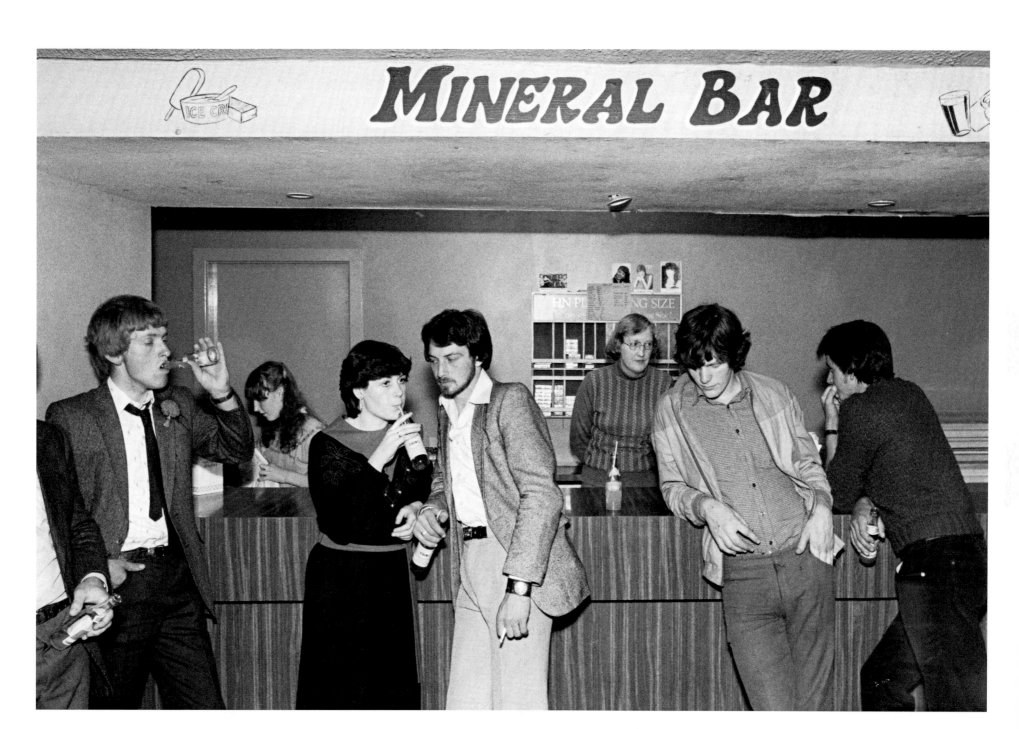

Rainbow Centre, Glenfarme, County Leitrim, Ireland, from 'A Fair Day', 1980–3

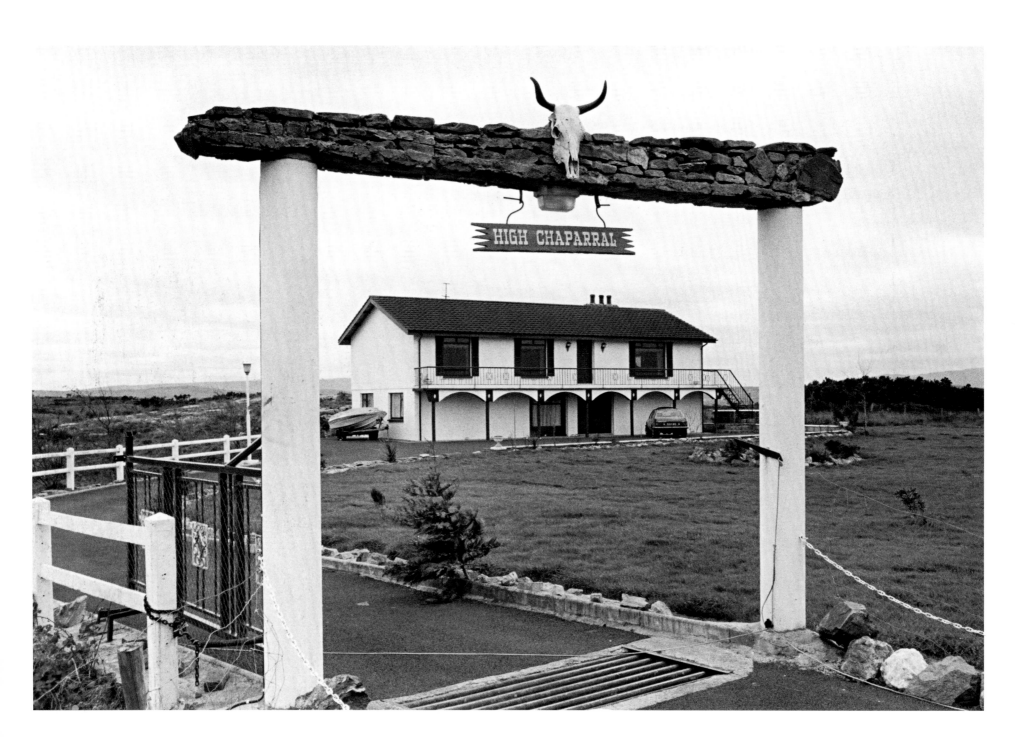

High Chaparral

Westport, County Mayo, Ireland, from 'A Fair Day', 1980–3

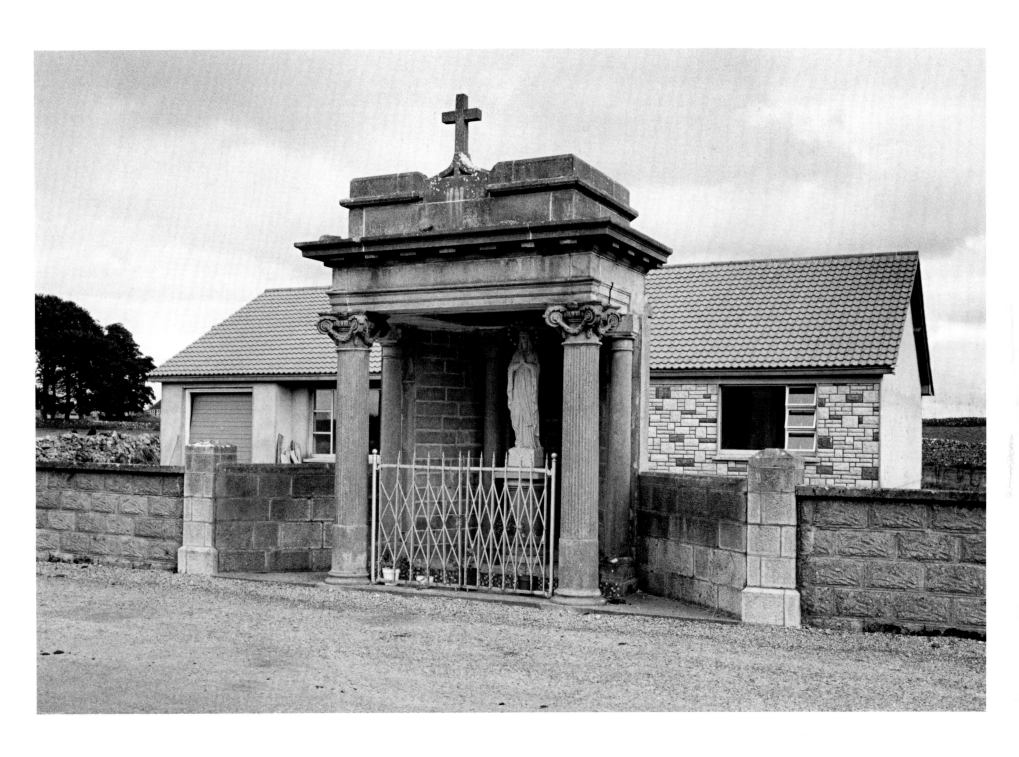

Athleague, County Roscommon, Ireland, from 'A Fair Day', 1980-3

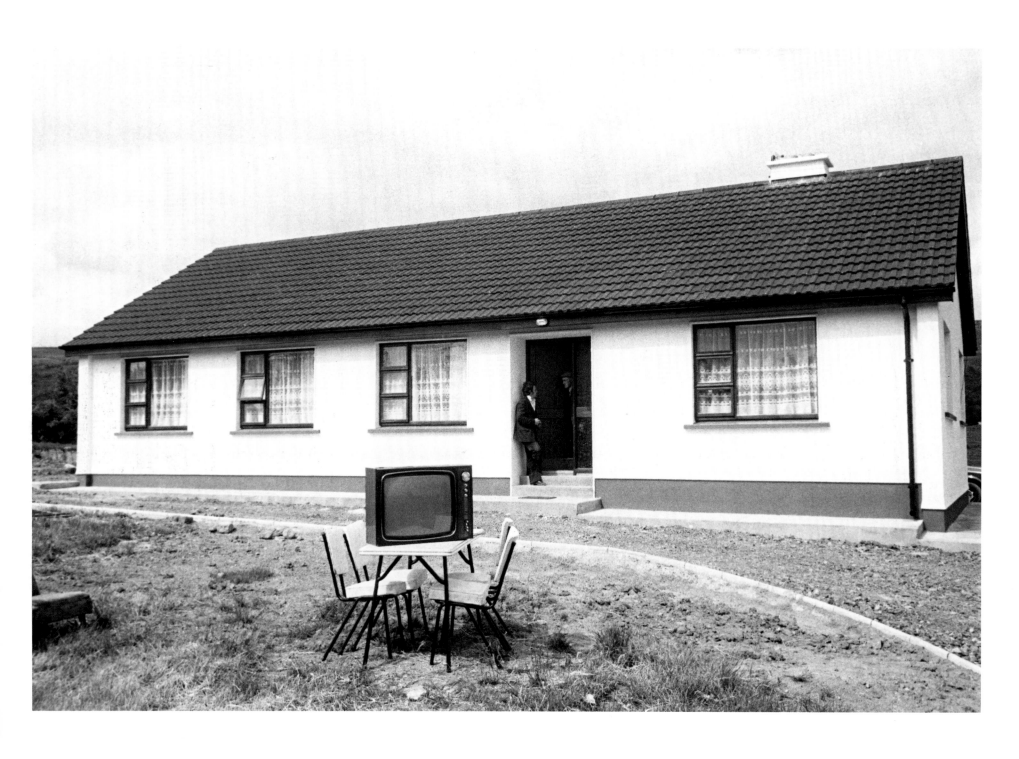

Keadue, County Roscommon, Ireland, from 'A Fair Day', 1980–3

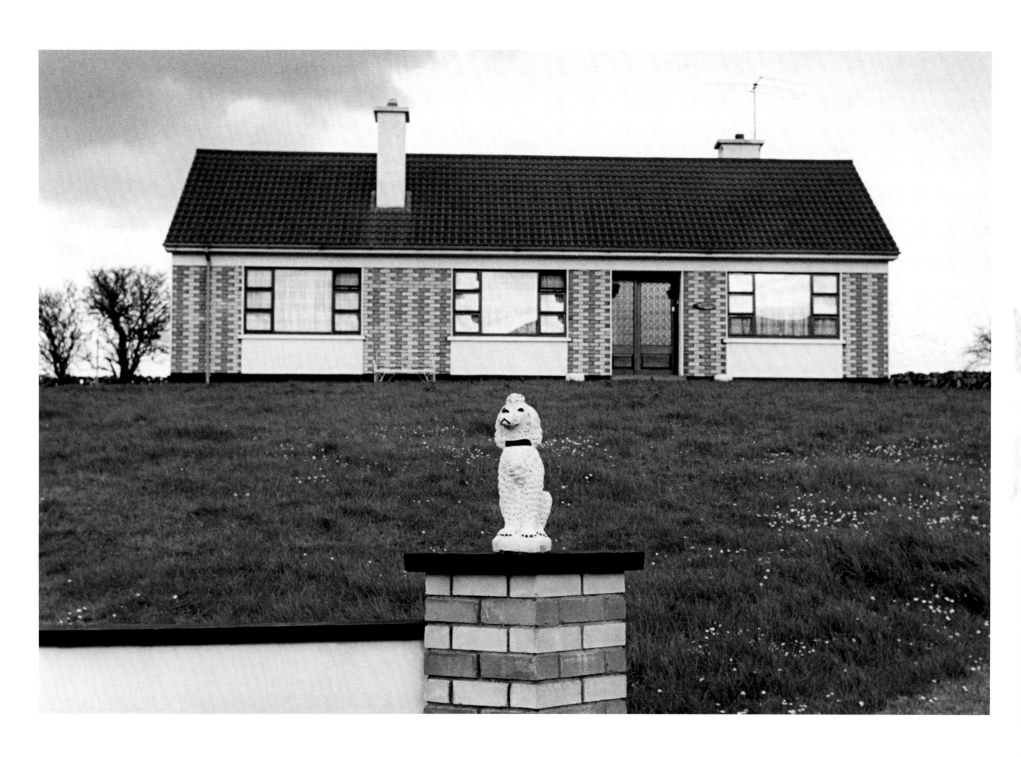

The Burren, County Clare, Ireland, from 'A Fair Day', 1980–3

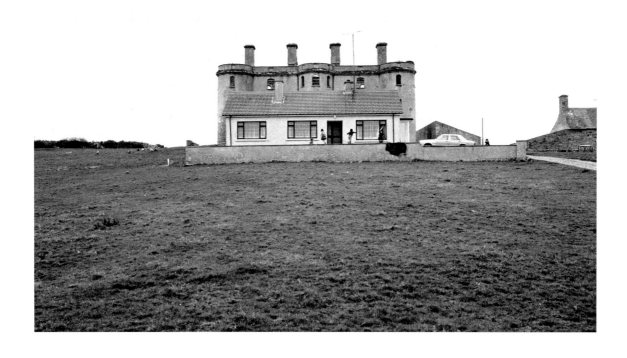

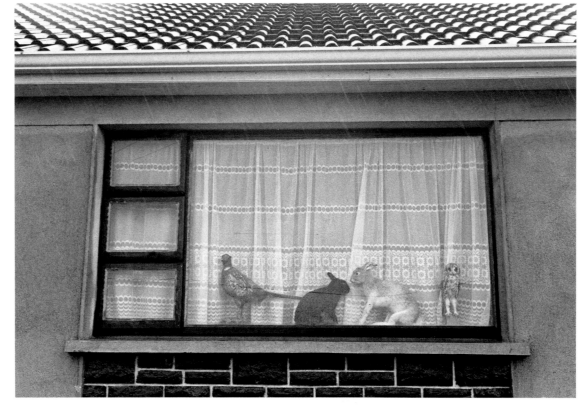

Top: County Donegal, Ireland, from 'A Fair Day', 1980–3 Bottom: County Donegal, Ireland, from 'A Fair Day', 1980–3

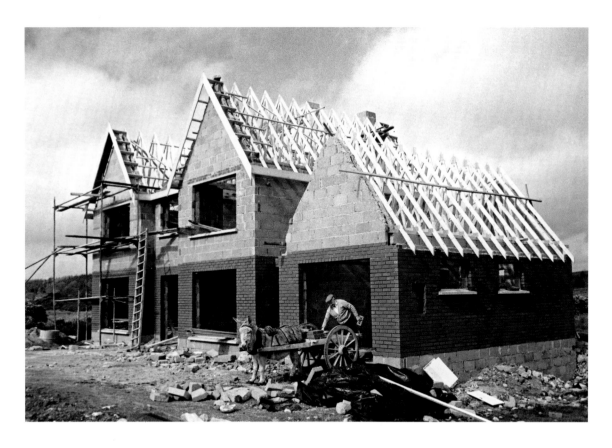

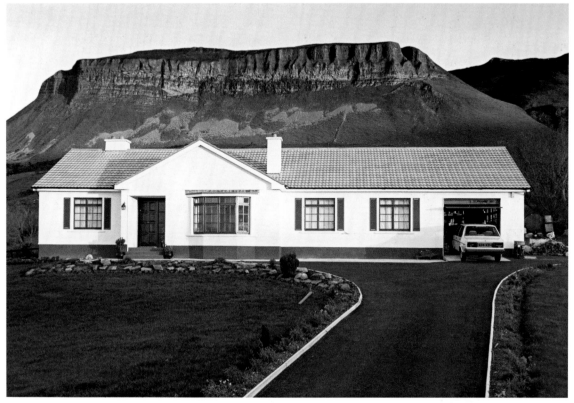

Top: County Mayo, Ireland, from 'A Fair Day', 1980–3 Bottom: County Sligo, Ireland, from 'A Fair Day', 1980–3

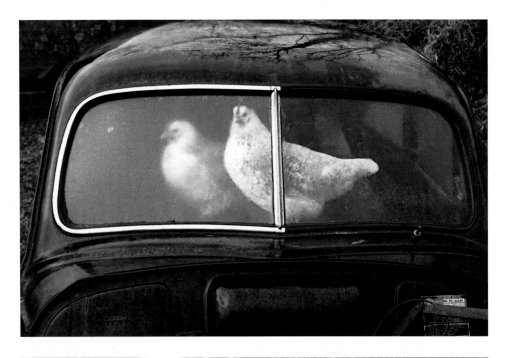

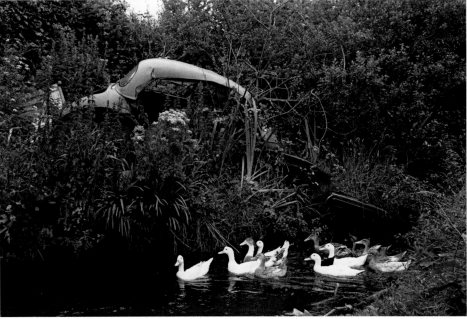

Abandoned Morris Minors, Ireland, from 'A Fair Day', 1980–3

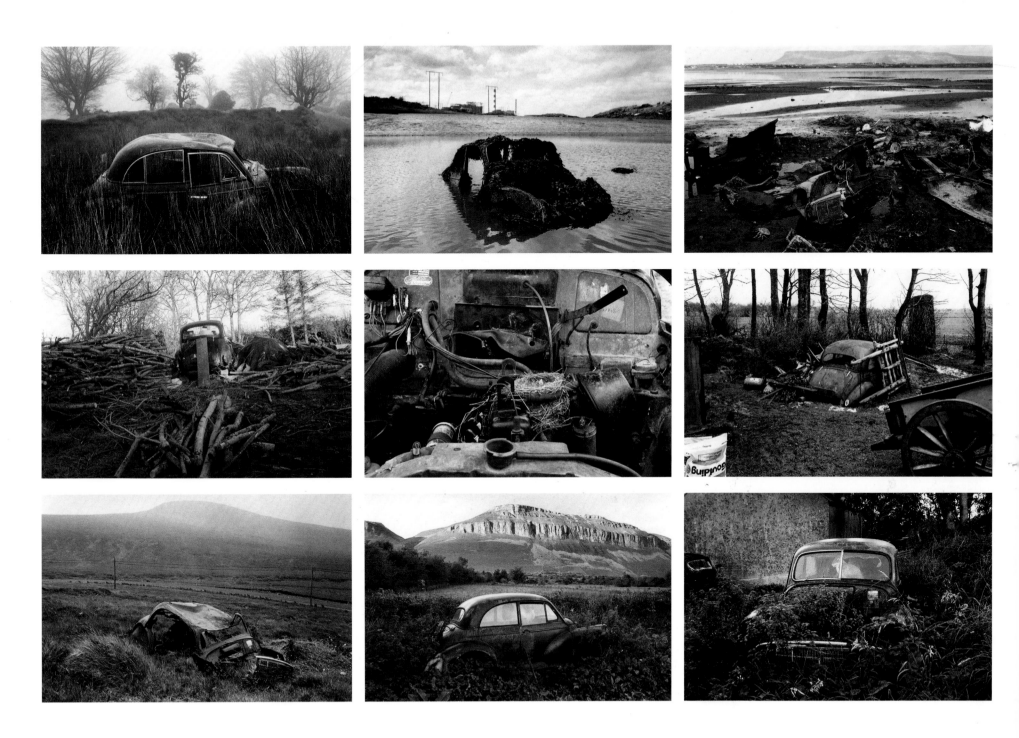

Ordinary

colour documentary

When Parr returned to England in 1982, he and Susie bought a house in Wallasey, on Liverpool Bay, the furthest tip of the great conurbation that includes the city of Liverpool, Ellesmere Port and, beyond that, Manchester, Salford and Hebden Bridge. To the north are the former cotton producing towns of Rochdale, Bolton and Wigan, leading onto the Lake District. To the south is Cheshire and North Wales. Just a few miles from Wallasey is the seaside resort of New Brighton, which was to be the major focus of Parr's shift into colour documentary in the mid-1980s. He moved away from the 35mm camera, and bought a Plaubel, a medium-format German camera with high definition.

Parr had become fascinated with the new way of seeing that he had observed in the colour documentary work of American photographers William Eggleston and Joel Sternfeld, whose photographs of everyday things and ordinary people were infused with a particular menace. While Parr's photographs of Crimsworth Dean and Hebden Bridge had been a gentle comedy, his new work, inspired by the photographs he had seen in William Eggleston's *Guide*

(1976), was on the brink of becoming a raucous celebration of the everyday. In Hebden Bridge, Parr had wanted to belong, but in Merseyside, he was an outsider, an observer. The photographic and arts communities that had surrounded and to some extent supported him in Manchester and Hebden Bridge were now quite distant. Only a few people within easy travelling distance knew enough about the photography scene to become close associates. One of these was Neil Burgess, a graduate of York University who had become interested in photography through his connections with Impressions Gallery.

Burgess had taken the job as Director of Open Eye, a photography-only space in the centre of Liverpool. Later Bureau Chief at Magnum Photos and then Director of the Network photo agency in London, Burgess was ambitious, determined and fascinated by contemporary photography. It was at Open Eye that Parr first exhibited his groundbreaking series of colour documentary photographs, 'The Last Resort', made in the decaying seaside resort of New Brighton, just a few miles along the coast from Wallasey.

Here he became friendly with Tom Wood, a photographer who was also working in New Brighton, and at one time there was an idea that their work there could form a joint project. Although they exhibited together, Parr went on to make a monograph of his photographs.

When Parr returned from Ireland, the British photographic scene had fragmented. Peter Turner had given up the editorship of *Creative Camera* and was working with his partner Heather Forbes in their book distribution and publishing company Travelling Light. The debates that had emerged in the 1970s around figures such as John Szarkowski (the influential curator of photographs at New York's Museum of Modern Art) and the mystical landscapist Minor White (1908–76) were no longer seen as relevant to a new generation that had become interested in the theoretical base of photography (epitomized in the writings of European theorists such as Roland Barthes and Jacques Derrida) and in the ways in which the politics of gender and race could be expressed through the practice of photography. In the outside world, Thatcherism was gathering pace,

laying the foundations for the most controversial social revolution since the establishment of the Welfare State. In 1984 the coal miners went on strike (and were subsequently defeated), provoking a conflict between government and unions that was to change the face of industrial relations in Britain for the foreseeable future.

In 1985, Peter Turner curated the exhibition 'American Images 1945–1980' for the Barbican Art Gallery in London, and was taken to task by the critics. The show was criticized for its lack of politics, its lack of women, its lack of theory and its elitism. Despite the fact that all the great names were included – Lee Friedlander, Ansel Adams, Minor White, Lewis Baltz, William Eggleston, Joel Sternfeld, Richard Misrach – the exhibition was not a success. The art public were looking towards Europe for signs of a new wave, and found it in the works of German artists such as Thomas Ruff and Thomas Struth and, in France, in the work of Christian Boltanski and Sophie Calle. In Britain, figures were emerging who would set new agendas in photography – Jo Spence, who used photography as an autobio-

graphical, political tool; Mitra Tabrizian, who as a graduate of Victor Burgin's course at the Central London Polytechnic worked with photography and text; and Helen Chadwick, whose startling photo-sculptures had achieved critical recognition with her 1983 solo show at London's Serpentine Gallery. Swinging away from the notion of the master photographer, photography had become politicized.

Parr's photography, though modelled on the new wave of the USA, emerged as a central topic of this new debate, as he produced, from an obscure seaside resort in Merseyside, some of the most interesting and controversial pictures of the decade. From 1982, Parr worked to refine his colour documentary picture-making, to give it the strength and precision necessary to produce a major new series. As well as making photographs in New Brighton, he created a commissioned work for the Documentary Archive in Salford, eventually exhibited as 'Point of Sale'. It is an intriguing and powerful series, spinning between Parr's fascination for the vestiges of an older, more gentle society and a new, anxious consumerism. He wrote a diary detailing the progress of

the commission, which illustrates how he moved between the warmth and coziness of neighbourhood hairdressing salons, old cobbler's shops, family bakers and cheap shopping centres. His wistfulness for the past and his excitement about the present are both potent and endearing:

'Thursday 28 March 1985: I meet Mr Devereaux (Director of Cultural Services Dept. for Salford City Council) at the Local History Library in Salford. Also met Mr Shirt, local History Librarian. We look at the boundaries of the "New Salford" and I explain our retailing idea. Both had a lot of trouble pinpointing areas where there may be a tight-knit working-class area with terraced houses and of course corner shops. We got a bit distracted by Norman churches, museums, canals, etc. etc.

'Mr Devereaux takes me for a spin round, first to Liverpool Road – looks good – will return. Then to Eccles shopping centre. We park in a multistorey car park. The main cinema has been turned into a Kwik Save – will follow up. Very dated 1960s (but "modern") Centenary house run by Co-op. I note a corner shop very near the main Co-op

Shopping Giant on the corner of Stapleton Street and Claremont Road. Down to Salford docks, which are being demolished, and back to Salford Library. I return to Salford Shopping Centre and make notes in all the big superstores. I walk round the terraces off Lugwaring Road and start to find notices in newsagents for "Party Plan Agents". Occurs to me it would be good to photograph a photographer doing home and studio portraits. Find corner shop just like Winifred Andrews' on June Street …

'Monday 1st April: I drop the banner from Regent Road Wesleyian Sunday School, that I found and rescued in 1975 when they were demolishing that chapel, off at the Local History Museum. On to Chapel Street, the bit of old Salford near the centre of Manchester. Find an amazing barber called "Fred's". I go in and introduce myself and arrange to come back and shoot some photos. Wander up to the bus station, noticing the abundance of cafés and then turn left into the back streets. A derelict area with a bit of industry and very little housing. On to Lower Broughton shopping centre, a modern set of units. I ask the manager of the

Iceland Frozen Foods shop if I can take photos – doesn't seem any problem, but she must check with the powers that be. Great Cheetham Street and find tightly positioned terrace houses running off down. I remember trying to rent a house in this vicinity. The only building left is the Duke of York pub on Marlborough Road. I glance at remarkable interior of a ladies' hairdressers, orange and green walls, very antiquated with a poster of Charles and Di on the wall. A stony silence when I go in. I explain my business and after some persuasion the woman agrees to me coming in next week. I notice that the corner shop, which was so common in the old Salford, even today off the Longworthy Road is very rare in this area. On to Swinton and look round the shopping centre. I'm very pleased to find a card in the window for "Sarah Jane Lingerie", 20% commission if you hold a party. How will they react to me asking to take photos? I wish I was a woman photographer. Walkeden next and the further away from the centre (Manch./Salford) the slightly more prosperous it gets. Walkeden has a health food shop and a garden centre, an enormous Tesco's, and

I ask to see the manager at the enquiry desk. I explain what I want and she phones. No is the answer, from his deputy. Never trust a deputy manager. I shall have to phone or write direct to the manager, but I do anticipate trouble with the big hypermarkets. Little Hulton is the last stop for today. En route I notice "Mr Frederick". I call in and a wonderful gay owner says I can take photos but he can't guarantee any customers, it's an exclusive ladies fashion shop. His customers, who often make appointments, "know where they are in life", i.e. well off. The "I'm off to Ascot" labels and the kitsch decor are lovely. I look forward to doing a portrait of Mr. Fred.'

In his wanderings around Merseyside, Parr produced photographs that powerfully illustrate his own sense of flux. It can be hard to leave good things behind. A girl in a pink party dress runs down a street of decaying low-rise blocks. Weeds grow through the paving stones that were laid so hopefully in the 1960s; the windows of a community room are bricked up and a car lies on its side. But the child, hair in bunches, immaculate in pink clothes and white

socks, runs oblivious of it all, hopeful, energetic, full of life. Parr would produce few such images in the years to come. By the mid-1980s, this slight urban fairy would become a consumer of fast food, a participant in foolish competitions, a raucous character in Parr's saga of the post-industrial North. His photographs of women congregating in the hairdressers' salons (which he describes so well in the Salford diary) and men at the barber's have a warmth that accompanies their sharp social observation. In his Salford diary Parr charted with considerable accuracy the ways in which life in the North was changing, from the traditional, warm, slightly chaotic community he had known and liked in Hebden Bridge, to the grim conglomeration of shopping centres, supermarkets and redundant terraced streets that he found in Salford:

'One thing that is dawning on me: one breed of shops that has survived very well are barber's and hairdresser's, these cannot be replaced by hypermarkets, the personal service is vital. As the corner shop slowly vanishes, the centre of gossip and chat must be in these establishments.

I watch a barber of Mather Road with a sign saying "back from lunch at 2.30". It's 2.25 and there's a queue already. Apart from the P. O. [post office] on pension day, few shops are honoured with a queue these days. If I was a script-writer for *Coronation Street* I'd bring a barber or a hair-dresser into the story.'

Down at the shopping centres, Parr made a very different kind of photograph. A skinny man with no shirt clutches plastic carrier bags. He has been to Kwik Save, a cheap, unpretentious food shop. Parr became fascinated by Tesco's food stores (long before the days when it remodelled itself as a slick, multi-range food and household goods outlet) and by Marks & Spencer's and Iceland. He began to use fill-in flash in the large stores, while still relying on natural light in the small hairdressers', bakers' and cobblers' shops.

'In a shop like Betty's [hairdresser], I prefer the natural light, which is very attractive, and because people are generally quite still, this is very practical. In a large super-market, or indeed M&S and Iceland freezer centre, I like to use fill-in flash but keeping it down so the camera picks up the ambient light too. This is not only practical because people are constantly moving around, thus making it almost impossible to use a tripod with any dexterity, but also for me it has the added bonus that the flash can help to express the alienation which is so often a trademark of these large anonymous stores. It also ensures that all the detail in the face comes out because this can often be a couple of stops lower than the general background.'

Parr attended Tupperware parties and lingerie parties and accompanied an Avon lady on her rounds. He photographed in a poodle parlour and waited in vain for a Saint Bernard dog to keep its appointment. He became a regular visitor at Betty's hairdressing salon. He liked to photograph in all-female environments. Despite his initially frosty reception at Betty's, women were less suspicious of a photographer than men. (When he photographed in a bookmaker's shop, many of the customers wanted to know if he was from the police or social security.) Women shopped more and took longer in their shopping, particularly for clothes. He noticed that mothers and grown-up daughters would

During the Salford project, Parr was attracted to small, old-fashioned shops like Betty's hairdressing salon and F W Davies cobbler's

Frozen meals available for 79p at Iceland supermarket in Salford, 1985

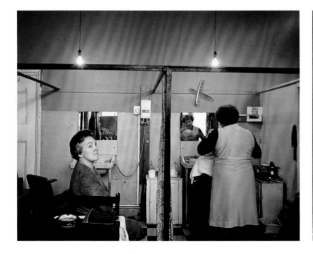

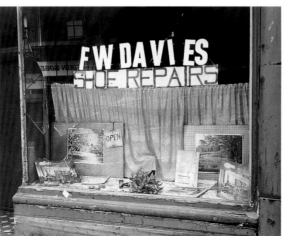

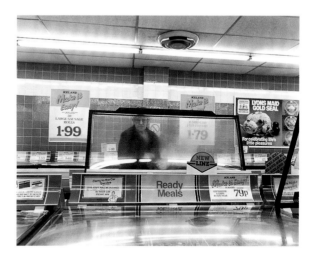

often go shopping together, with a baby in the pushchair. Time and time again, in later projects, and up to the present, Parr would focus intently on women, particularly the middle-aged. Perhaps he sensed their greater vulnerability; perhaps he was attracted by the ways in which they wore the disguises of make-up, hats, jewellery. In later years, Parr's attention to the details of women's appearance has become a hallmark of his work.

Parr's photography mirrored an important social change in 1980s Britain: more women began to work away from home than ever before and consequently their disposable income increased. Phrases such as 'shopaholic' and 'shop till you drop' gained currency. Women too were playing an increasingly major part in the worlds of curating, collecting and commissioning on which Parr was dependent for his progress as a photographer (the Salford project, for instance, was commissioned by Audrey Linkman, Director of the Documentary Archive in Manchester). The photographic community of the 1970s was predominantly male with an occasional nod towards feminist practice, and key

bodies such as the powerful Photographic Committee of the Arts Council of Great Britain, which made so much of the photographic policies of the 1970s, included women members only rarely.

There is much in the Salford diary that illuminates Parr's work, his interests and his methods. Much too about the persistence and organization of the determined documentary photographer; much that is comic (his descriptions of under-managers, canteen meals, Tupperware gifts, store detectives); sometimes irritating (his surprise that elderly poor people check their shopping bills to see if they've been overcharged); sometimes crafty (leading hostile subjects to believe that he was a Manchester Polytechnic photo student, sneaking into the Job Centre to snatch a few photos); often respectful (his delight in the family bakers, the cobblers, the fish and chip shops) and much that indicates how Parr's work would develop over the decade and beyond. One can only regret that this is the only photographic diary that Martin Parr has ever kept (at the insistence of Audrey Linkman) for, in its own way, it is as valuable an insight into

a society in flux as were the writings of Henry Mayhew or Joseph Rowntree in the nineteenth century.

Parr's social documentary photography would attract much criticism as the decade went on. Often, this was from people who were frightened by the Britain he photographed; people whom Parr saw as 'left-wing trendies', who still believed in the existence of a working-class culture born of the Jarrow March and the General Strike, combined with a heady mix of the film *Saturday Night and Sunday Morning*, and television favourites *Coronation Street* and *Steptoe and Son*. (He once contemplated serving such types at a dinner party with 79p Iceland frozen meals found in his travels around the supermarkets.)

Parr knew that Britain was changing rapidly, and he was interested in change. Over the years, and perhaps in the face of criticism, he has perfected a way of talking (or perhaps not talking) about his photography. He establishes the distance between himself and his subjects, insists that he photographs things and people because they are 'interesting' and not because he is touched by them. The Salford

diary, designed to take its place in an archive rather than to be published, is perhaps the more authentic voice of this complex and contradictory man.

The series contained photographs of both enormous warmth and precise social comment. For Parr, it was a fascinating period of re-evaluation and exploration, the remodelling of a style of photography that for ten years had looked to the quirky and eccentric British past as its central inspiration. The difference between the Hebden Bridge photographs and this new prodigious production of work was that Parr no longer felt an affiliation to a place or a community. Speaking in 1992 about 'The Last Resort', he remarked:

'The point is, I'm less interested in the fact that these people aren't well off financially as in the fact that they have to deal with screaming kids, like anyone has to. Middle-class people, unless they're so well off that they're cloistered and they don't see their kids, have to deal with the same problems – you know, the baby that won't stop crying – as anyone else, and I'm more interested in those elements as opposed to depicting the working classes in basically a very run-down area of Liverpool. I'm glad that I'm showing this run-down area, because I'm also interested in making the photographs work on another level, and showing how British society is decaying; how this once great society is falling apart. The work in New Brighton, for example, would work in this way: first off you're dealing with your own personal observations about the relationships with kids and their parents and the adults who are there, which is why people go to a seaside resort in the first place. Secondly, you're looking at class aspects of life, which I find I don't have a problem with, though I acknowledge that many people do. And thirdly, you're looking at wider aspects of the decay in the fabric of a society, our supposedly affluent society. So there are many aspects that come together to make the work succeed … [In New Brighton] I was looking for the vulnerabilities you can get within a public situation. Unless it hurts, unless there's some vulnerability there, I don't think you're going to get good photographs.'

While 'Point of Sale' received little or no public attention, 'The Last Resort', made in New Brighton between 1983 and 1986, attracted more comment. Though Parr's career had (especially compared to those of some of the other independent photographers) been relatively successful, the London galleries remained aloof. The Hebden Bridge work, titled by Parr 'The Nonconformists', had showed at the Half Moon in East London in 1981, but had not attracted much attention. To launch his work, Parr still had to depend on local venues and publicly funded independents in the regions, such as the Impressions in York and the Orchard in Derry. His 1977 exhibition at the Photographers' Gallery in Covent Garden was not followed up by subsequent shows and it must have seemed at times that the energy he expended and the innovation in his work was not enough for the galleries whose support he needed to climb one more rung of the photographic ladder. The spell was finally broken by the publication and exhibition of 'The Last Resort' in 1986 at the Serpentine Gallery in London. The Serpentine was recognized as one of London's major art venues and had, during

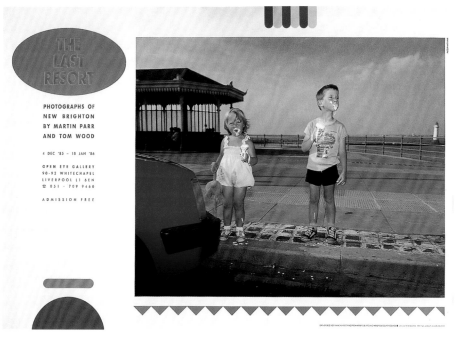

THE LAST RESORT

PHOTOGRAPHS OF
NEW BRIGHTON
BY MARTIN PARR
AND TOM WOOD

4 DEC '85 – 18 JAN '86

OPEN EYE GALLERY
90-92 WHITECHAPEL
LIVERPOOL L1 6EN
☎ 051 - 709 9460

ADMISSION FREE

the 1980s, become interested in the new photography, showing work by Chris Killip and Graham Smith and Fay Godwin's series 'Land' in 1985.

But even the reviews of 'The Last Resort' at the Serpentine avoided a serious discussion of Parr's photography. Though the series has always been labelled 'controversial' there is no evidence of a critical debate in the articles generated by the show. Most of the critics were satisfied with describing the pictures in prose little short of purple: 'This is a clammy, claustrophobic nightmare world where people lie knee-deep in chip papers, swim in polluted black pools, and stare at a bleak horizon of urban dereliction', said Robert Morris in *The British Journal of Photography* in August 1986; or, from David Lee in the August 1986 issue of *Arts Review*:

'[Parr] has habitually discovered visitors at their worst, greedily eating and drinking junk food and discarding containers and wrappers with an abandon likely to send a liberal conscience into paroxysms of sanctimony. Even moments of petting intimacy appear pathetic given their gaudy surroundings and the posturing of its protagonists. Our historic working class, normally dealt with generously by documentary photographers, become a sitting duck for a more sophisticated audience. They appear fat, simple, styleless, tediously conformist and unable to assert any individual identity. They wear cheap flashy clothes and in true conservative fashion are resigned to their meagre lot. Only babies and children survive ridicule and it is their inclusion in many pictures which gives Parr's acerbic vision of hopelessness its poetic touch.'

Strong words indeed, but more a reflection on the reviewers than the reviewed. Various writers talked about the horrors of working-class flesh, the seas of litter, the appalling clothes, the crying children. So what was it about 'The Last Resort' that so terrified and disgusted the people who wrote about it? There is some litter, admittedly, but it's never knee deep, and there are some fat people, but they're not gargantuan and they're not in the majority. There are crews of babies who seem to be having a good enough time, eating, drinking, even smiling, and a lot of very pretty women taking part in beauty competitions, dancing, sunbathing, talking to other women. There are families who may well be suffering under Thatcherism, but they're still managing to have a good day out. There are people who look ridiculous in their swimsuits, but Parr was never a fashion photographer. And yes, it's a tatty, peeling kind of place, but then a lot of England is tatty and peeling. It disgusted David Lee and frightened the life out of Robert Morris, but 'The Last Resort' wasn't frightening or disgusting, or even very controversial. It was comical, touching, skilfully seen, lively and vigorous. It wasn't what journalists wanted it to be, and what they said it was. It was by no means Martin Parr's condemnation of Thatcherism, but rather an exercise in looking. There's no cynicism in Parr's gaze, just interest, excitement and a real sense of the comedic. For all that Parr himself has said about the vulnerability he likes to capture in his photographs, no one in 'The Last Resort' looks particularly vulnerable; quite a lot of them are smiling and most of the others are either asleep, sheltering from the rain, smoking, eating or watching their

children. Some of them, admittedly, look bored, but then, day trips can be boring.

The next time such a flurry of media response would come in reaction to a series of British photographs would be with the publication of Richard Billingham's *Ray's a Laugh* in 1996, a raw and moving portrait of a family in the West Midlands. The critical response to 'The Last Resort' was primarily a class response (Morris for instance referred to New Brighton as 'a post-industrial hell hole') and it was unfortunate that this response, sparse and uninformed as it was, somehow came to be seen (by Parr himself as well as in a wider context) as a 'debate'. 'The Last Resort' contains some unforgettable photographs, as lyrical as a great pop song, as raucous as music hall. Britain was in a state of political crisis when Parr was photographing in New Brighton: as a nation, we focused far more acutely on national politics than we do in 2002. Critics, curators and the public saw Parr's photographs as being political, scathing and controversial in 1986 because so many of the events around them, at the height of Thatcherism, were highly politicized, controversial and deeply disturbing. Inevitably, the mirror that we held up to art, life, ourselves in the mid 1980s was one that produced a disturbing and dramatic vision. We were almost demented. Parr's photographs of New Brighton, whether they fitted or not, became a part of that skewed and hysterical vision.

Parr himself has never seen 'The Last Resort' series as directly political. As a new parent, he was fascinated by babies and families just as, when he made 'Love Cubes', he was fascinated by couples, or when he moved to a genteel area of Bristol in 1987 he became intrigued by middle-class rituals. As an Englishman in Ireland he was interested in the Irishness of people and places, from the building of grand porticoed bungalows to an auction of a field of hay. If his work is controversial, it is perhaps because we believe too deeply in the power of photography, or because we are thrilled by the idea of social chaos, or because we hate the kind of people who have garden parties, enter little pots of lemon curd in a jam-making competition or sing carols in each other's houses. Parr's photography is uncomfortable because in many ways it brings out the worst in us, makes us scornful or silly, snobbish or cynical. In some ways, his photographs are a kind of practical joke, seemingly harmless but destined to cause us to make fools of ourselves. In his next major project of the 1980s, Parr was to play the jester at the court of consumerism with real mischief.

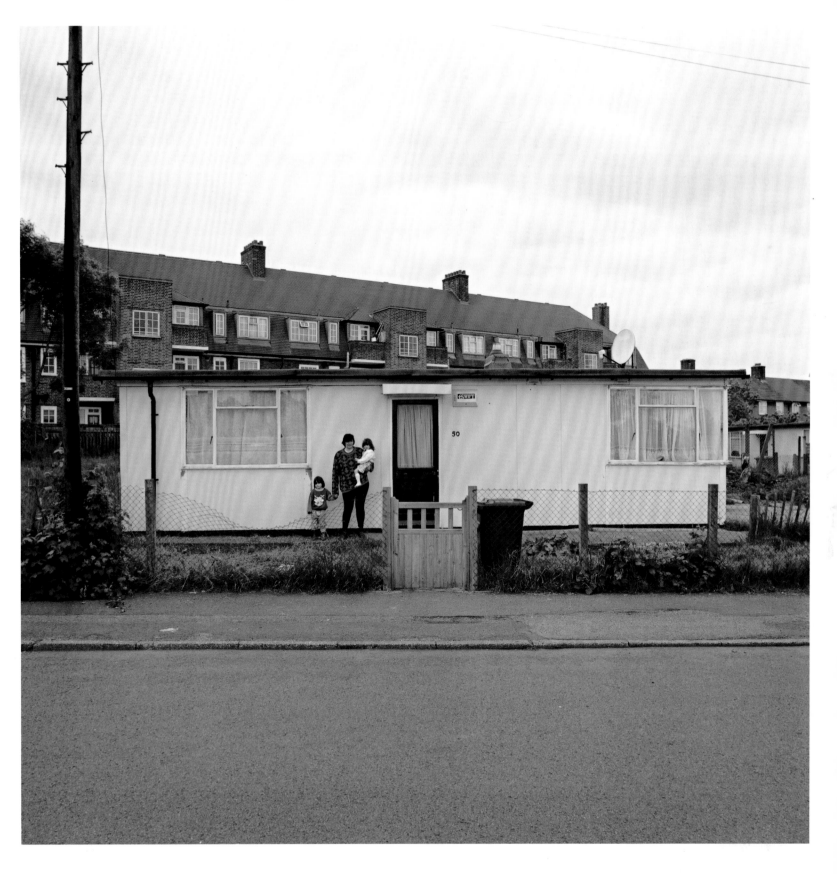

Wolverhampton, West Midlands, 1996, from 'Prefabs'

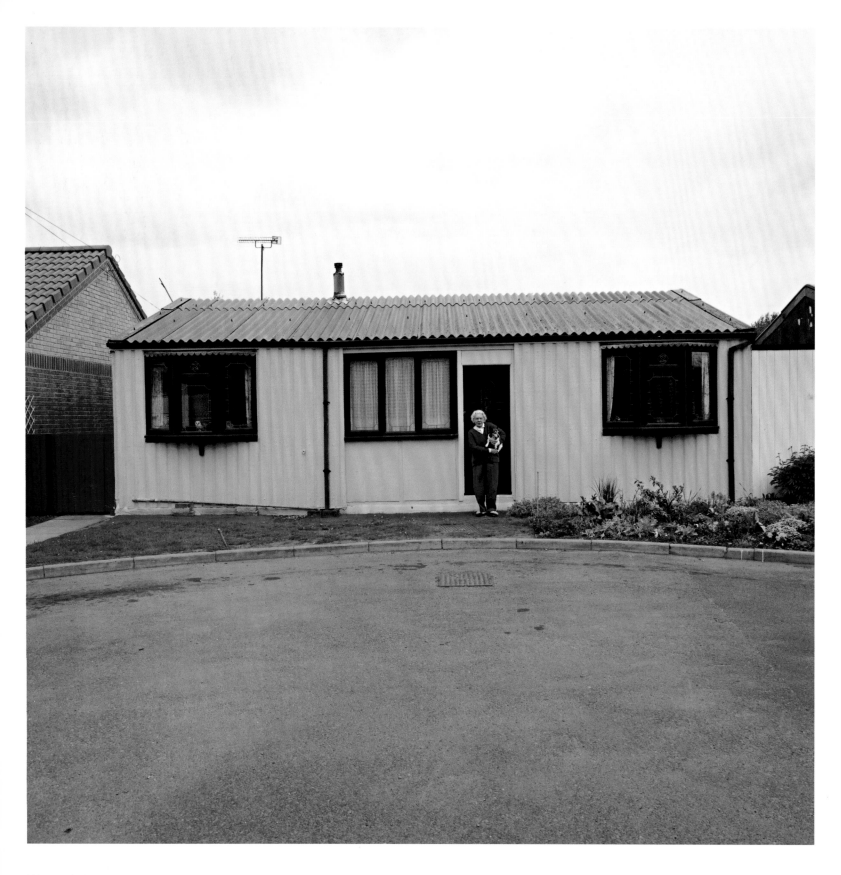

Bristol, 1996, from 'Prefabs'

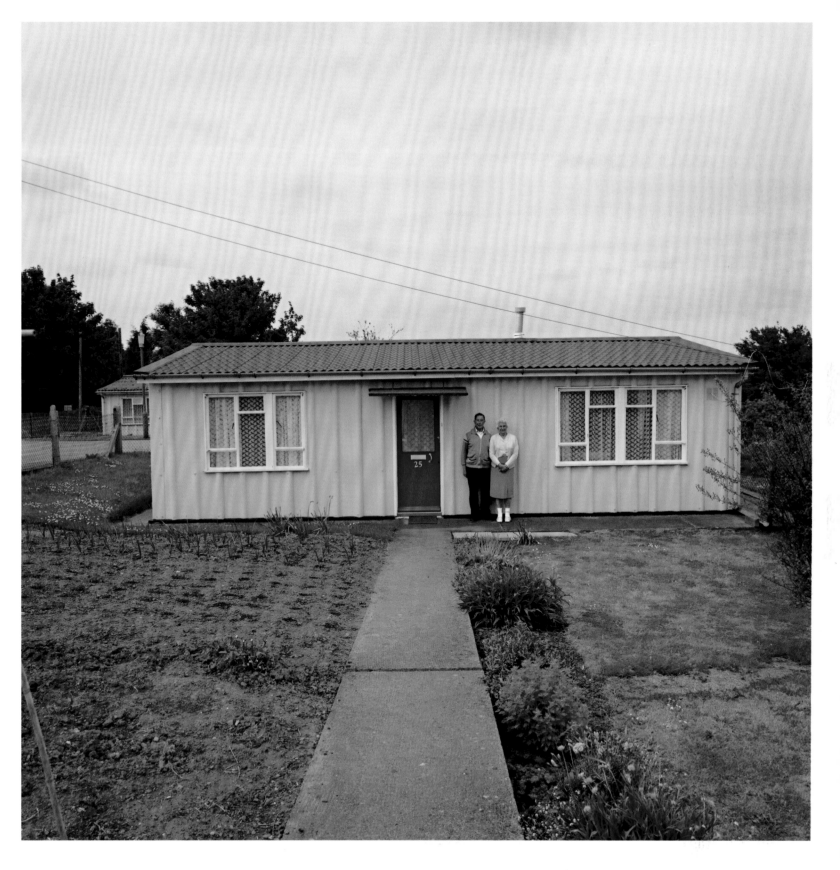

Bristol, 1996, from 'Prefabs'

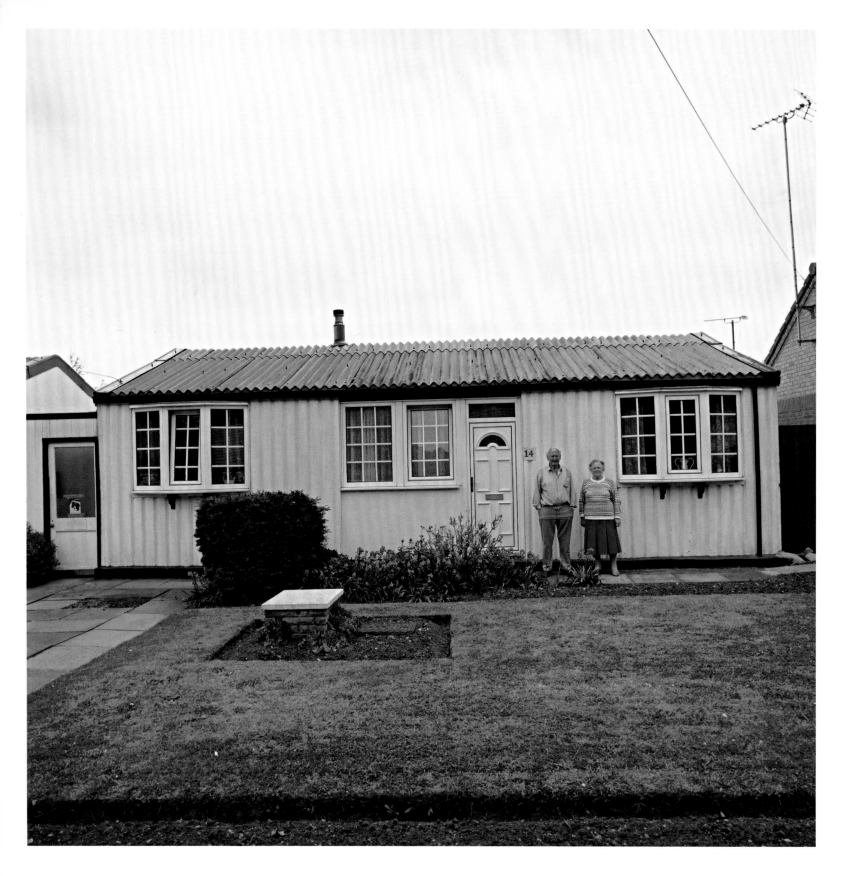

Wolverhampton, West Midlands, 1996, from 'Prefabs'

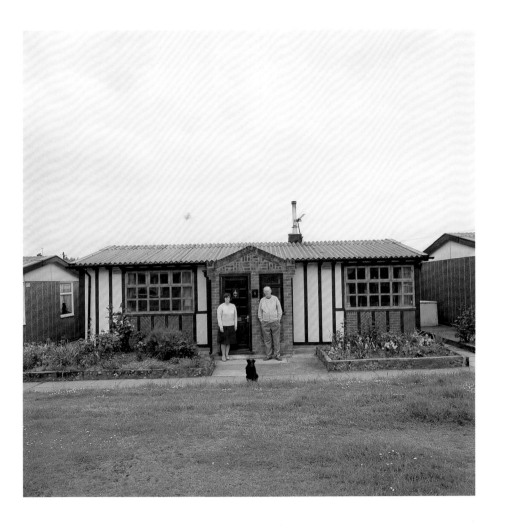

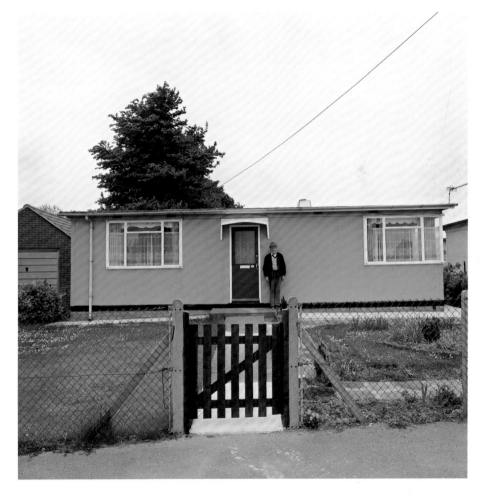

Wolverhampton, West Midlands, 1996, from 'Prefabs'

Bristol, 1996, from 'Prefabs'

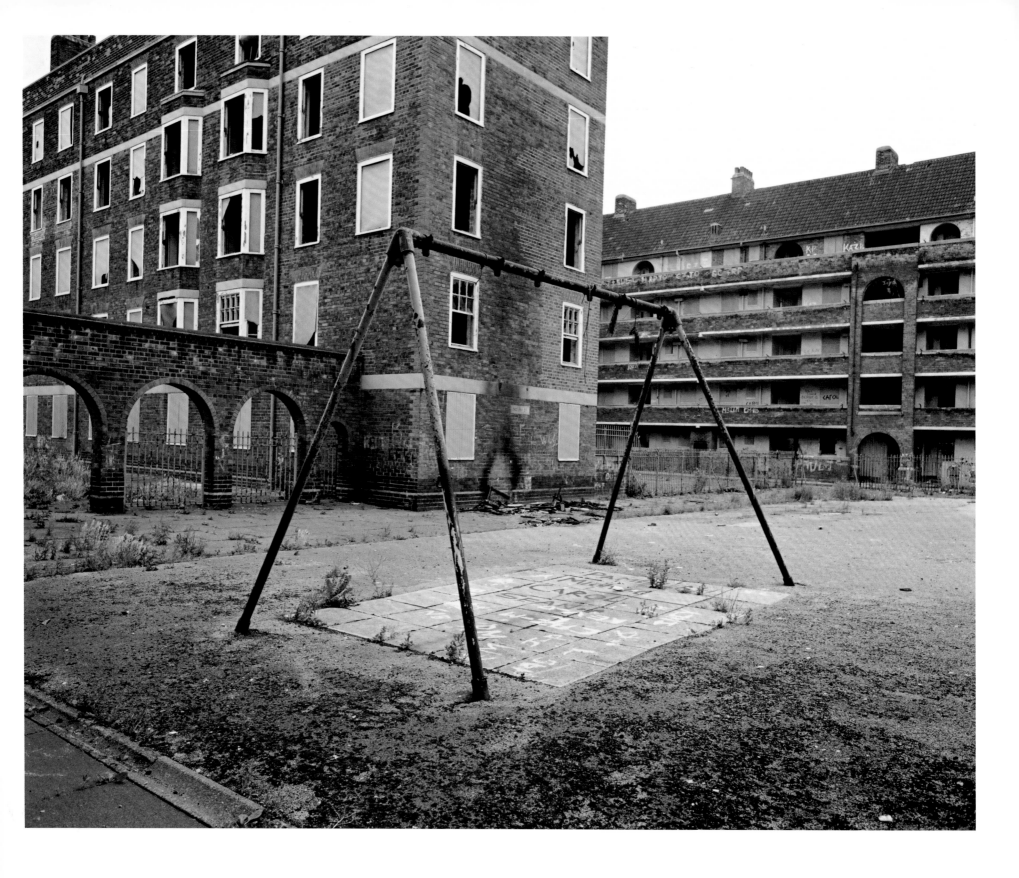

Liverpool, 1982

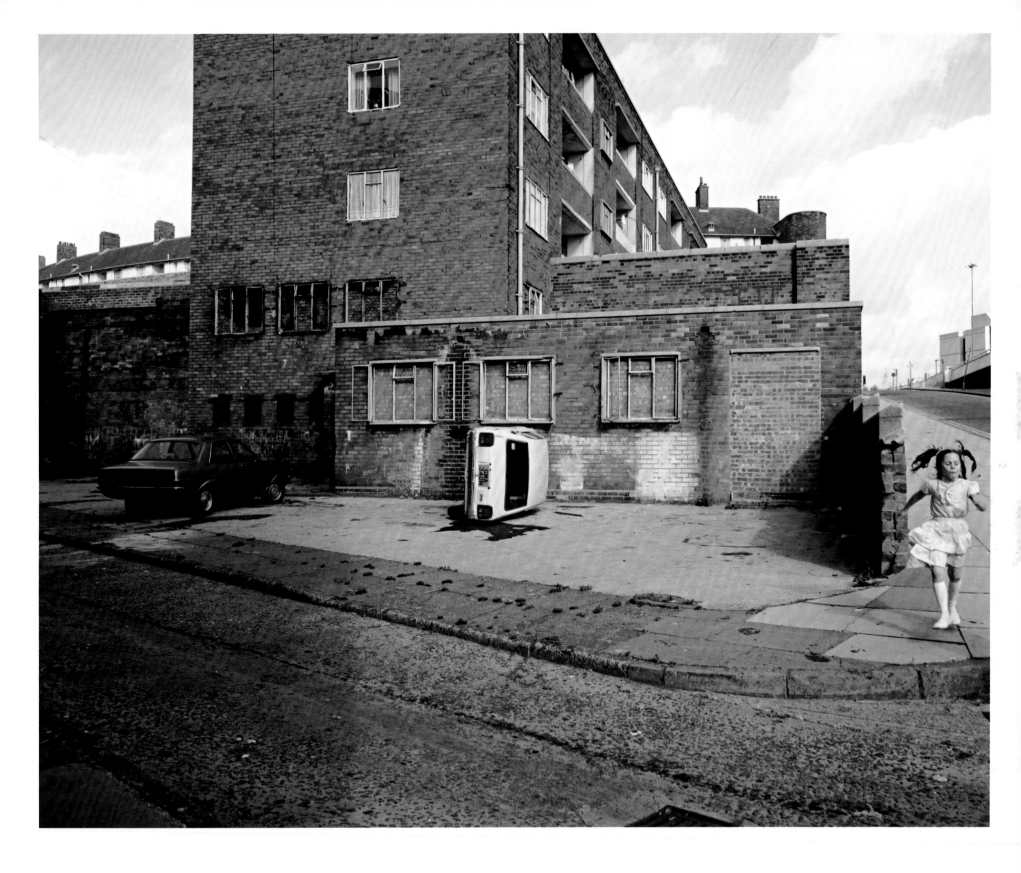

Liverpool, 1983

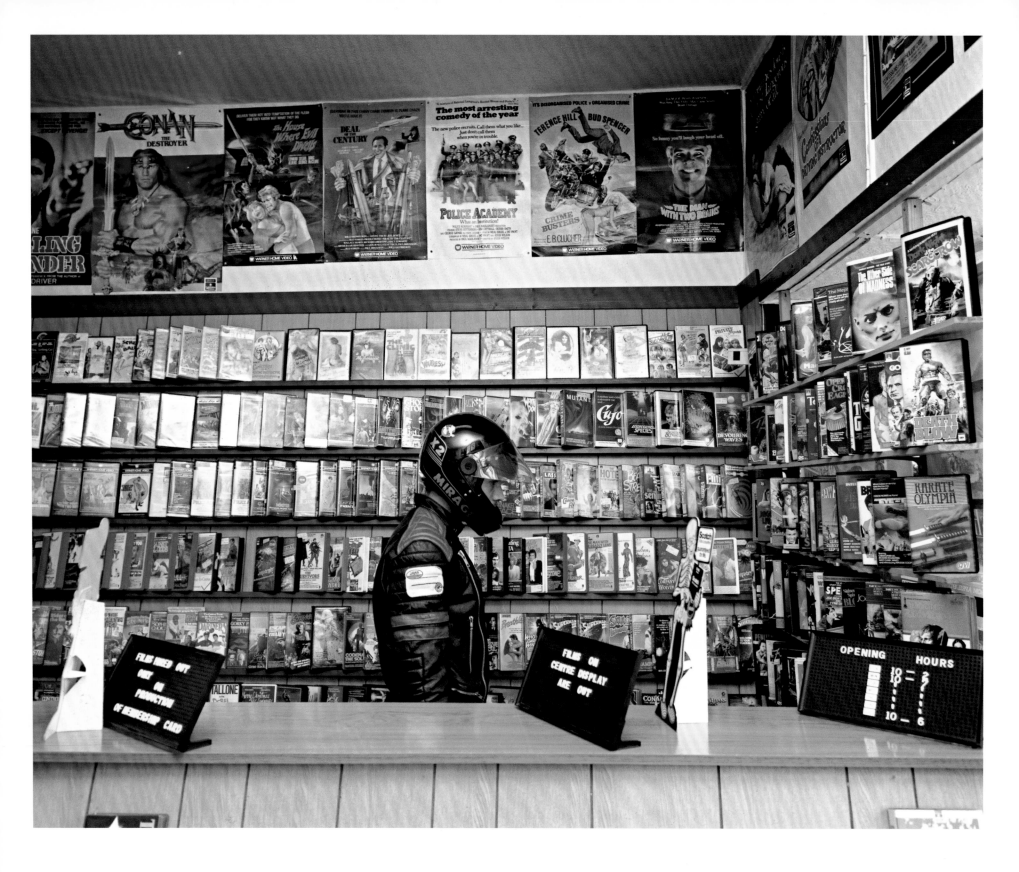

Video shop, Salford, Greater Manchester, 1985

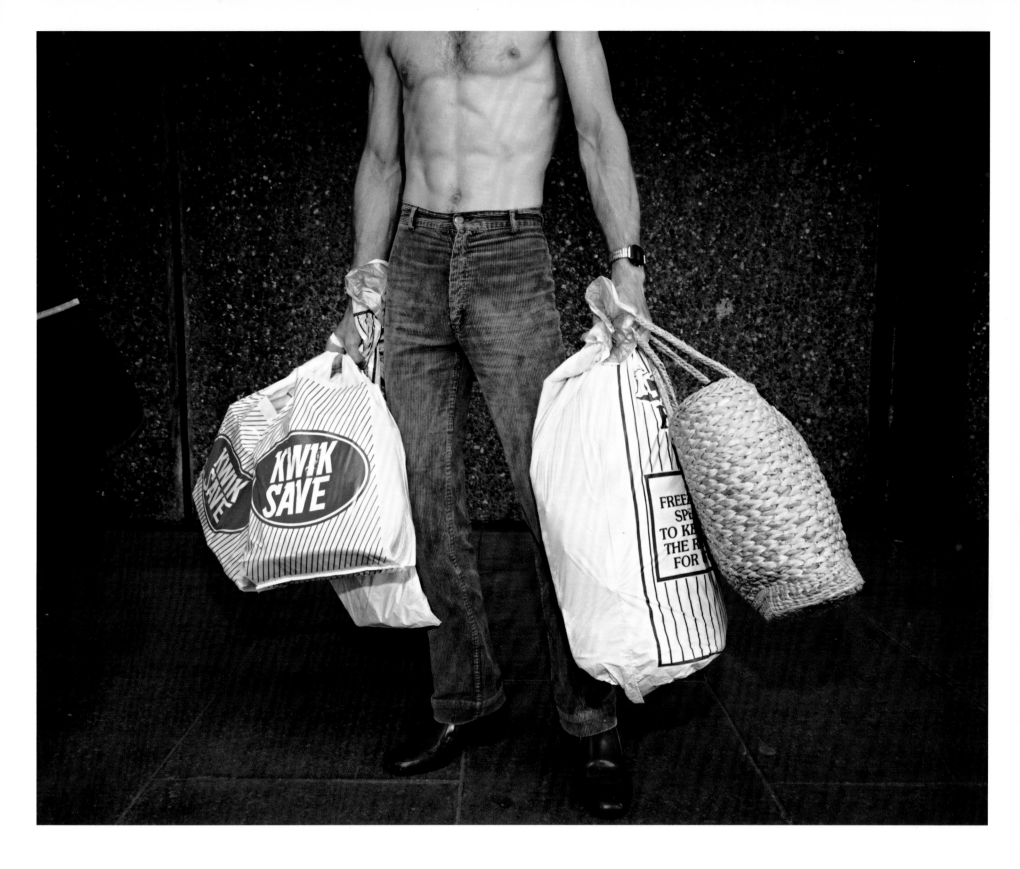

Salford, Greater Manchester, 1985

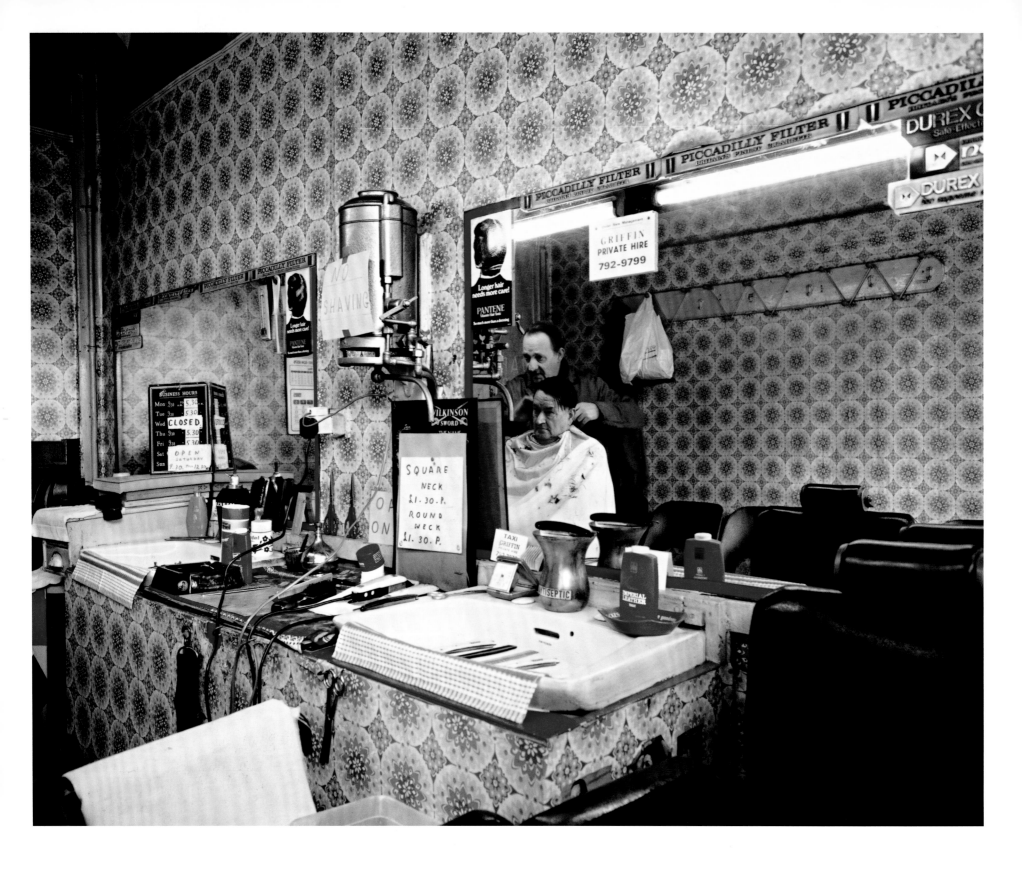

Fred's barber shop, Salford, Greater Manchester, 1985

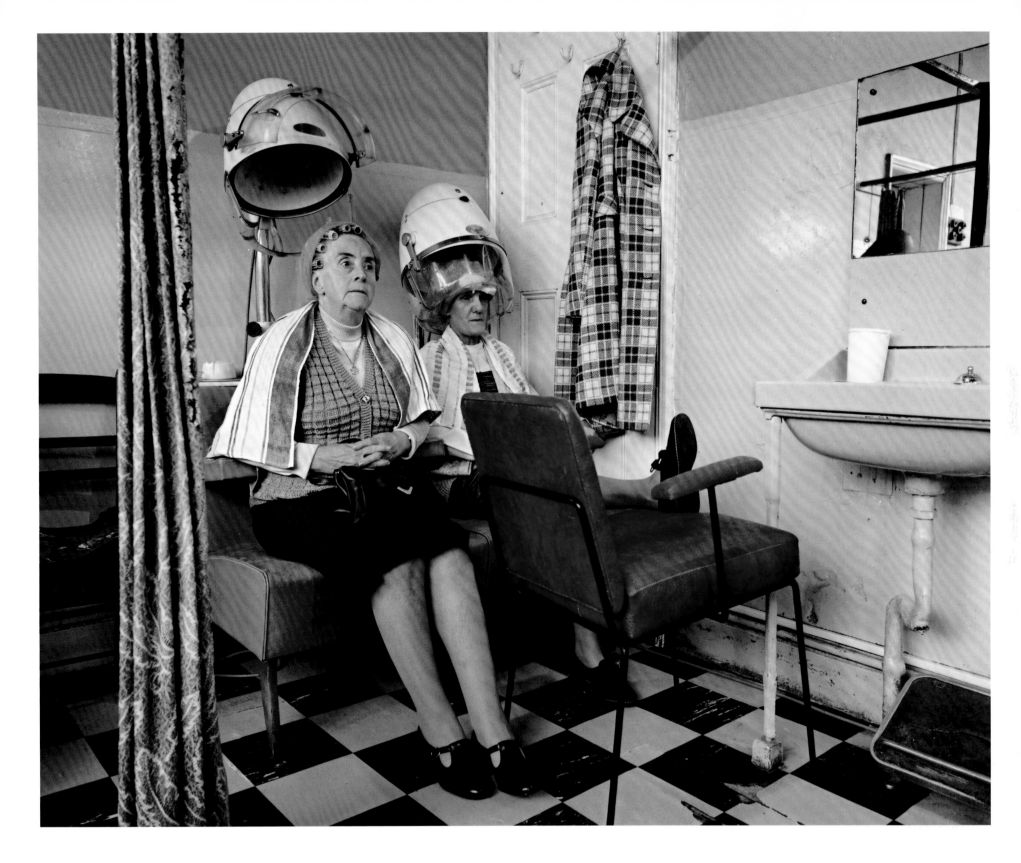

Betty's hairdresser's, Salford, Greater Manchester, 1985

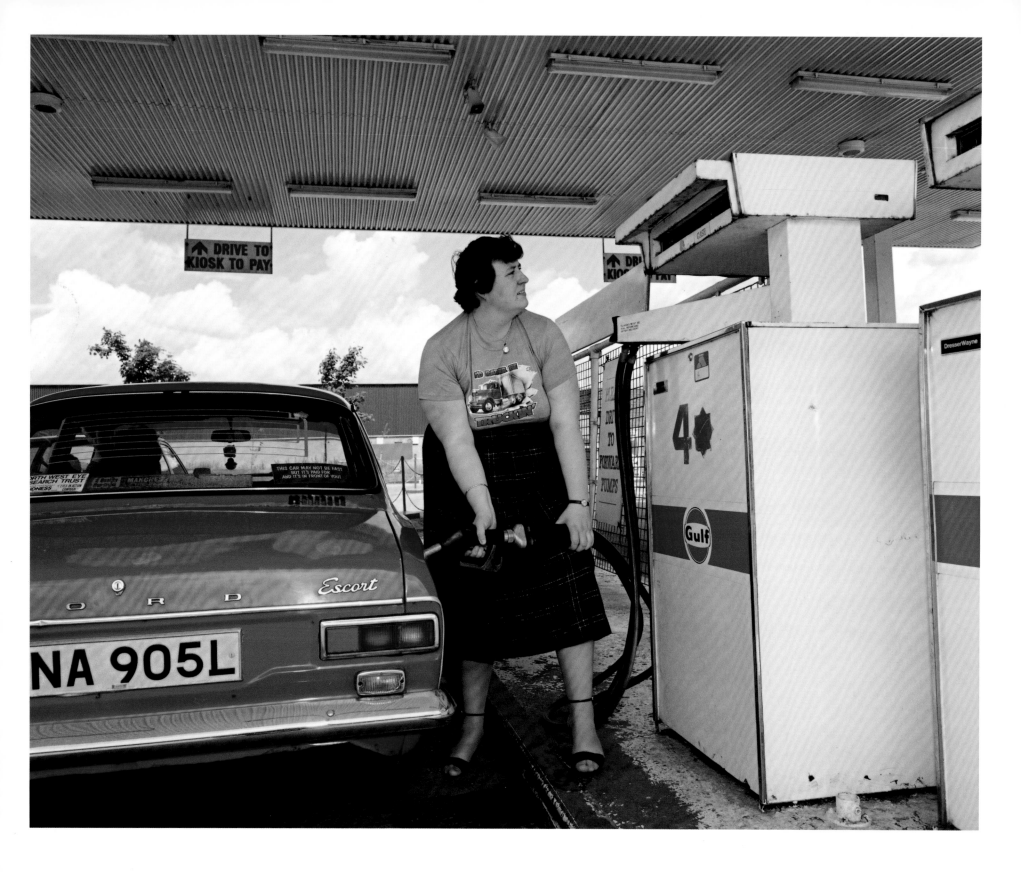

Salford, Greater Manchester, 1985

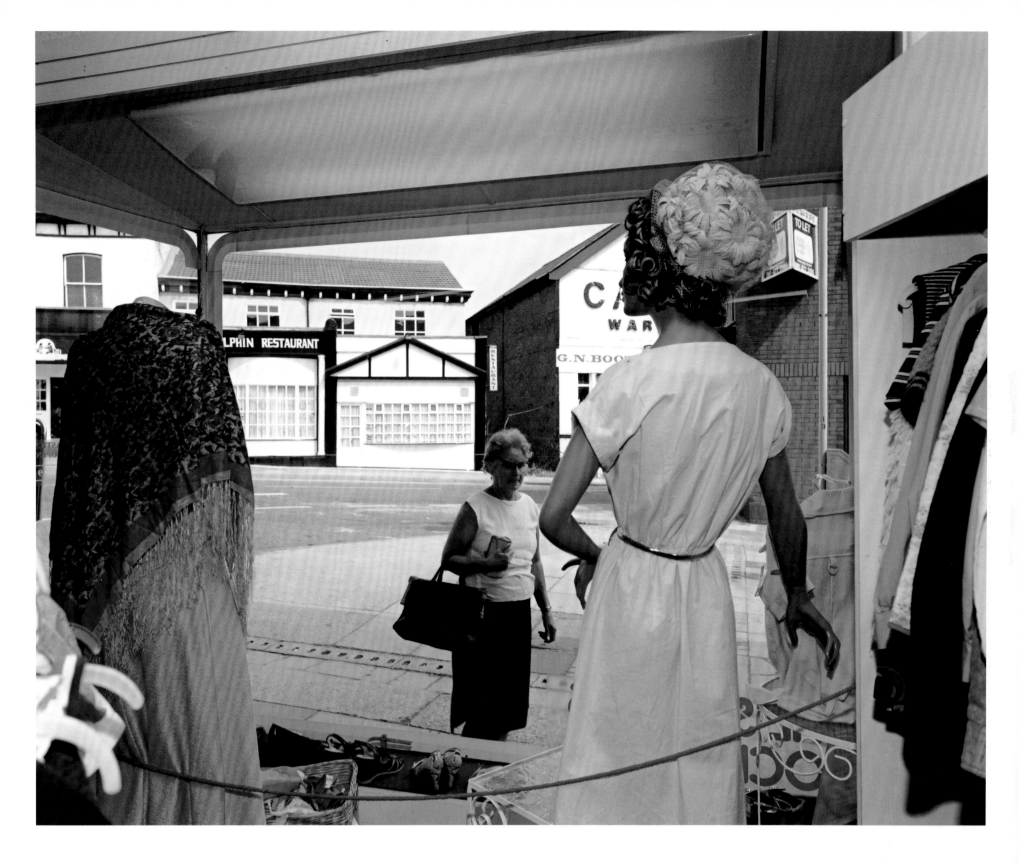

Charity shop, Eccles, Lancashire, 1985

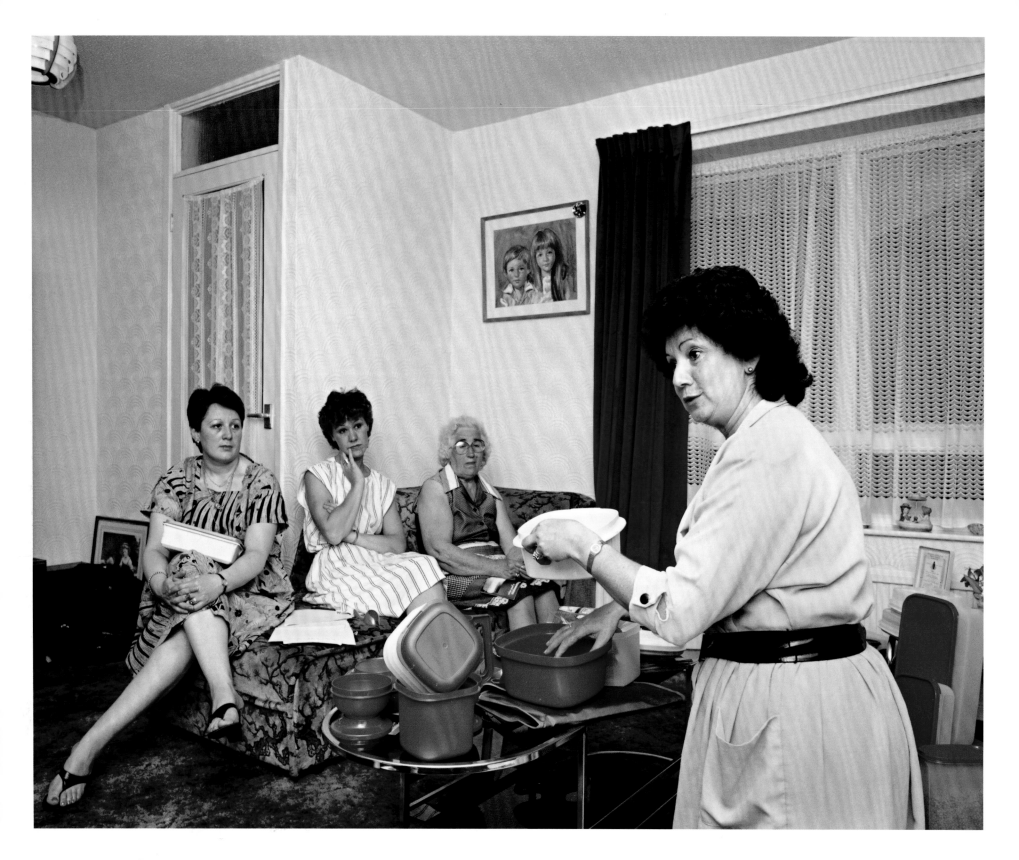

Tupperware party, Salford, Greater Manchester, 1985

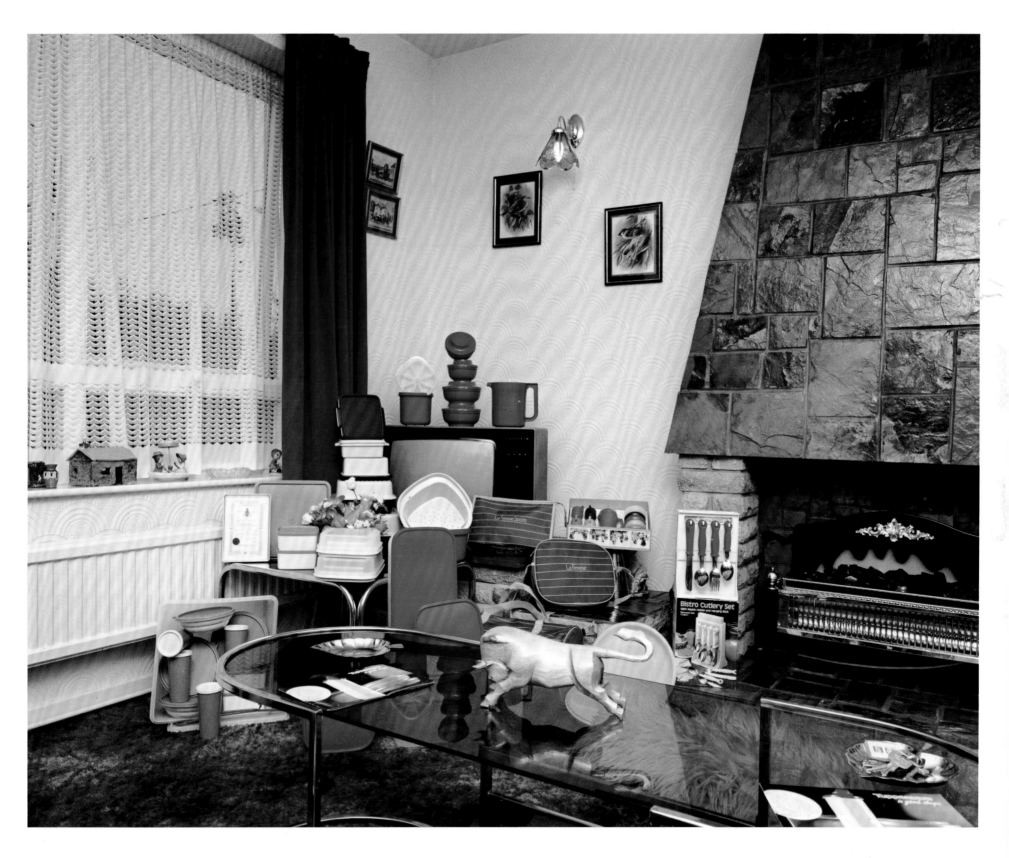

Tupperware party, Salford, Greater Manchester, 1985

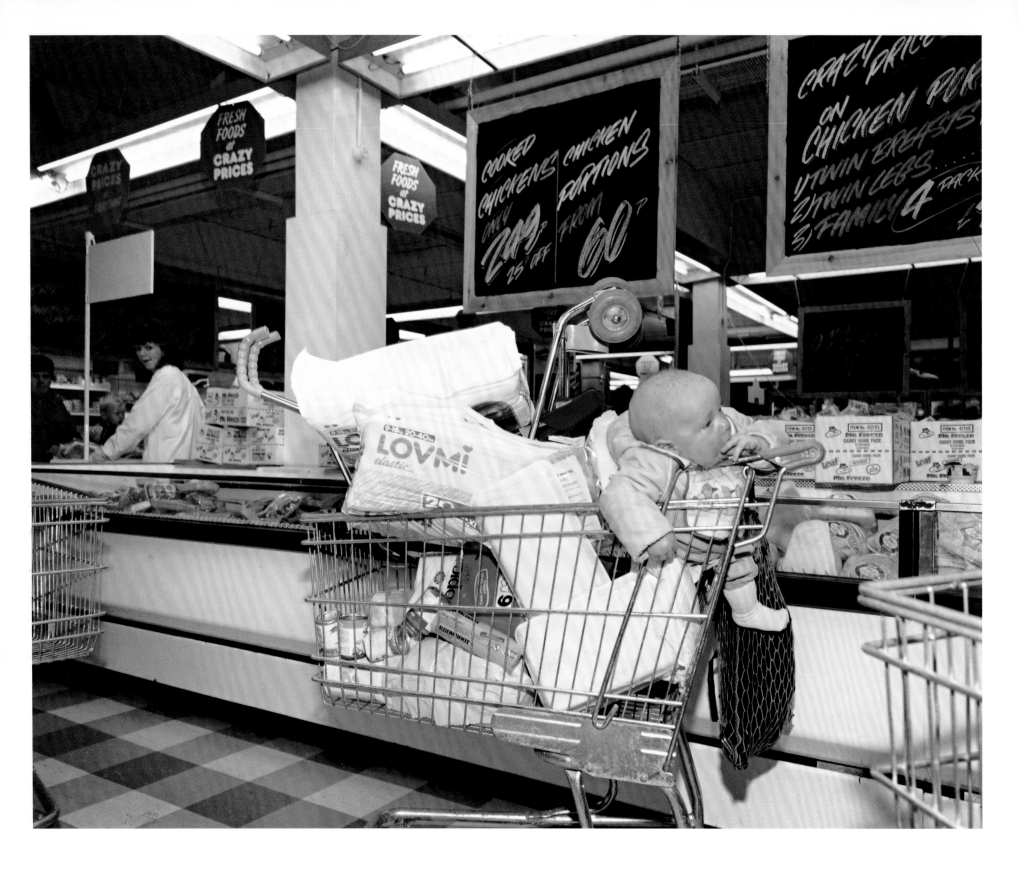

Crazy Prices supermarket, Dublin, Ireland, 1985

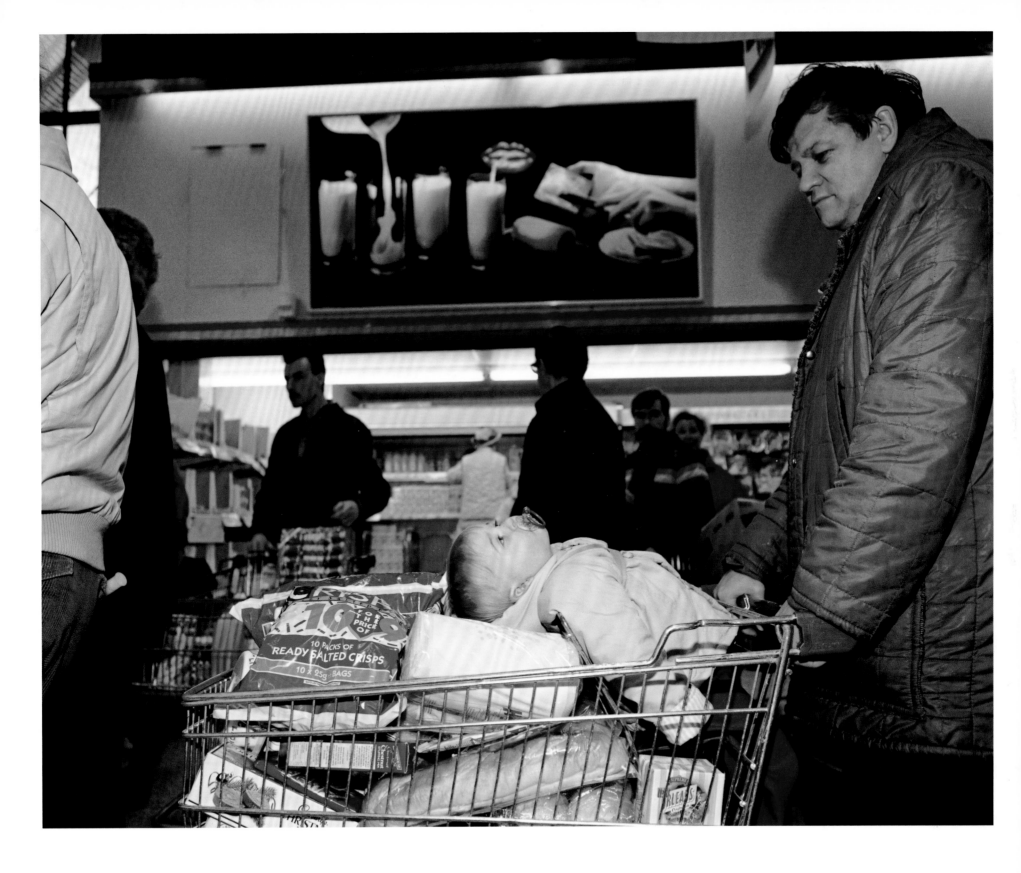

Gateway supermarket, Nailsea, Somerset, 1990

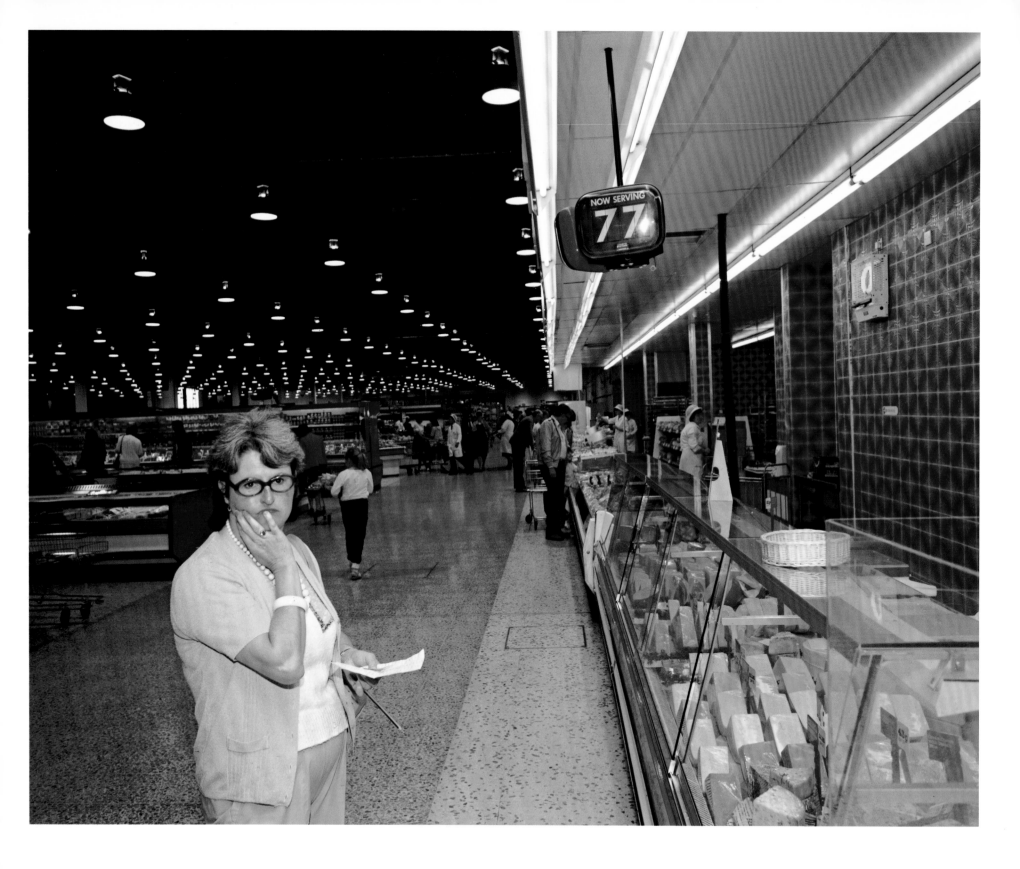

Tesco supermarket, Salford, Greater Manchester, 1985

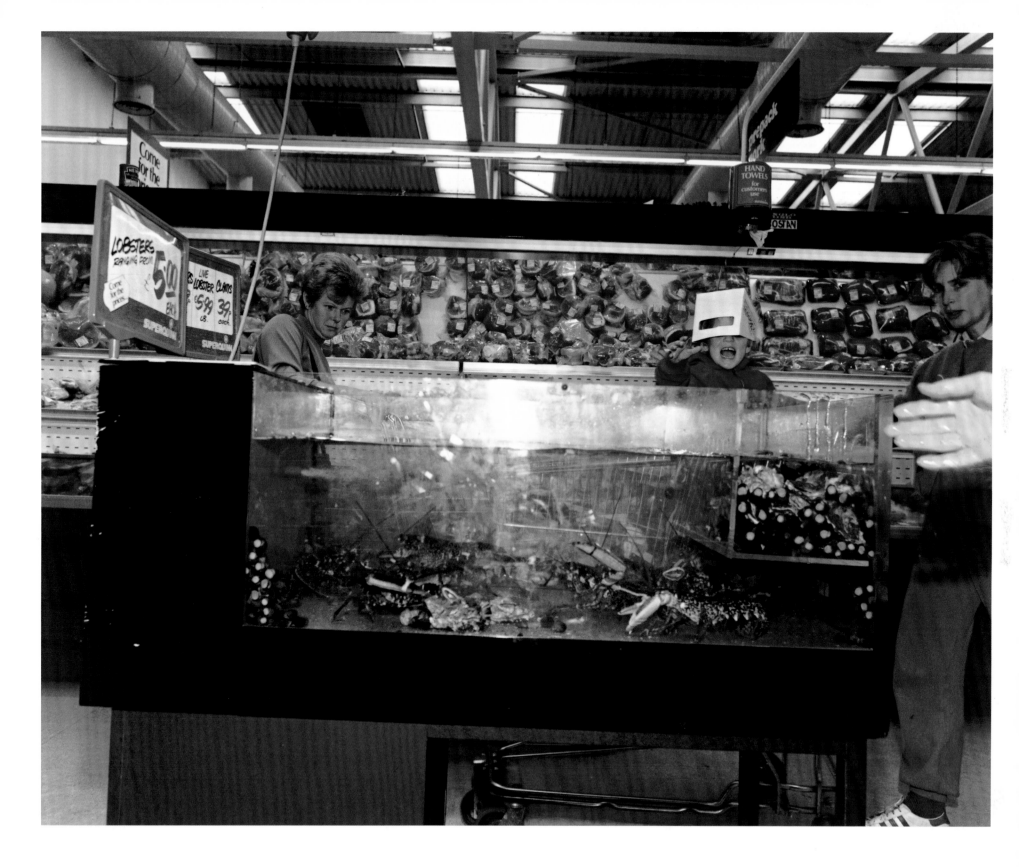

Superquinn supermarket, Dublin, Ireland, 1986

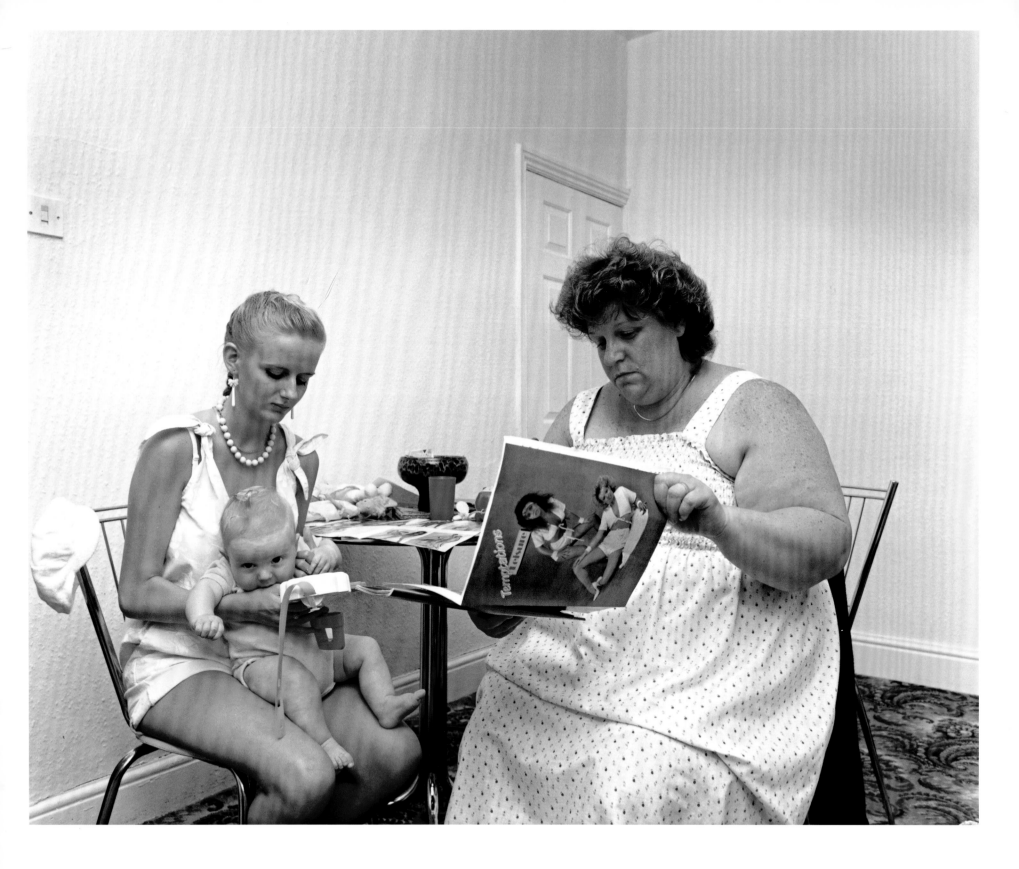

Lingerie party, Salford, Greater Manchester, 1985

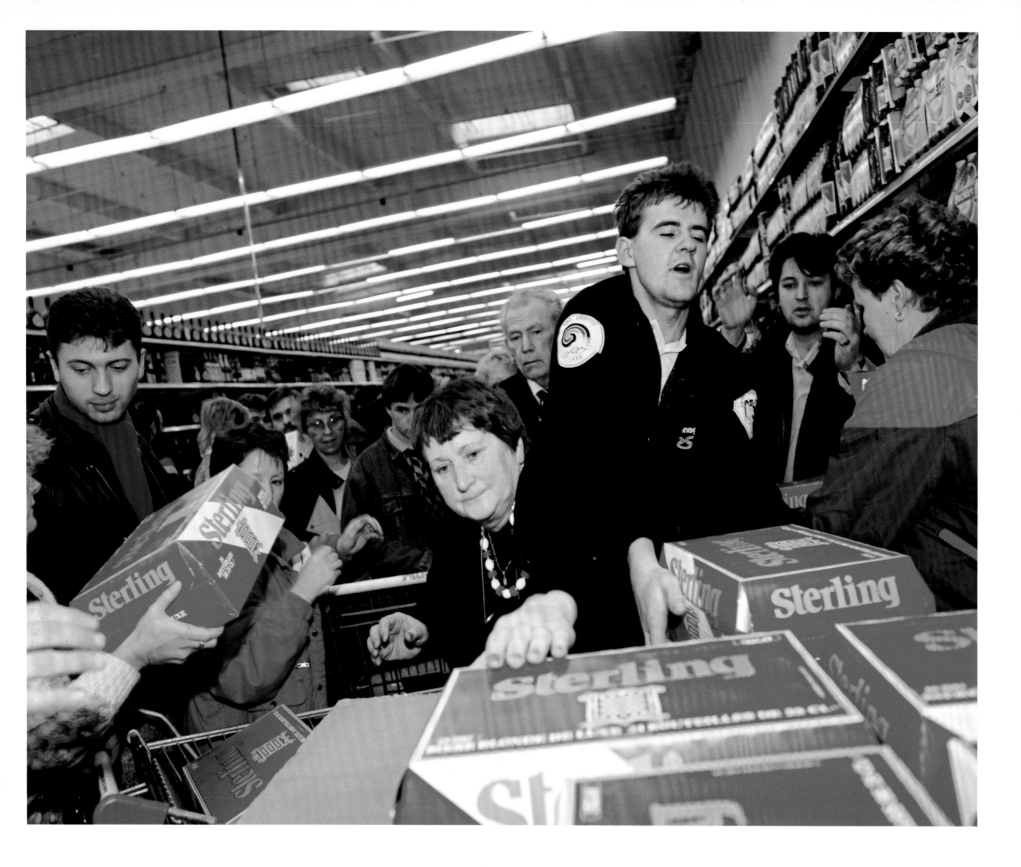

Auchan hypermarket, Calais, France, 1988, from 'One Day Trip'

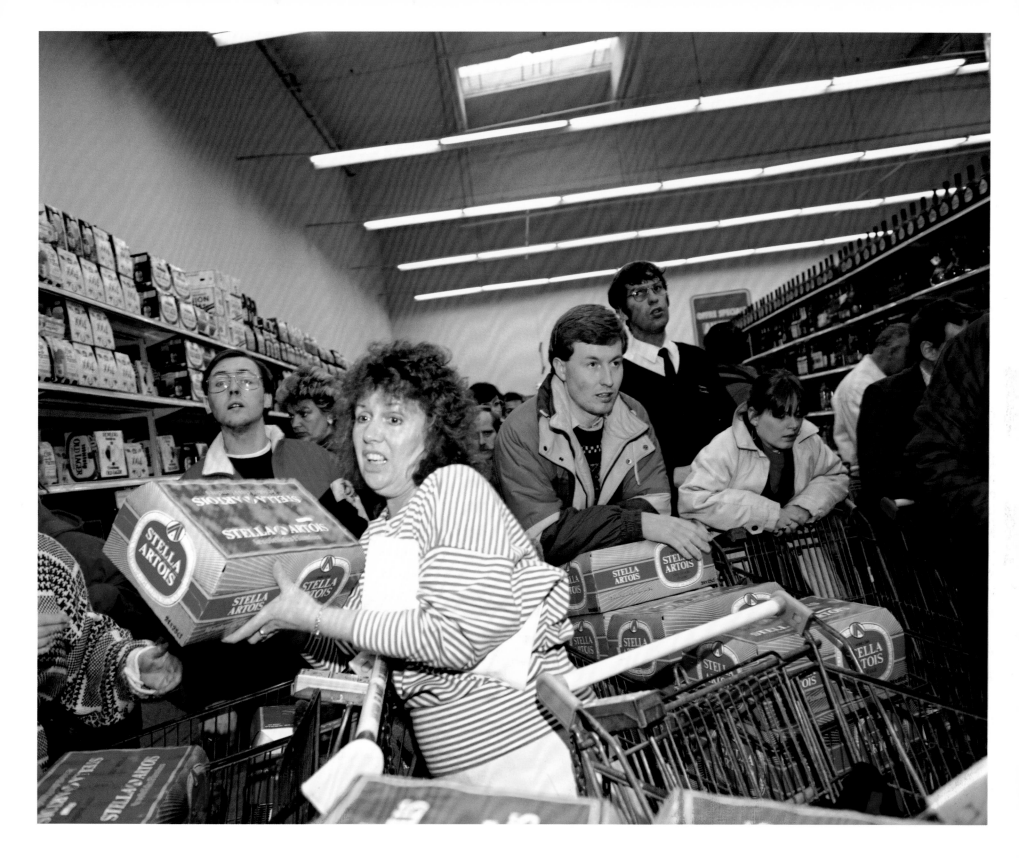

Auchan hypermarket, Calais, France, 1988, from 'One Day Trip'

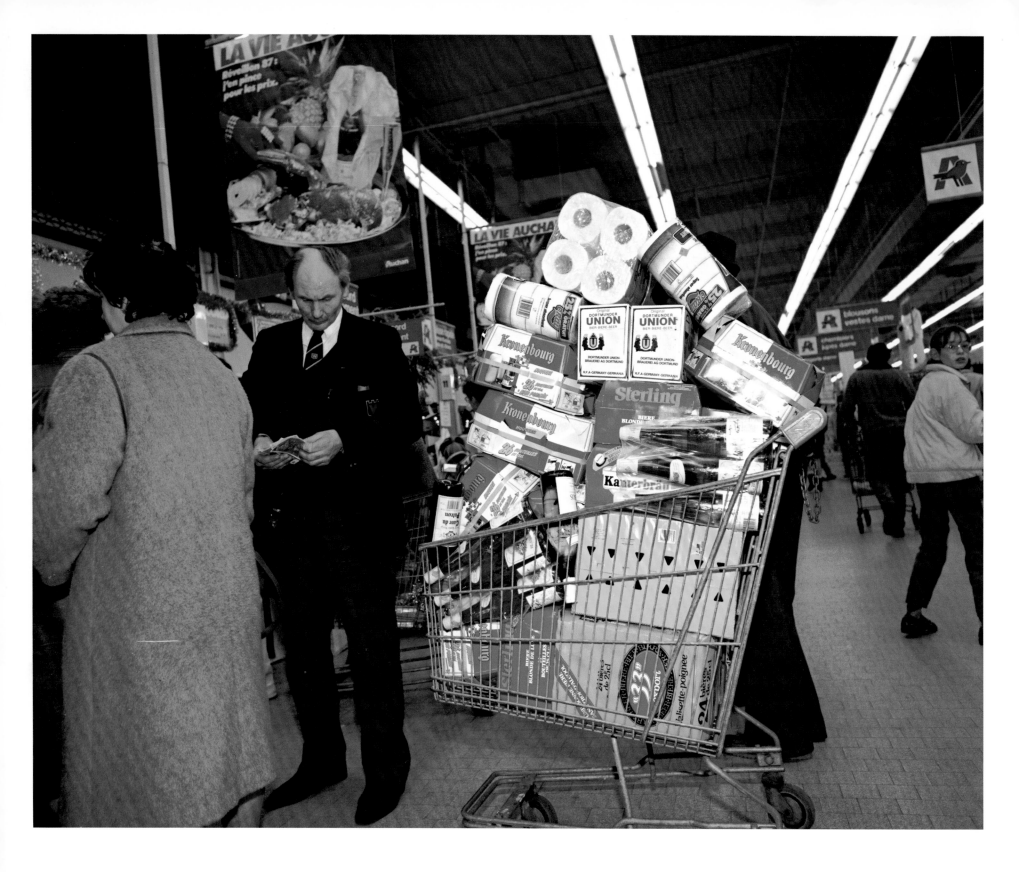

Auchan hypermarket, Calais, France, 1988, from 'One Day Trip'

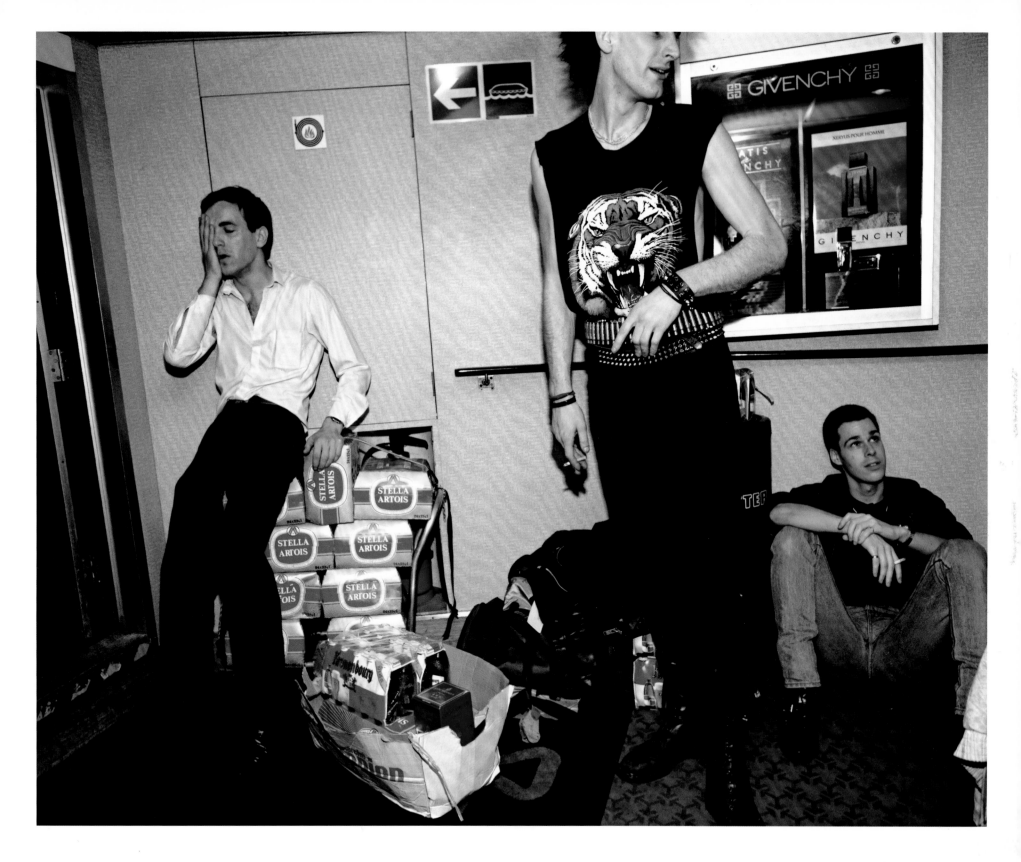

Dover–Boulogne channel ferry, 1988, from 'One Day Trip'

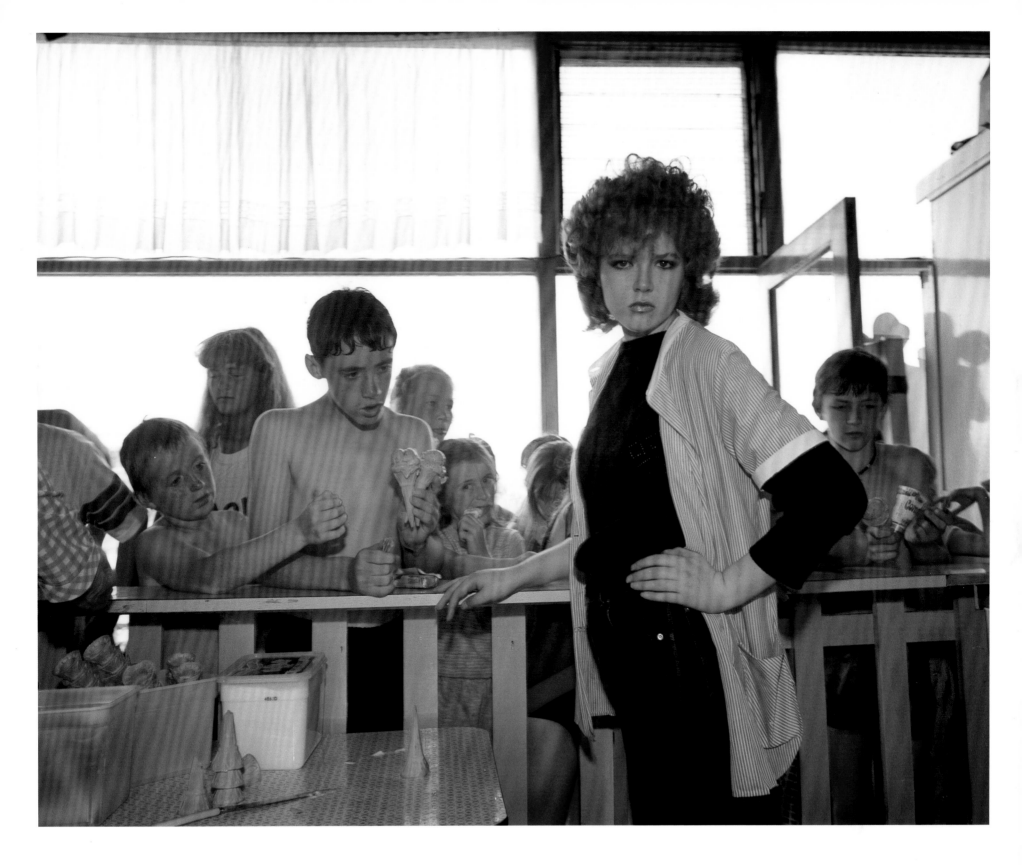

New Brighton, Merseyside, from 'The Last Resort', 1983–6

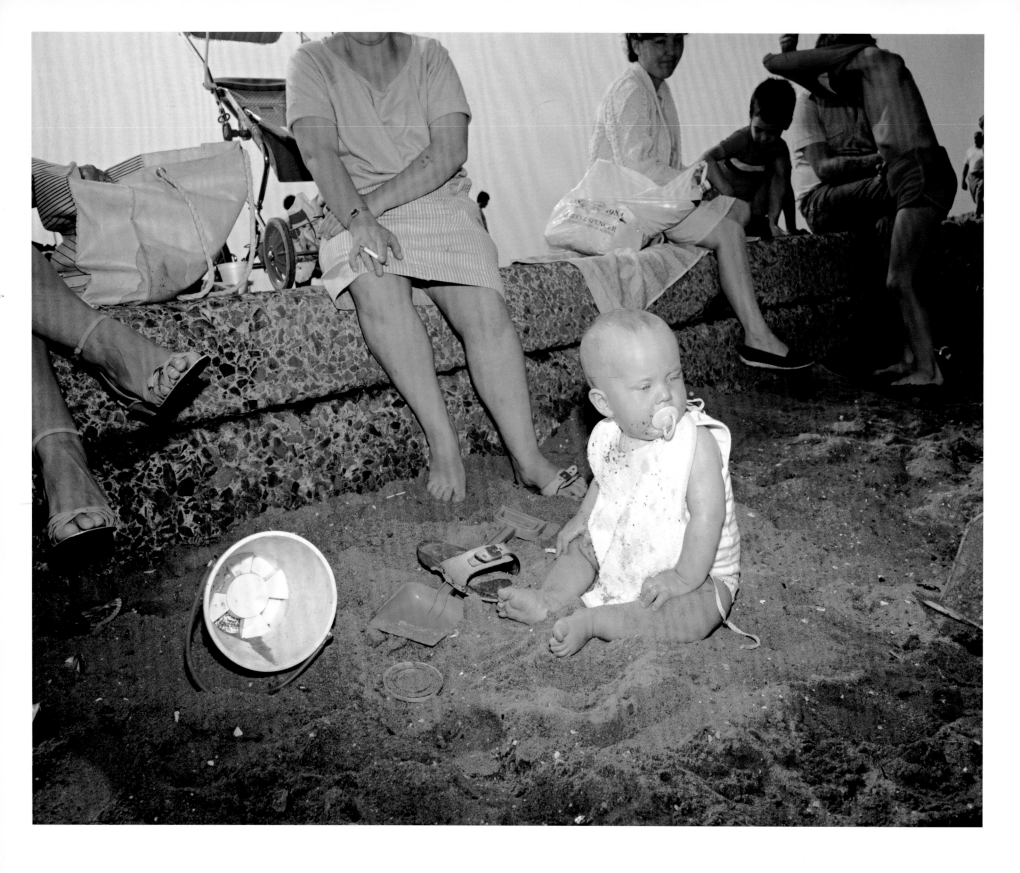

New Brighton, Merseyside, from 'The Last Resort', 1983–6

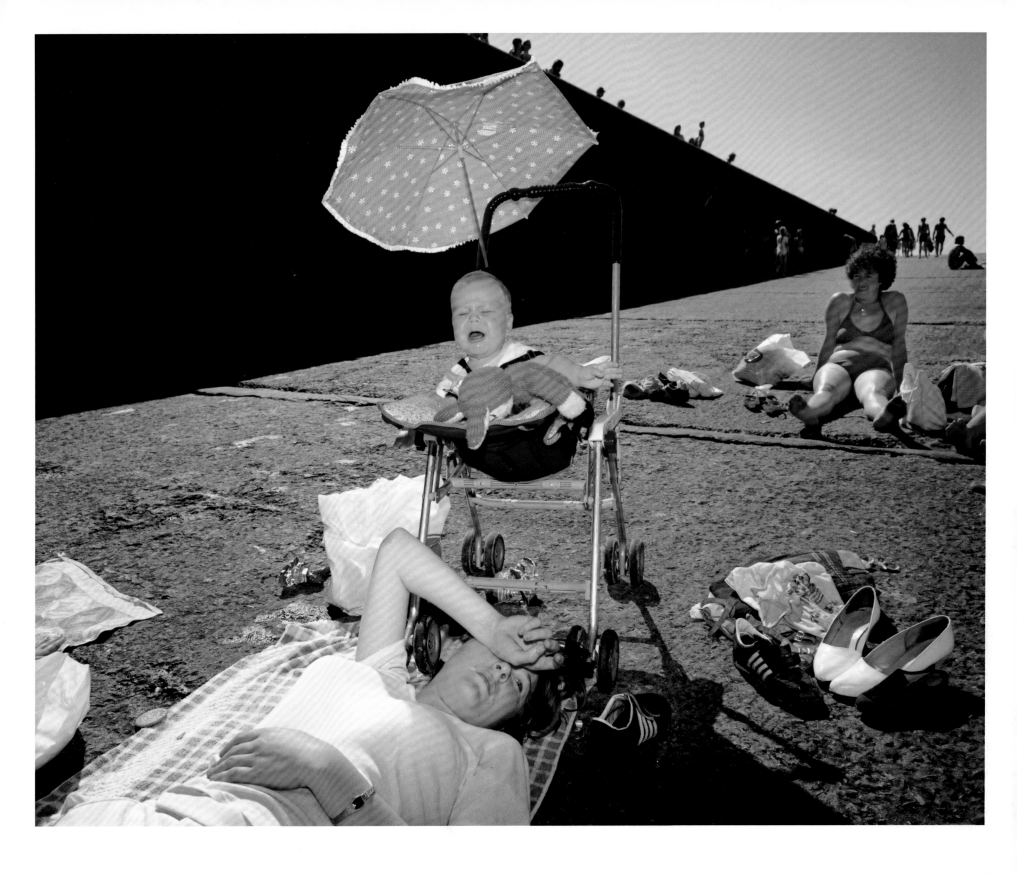

New Brighton, Merseyside, from 'The Last Resort', 1983–6

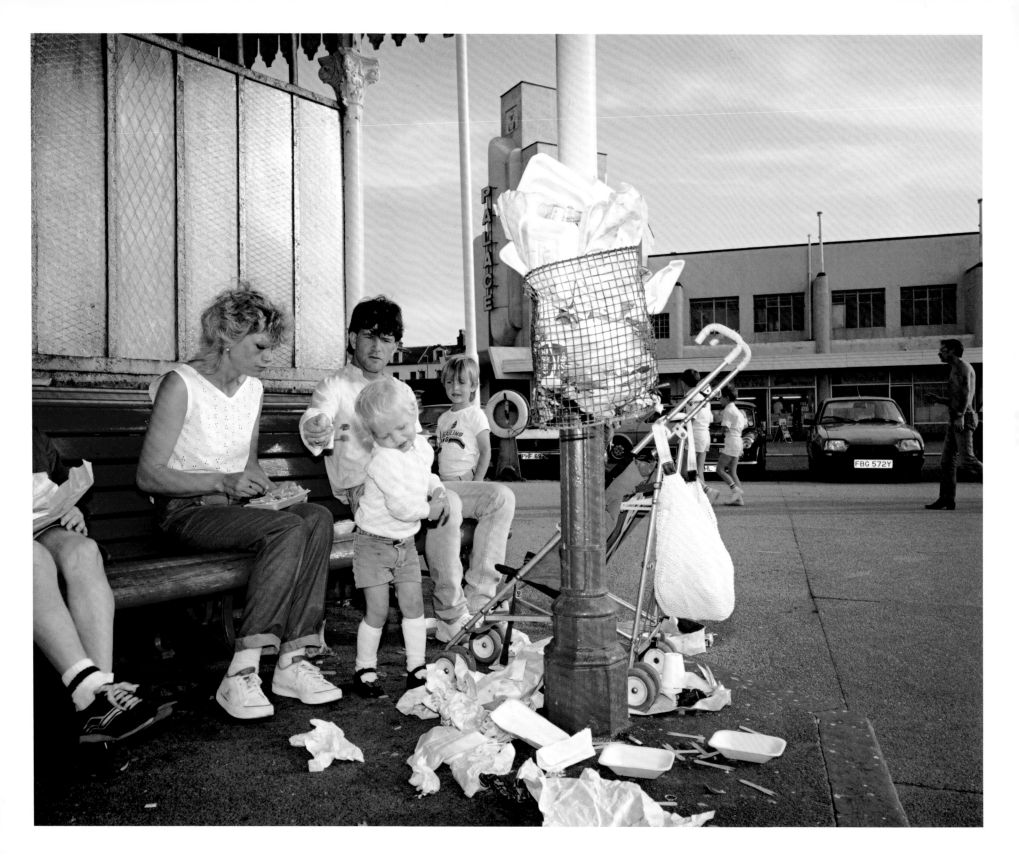

New Brighton, Merseyside, from 'The Last Resort', 1983–6

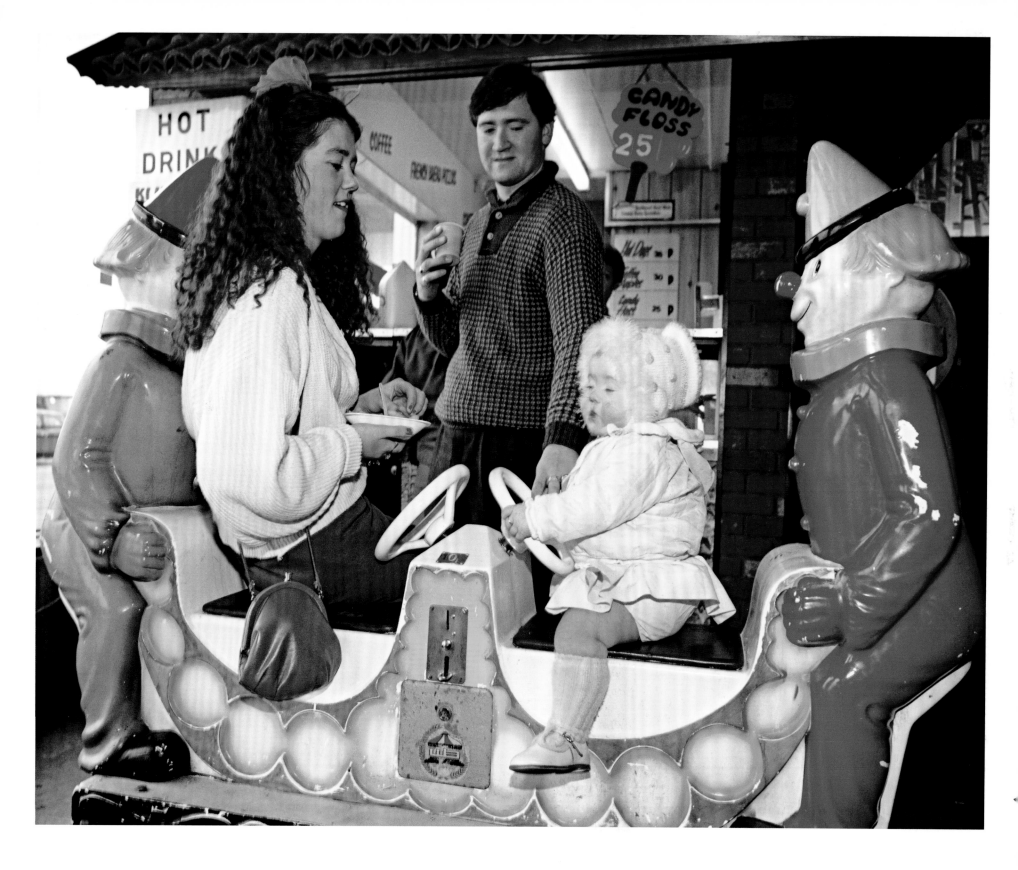

New Brighton, Merseyside, from 'The Last Resort', 1983–6

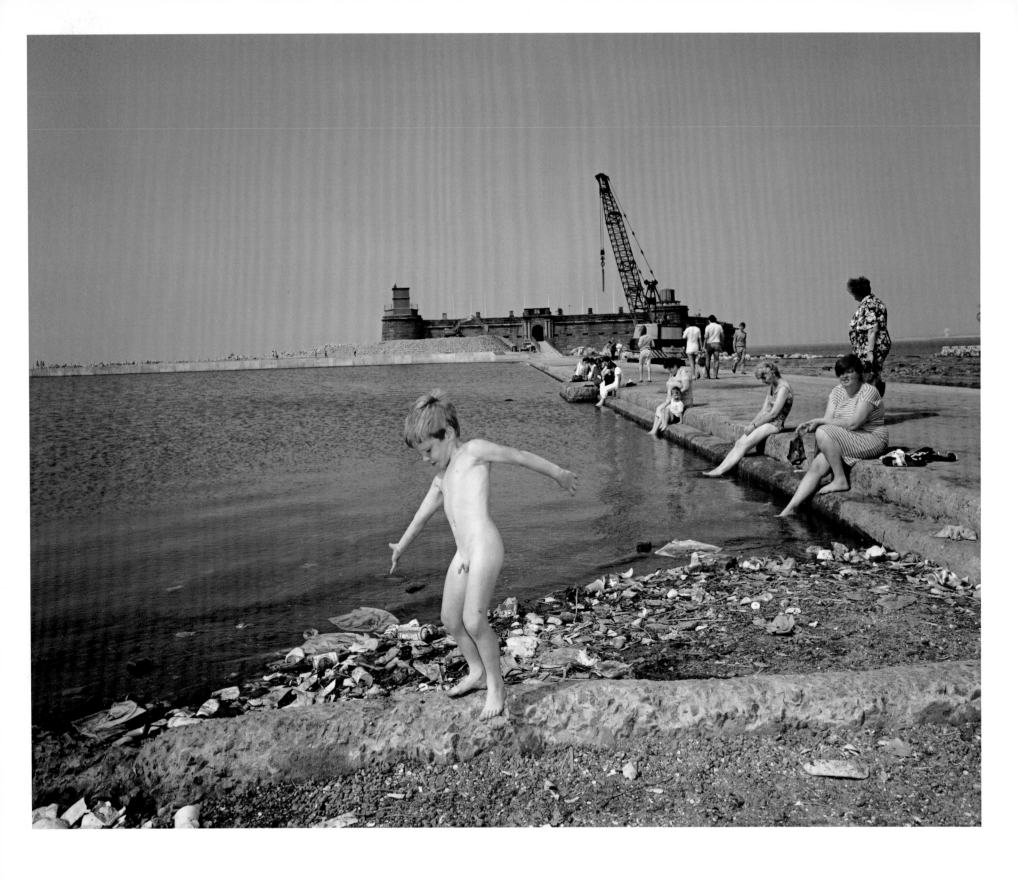

New Brighton, Merseyside, from 'The Last Resort', 1983–6

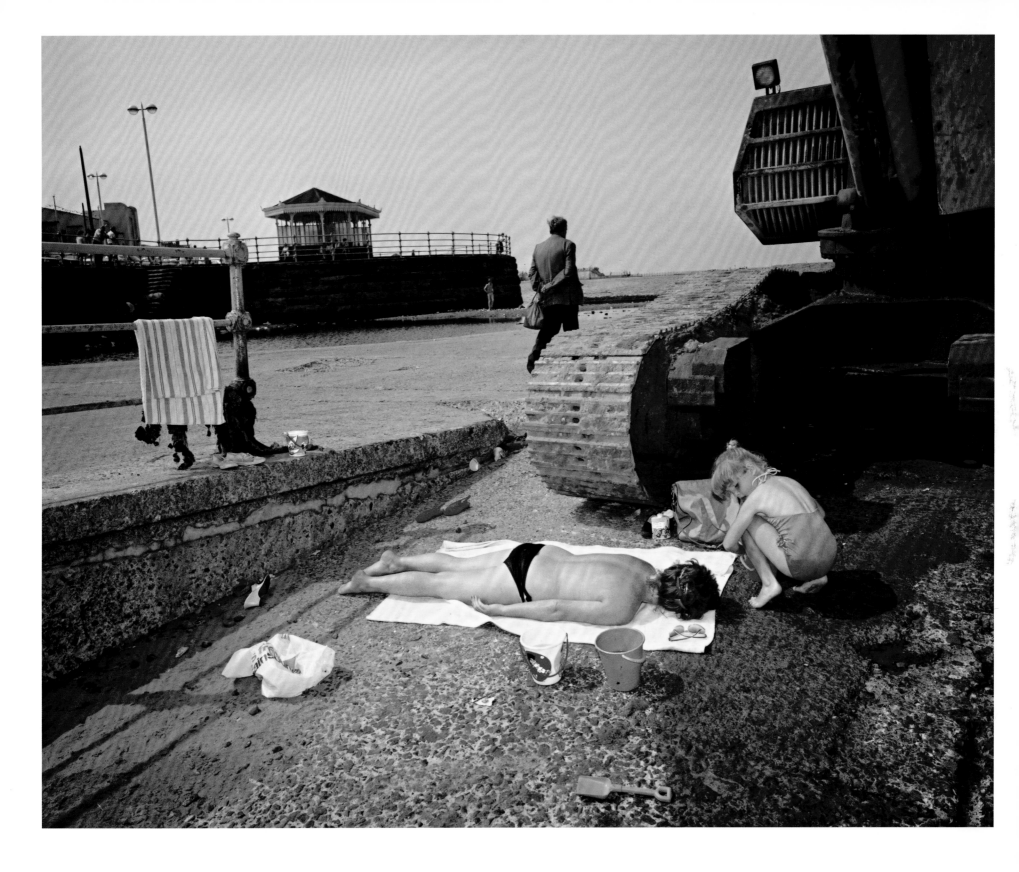

New Brighton, Merseyside, from 'The Last Resort', 1983–6

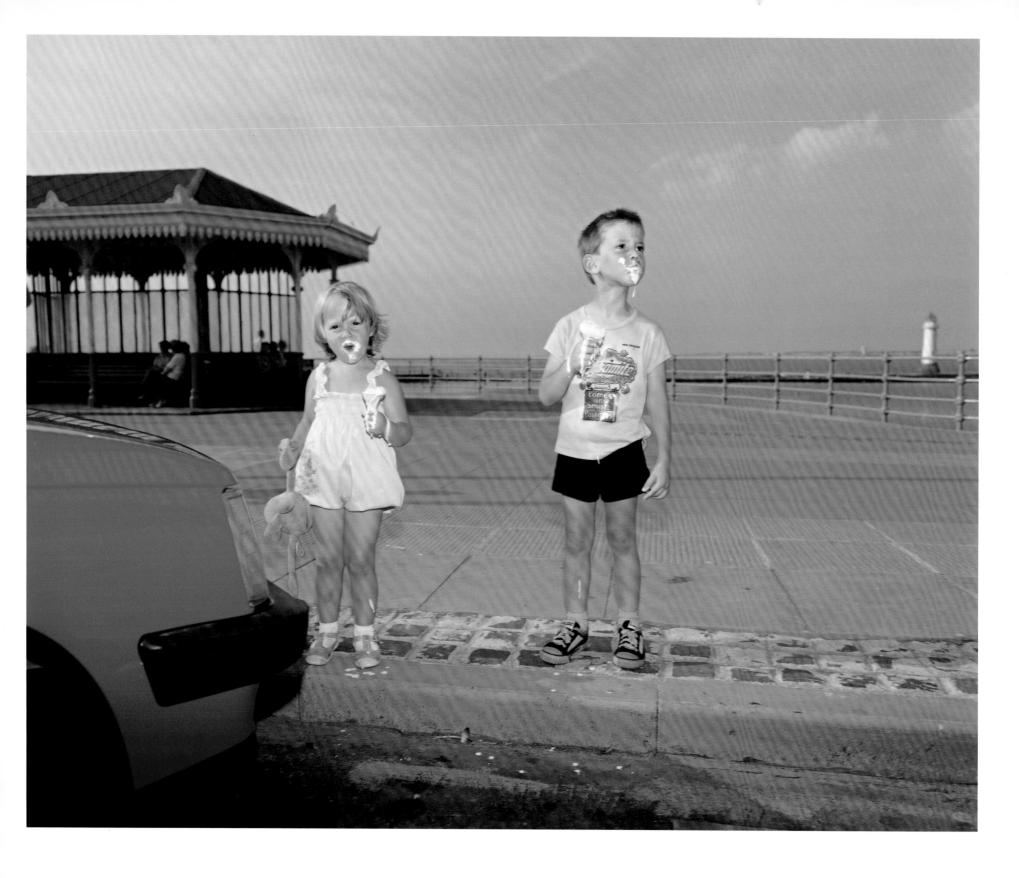

New Brighton, Merseyside, from 'The Last Resort', 1983–6

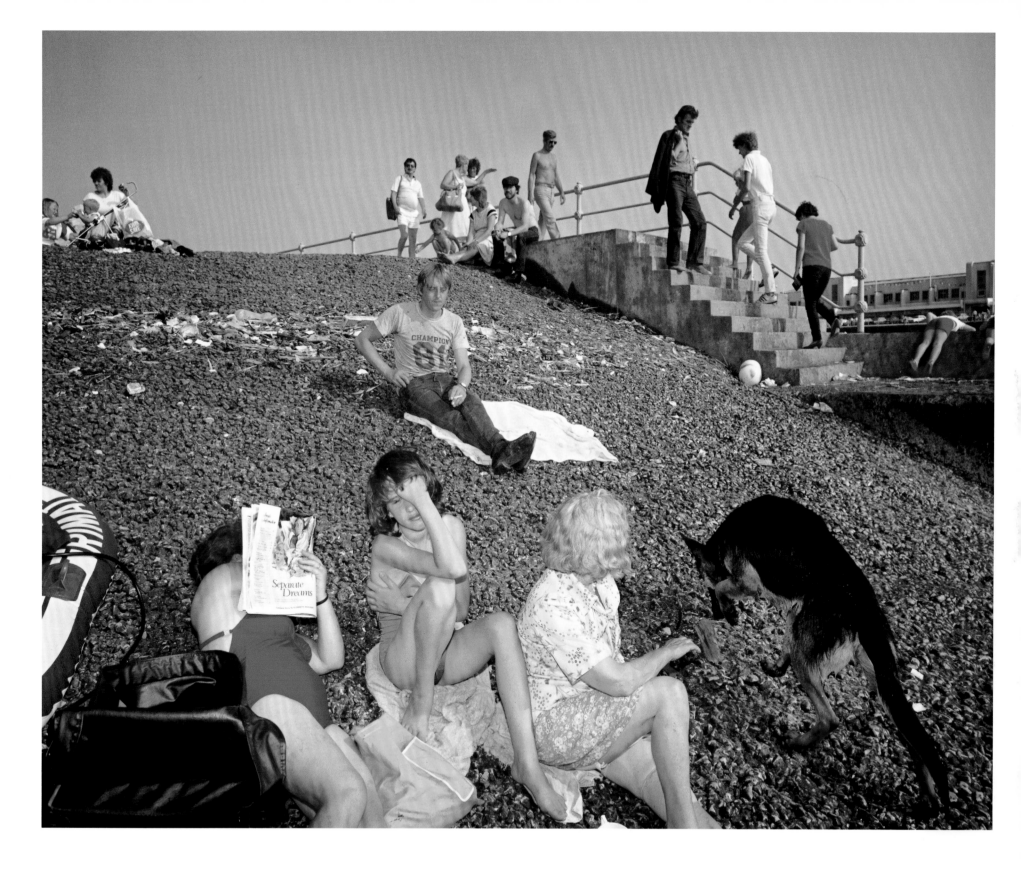

New Brighton, Merseyside, from 'The Last Resort', 1983–6

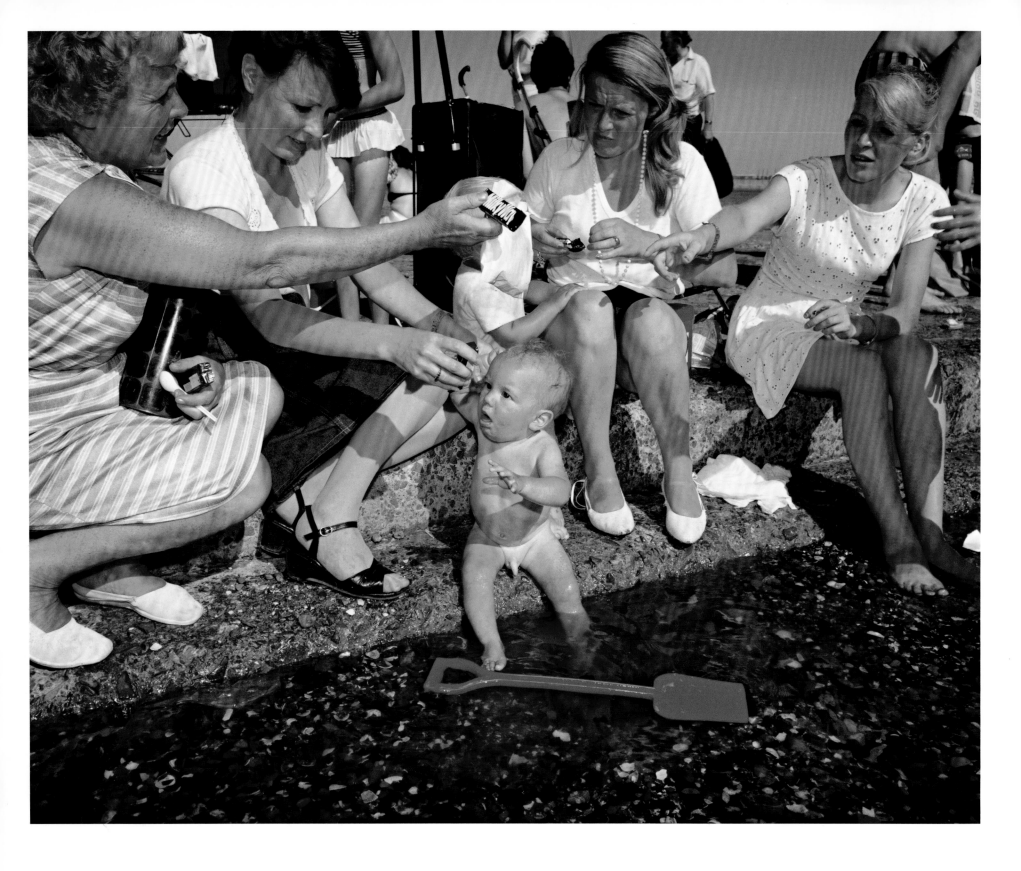

New Brighton, Merseyside, from 'The Last Resort', 1983–6

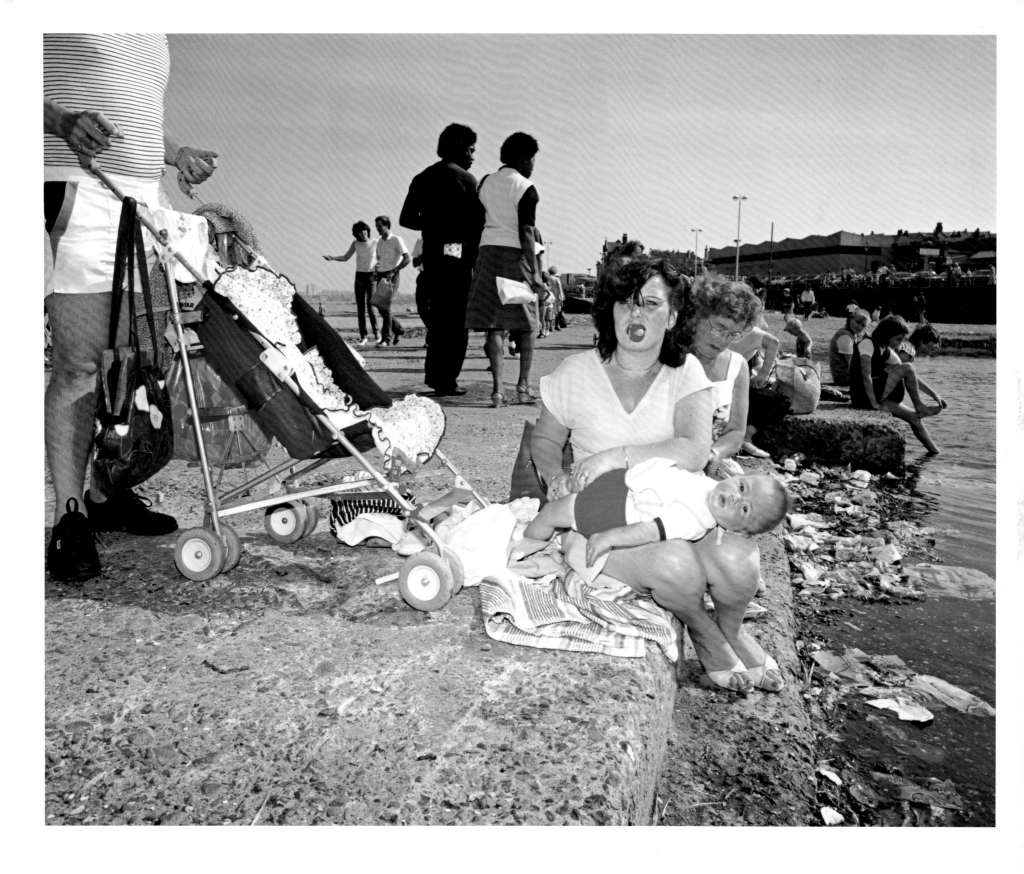

New Brighton, Merseyside, from 'The Last Resort', 1983–6

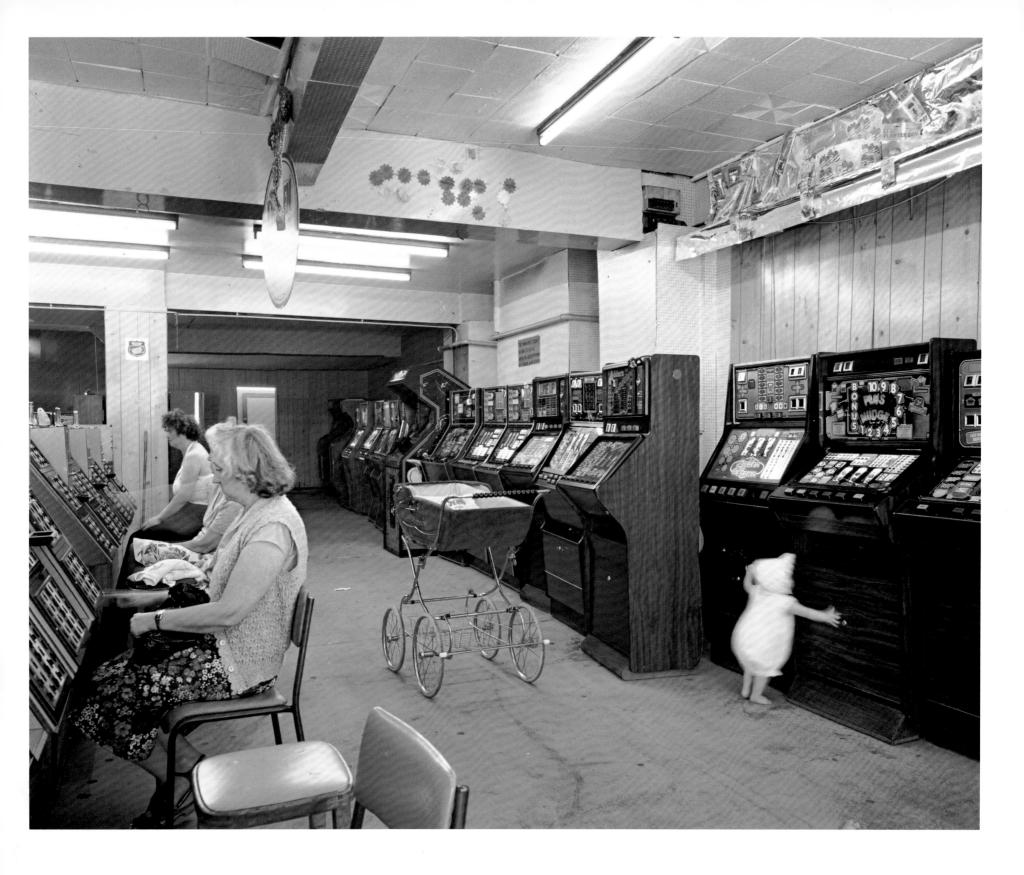

New Brighton, Merseyside, from 'The Last Resort', 1983–6

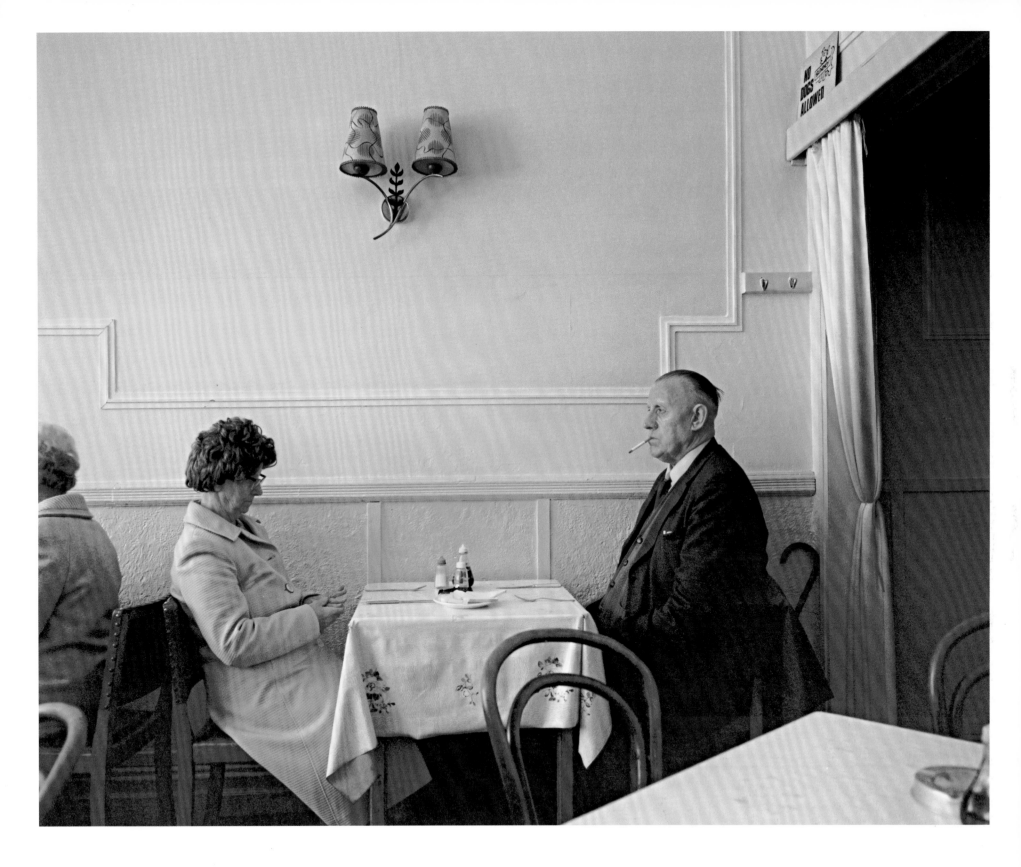

New Brighton, Merseyside, from 'The Last Resort', 1983–6

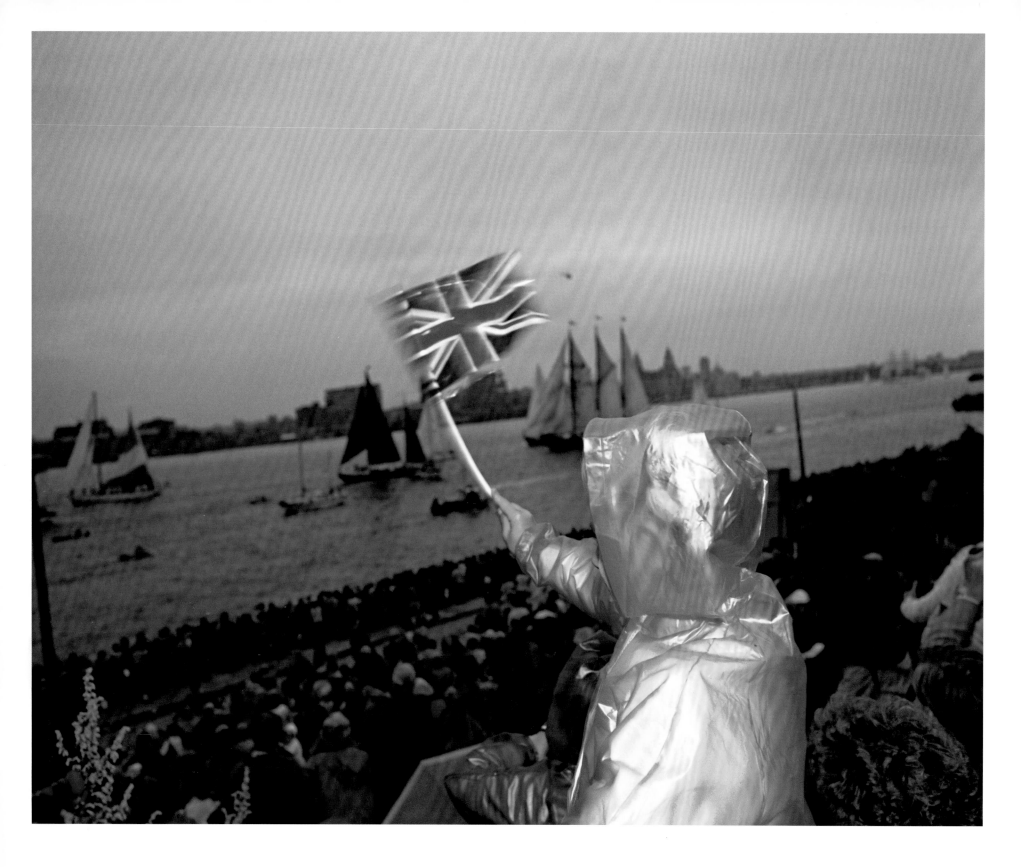

New Brighton, Merseyside, 1988

Vanity Fairs

new aspirations

By the 1980s, the new documentarists had achieved a certain measure of critical and public recognition. Of Parr's contemporaries, Chris Killip was by far the most successful, attracting the interest and support of Mark Haworth-Booth at the V&A, a patronage that resulted in three exhibitions (or contributions to group shows) in the 1980s, culminating in his book *In Flagrante* in 1988. Brian Griffin had also enjoyed considerable exposure in the 1980s, with solo shows at the Photographers' Gallery (1986) and the National Portrait Gallery ('Work', 1989). Paul Graham published and exhibited major pieces of work throughout the decade, including in 1986 'Beyond Caring' (on DHSS offices) and 'Troubled Land' (1987, work about Northern Ireland). John Davies with whom, along with Chris Killip and Graham Smith, Parr had developed a close photographic friendship during the early 1980s, was also developing a successful career, particularly as a commissioned artist in mainland Europe. Some of this exposure was undoubtedly due to publishing initiatives that had emerged in the UK. These included the Arts Council Photography Publishing Grants, which supported Parr's books *The Last Resort*, *Bad Weather* and *A Fair Day*, as well as Paul Graham's *Troubled Land*, Peter Fraser's *Two Blue Buckets* (1988), Paul Reas' *I Can Help* (1988) and Anna Fox's 1989 *Workstations* (looking at office life in the Thatcher years); the emergence of Travelling Light, the publishing and distribution company run by Peter Turner; and, most important of all, Cornerhouse publications, operated from Manchester by Dewi Lewis. It was the dynamism of Lewis at Cornerhouse and the availability of Arts Council funds that really propelled the new British documentarists (who by the end of the 1980s included Parr and Paul Graham's former students Anna Fox and Paul Seawright) into the public arena. And it was more than that – for these were photographers who passionately believed in the importance of photographic books (in the days before young photographers became affiliated to private galleries and began to tread the traditional path of exhibition catalogues and carefully chosen collectors lists) both as expressions of their work and as promotion of it. With these meticulously produced books, usually printed by Jackson Wilson, just around the corner from Harry Ramsden's near Leeds, they were able to self-promote their work around the world. This group, including both the older generation of Parr, Killip and Graham, and the up-and-coming colour documentarists including Reas, Fox and Seawright, were the most dynamic force to have emerged in critical documentary photography since its renaissance in the 1970s.

Though the Serpentine showing of 'The Last Resort' might have attracted more reviews than it did, it nevertheless proved to be a major step in Parr's career as a photographer. He gained important support from the powerful French photographic establishment when it was shown in Arles in 1986 and the work singled him out as the most important documentary photographer of his generation, the only one of the Manchester group to have achieved such prominence. It even put him on more equal terms with Killip. Parr was well aware of his need both

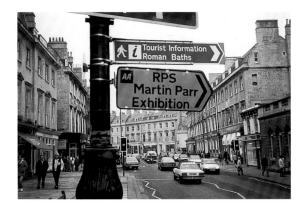

Parr's growing reputation warranted
a road sign to direct traffic to his
exhibition 'The Cost of Living',
Bath, 1989

for a major institutional supporter (the Arts Council, with its limited funds, was committed to supporting new photographers) and for a competent dealer to handle the sales of his prints, preferably in the UK. He had neither (his US dealer Janet Borden began to show his work only in the early 1990s and dealerships in the UK still revolved around a few, highly elitist galleries in central London), so once again, he was canvassing for support for his new project, which would centre around middle-class people in the South of England.

Martin and Susie Parr moved from Wallasey to Bristol in 1987. It was a dramatic shift for Parr, who, for so many years had used the North of England as his primary subject matter. In Bristol, things were very different. Bristol is a complex city. Its centre was a victim of post-war rebuilding that left it bleak and anonymous. A significant port for slavers, merchants and other sea-based industries in the nineteenth century, it has a history both of immense wealth and real poverty. The ornate terraces of Clifton (to which the Parrs moved) stand in stark contrast to the run-down council estates and miles of suburban housing that radiate out from the centre. Bristol has a substantial black community, a relatively thriving collection of artists and crafts people, a long-established university, some industry, a museum, two publicly funded art galleries and a fast train to London. It also has a sizable professional community, revolving around its hospitals, the university and the BBC. Like Dublin, a city with a similar past, it is made up of very distinct enclaves.

In London, wherever one lives, it is impossible not to be aware of the gradations in standards of living, the presence of, and cultural differences between, ethnic groupings, the vast proliferation of different kinds of people and neighbourhoods. Though London has its own enclaves too – Wanstead accountants, Hampstead media-ites, Hackney artists, Portobello fashion types, Docklands brokers – the composition of the city, the reliance on public transport, the need to travel from one part of the city to another makes it impossible not to be aware of the great demographical spread of the metropolis. London does not allow for too much complacency. In the major regional cities of Britain – Bristol, Leeds, Manchester, Birmingham – things are very different. Lacking fast efficient public transport, travelling between home and work is a far more private business than it could ever be in the capital; populations split between those who drive and those who have to wait for the bus, and while there are not perhaps the dramatic differences of wealth that one can observe in London, New York or Paris, the class divide is more intense. The kind of upward social mobility that is one of the great fascinations of capital cities is not nearly so apparent in the regions, where the labour force is more placid and more rooted. In the regions, people still know their place.

In order to make his new project on the English middle classes, Parr had to be in a city like Bristol. London was still the centre of power, the hub of the media, of the art world, of finance and politics, but for the kind of middle-classness that Parr wanted to photograph, Bristol was perfect. The upper-middle classes there were easy

Magazine cover, poster and exhibition
invitation from the 'Chew Stoke'
project, 1993

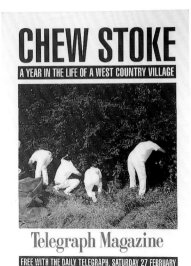

**A year in the life
of an English village**

to read: they were mostly white, mostly of the same generation as Parr himself. There were no get-rich-quick types, no Saatchi artists or pop stars' accountants, no entertainment lawyers or commodity brokers. The people Parr set out to photograph, in this, his first great satire of English life, were the professionals, the men and women with solid jobs in the National Health Service or in the top ranks of education, who holidayed in Tuscany or the Dordogne; careful, thoughtful people who usually voted Labour (although Parr would also venture out to the Tory heartlands with great effect). While in New Brighton Parr had looked for children, groups of women, cigarettes, litter, burger bars, crowds, concrete and decay. In the Southwest, he renewed his interest in couples, in nuclear families, in the strange territory of the semi-rural.

Parr had taken real pleasure in the photography of New Brighton. He liked the Northern English seaside. It was decaying but still raucous and it had a simplicity, an innocence, that he found immensely appealing. It is significant that Parr recorded no adverse reactions to

the photographs from people who appeared in them and would often use this fact as a line of defence when he was challenged about the ethics of the series during the 1980s. He photographed New Brighton in a clear-eyed way, and while his view was very different from that of Tom Wood, who made an extensive long-term study of the resort, his photographs were not so different from those he had made in Hebden Bridge or for the 'Beauty Spots' series.

In the series that Parr began when he moved to Bristol – which was published as *The Cost of Living* in 1989 with a concurrent exhibition at the Royal Photographic Society in Bath – Parr photographed a subject that he saw as being politically and culturally significant. The Thatcher revolution had unsettled Britain: for the first time since the Second World War, money was more important than class; social benefits and social rights were being eroded across the nation. A battle was being fought around notions of culture, economics and the workings of the Welfare State. The class boundaries were blurred, and for

the first time it was acknowledged that Britain had a significant underclass of people who were disenfranchised and increasingly angry. The Brixton riots and the marriage of Diana Spencer to the Prince of Wales took place in the same year; Margaret Thatcher had broken the miners and taken Argentina to task over the Falkland Islands. The railways and the telephone companies were sold to the highest bidder and at the end of the decade, the Berlin wall came down. European society was in flux.

Parr had talked about photographing the middle classes with Daniel Meadows, who by that time was living in Newport and teaching on the documentary photography course. Meadows' career had taken a different path from Parr's: since the mid-1970s he had been immersed in broadcasting, teaching and stills photography for movies. But he was still passionately interested in making documentary projects, and for some time had been developing the idea of a photo series about middle-class life. Meadows' book on suburbia, *Nattering in Paradise*, was published in 1989, a dense and interesting combination

Catalogue for an exhibition initiated by Parr, of the postcard photographer John Hinde, Irish Museum of Modern Art, 1993

of photography and oral history. Parr's *The Cost of Living* came out in 1989, with a text by the journalist Robert Chesshyre, with whom Parr would develop a solid professional relationship during the late 1980s and 1990s. The texts that accompany photographers' books are almost always problematic. The publisher wants something easily readable, two or three thousand words that will sit tidily in a small section near the photos, while the photographer wants an accompanist, like a singer will have a pianist, keeping time, maintaining harmony. Every so often, text and photographs become an exciting and challenging combination, each working to illuminate the other – Stuart Cosgrove's essay for Paul Reas' *I Can Help* (1987), for example, or Mieke Bal's text for Anna Fox's *Zwarte Piet* (2000). In many ways, Chesshyre's text was the perfect accompaniment to Parr's photographs since it trod a rather uneasy path between guilt about being middle class and a somewhat gleeful acceptance of it. Looking at it now, just over a decade since it was written, it seems strangely old-fashioned.

But Parr's photographs could have been taken yesterday, and in this, one of the most powerful and thought-provoking of all his projects, the full scope of his photographic virtuosity and the direction of his satiric intent are clear. There is an overriding sense in 'The Cost of Living' of the English middle classes as a kind of bizarre sect, with rituals as ridiculous and as desperately dowdy as a 1940s drawing-room comedy. In the crafts tent of a country show, a woman inspects a poorly designed pottery owl. A middle-aged woman wearing a trilby hat and glasses holds up a brightly coloured designer knitwear jumper; the shop assistant, holding a mirror, wears a slight grimace of horror. A young man who looks like George Michael gazes deep into the eyes of a young woman who resembles Paula Yates, at a launch party for the new G-registration number plate. A woman with clothes the colour of *pot pourri* stares at jars of *pot pourri*. A young couple wearing shorts passes by a reproduction of a painting by Vincent Van Gogh in a brand new branch of Ikea. The builders are just finishing a thatched-roofed Tudor detached house in Milton Keynes, and Morris dancers jig and tinkle in front of McDonald's. People are choked by barbecue smoke, hang ruched satin blinds in front of a perfect English landscape, arrange pink paper napkins in sundae glasses, sit in dining rooms that are too small. They attend school speech days, gymkhanas, private views, coffee mornings, fêtes, fundraisers and garden parties. In some ways, they are not so different from the Liverpudlians in New Brighton, finding something to eat, something to buy, something to do. It's just that they don't seem to be enjoying it as much.

In 'The Cost of Living', Parr's eye had never been so acute. He mobilized all the visual devices he had learned over the last twenty years and packed them into one terrific visual *tour de force*. The photographs are layered with meanings, agendas and jokes, and the result is a comedy of manners that is perfectly conceived and executed. In a photograph taken at an ante-natal class held in a sitting room, he photographs the strange spectacle of men and women crouched together among the sofas and

Parr's work used on a poster, brochure
and matchboxes for the 'Theater der
Welt' festival in Dresden, 1996

the mugs, simulating the process of labour. Three young mothers sit at a kitchen table during a National Childbirth Trust coffee morning. They are bright and tidy and sticking to a schedule. A woman holds up a small child wearing glasses and a ski suit on an artificial ski slope, and one wonders what was in it for either of them. A group of women watch another woman in a white cap and a shawl making lace with bobbins in a country in which lace is not worn any more, and if it were, would be made by teenagers in a breeze-block hut in the Third World.

'The Cost of Living' is about a great many things. It is about miniaturizing the aristocratic, faux-fabric wall-paper, small Tudor mansions, new things that look old. It is about acquisition: buying a bonsai tree or a ball dress, a white sofa or a metre of half-price Laura Ashley cloth. It is about anxiety on a quiet but nevertheless colossal scale; anxiety about keeping fit, looking good, doing well, knowing the right thing to say, sticking together. Whether they are cropped-haired girls selling Nicaraguan coffee at

a city festival, or Conservative Party members celebrating election victory with sausage rolls and cold chicken, there is something both horrifying and endearing about them all. No one ever overdoes it in these photographs: a kiss is a peck on the cheek, a paper plate is more practical than china. No one smokes or gets drunk or sniggers at pottery owls. At the sales, well-dressed men struggle to buy ties that are exactly the same as the ones they are wearing; small children on ponies bake in the heat wearing thick tweed jackets and string tied round their waists. People look at old things – cathedrals, pretty villages, statues, paintings – and when they get home, they try to copy them.

In William Makepeace Thackeray's great novel of class, money and culture, *Vanity Fair* (1847–8), the plot revolves around the fortunes of a young woman, Becky Sharpe, as she navigates through the British class system, brushing, along the way, with the aristocracy, the business classes and a raffish European bohemia. She fights her way out of poverty by being aware of other people's weaknesses,

desires and anxieties and using them to her own advantage. If Becky Sharpe were the heroine of a contemporary novel, she would probably have looked at the world in the same way that Parr does. In the time that it takes to make a photograph, she too would have taken in the ruched satin blinds and the pink paper napkins. She might have noticed the row of bright cerise lupins rearing jungle-like against a panelled garden fence at a Conservative summer party, putting the floral-print dresses to shame. She would certainly have noticed that everyone is a little bit afraid.

In a 1992 interview, Parr remarked of 'The Cost of Living':

'Unless you're putting yourself on the line to a certain extent, I don't see how it's really going to take off. In "The Cost of Living" I was very much examining my own position as, first off, a middle-class person, and secondly as a person who has flourished in a political climate that I feel somewhat opposed to but nonetheless have done very well out of thank you, and thirdly, my own

In the 1980s and 1990s, Parr's work
began to appear regularly in mainstream
magazines

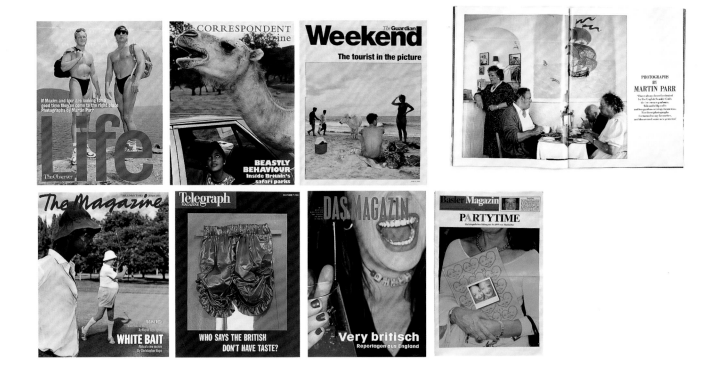

guilt about being a relatively affluent person in modern
Britain. So I try and make all these things have some
sort of significance back to things I'm looking out for and
discovering myself. It's because I'm a consumer that I can
recognize the consumer element in other people and in
society as a whole.'

Writing about 'The Cost of Living' (in 'Class
Conscious', *Creative Camera,* 1990*)* Richard Ehrlich
remarked:

'Followers of [Parr's] work can trace an interesting
development here. The "choreographed compositions" (his
own term) of Parr's early black-and-white work gave way,
in "Bad Weather", to a looser, more enigmatic pictorial
construction. Choreography was to return in "The Last
Resort", with its need to make sense of large groups. In
"The Cost of Living", the world has again been de-choreo-
graphed, producing imagery that's closer in spirit to the
apparent visual anarchy of Garry Winogrand's *Public
Relations* (1977). Winogrand and Diane Arbus strike me
as the two most important photographic presences

behind "The Cost of Living" … Some people criticized
"The Last Resort" as being voyeuristic and/or patronizing,
and "The Cost of Living" will be open to the same kind
of criticism, particularly as the satire is even more biting.
People are most vulnerable to satire when they take
themselves seriously, and the people in "The Cost of
Living" take themselves very seriously indeed … Parr has
caught the comfortable, confident classes at the apex
of their pride. Yet somewhere, I feel, in the midst of that
prosperity, the seeds of decline are germinating slowly.'

An important connection between 'The Cost of Living'
and the earlier work in New Brighton and Salford can be
traced in the documentary project that had been commis-
sioned by the French Mission Photographie Transmanche
and published under the title *One Day Trip.* Parr had
been interested in the recent British phenomenon of
travelling to France for the day to buy cheap alcohol at
French hypermarkets, and chose this as the theme for the
commission. The photographs he made were a raw and
powerful examination of supermarket shopping on a

bizarre scale. It was as if 'Point of Sale', 'The Last Resort'
and 'The Cost of Living' had been melded together, and
then the humour taken out, leaving a bleak and pitiless
picture of clumsiness and greed.

In 1991, Parr took part in an exhibition on which he
had acted as an informal advisor to Susan Kismaric,
curator at the Museum of Modern Art in New York.
Entitled 'British Photography from the Thatcher Years',
the exhibition had originally come together at the 1986
Houston Fotofest, an increasingly dynamic and influen-
tial event. For Parr, it was a significant achievement,
exposing his work to the most important photography
audience of all: the curators and critics of New York. It
was also something of a swan song for the group of pho-
tographers who had come to represent the culmination
of the independent documentary movement (apart from
Brian Griffin, who declined the MOMA show): Paul
Graham, John Davies, Chris Killip and Graham Smith.

In Britain, too, there was something of a swan song, in
the form of 'Through the Looking Glass: Photographic

Art in Britain 1945–1989', curated by Gerry Badger and John Benton-Harris for the Barbican Art Gallery in London, which opened in July 1989 to coincide with the 150th year of photography. Parr was represented by photographs from 'The Last Resort', 'Bad Weather' and 'Point of Sale', and the exhibition included classic figures such as Bill Brandt, Angus McBean, Nigel Henderson and Bert Hardy, while the 1970s generation included Parr, Chris Killip, John Davies, Chris Steele-Perkins, Graham Smith, Mari Mahr, Paul Graham, Peter Kennard and Calum Colvin. Photojournalists such as David Hurn, George Rodger, John Sturrock and Don McCullin were also exhibiting, as was the younger generation of documentarists, including Anna Fox, Paul Reas and Sue Packer. It was an important and exceptionally unbiased exhibition, with artists such as Susan Hiller, Tim Head, Keith Arnatt, Andy Goldsworthy and Helen Chadwick also taking part. While some of the exhibitors disappeared completely from the photographic scene in the years to come, many have continued to work and exhibit. But, despite its suc-

cess, 'Through the Looking Glass' would be the last substantial survey exhibition of British photography to be assembled in a major British venue. In his introduction to the Houston exhibition in 1986, Parr had remarked on the continuing marginalization of photography. But by the beginning of the 1990s photography was no longer regarded as a separate art form by the art world and the major institutional funders. It had been absorbed, for better or for worse, into the mainstream establishment.

While his own achievements had been gratifying, Parr was also to get much satisfaction from promoting the work of a younger group of photographers, some of whom he had taught at the West Surrey College of Art and Design at Farnham and at the Documentary Photography Course in Newport. The photography course at Farnham, under the leadership of Martin Roberts and subsequently Peter Hall, had become a focal point for the new documentarists. Parr taught there from 1983 to 1990, along with, at varying times, Paul Graham and Peter Fraser. Students on the course included Anna Fox, Paul

Seawright and David Moore, all of whom went on to produce acclaimed critical documentary projects in the 1990s. In 1992, Parr organized an exhibition of the work of some of the younger photographers, whom he believed represented the new wave in colour documentary. The show was called 'Current Account' and included work by Paul Seawright, Anna Fox, Anthony Haughey, Ken Grant and Robin Grierson. In his introduction to the exhibition, Parr wrote:

'Traditionally, documentary photographers and photojournalists sought out the injustices of the world (war and homelessness etc.). They hoped that the process of pointing their cameras at the sources of struggle or injustice would influence opinion and indeed change the world for the better. The photographers featured here are more concerned with a personalized point of view of the world and using a new and fresh language to express these ideas … What lesson can we learn from the photographs presented in this exhibition? For me, these photographs demonstrate that opposing poles can be observed

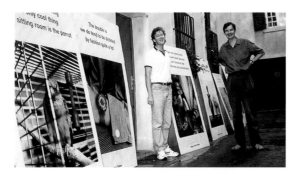

and interpreted in society: order and chaos, affection and aggression, attraction and repulsion, good and bad. These tensions create a sense of uncertainty that gives the photographs considerable power. The photographs are asking questions, not proposing the answers.'

During the 1980s Parr had published books of *The Last Resort* and *The Cost of Living*, two of his most important series. His work was fashionable and in demand, and he had exhibited throughout Europe. Neil Burgess, who had supported 'The Last Resort' at the Open Eye Gallery, had moved to London and was working for the Magnum photo agency, which represented internationally known photographers such as Henri Cartier-Bresson, Elliott Erwitt, Eve Arnold and Gilles Peress. Burgess opened up the doors of mainstream photojournalism to Parr, setting up contacts with the major picture magazines. Parr was impressed by Magnum and saw the advantages that membership of a powerful international agency with a historic past could bring. In 1988 he applied to become a nominee, the first step in a lengthy process towards

becoming a full member of the co-operative. By joining Magnum, he found a channel for his work that would bring high returns, both financially and professionally. The editorial photography market was booming, and Magnum had strong links with corporate clients, advertising agencies and international commission projects. From the time that Parr became a nominee of Magnum, his future as a photographer was secured, and he took part with much enthusiasm in the international distribution of photographs and photo stories. After twenty years as a documentarist working on lengthy projects to be published as books and exhibited, Parr was shifting ground, moving into a fresh arena in which he would encounter a new and influential peer group, based squarely within the media industries.

In 1992 Parr found a twin soul in the perhaps unlikely form of Nick Barker, a producer/director at the BBC in London. Barker had come up with an idea to make a series of documentaries about British lifestyle, focusing on the way in which people construct their home interi-

ors. Parr was to make a set of photographs at the same time, of the subjects that Barker chose. From the beginning, *Signs of the Times* was a mesmerizing project, and it became one of the defining TV moments of the 1990s. First shown in 1992, it struck a raw nerve in the British public, as a carefully selected cast of people talked about their taste. Barker and his team had videotaped two thousand possible participants before they selected the people who finally appeared in the films. Barker is a far bolder and more articulate personality than Parr, but like him, had the ability to identify a moment in popular history and make it into a mass-market media event. What Barker and Parr chronicled was what happens when design becomes transmuted into popular taste. They reported on the death throes of the ruched Venetian blind, the mug tree, the dried flower and the pine kitchen. Barker chose people for his films that, try as hard as you might, you could not help but laugh at, even if you felt a bit ashamed when you did so. There was the young man whose bedroom, with its walls of car photos, was

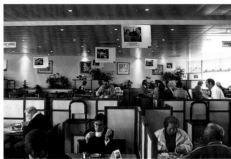

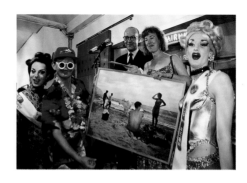

invaded by his girlfriend, who used a flowery quilt as her defence against his masculinity. Or the minimalist architect who subjected his family to a reign of taste-terror: all white, no bric-a-brac. His wife confided (to the camera) that 'You have to be very brave to live in a minimalist environment. Whenever people visit us I always feel I'm on show'. A swirly plastic border around a white plastic light switch created a 'cottagey stately home kind of feel' for one couple, and a mock-Tudor hallway was for another homeowner 'a little bit of old England'.

But Barker did not run the risk (as Parr, undoubtedly, in the past had done) of concentrating on one section of society. The films were as revealing about the kinds of people who lived in the types of homes that Barker and Parr themselves owned as they were about the people who aspired to a middle-class lifestyle. A smug couple sat in a tasteful grey and white sitting room and talked about having 'sufficient confidence to have an idea about what we want to do, and do it properly', and one could only cringe. In the films, Barker went beyond what any

photograph, however incisive, can do. He touched on the great sadness of our interior lives, on the terrible moments where things become more important than people, the moments when what Philip Larkin bemoaned as 'the pictures and the cutlery. The music in the piano stool, that vase' become things that tie us down, identify us to our peers, make us ashamed or frightened or inappropriately proud of what little we have. *Signs of the Times* may, ostensibly, have been about taste, but really, it was about our dreams, our desires, to be better people than we feel we are, to be more glamorous, more impressive, more satisfied. An elderly couple despaired over their 1960s furniture, but all the time one suspected that the furniture was only the outward expression of the problem. Worlds in a grain of sand.

Signs of the Times was shown at a time when the notion of heritage culture had become a much-discussed issue. Books such as Paul Theroux's *Kingdom by the Sea: A Journey Around the Coast of Great Britain* (1995), Patrick Wright's *On Living in an Old Country* (1985) and

Robert Hewison's *Culture and Consensus: England, Art and Politics Since 1940* (1995) were looking at the ambiguities of our national culture. In their time, they were the talking points that anti-globalist books such as Naomi Klein's *No Logo* (2001) and Eric Schlosser's *Fast Food Nation* (2001) are today.

It was a theme that Parr had been exploring in his photography since the late 1980s, both in 'The Cost of Living' and in his series 'Small World'. The reign of Margaret Thatcher as Britain's first woman Prime Minister from 1979 to 1990 changed not only the social and economic face of Britain, but also its cultural and visual appearance. The race for owner-occupancy in housing (which was accelerated by the Thatcher government's granting of the right to buy social housing for private occupation) generated an explosion of new homes – quaint, misproportioned postmodernist English cottages in rows. Council houses, designed to be simple well-constructed rented homes for low-income families, sprouted porticoes and conservatories, and the DIY industry flour-

ished. For Parr, *Signs of the Times* was more than an interesting collaboration with a talented film-maker, it was, in many ways, a summing up of all the issues that had preoccupied him through the 1970s and 1980s, a final acknowledgement that the disappearing Britain he had photographed in the 1970s, a Britain he had liked so much, had finally gone. The stringent Methodist upbringing, which had taught him to believe in diligence and simplicity, had led Parr to disapprove of much of what Barker was filming. It was a difficult situation to be in.

Increased wealth across the nation, coupled with more competition in consumer goods and services, brought about, in part, by the Thatcher revolution, had made many things more accessible to ordinary British people. For the first time, a holiday to Thailand or Africa was only a little more expensive than one to Greece or Spain, and the coming of self-assembly furniture to design chains such as Habitat, MFI and Ikea meant that a large range of different kinds of household furniture and goods were now available to the high-street shopper. Not surprisingly, it was a time of confusion: tourists were pestered and waylaid in Africa and India in a way they had not been accustomed to in the European resorts, and the proliferation of a range of styles inevitably led to a sometimes bizarre mishmash of ideas for the domestic interior. It could be said that Parr, with Barker in *Signs of the Times* and the follow up project about people and their cars, *From A to B*, and on his own in 'Small World', was laughing at ordinary people who were making the most of their new opportunities. And perhaps, to some extent, he was. But behind the mocking, there was also a sadness, a nostalgia for June Street and Hebden Bridge, for the trip to the seaside and the holiday camp, for a way of life that Parr had idealized.

For Parr, the early 1990s was an exciting time. The collaboration with Barker was perhaps the most fruitful of his career and gave his work tremendous exposure: a selection of the photographs with quotes from their subjects was displayed throughout the London Underground network, and on the advertising boards at bus stops around the country. Parr had also begun to receive commissions from Michael Collins, the recently arrived picture editor at the *Telegraph Magazine*, and the 'Signs of the Times' photographs were featured in the *Saturday Telegraph* supplement, as well as being discussed in a feature article in the *Independent on Sunday Magazine*.

The 1980s and early 1990s had been a period of both innovation and consolidation for Parr. As well as making his seminal photo series, he had developed significant organizational and promotional skills to ensure that almost all of his work was published as books and made into exhibitions. He had been an influential and powerful teacher, particularly at Farnham. He was a serious collector of photographic books and postcards, making a collection that, during the 1990s, would rival (perhaps even overtake) the national collections at the V&A and the National Museum of Photography. His photography was now a highly marketable commodity affording him, in the years to come, seemingly endless possibilities.

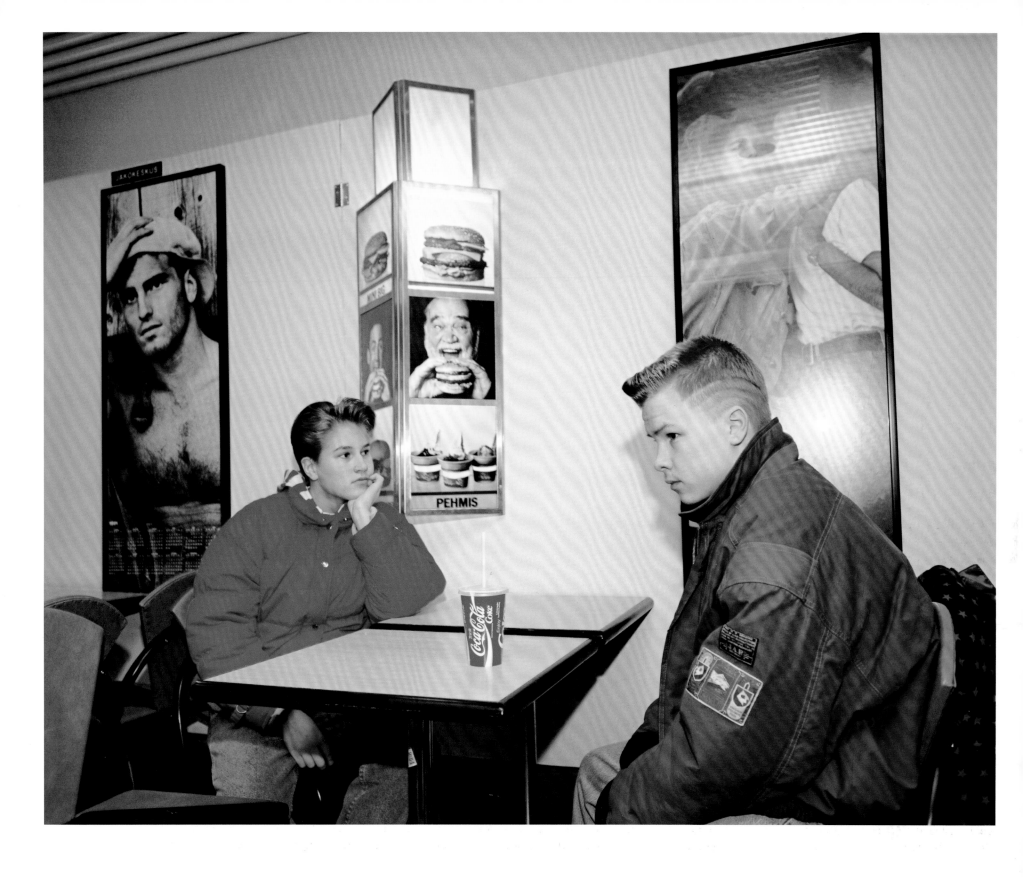

Kotka, Finland, 1991, from 'Bored Couples'

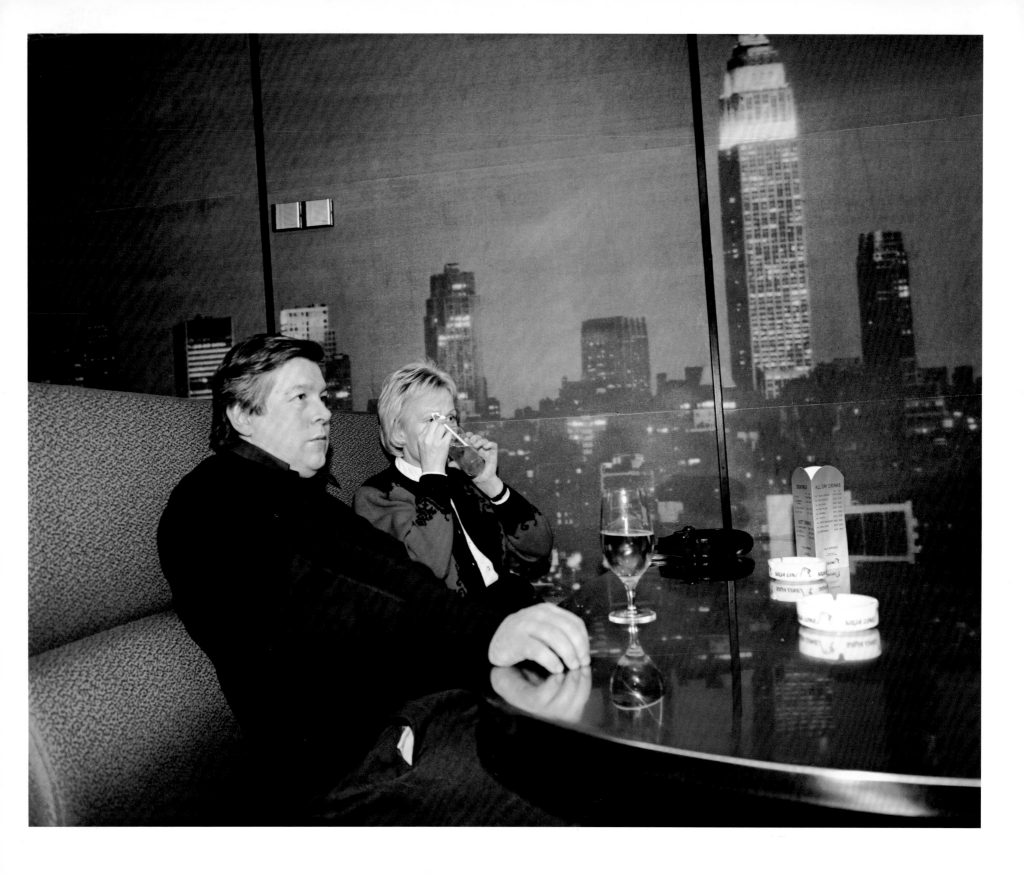

Ferry between Helsinki and Stockholm, 1991, from 'Bored Couples'

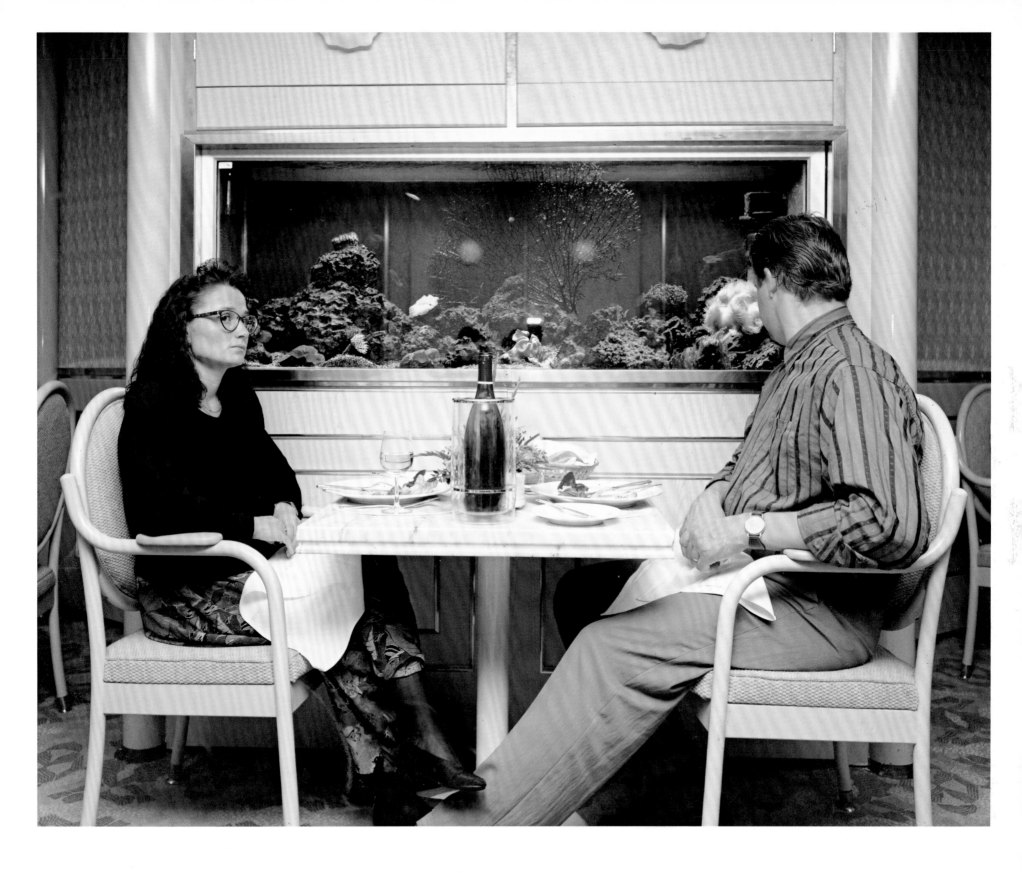

Ferry between Helsinki and Stockholm, 1991, from 'Bored Couples'

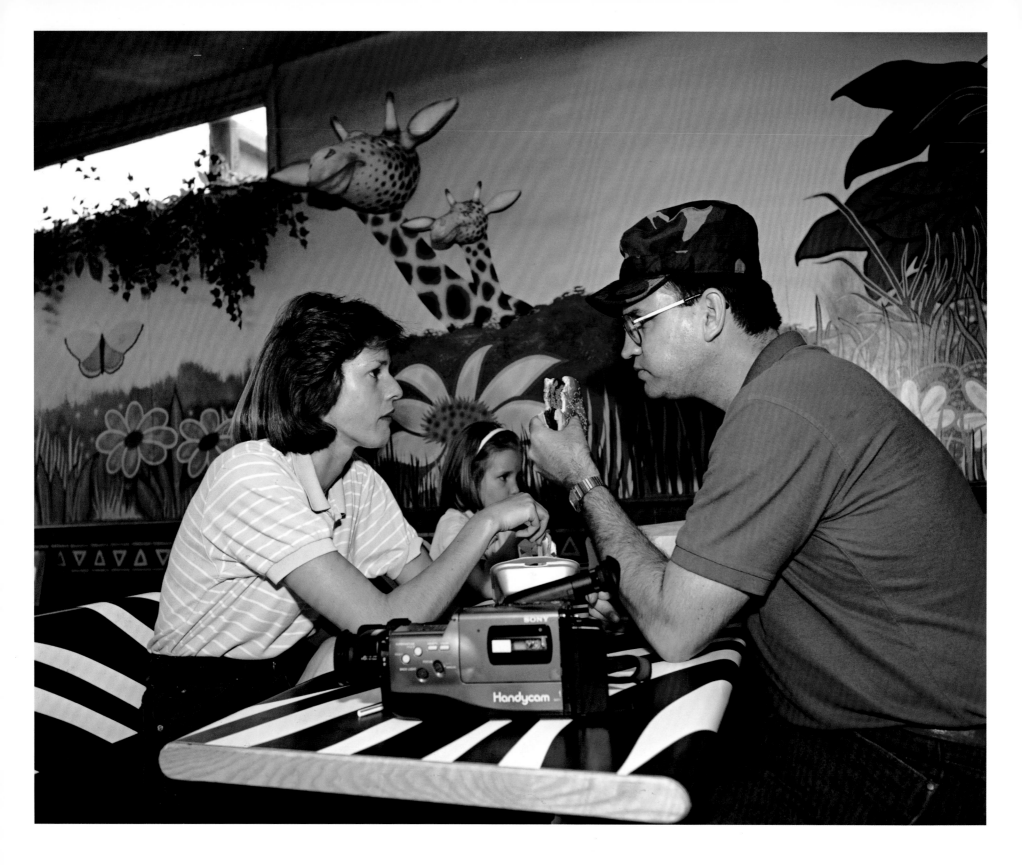

Bongo Burger Bar, Windsor Safari Park, Berkshire, 1991, from 'Bored Couples'

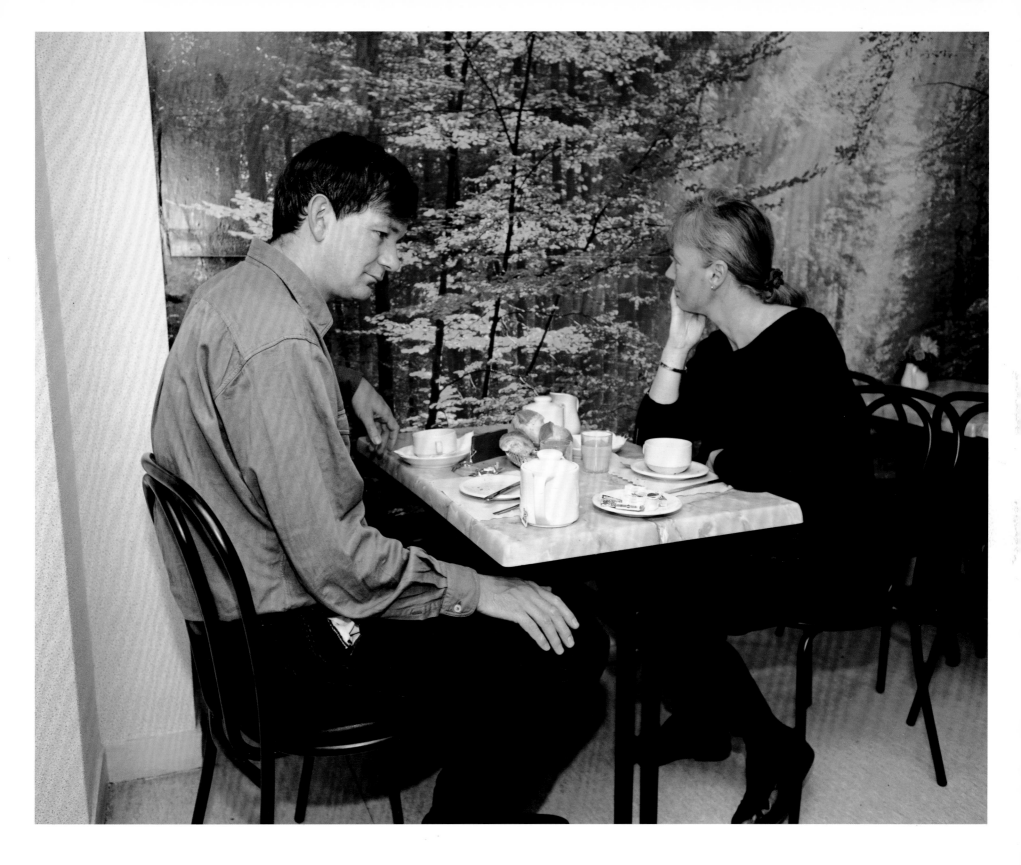

Paris, 1993, from 'Bored Couples'

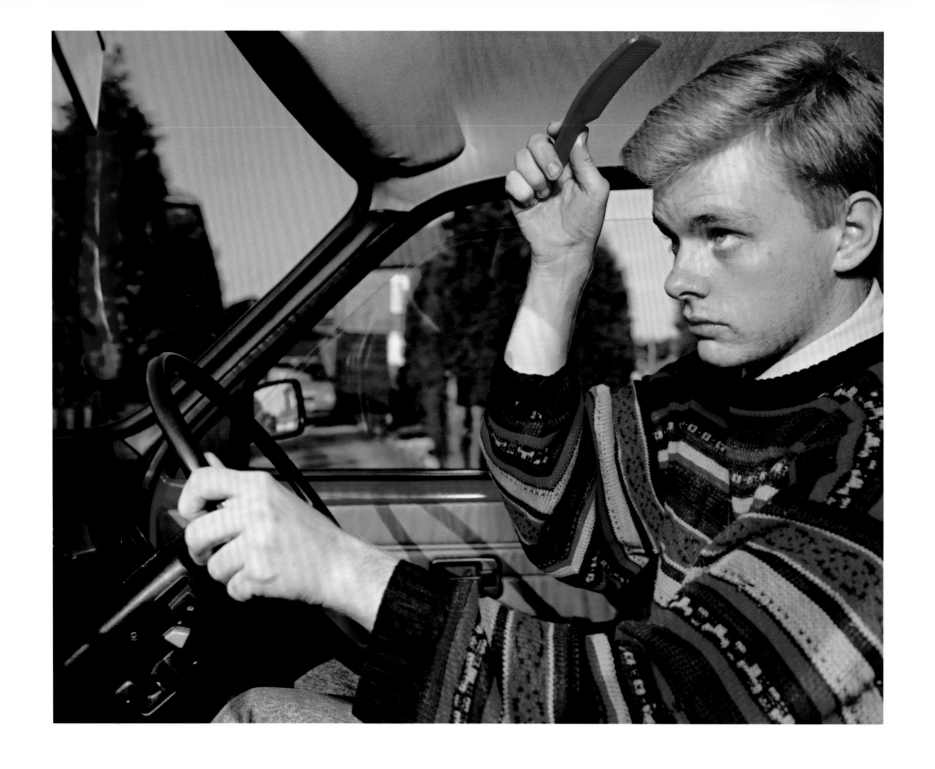

As far as my social life is concerned, the Metro is a no-go area.
I think I'd look so much better sat in an XR2

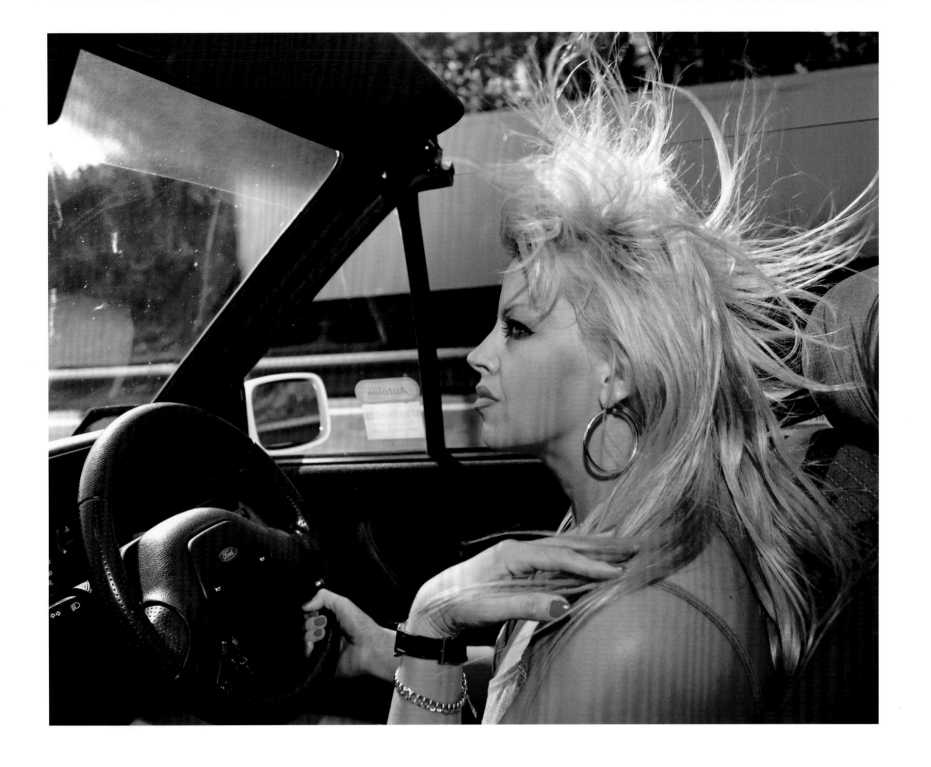

I feel that other women on the road react to me in a nasty hostile sort of way.
For some reason this hate comes across. I mean, I give way to them
so why don't they give way to me

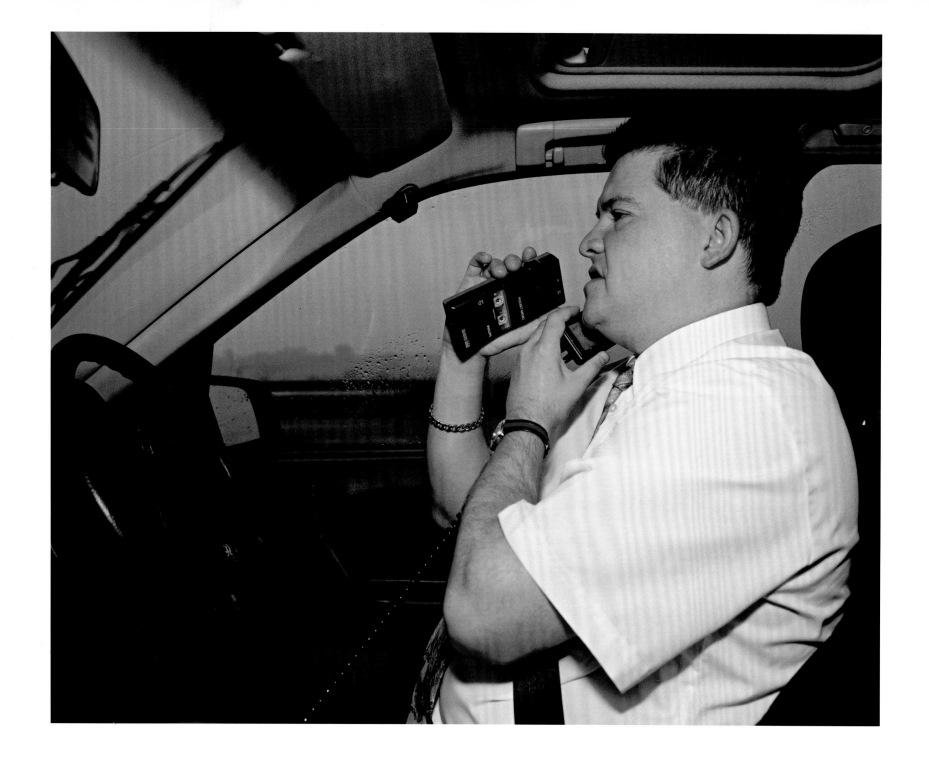

I like to think I'm quite successful because I've got a Cavalier 2 litre GLi.
I sell industrial packaging machines – something with a bit of esteem
not like Derek in *Coronation Street* who sells novelty items out of a bloody suitcase

From 'From A to B', 1994

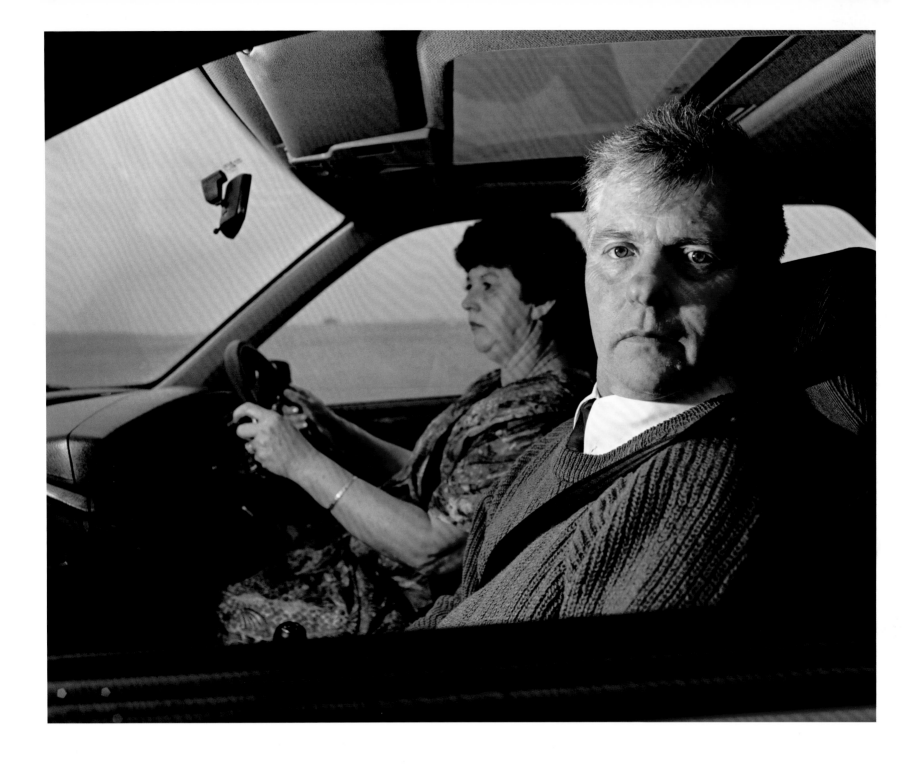

Ken's slow. I think it's his age.
When we're driving on the motorway everything belts past us
and he's chugging along at fifty-five on the inside lane

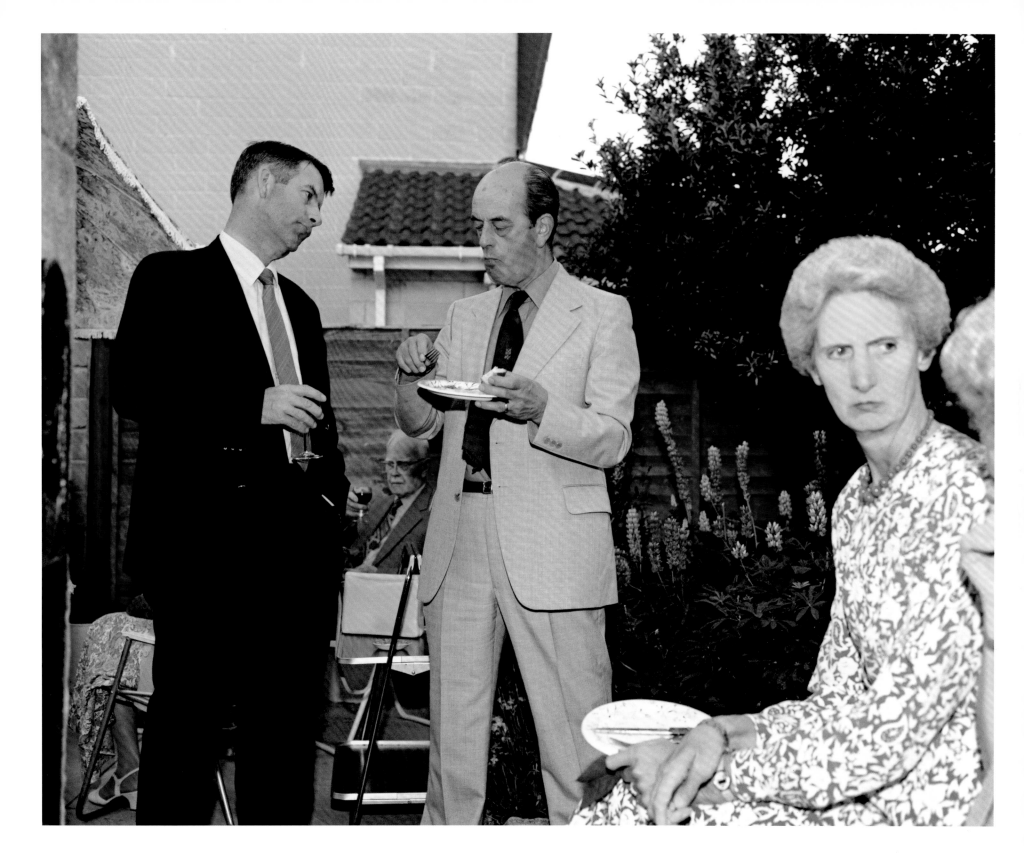

Conservative 'midsummer madness' party, Bath, Avon, from 'The Cost of Living', 1986–9

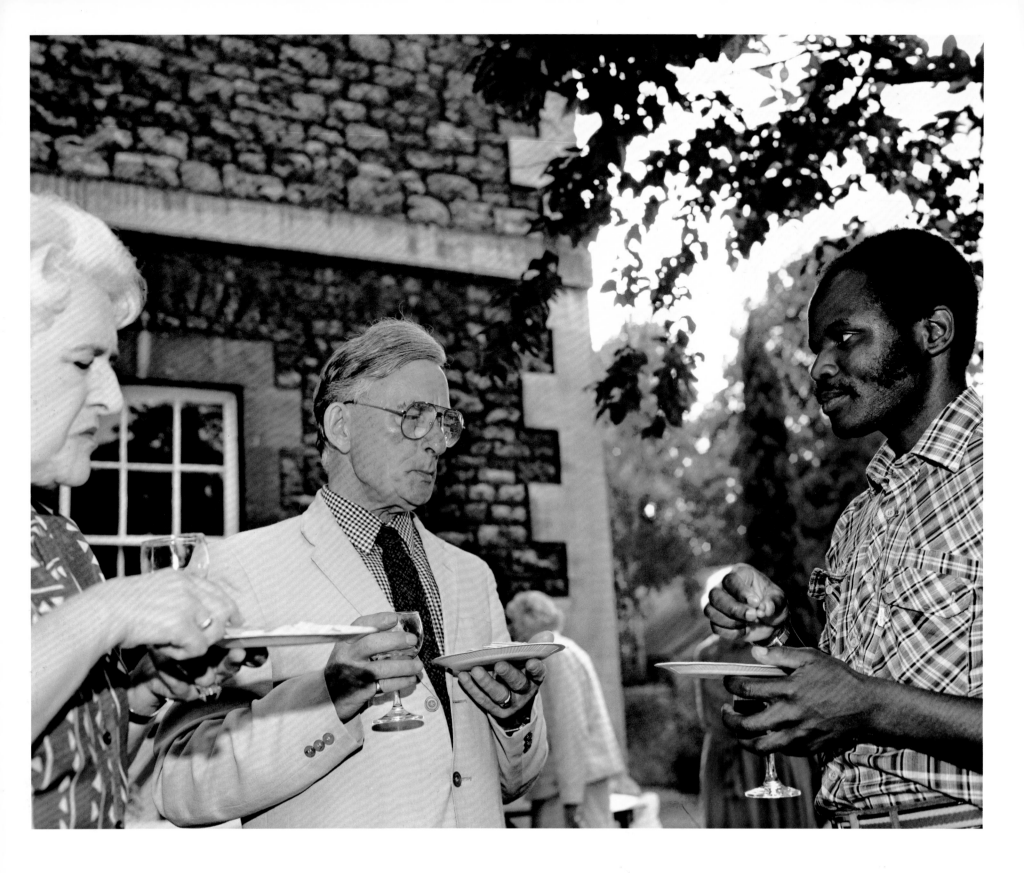

Royal Commonwealth Society 'function for a summer evening', Bristol, from 'The Cost of Living', 1986–9

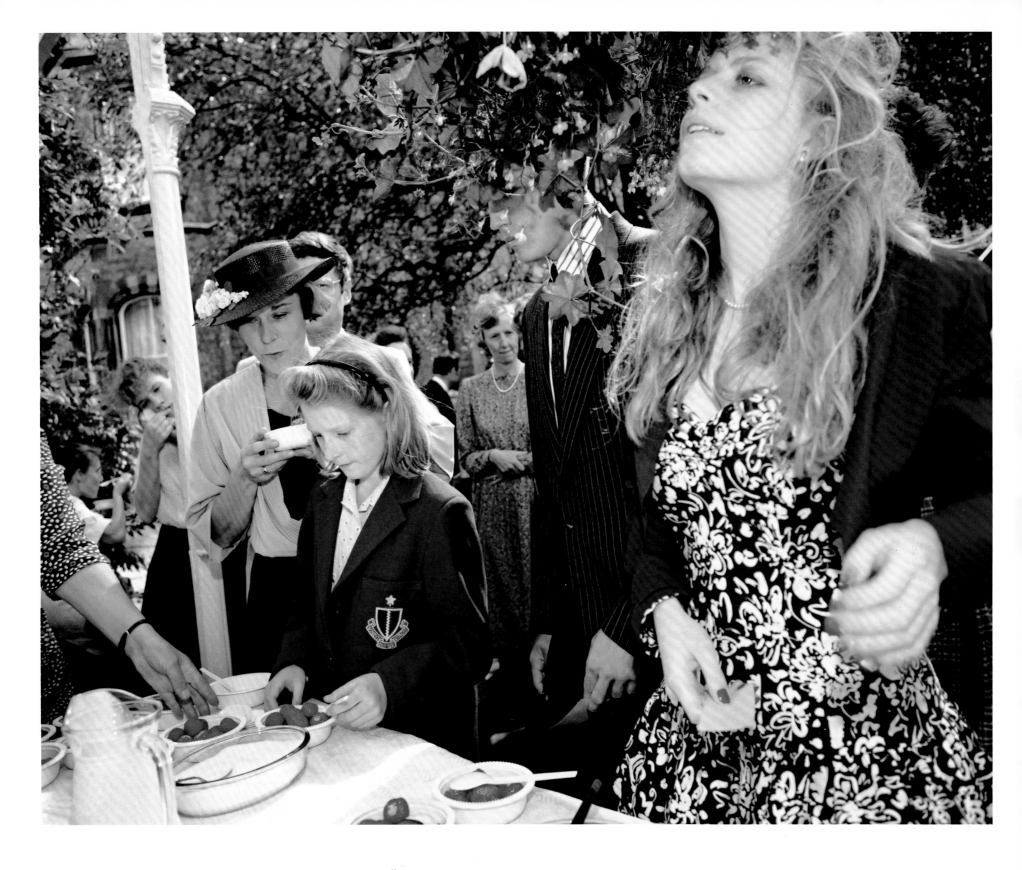

Malvern Girls School, Worcestershire, from 'The Cost of Living', 1986–9

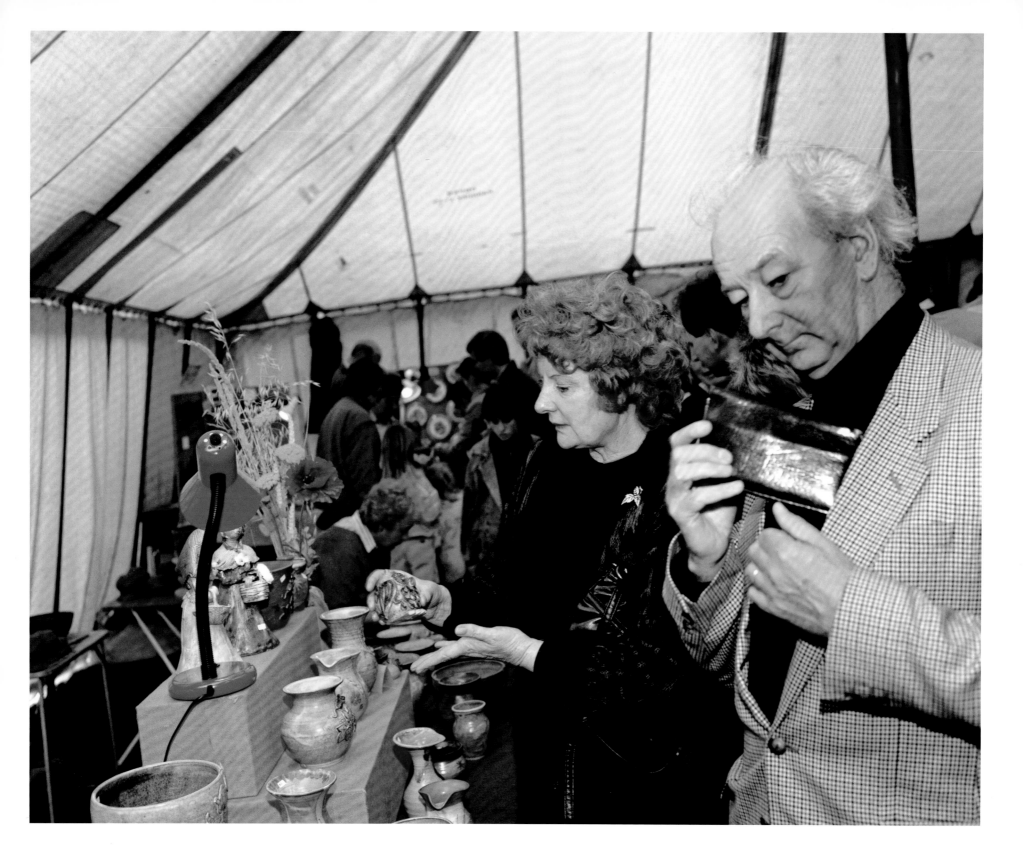

Crafts tent, Leeds Castle, Kent, from 'The Cost of Living', 1986–9

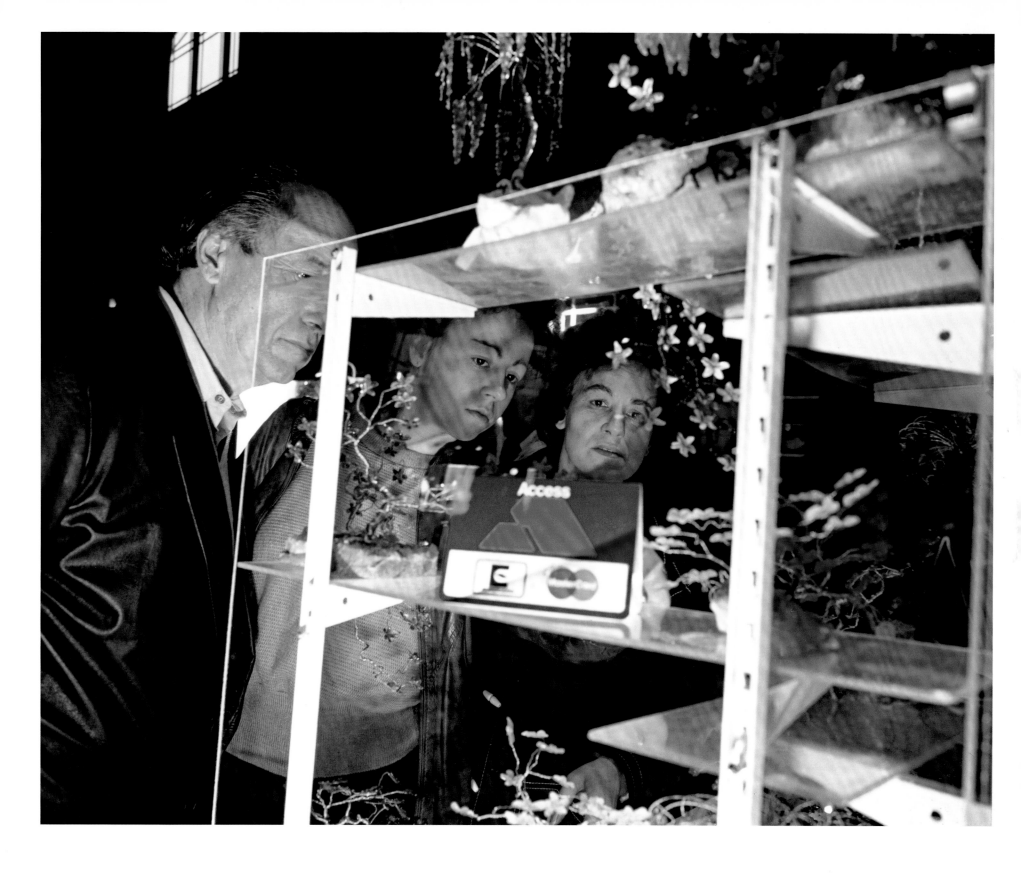

Craft fair, Malvern, Worcestershire, from 'The Cost of Living', 1986–9

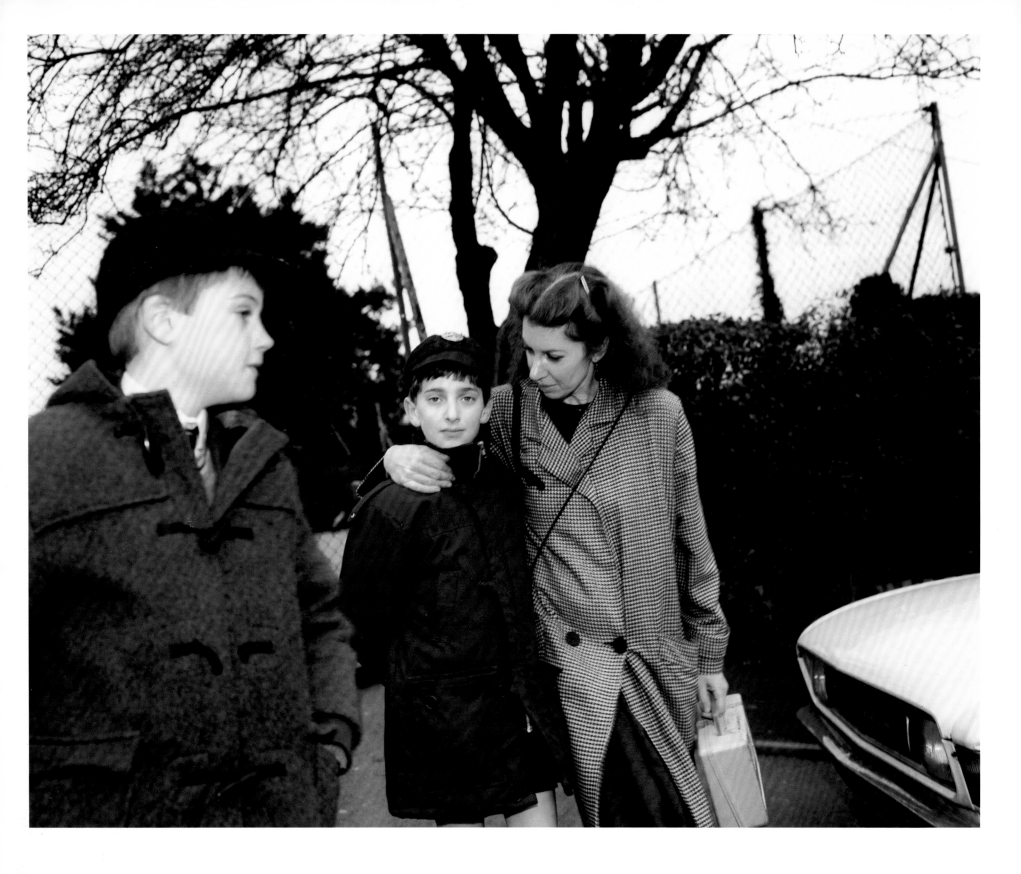

Bristol Grammar School, from 'The Cost of Living', 1986–9

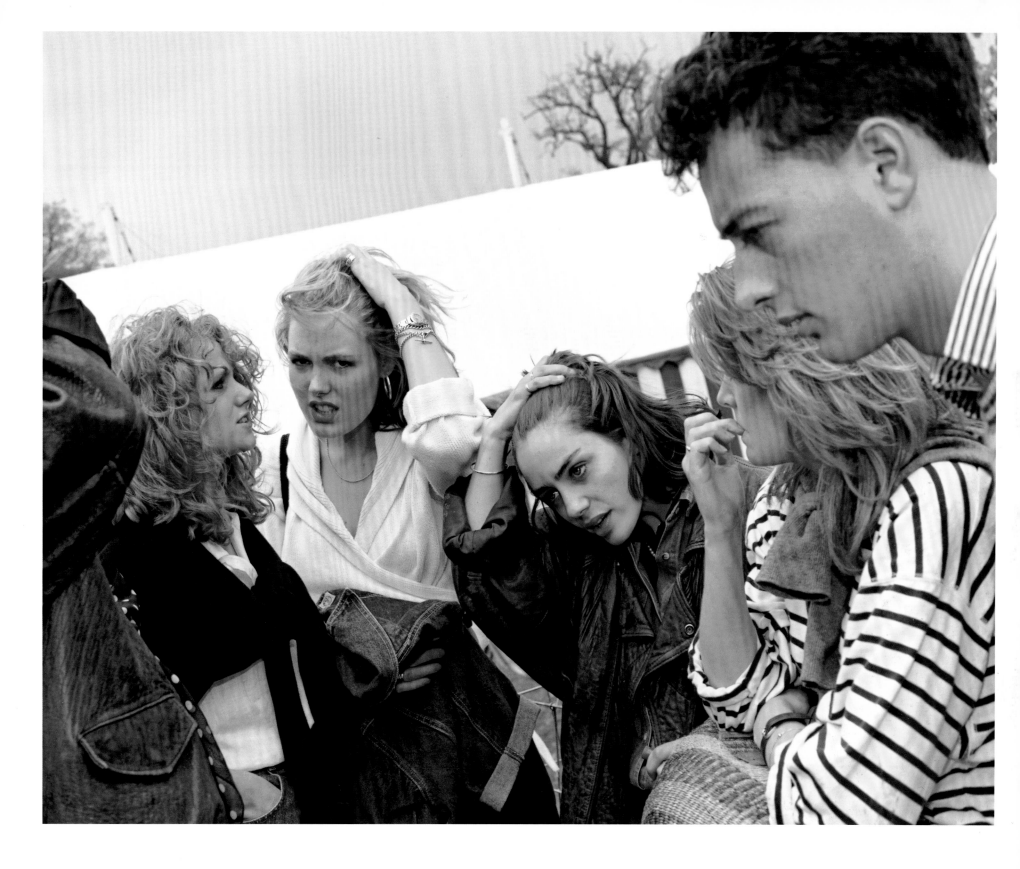

Badminton Horse Trials, Gloucestershire, from 'The Cost of Living', 1986–9

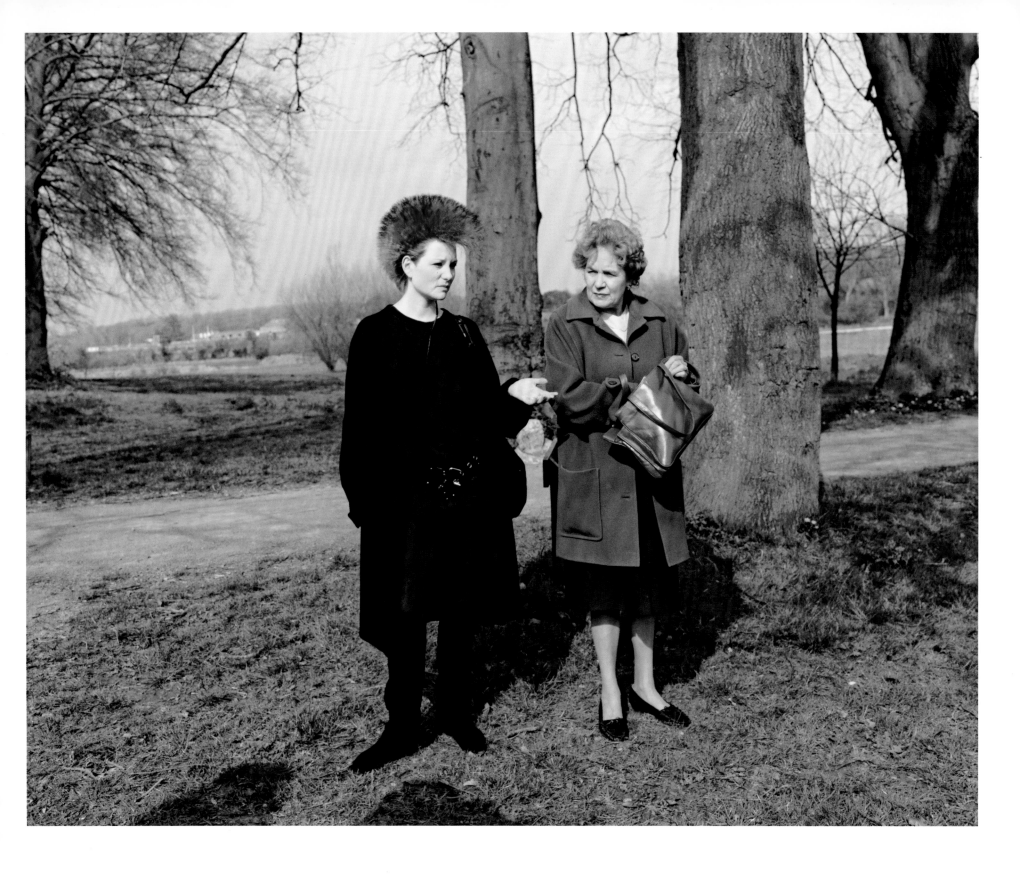

Newport, Wales, from 'The Cost of Living', 1986–9

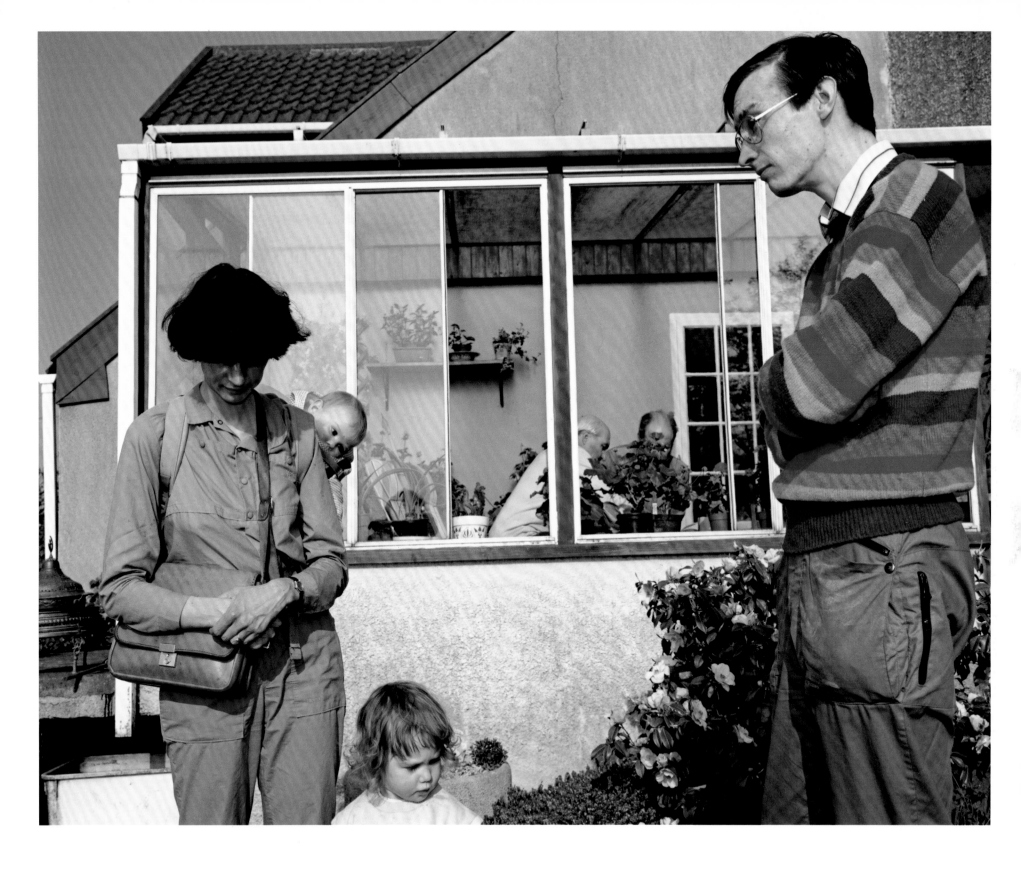

Garden open day, from 'The Cost of Living', 1986–9

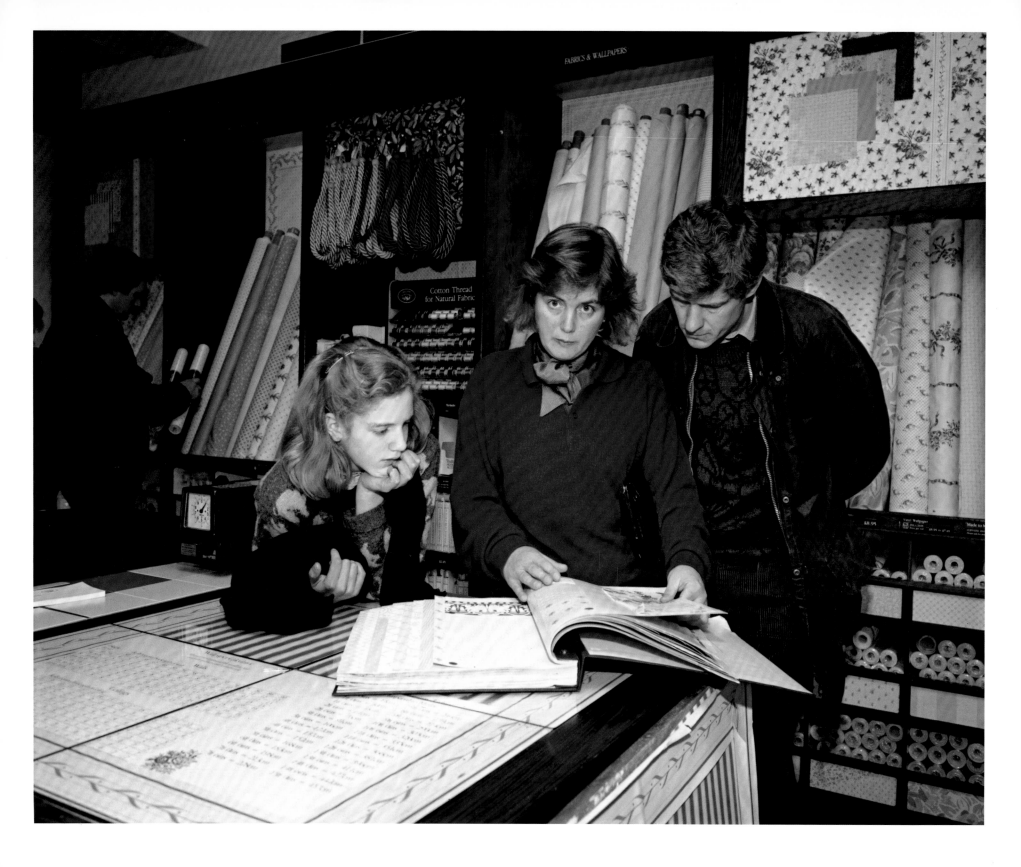

Laura Ashley, Worcester, from 'The Cost of Living', 1986–9

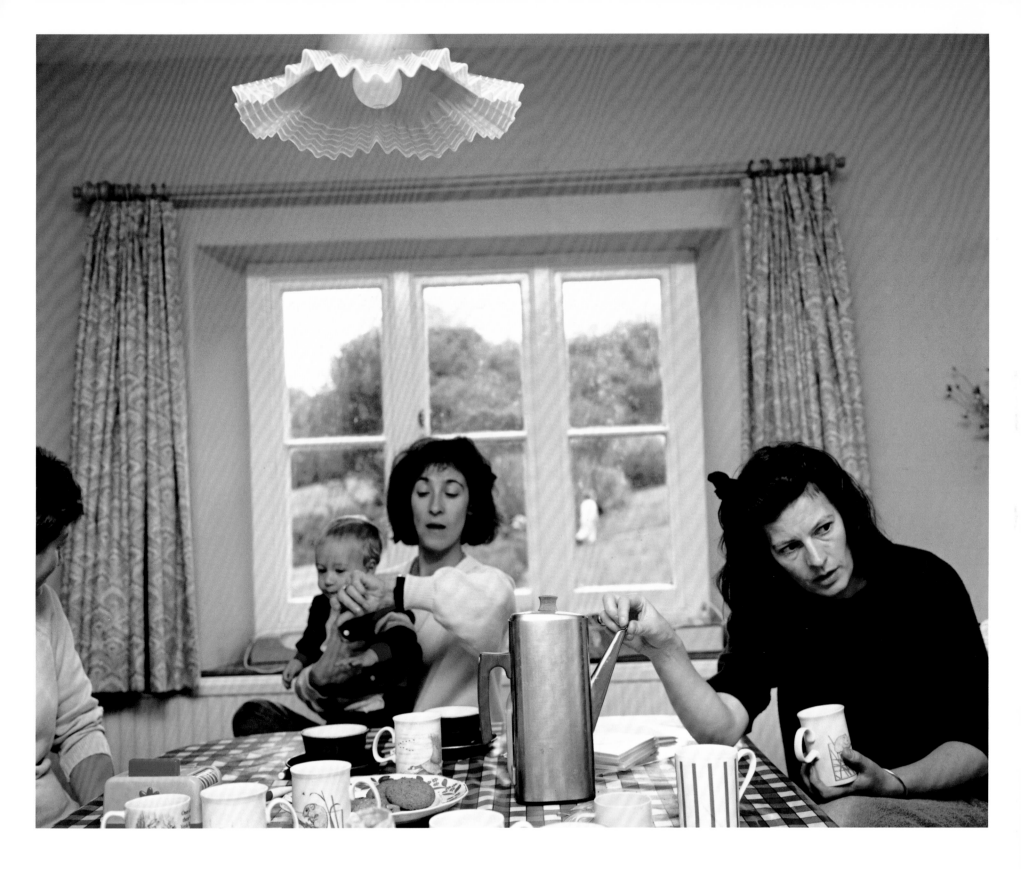

National Childbirth Trust coffee morning, Chew Magna, Somerset, from 'The Cost of Living', 1986–9

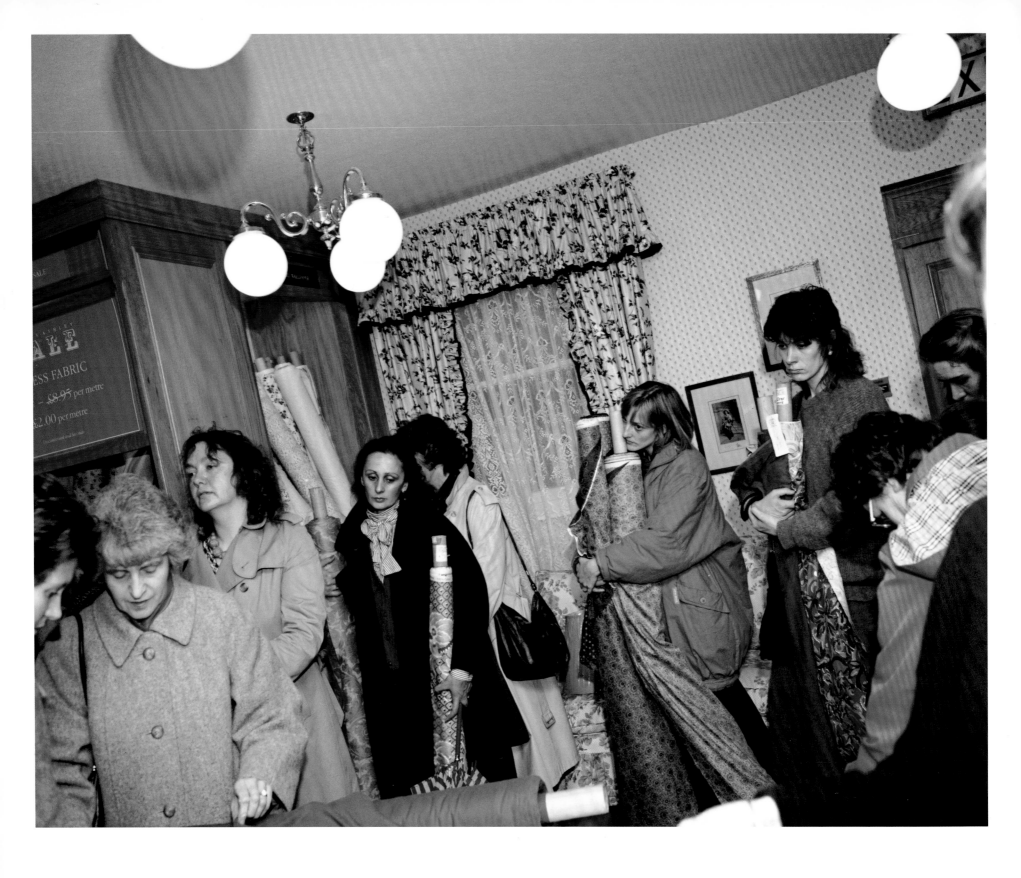

Laura Ashley sale, Bristol, from 'The Cost of Living', 1986–9

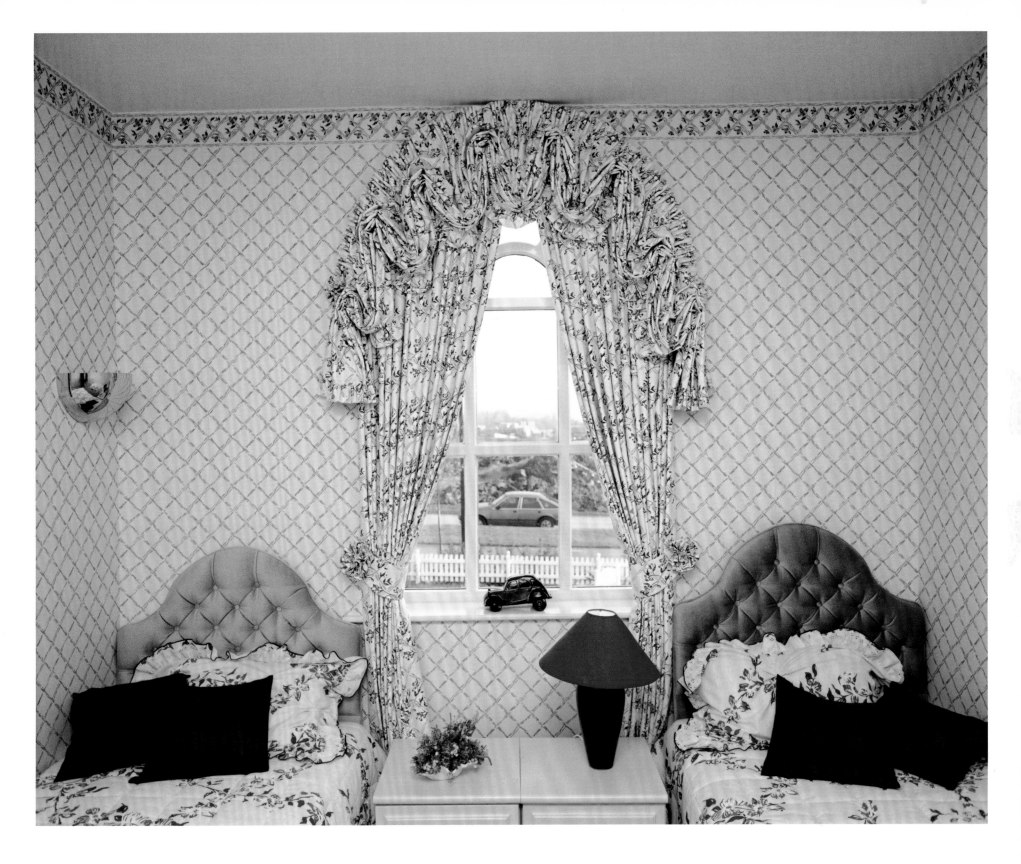

Show house, Bath, from 'The Cost of Living', 1986–9

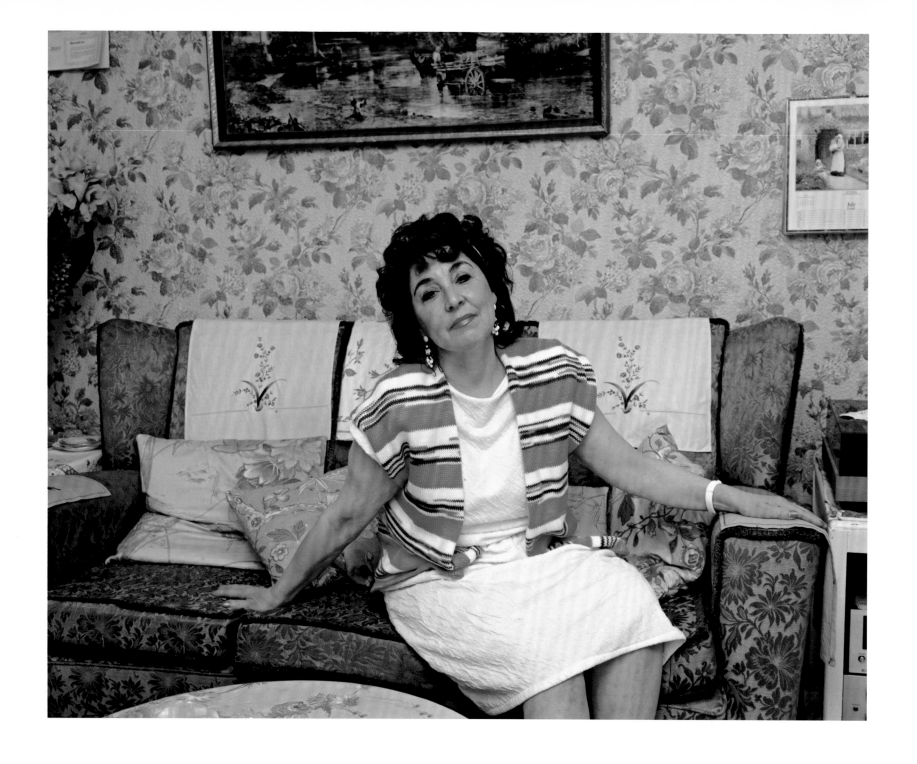

When I looked at the wallpaper and the wallpaper looked at me
we instantly fell in love

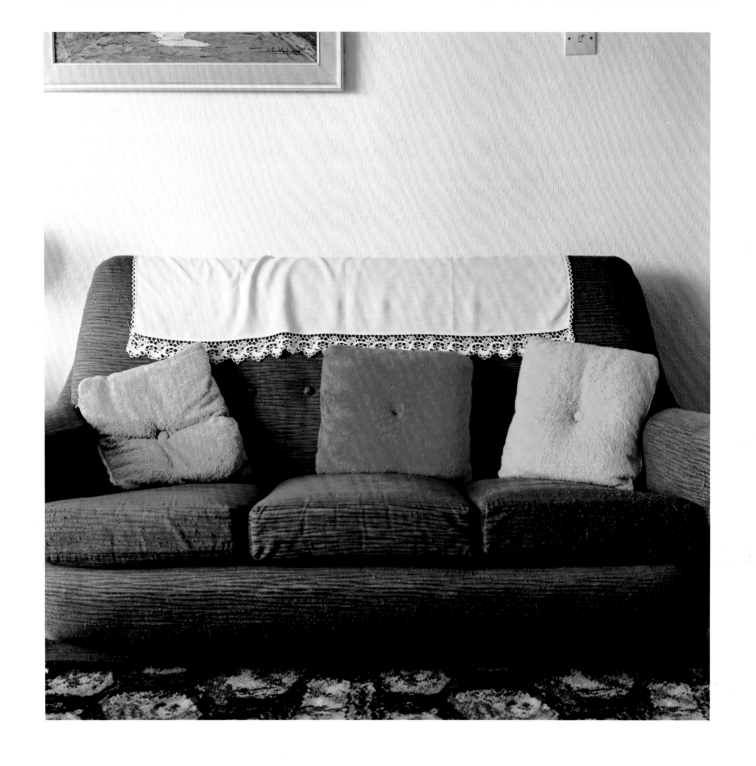

We keep buying things 'that'll look better'
and it just doesn't

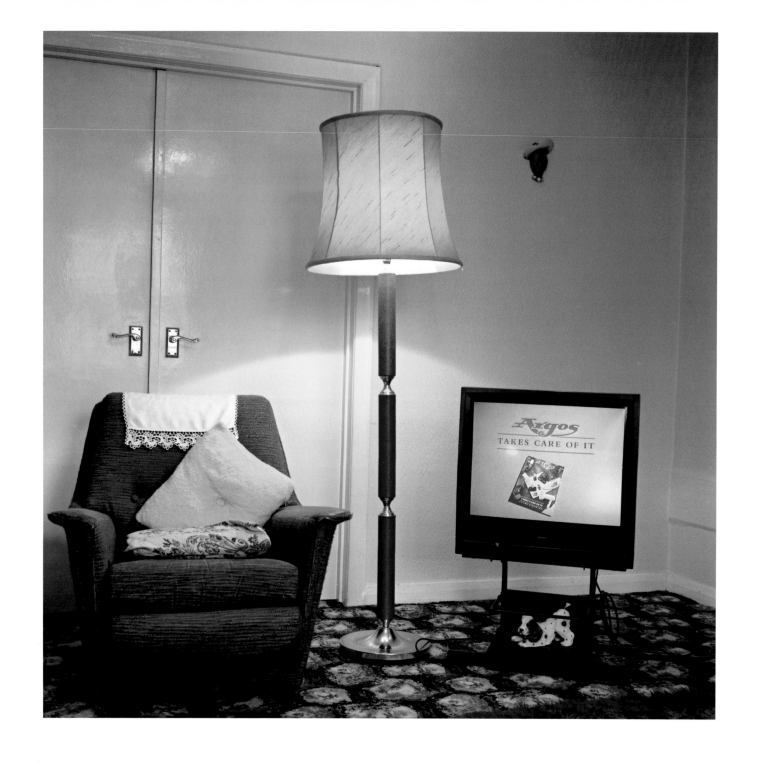

But in the 1960s this was really tiptop fashion

From 'Signs of the Times', 1992

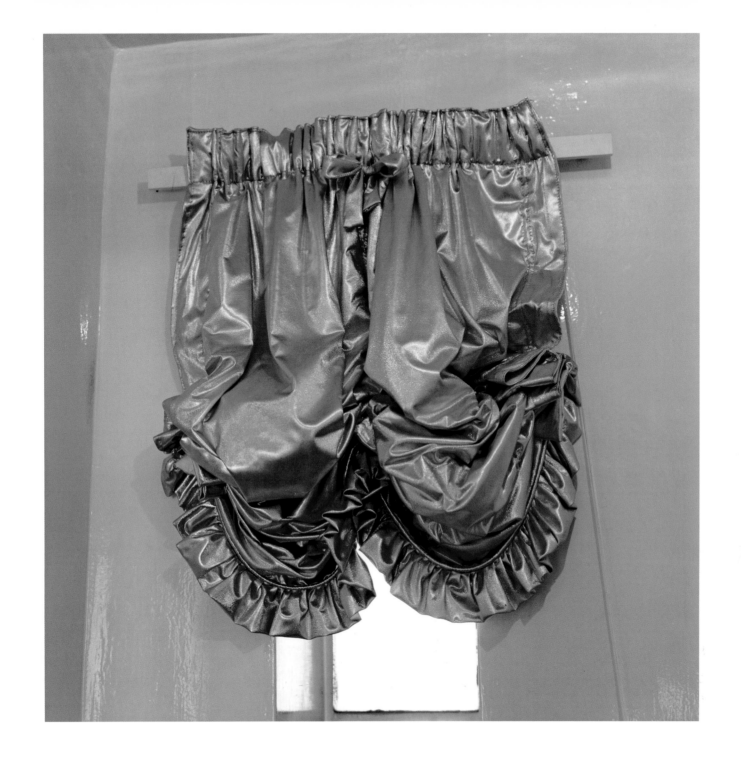

I get such pleasure from them every
day I sit in the bath

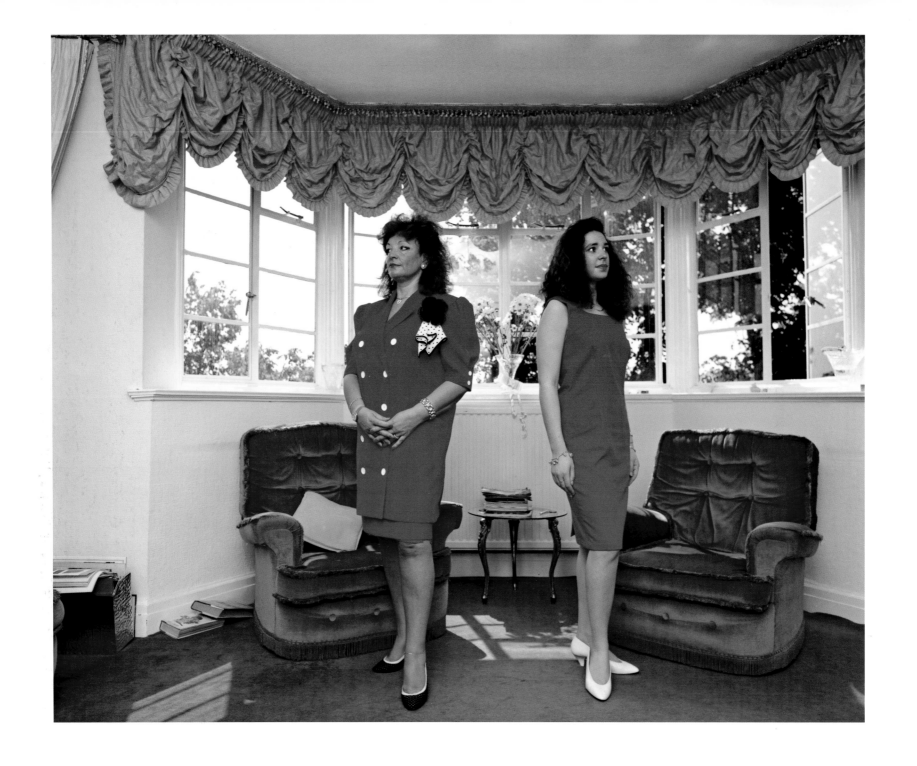

I don't think it's anything particularly forced on Deborah.
We've just always enjoyed the same sort of things

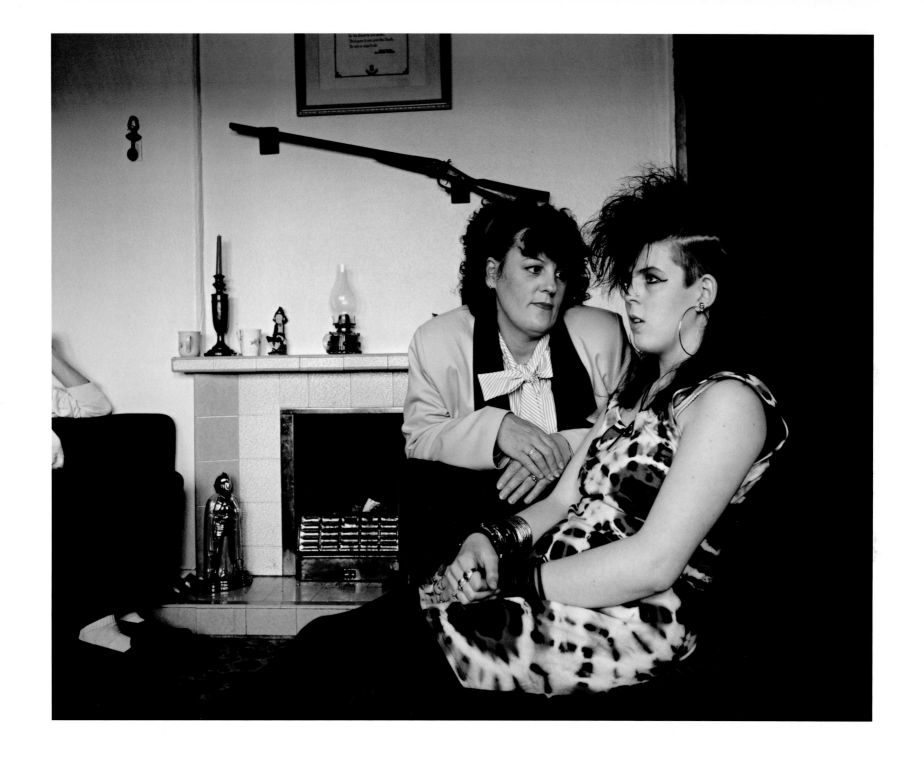

Underneath it all she really is a lovely girl

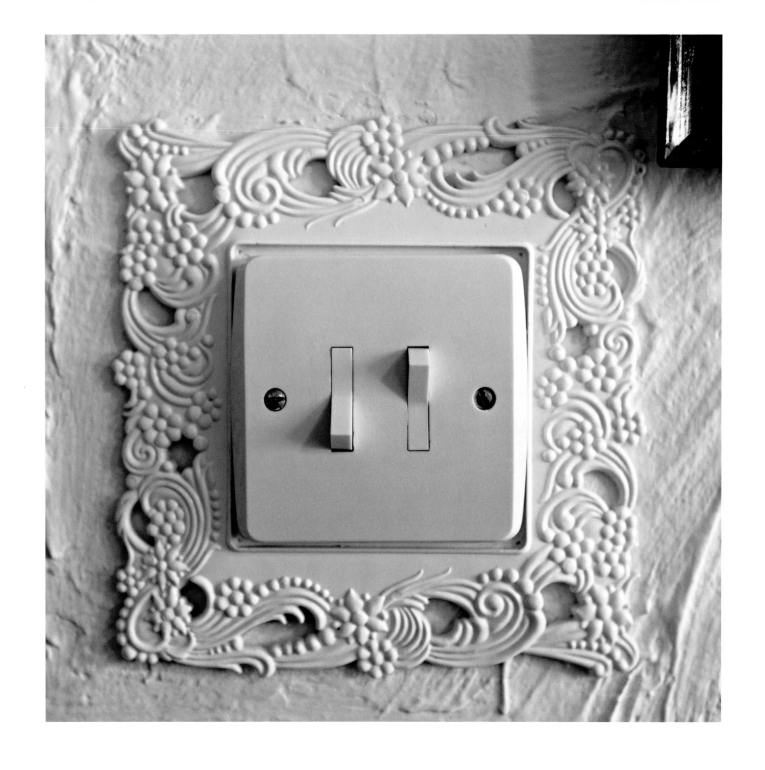

We wanted a cottagey
stately home kind of feel

From 'Signs of the Times', 1992

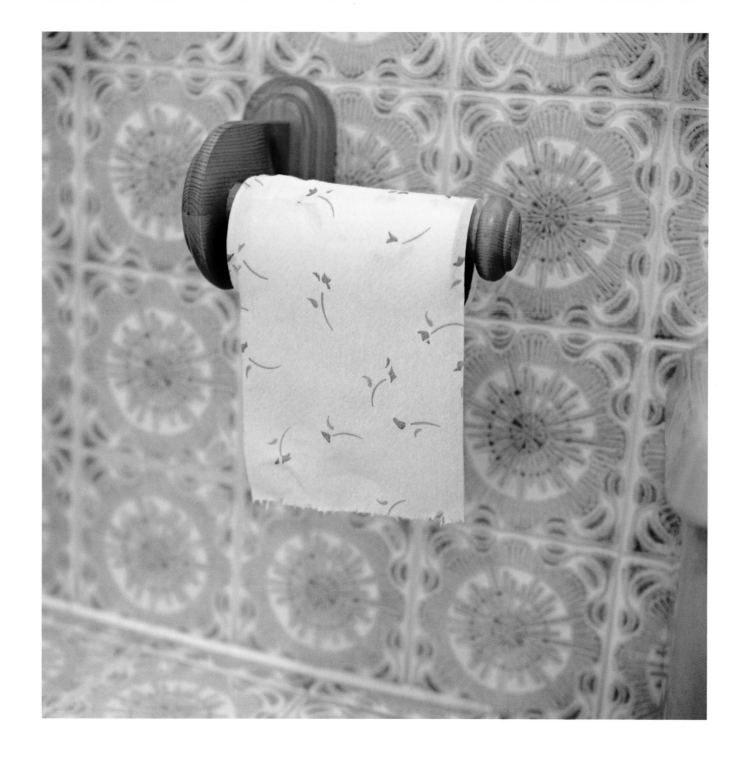

Sue has definitely given the bathroom the feminine touch

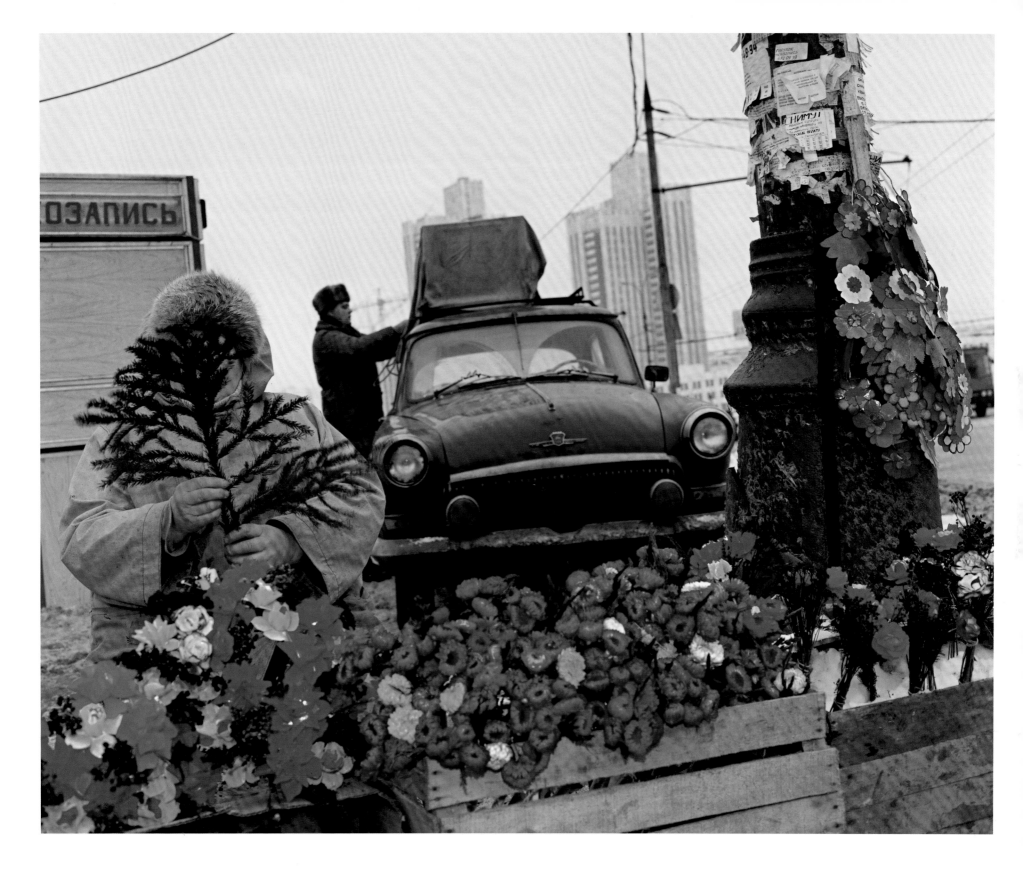

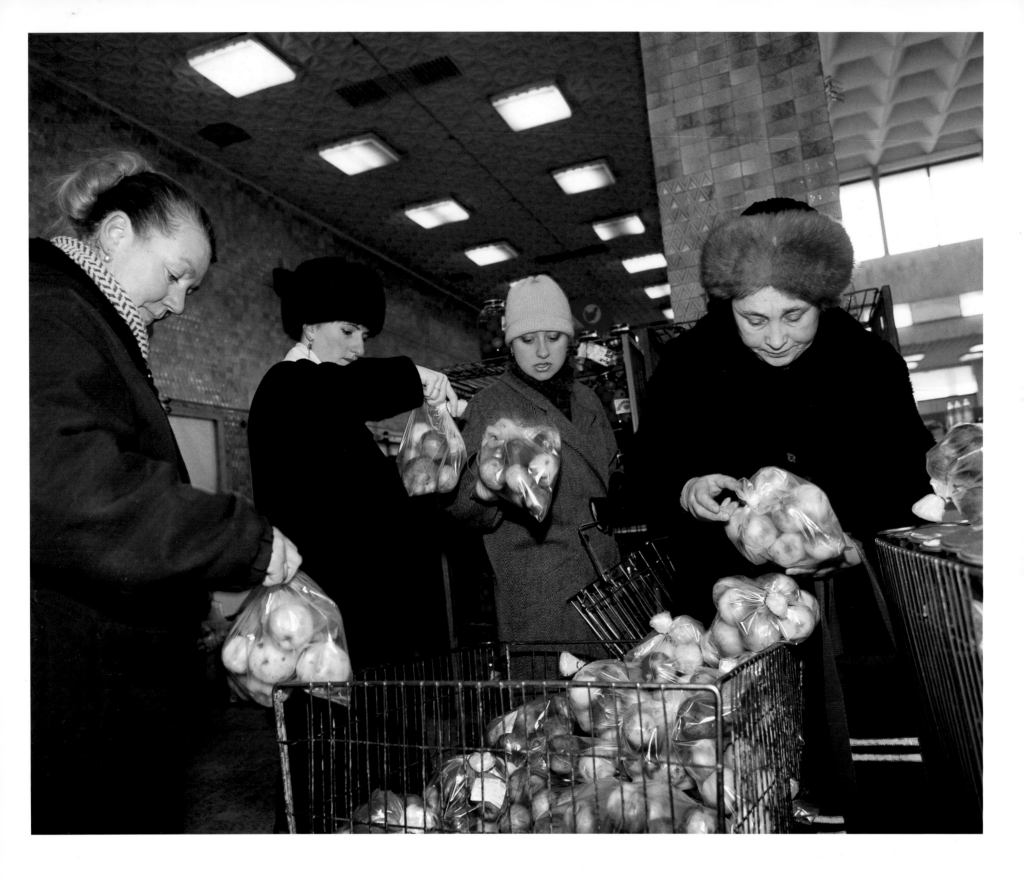

St Petersburg, 1991

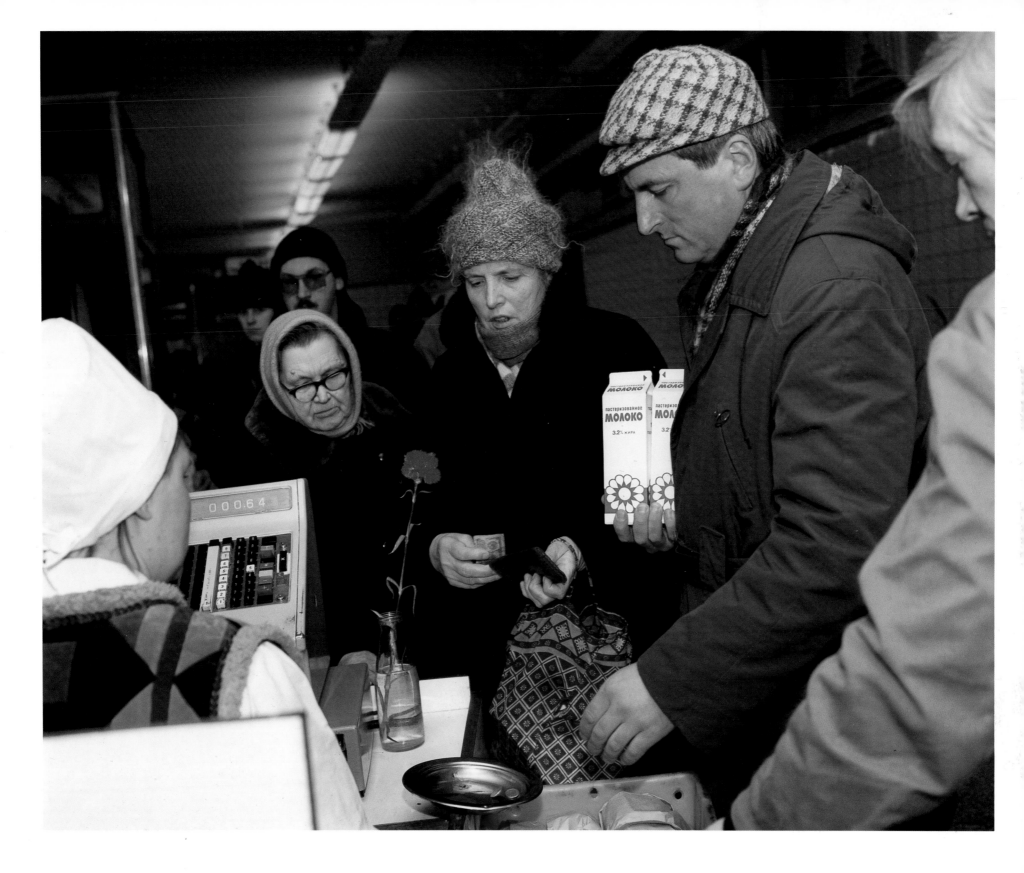

St Petersburg, 1991

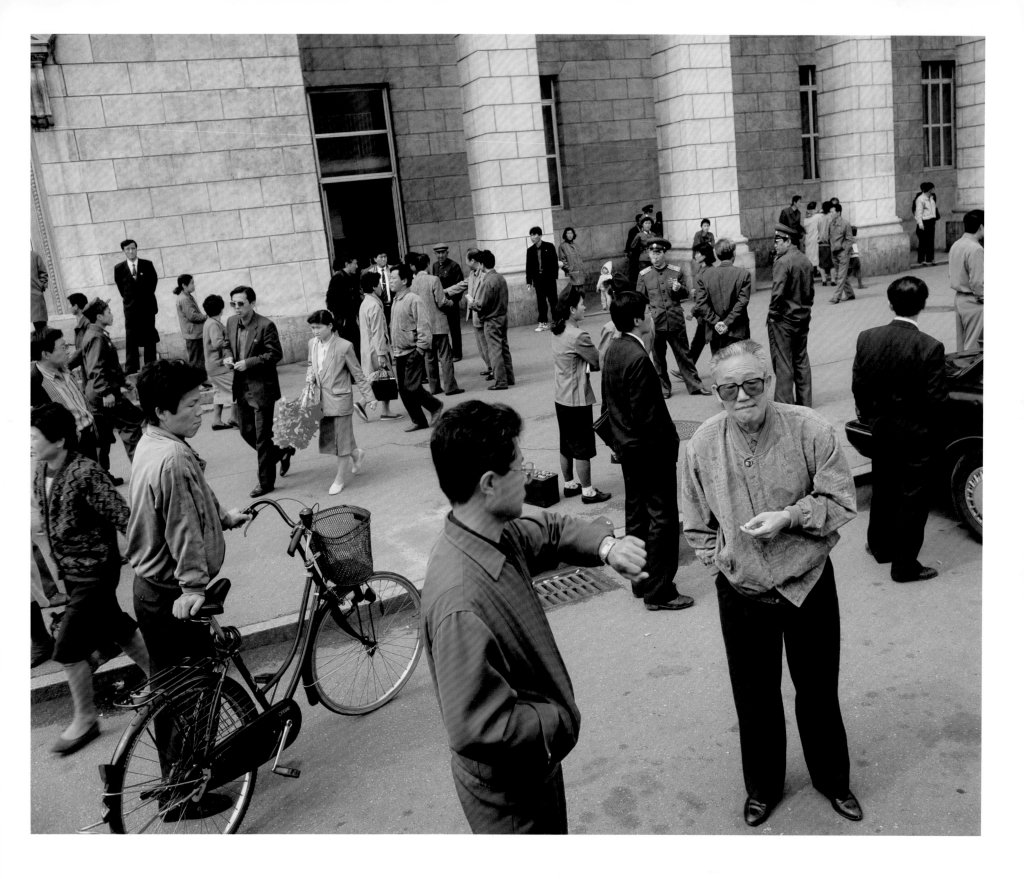

P'yŏngyang, North Korea, 1996

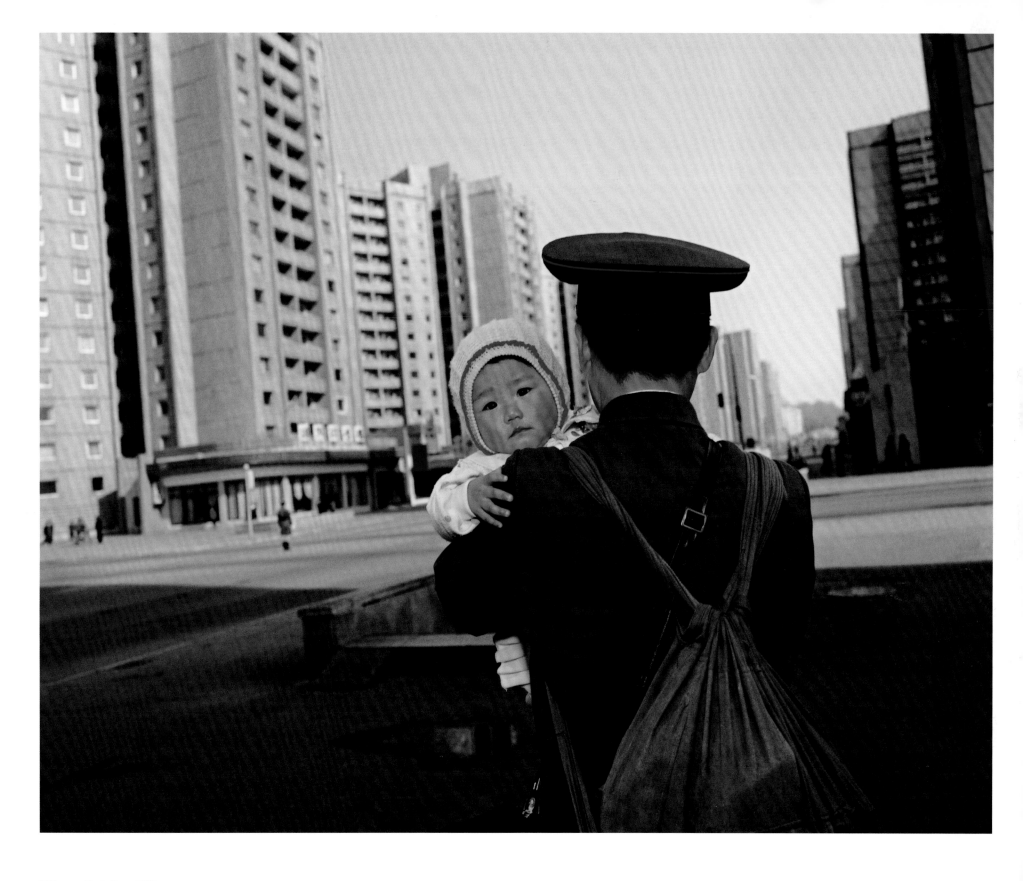

P'yŏngyang, North Korea, 1996

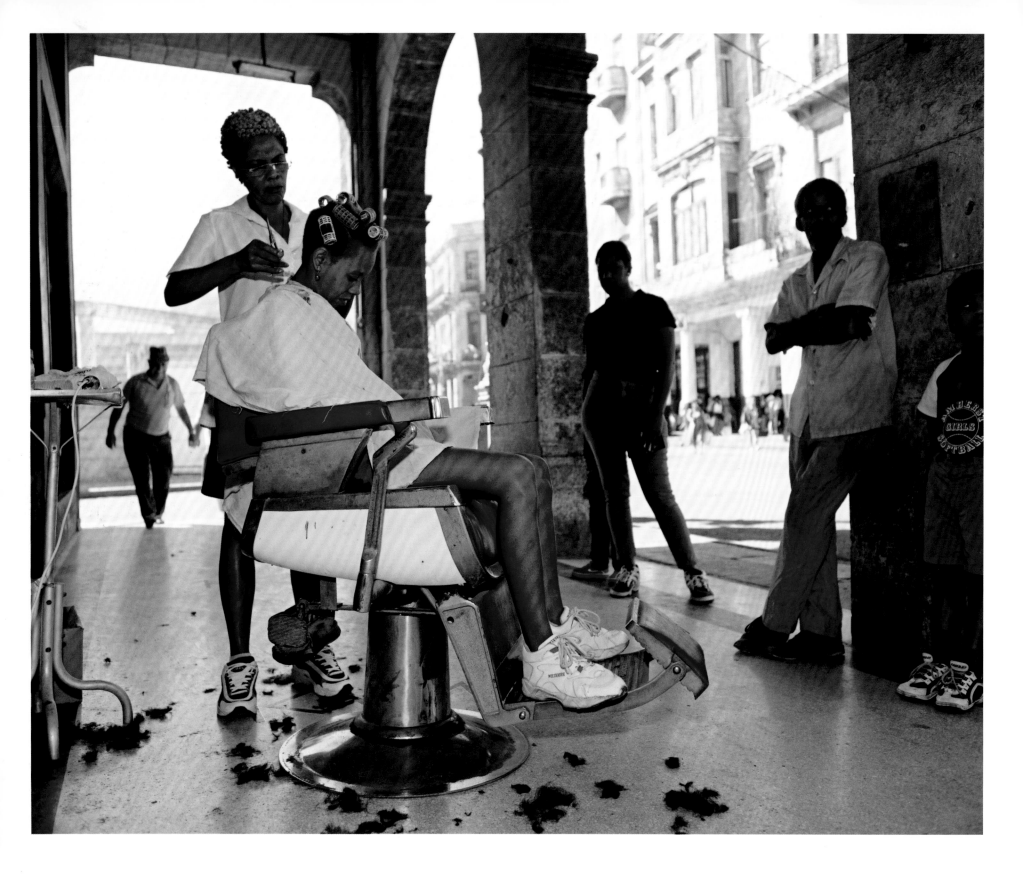

Havana, Cuba, 2000

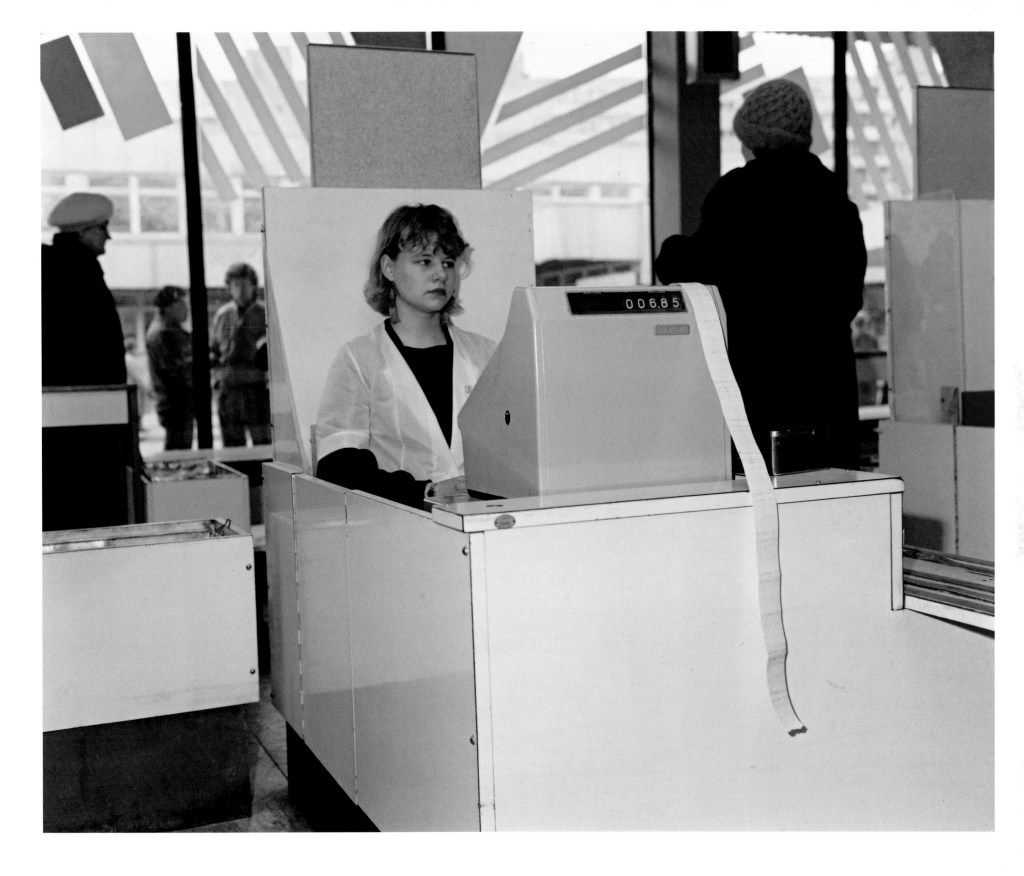

Tallin, Estonia, 1992

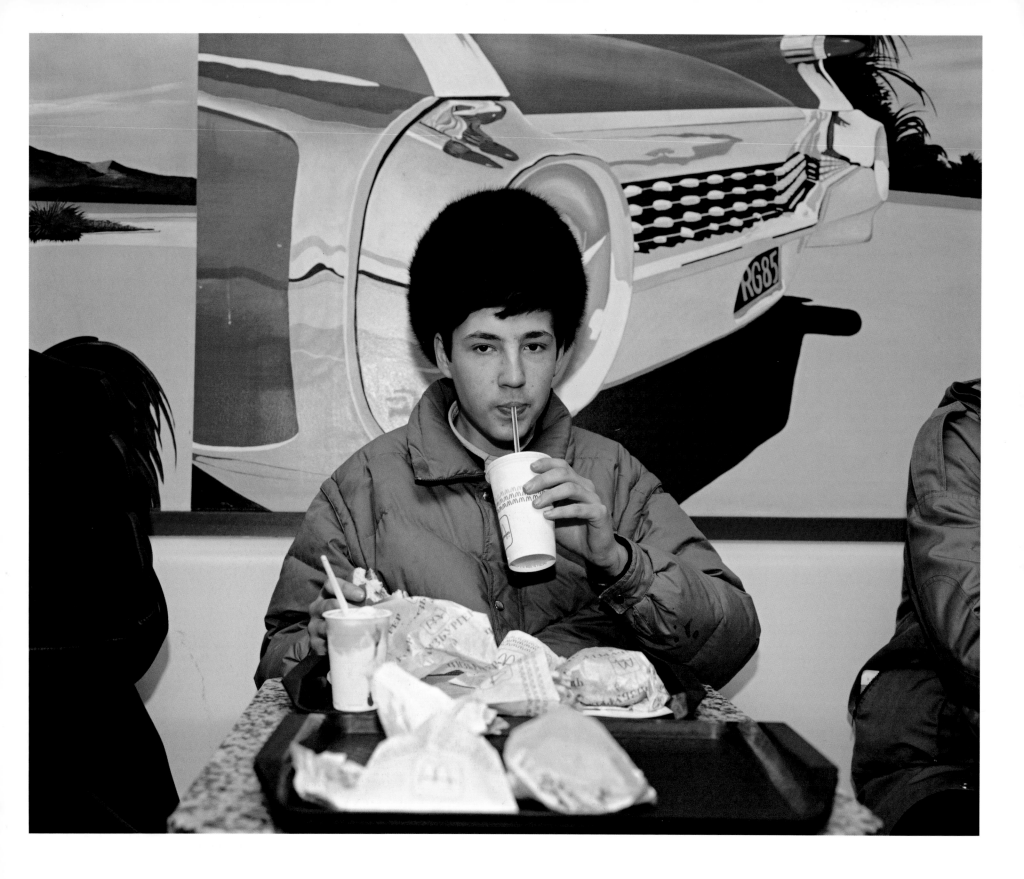

McDonald's restaurant, Moscow, 1991

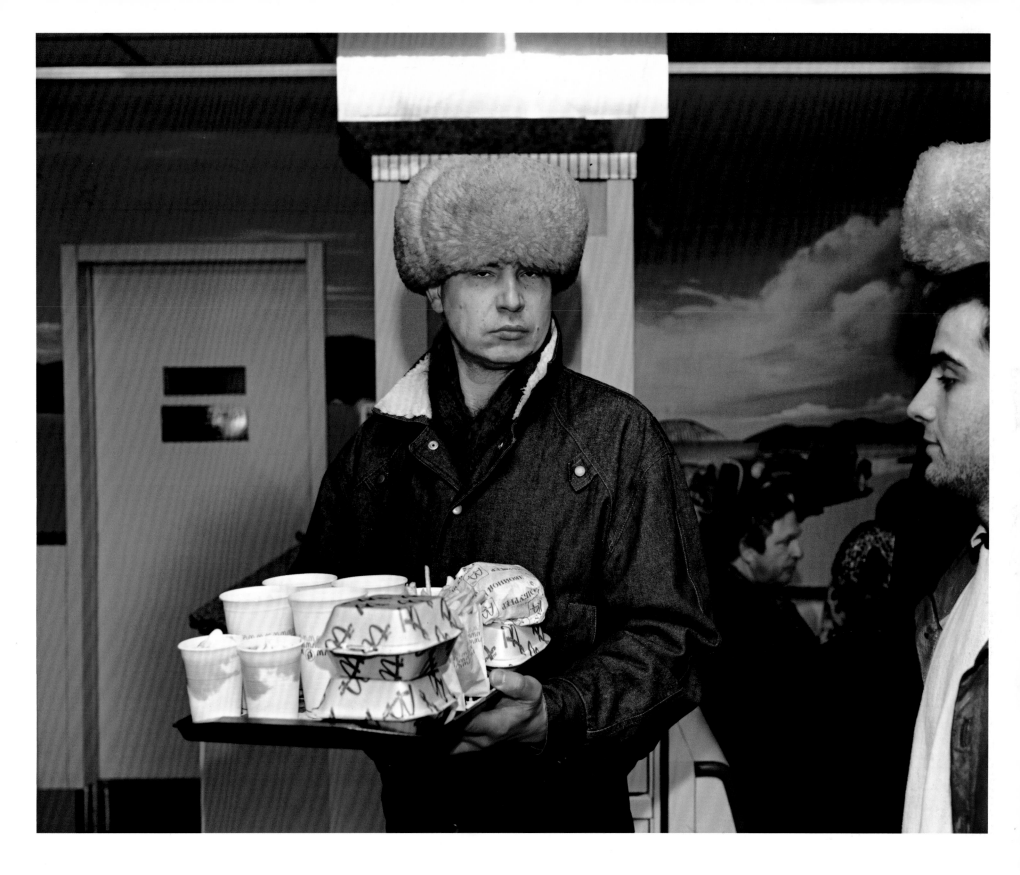

McDonald's restaurant, Moscow, 1991

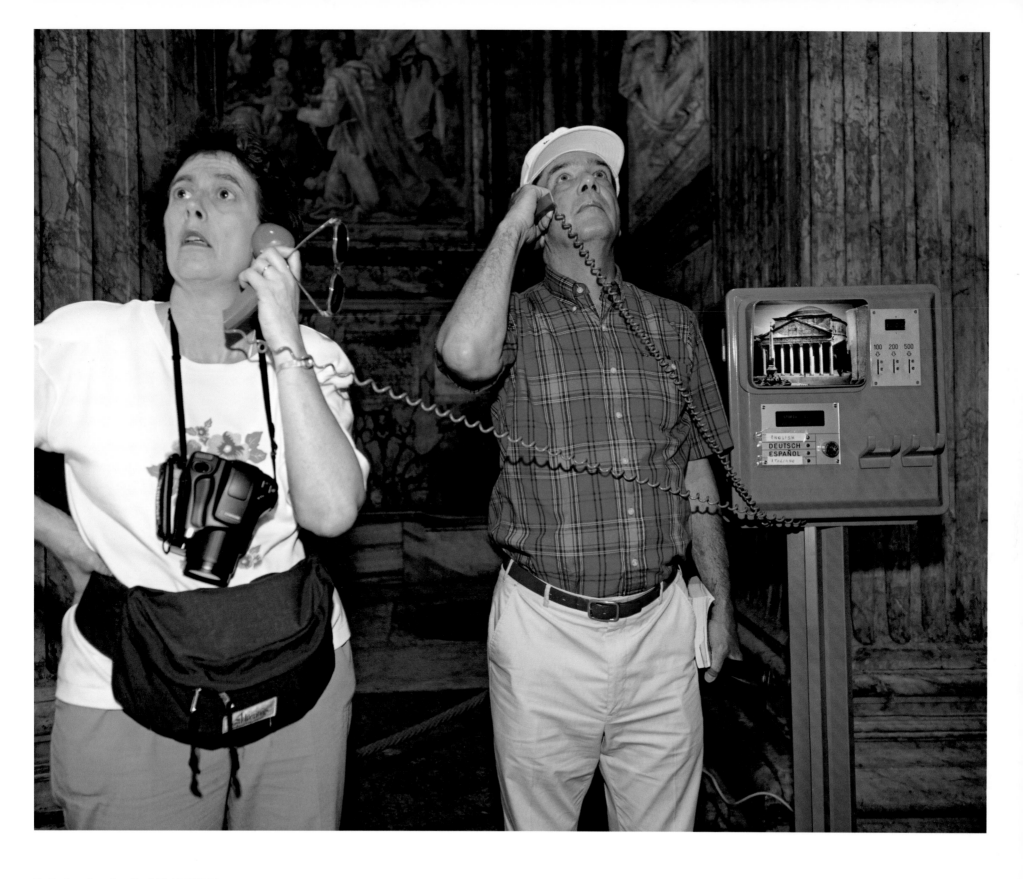

The Pantheon, Rome, from 'Small World', 1987–94

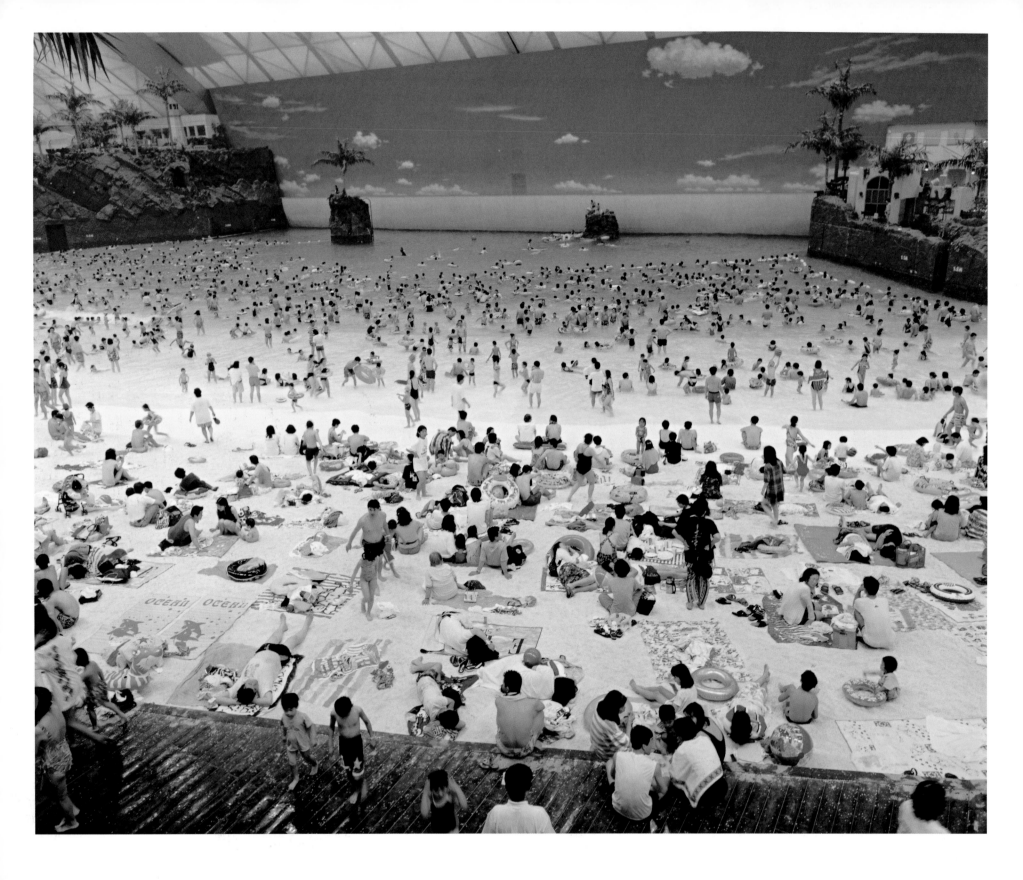

Ocean Dome, Miyazaki, Japan, 1997

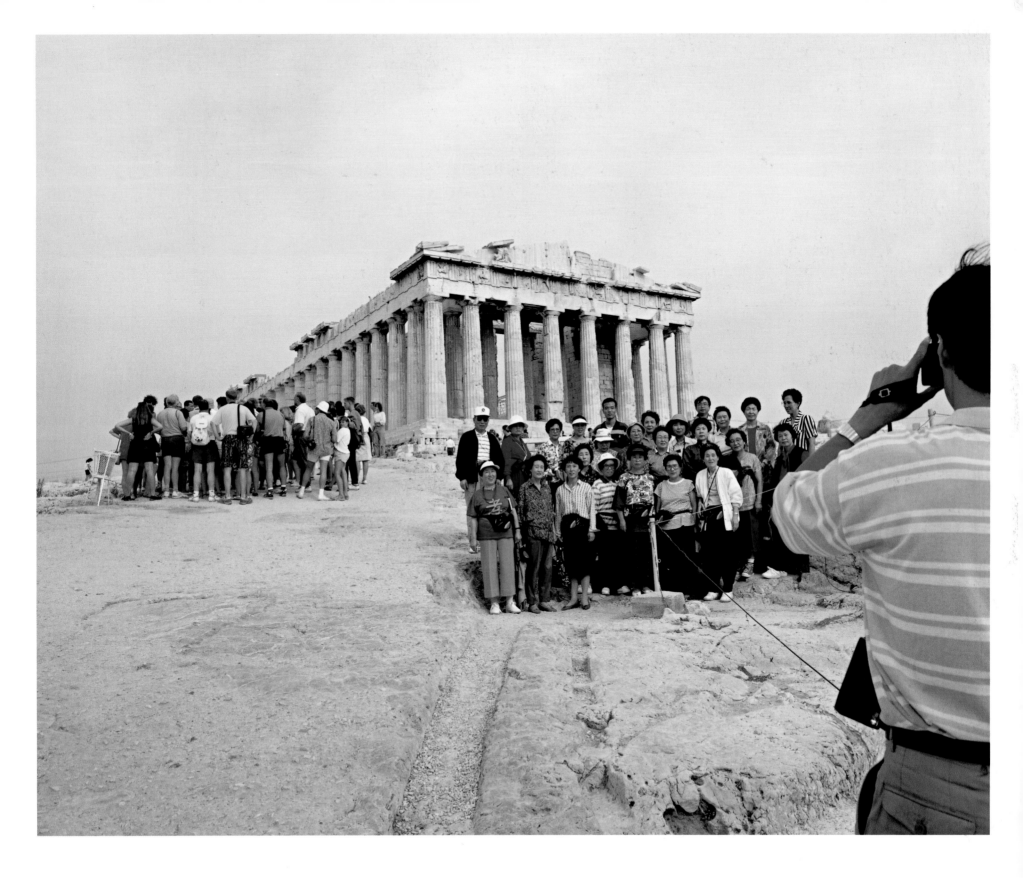

The Acropolis, Athens, from 'Small World', 1987–94

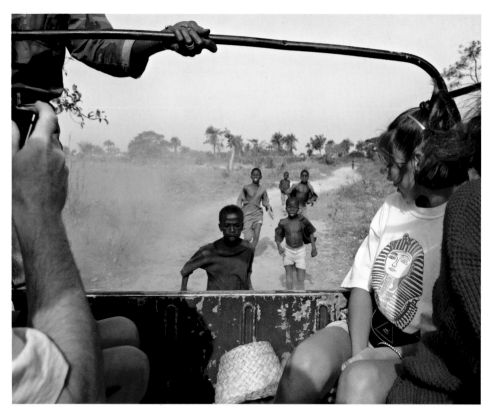

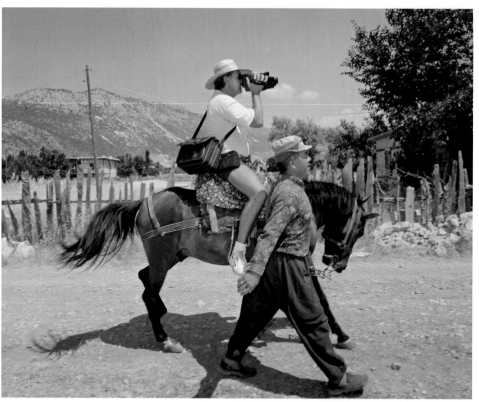

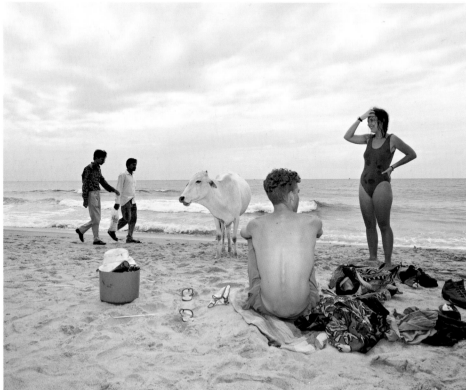

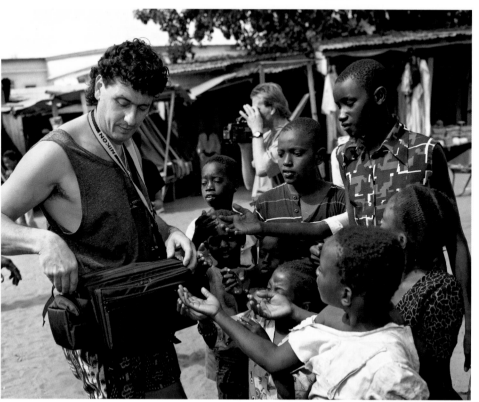

From 'Small World', 1987–94
The Gambia / Kalkan, Turkey
Goa, India / The Gambia

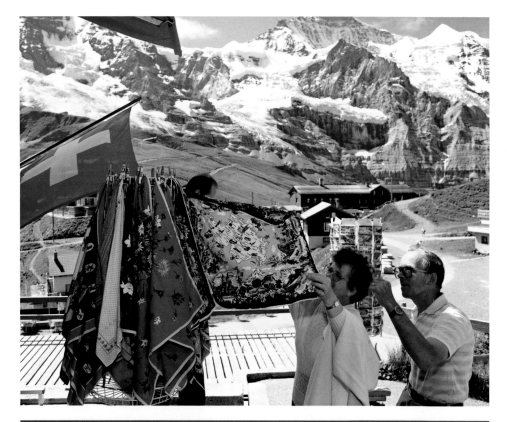

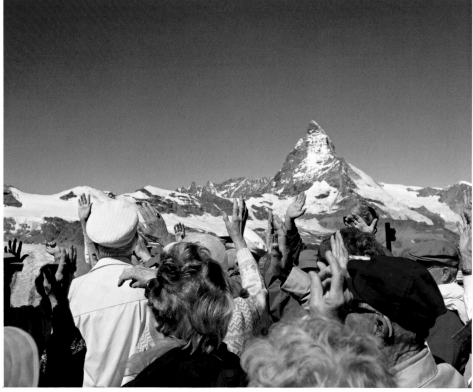

From 'Small World', 1987–94
Kleine Scheidegg, Switzerland
The Matterhorn, Switzerland

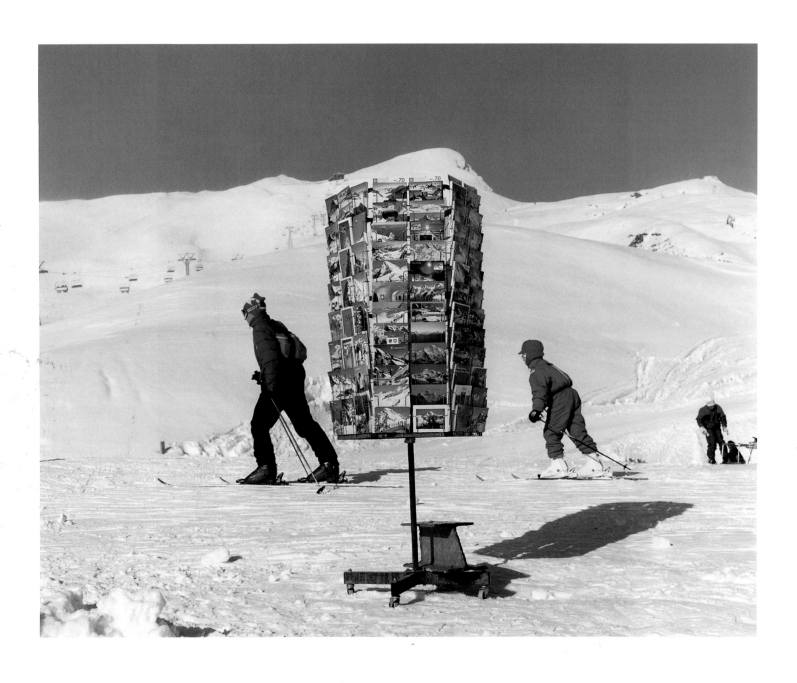

From 'Small World', 1987–94
Kleine Scheidegg, Switzerland

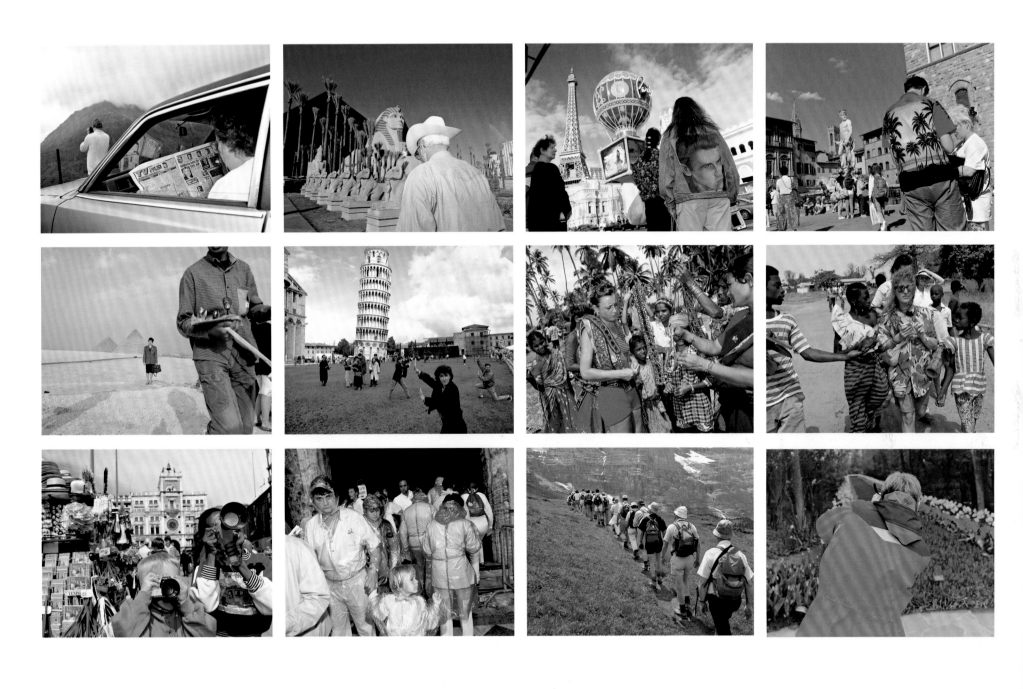

From 'Small World', 1987–94
Snowdonia, Wales / Las Vegas / Las Vegas / Florence, Italy
The Pyramids, Egypt / Pisa, Italy / Goa, India / The Gambia
Venice / Venice / Kleine Scheidegg, Switzerland / Keukenhof, Netherlands

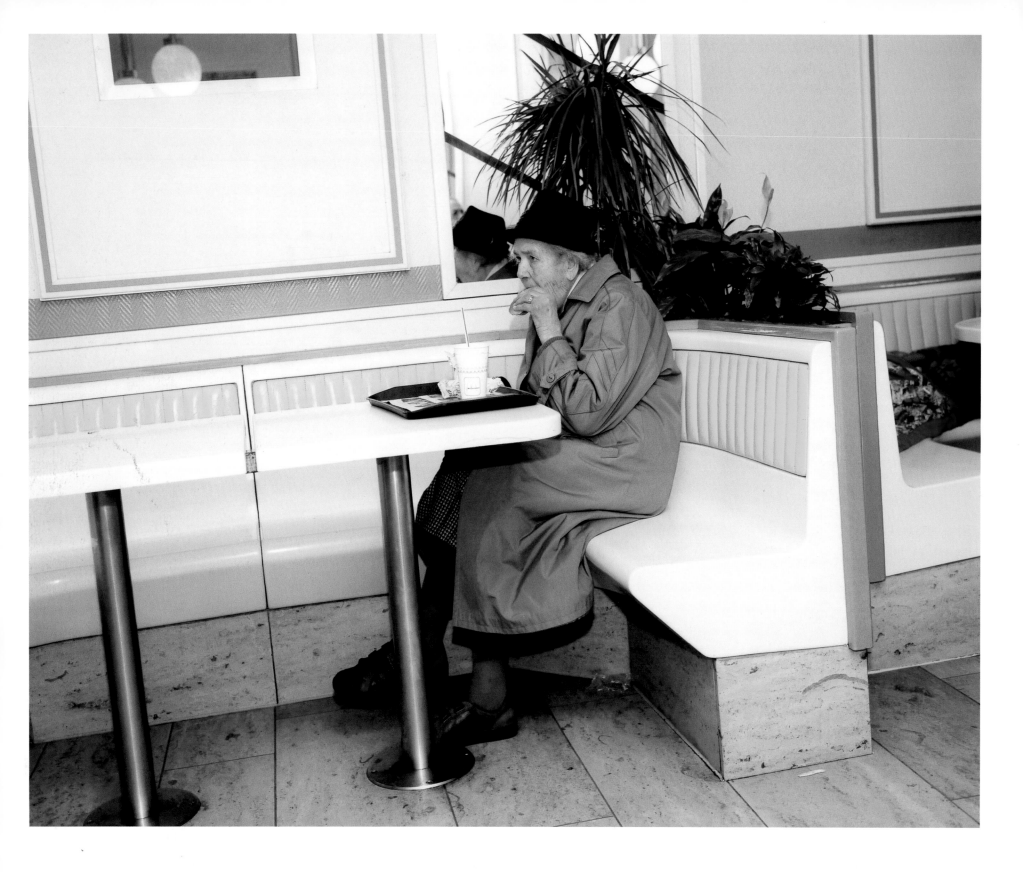

McDonald's restaurant, Munich, Germany, 1994

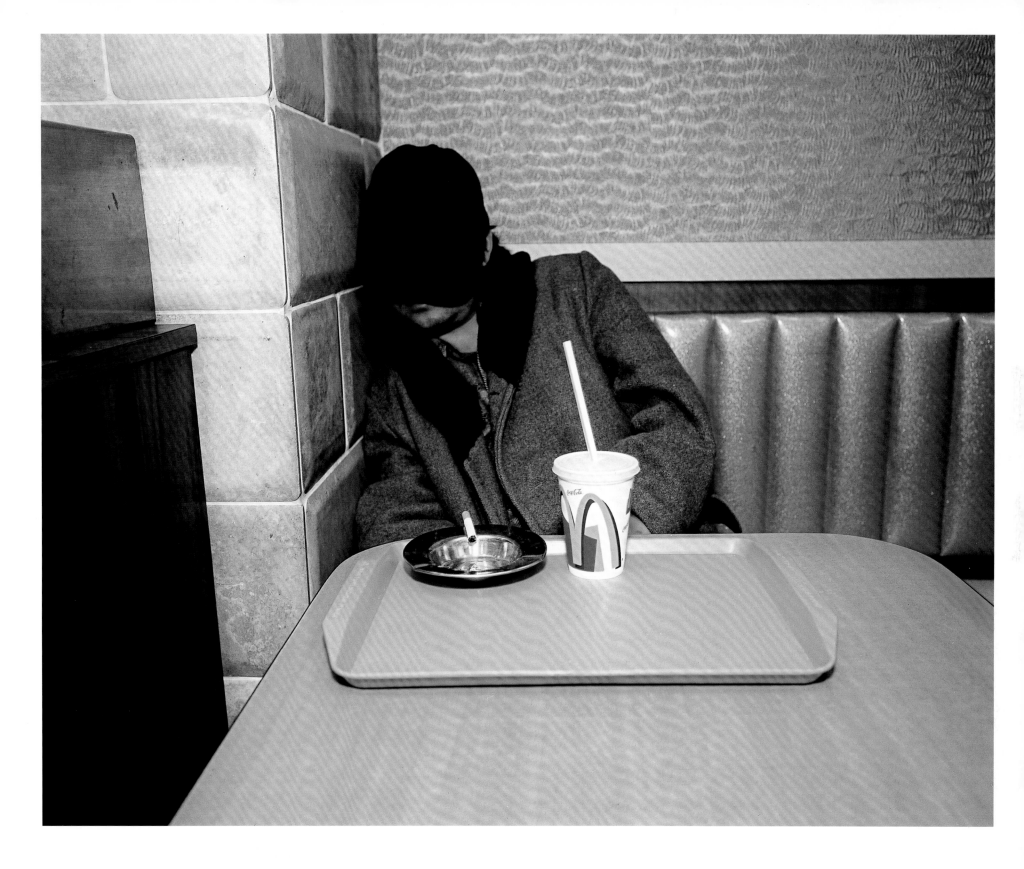

McDonald's restaurant, Tokyo, Japan, 2000

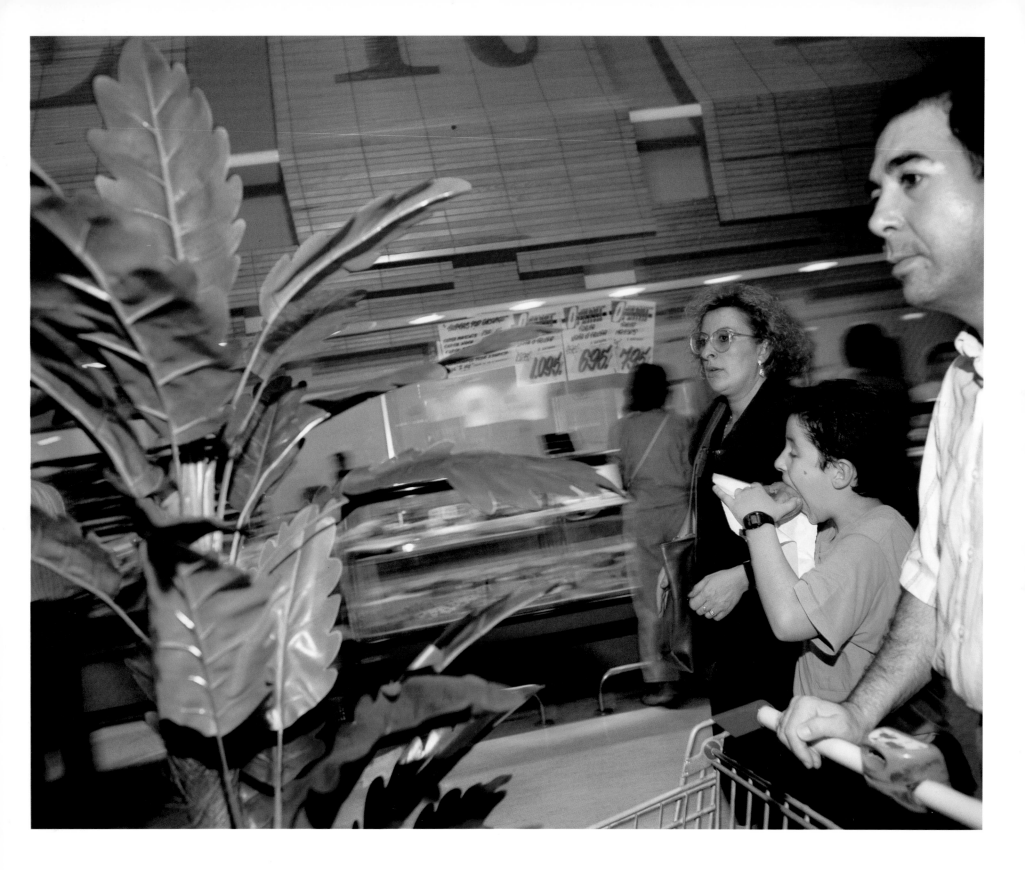

Almeria, Spain, 1992

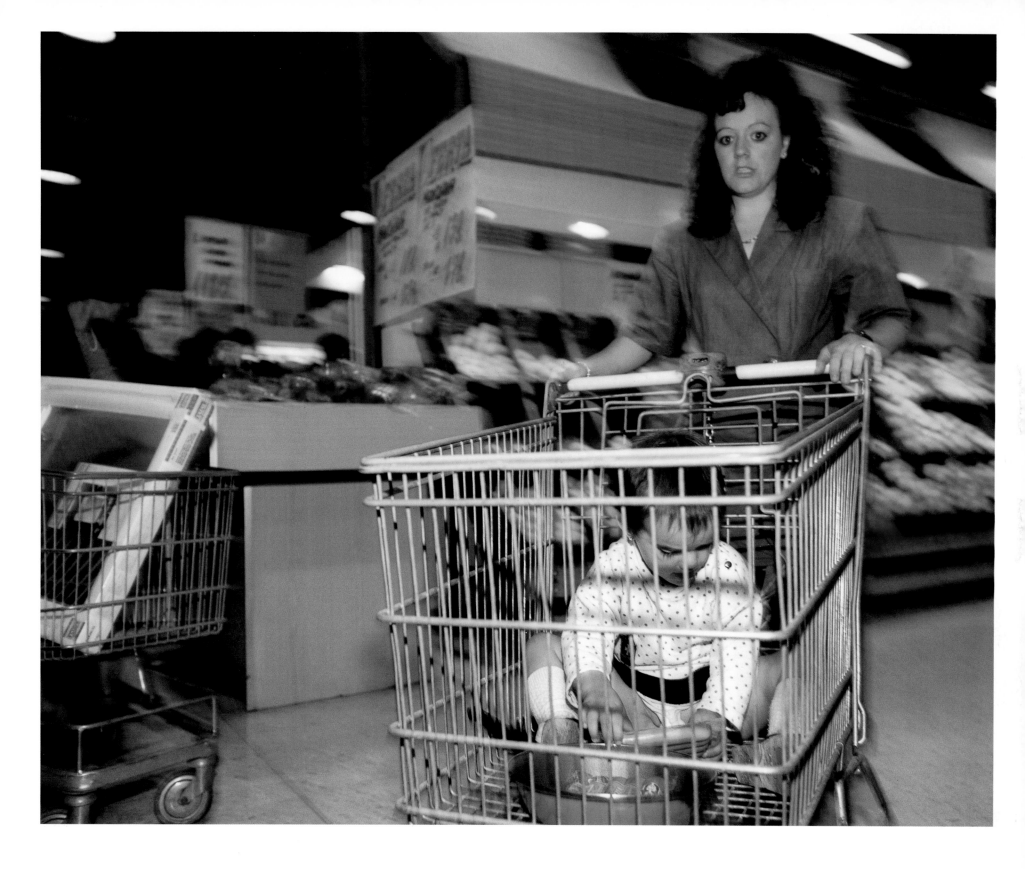

Almeria, Spain, 1992

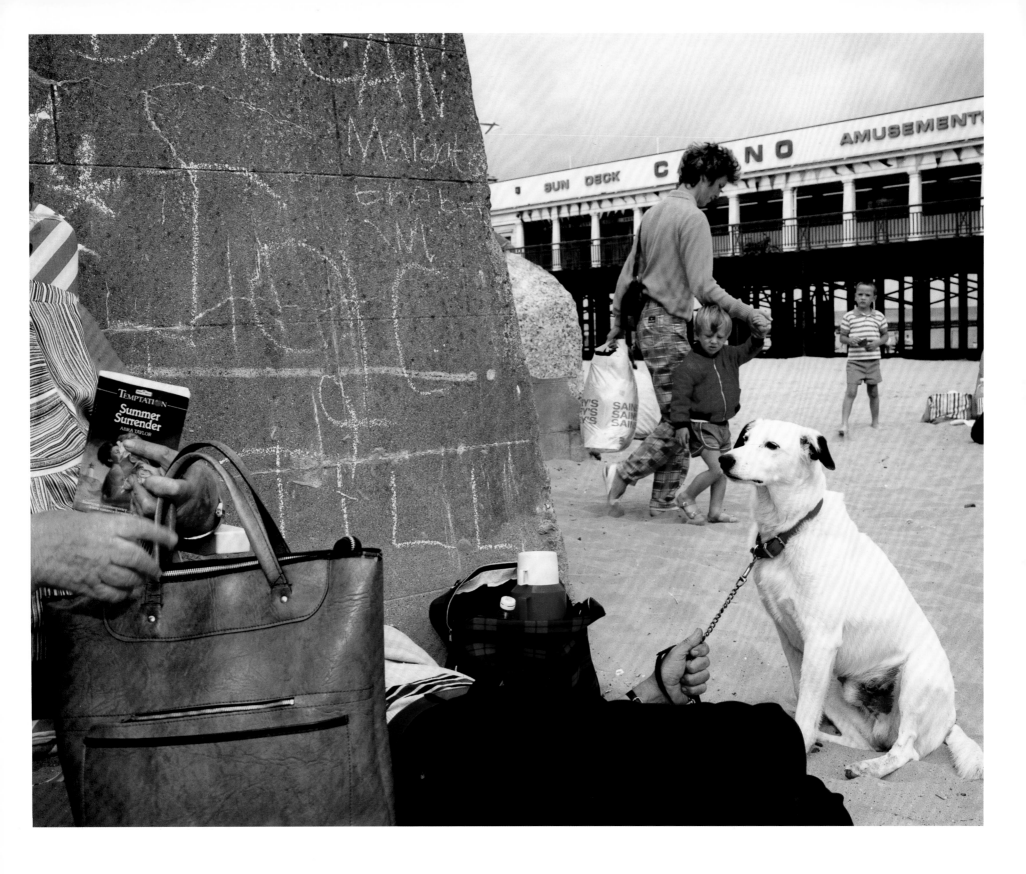

Margate, Kent, 1987

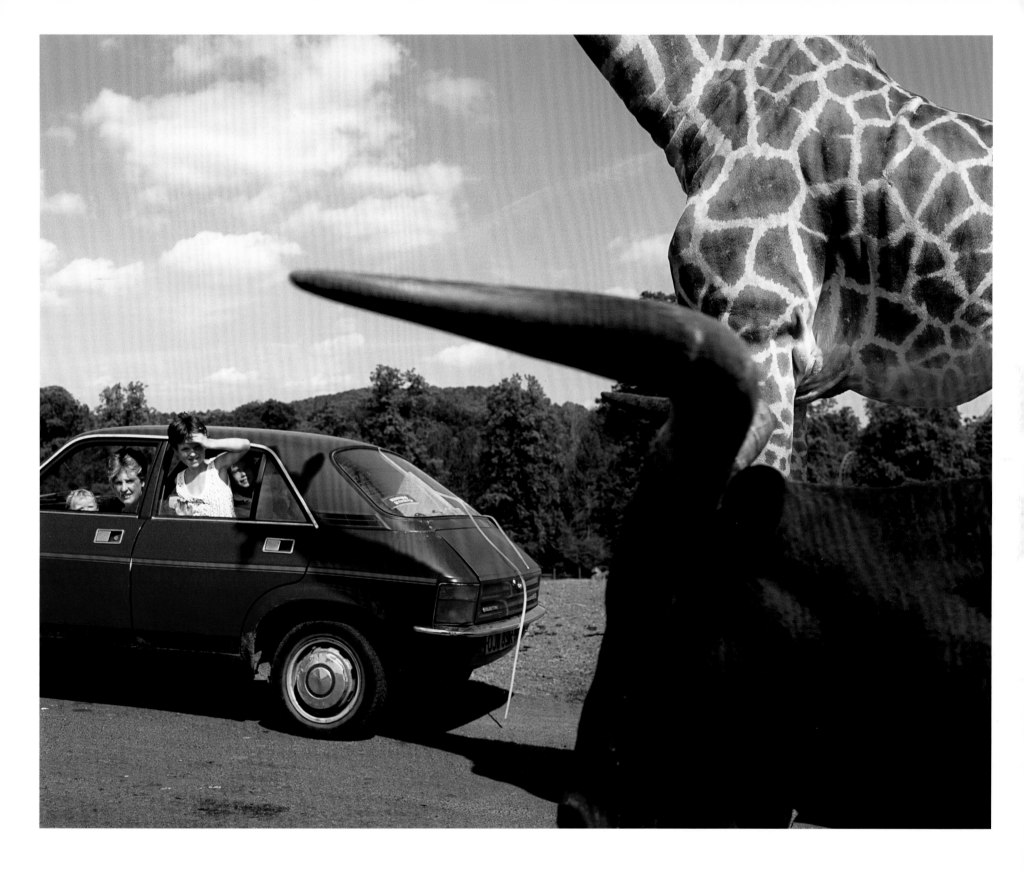

West Midlands Safari Park, 1988

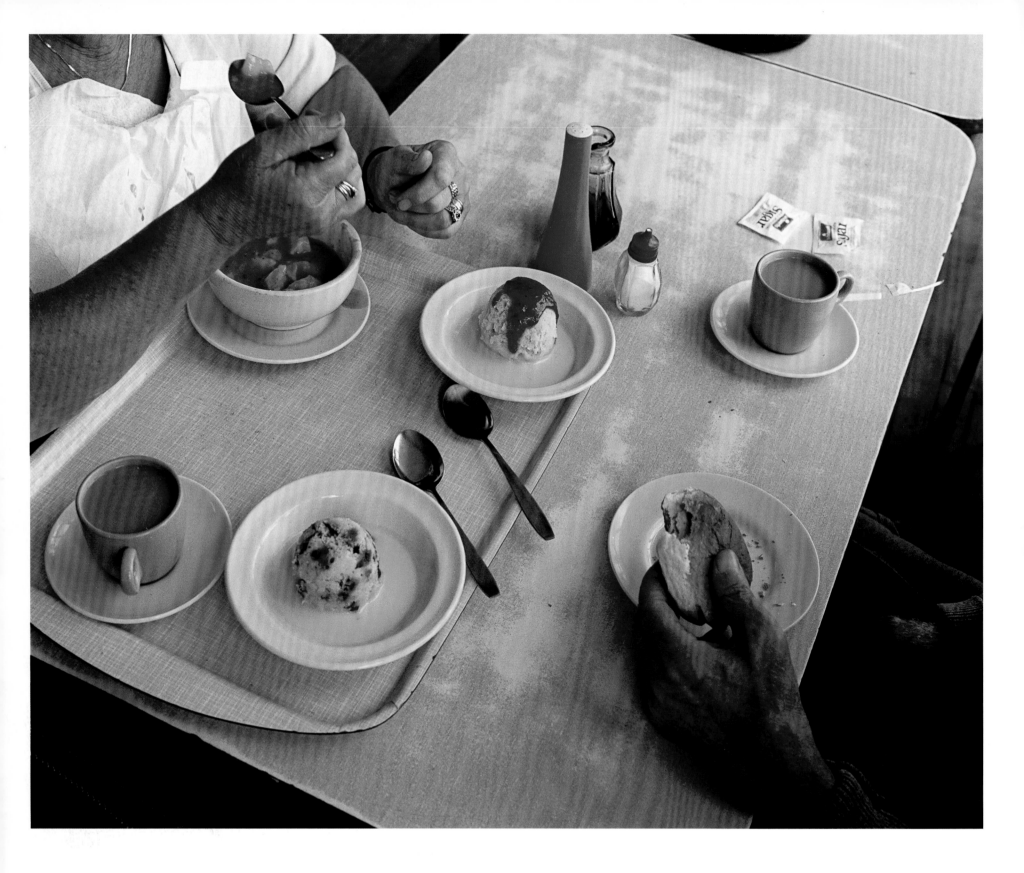

Margate, Kent, 1987

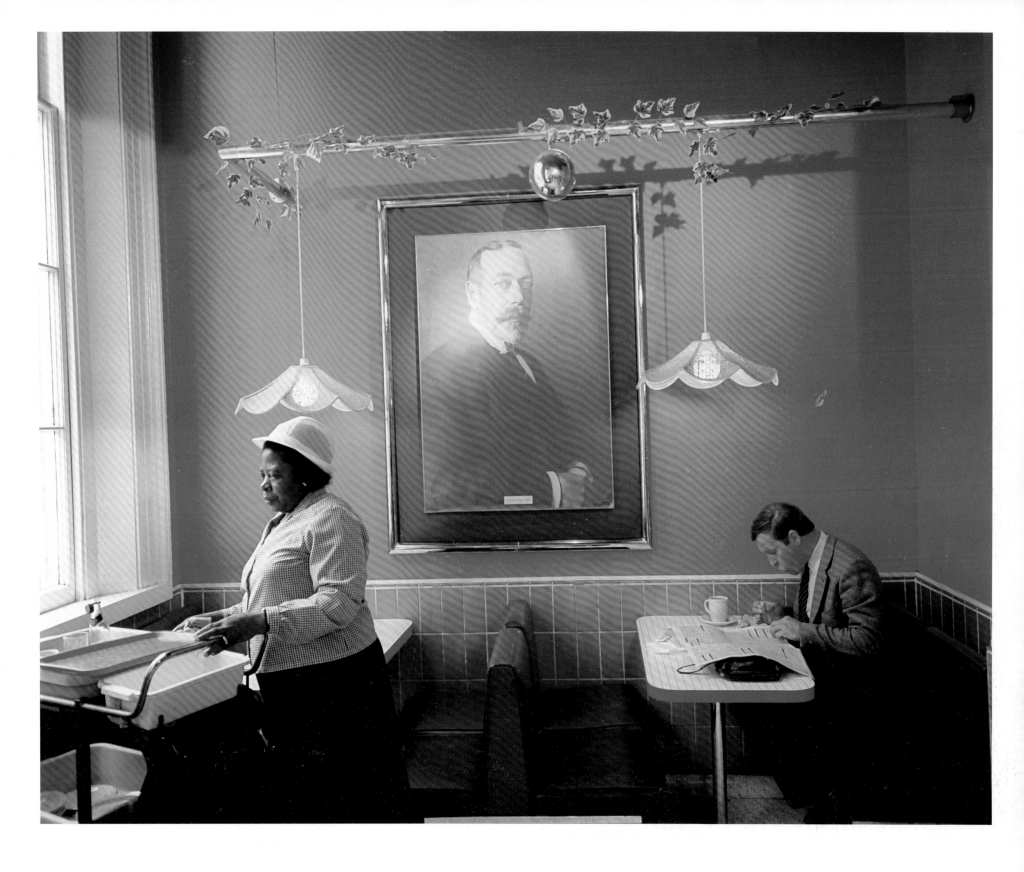

King's Cross Station, London, 1990

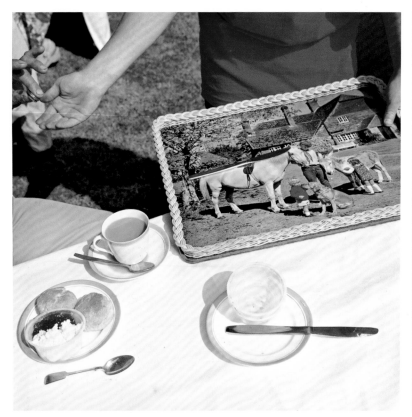
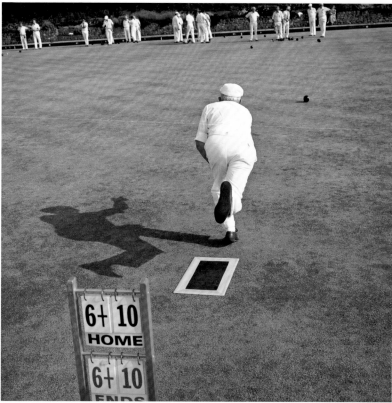
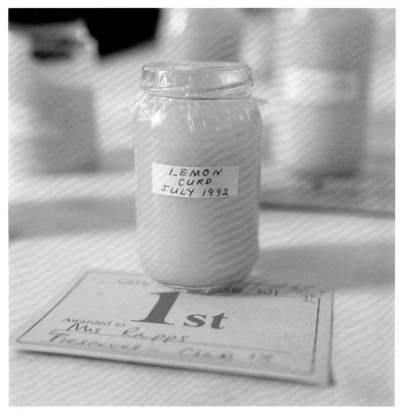
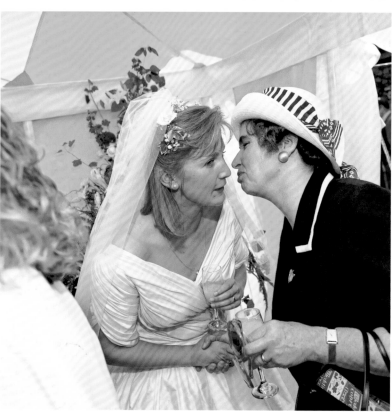

From 'Chew Stoke: a Year in the Life of an English Village', 1992

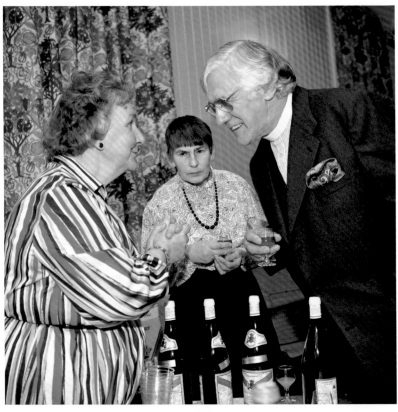

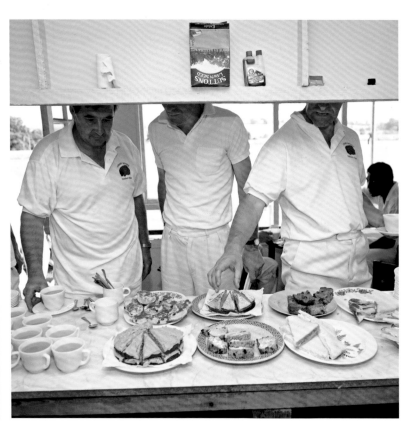

From 'Chew Stoke: a Year in the Life of an English Village', 1992

Close-ups in Parrworld

consumerism and globalization

Photographers are used to watching, not to being watched. As one of Britain's best-known and most media-accessible photographers, Parr has been the subject of a variety of interviews over the past ten years. *The Guardian* once sent one of its best columnists, Suzanne Moore, to interview Parr at home, but even she had difficulty in penetrating the skilfully constructed facade that Parr has erected between himself and the enquiring world. For Parr, the star of the amateur dramatic group in 1960s Surrey, is nothing if not a performer. He is used to being interviewed. So much so, that every interview, give or take a few changes, is the same. Using his house (which interviewers invariably describe as 'five-storied Georgian') in Bristol as a theatrical background, he has created a finely honed persona to present to journalists. Already conditioned to think of Parr as 'controversial' (for what editor wants an interview with an uncontroversial artist?) they are provided with a ready-made story – Parr's well-known quarrel with Henri Cartier-Bresson (co-founder of Magnum and highly suspicious of Parr's photography), the 'controversy'

around his 1980s colour documentary work, the oft-repeated description by picture editor Colin Jacobson of Parr as 'a gratuitously cruel social critic who has made a large amount of money by sneering at the foibles and pretensions of other people'. And then there are the Parr supporters, such as fashion designer agnès b., who thinks of Parr's pictures as 'affectionate'. And, of course, there is Parr himself, using the self-attacking stance that he has found to be the best form of defence: 'I'm so middle class, it's unbelievable', he says, 'My father was a civil servant. I was brought up in middle-class Surrey. That's it – it's a perfect middle-class pedigree' (interview with Rick Poyner in *Twice* magazine, summer 2001). Parr generally gives journalists what he knows they want to hear: a mixture of controversy and arrogance flavoured with guilt. He even looks the opposite of how a highly successful photographer should – he wears chain-store sandals and cheap shirts and has only a passing interest in consumer goods.

But of course, as we all know in post-millennium Britain, class doesn't matter any more, only money and

a certain kind of fame. So it's perhaps a little strange that Parr's acknowledgements of his 'middle-classness' carry so much weight with the kind of journalists who are usually sent to interview him. But Parr is a highly media-aware man – he spent the first ten years of his career trying to persuade the quality press to publish his work – and he knows that in the broadsheets (his key market), the class/guilt/affluence axis continues to carry weight; it is the quiet silent place at the heart of British society where class still matters. Parr is astute as a salesman – he knows his media market better than anyone else. But every so often someone springs a surprise on him, watches him watching, spins their own tale without the Parr spin.

This was the case when the fashion writer Tamsin Blanchard accompanied Parr and his assistant Peter Fraser to the Paris couture shows in July 2001 ('Models, Make-Up and £30,000 Frocks', *Observer Life*). The piece (which Parr had imagined would be a picture story about the shows, contributed by him, and a text piece revolving around the clothes, written by Blanchard) emerged as a

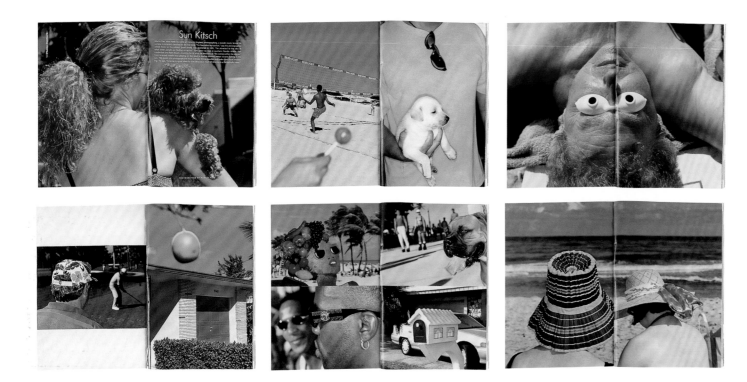

study of a documentary photographer at work. It profiled Parr as a photographer far from his usual *mileu*, subject to the rules and whims of the fashion pack. It described Parr's close friend and Magnum member Bruce Gilden being 'marched out of the Versace party' but not before he had managed to get a photo of Puff Daddy by brandishing his Brooklyn upbringing. It describes Peter Fraser as bored by the fashion: 'This, from a man who, by his own admission, spends his time photographing dirt.' 'And despite his A1 status backstage', observes Blanchard, 'Parr is quite nonplussed too. It is all a bit too fabulous. He wanted, he said, to photograph the reality rather than the fantasy.'

What he might have said is that he wanted to photograph what *he* sees as reality: a particular and specific Parrworld, a complex social ecosystem made up of well-defined elements. When Parr photographed the Paris couture shows, he was entering a stage-set of fantasies seriously created as such and, moreover, ones to which he had only limited access. Parr is more accustomed to

making what might, to you or me, seem very ordinary, into a riotous conglomeration of incongruous details, lit by bright flash and photographed with a camera more often used to photograph cells and bacteria.

Parr has always been fascinated by this most ambiguous of terms: *ordinary*. The elderly chapel-goers of Crimsworth Dean were 'ordinary' and so were the day-trippers to New Brighton. The young couples shopping in Ikea, they were 'ordinary' too, as were the tourists whom he would photograph for 'Small World' in the 1990s and the home decorators of 'Signs of the Times'. Some people, though not many, objected to being chosen as characters in Parr's theatre of the ordinary, and their photographs have now been withdrawn from his picture library. Some, such as picture editor Colin Jacobson, thought it was OK for 'ordinary people' to appear in a small-run book of critical documentary, but not in an advertisement for Pepe jeans. So the term 'ordinary', at least as applied by Parr and the other critical documentarists who emerged in the late 1980s and early 1990s, is a difficult definition to

get to grips with. In Parr's photography, 'ordinary' doesn't mean working class or middle class; it is no longer applied solely to the British. It no longer applies to a visit to Stonehenge or the Ideal Home exhibition, but can also encompass a trip to Las Vegas or the biggest shopping mall in the USA, or to the Venice Biennale. Far from being a study of the ordinary, Parr's photography is much more a study of what happens when we try to make our lives *less* ordinary, by going on holiday, visiting a theme park, browsing in a stately home, even attending an exhibition opening.

Parr has often said in interviews that he is merely photographing all the things he does himself, but nevertheless, there is disapproval in these photographs; a disapproval that was not present in the 1970s photographs of June Street, Butlin's or Hebden Bridge, in the mid-1980s documentation of New Brighton, or even in the Salford survey, 'Point of Sale'. Is Parr suggesting that people should know their place, that they should holiday at home and live in rooms where the furniture was built to last?

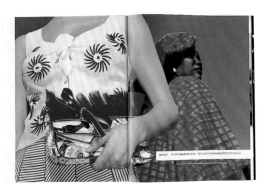

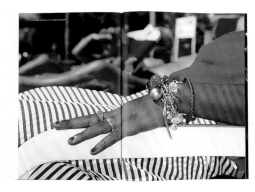

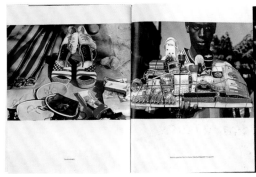

Or is he simply, in his Methodist way, commenting on how frivolous, insensitive and sensation-seeking we've become? In the 1970s, Parr photographed houses that were small and unassuming – June Street, Sarah Hannah Greenwood's farmhouse in Crimsworth Dean, holiday experiences that were basic and communal – Butlin's, the English seaside. Then he saw the society around him change – swagged curtains, faux country kitchens, package holidays to the Gambia, three-bedroomed manor houses on a new estate. Parr insists that when he began to photograph in colour in the early 1980s, it was to rid himself of what he saw as his own romance and nostalgia, to make photographs that were more raw, more witty, more nerve-wracking. But perhaps the pictures of the 1980s and 1990s, from 'The Cost of Living' through to 'Small World', 'Signs of the Times', 'Common Sense' and 'Think of England' are just as much a lament for what has disappeared as they are a satire on what took their place.

In 'Models, Make-Up and £30,000 Frocks', Parr had entered a world that had its own rules; far more complex

rules than those he would normally encounter. He was more accustomed to photographing ordinary people who want to look like jet setters than jet setters who look like ordinary people. Blanchard was struck by the incongruity of Parr's presence at the shows: 'And there's Martin Parr', she wrote, 'the man who spends all of two hours a year shopping for clothes – once at the January sales and once in July – in his Dockers chinos, crumpled shirt and signature sandals. He's worn his best leather ones especially. With socks.' Blanchard may well not have entered into this project specifically to write a story about Parr, and in fact, much of the text is taken up by description of the collections. But, unlike the journalists who have made the trip down to Bristol to become the recipients of Parr's carefully conceived version of himself, she was able to make a portrait that touched the reality of the photographer's life far more closely. And the pictures themselves, though perhaps not Parr's classic best, are, because of their reserve, more surprising than many of his recent photo stories. Parr is adept at photographing people's dreams – two weeks'

holiday in Spain and you can, for a moment, believe that you're an international jet setter; a night in a club and you imagine yourself on the pages of *i-D*. But when he confronted the deep suntanned faces of Donatella Versace and Valentino, photographed a model eating French fries without letting them touch her lips, he was photographing not the fantasy, but the real thing; the tawdry thing that dreams are made of. The designers and supermodels he portrays are not beautiful; their sun tans are too deep, their clothes too flashy, they are insolent and superior. The models are thin girls wearing clothes of the deepest absurdity, swathed and wrapped, bundled up like packages.

What one must always remember about Parr is that he is a documentary photographer, fascinated by the visual, as fascinated as he always was by the bizarre juxtapositions and situations that ordinary life brings. Despite his well-rehearsed feelings about his place in the class system, he is a populist, interested in the things that everyone does: going on holiday, buying furniture, eating, travelling, dressing up. Though his vision is always an idiosyncratic

one, it is also one that is deeply rooted in his beginnings as an artist, and it is this that has made his documentary photography so singular. It is informed not just by the classic masters of alternative documentary photography – Garry Winogrand, Diane Arbus, William Eggleston et al – but by his interest in kitsch and popular art (three versions of Constable's *The Hay Wain* in the first incarnation of 'Home Sweet Home', for example, his collections of contemporary folk art, Miners' Strike plates, printed milk bottles etc.), in what he might call 'bad taste'. But a more considered view would see it as an indulgence in the decorative and the unendorsed, relatively unhindered by the dictates of fashion.

You could say that Parr is the Max Wall of contemporary photography: a raucous music-hall turn informed by a sense of loss, of pathos, of never belonging. Parr has managed to turn all this to his own gain. Advertising agencies and magazine editors are attracted to the directness of his style, the way he has of choosing subjects that make them feel both uncomfortable and superior.

In the mid-1990s, Parr began 'Common Sense', the series that he sees as one of his most important, though reactions to it have been distinctly varied. Published in 1999, the book *Common Sense* is a highly significant collection of photographs. The cover image is of a section of a rusty globe, made into a moneybox, highlighting Parr's growing preoccupation with globalism and the corporate culture, which, by the late 1990s, had overtaken his interest in class. *Common Sense* is a dictionary of the 1990s; a work of deep foreboding mixed with high visual glee. A woman holds a 100-dollar bill between her teeth; hands fumble for Disneyland popcorn; people are getting fatter as they munch through doughnuts and hamburgers, ice cream and bacon. There is a rotten apple and a car seatbelt flung upon a pile of broken windscreen glass; blotchy red meat on a butcher's hook; skins seared and roasted by sunburn. There is a small forest of cigarette ends. There is Coca-Cola and Nike, Sony and Disney. Compared to this, New Brighton was Elysium. There is ruined food, left on the pavements to fester or be eaten by birds, and

a surfeit of fat and sugar. There is a photograph of maggots opposite a picture of French fries. A wasp feasts in a dainty bowl of jam; a plane is torn apart by an explosion of rust; and the Queen and the Duke of Edinburgh are covered by terrible blisters on a worn-out commemoration tray. And then there are the dogs: dogs in sunglasses, dogs in hats, poodles with red eye, dogs in wigs, china collies. And the cakes: grotesque smiling cakes of turquoise and pink, confectionery on speed. *Common Sense* is a violent book, its violence made even more acute when Parr interleaves his images with photographs that speak of his own veneration for the gentle and the traditional: a woolly mauve hat worn by an elderly woman, a cup of tea in a willow-patterned tea cup, a pensioner in flowery oven gloves holding a pile of flowery plates. Sandals worn with socks. Parr has a reverence for small things, for people who decide to do things under their own steam – village fêtes, homemade jam, carol-singing societies, clubs, dwindling congregations, people who go swimming on Christmas Day, even Tupperware. Parr, as politically

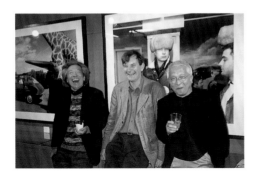

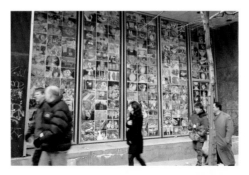

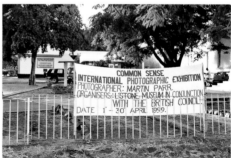

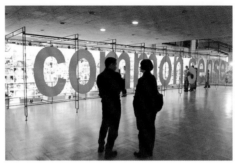

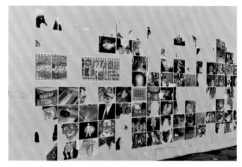

acute, populist and inherently romantic as he was in the Hebden Bridge days, attacks what demeans us by making fun of it, by drawing to our attention the grotesqueries of brands, the culture of consumerism, the fact that we are sold goods that are less than we deserve for more than we can afford. Parr is nostalgic about the loss of popular culture and bemoans the triumph of corporatism over community. 'Common Sense' is like a dictionary of sins, a malodorous concoction of the sugary, rotting and fascinating detritus of the Western world. And as such, it is one of Parr's most acute, and perhaps most underestimated, pieces of photographic work, which seems for him to have acted as a kind of liberation; a summation of three decades of photography.

Interviewed by Rick Poyner in the summer of 2001, Parr remarked that 'My best photography is behind me, rather than in front of me'. This opinion was perhaps prompted by the lukewarm critical reaction to his latest book of photographs *Think of England* (2000) compared to the enthusiastic response to *Boring Postcards* (1999),

taken from Parr's own collection, and *Autoportrait* (2000), a fascinating work of semi-self portraiture made up of studio portraits of Parr taken in small photographer's shops around the world. Both *Boring Postcards* and *Autoportrait* signal a departure from the high style of 'Common Sense', and a move back to the conceptualism of 'Home Sweet Home'. So much has been written recently about both of these projects that one feels that some time is needed to let the media hype die down and for reflection on how these two publications will sit within the entire context of Parr's work. Suffice it to say that both *Boring Postcards* and *Autoportrait* were highly coded responses by Parr to his position as one of Magnum's top photographers and to the proliferation of documentary photography, an expression, perhaps, of his frustration with the conservatism of the agency and the unwillingness of its members to modify its aesthetic and cultural terms of membership. And perhaps too, *Autoportrait,* with its constant remodelling of the Parr persona – from retouched teenager to muscleman, from astronaut to Arab, from Victorian

gentleman to Jeffrey Archer look-alike – is an acknowledgement, or even a reminder, that photography is often more accomplished, more freethinking in the vernacular than it is in the polished products of the photojournalist or the art photographer. And yet again, *Autoportrait* is a tribute to the unsung, to the modest street and studio photographers who, unimpressed by notions of 'reality' or 'truth', are determined to let us be who we want to be – spacemen, superheroes, aristocrats – for the split second that photography allows.

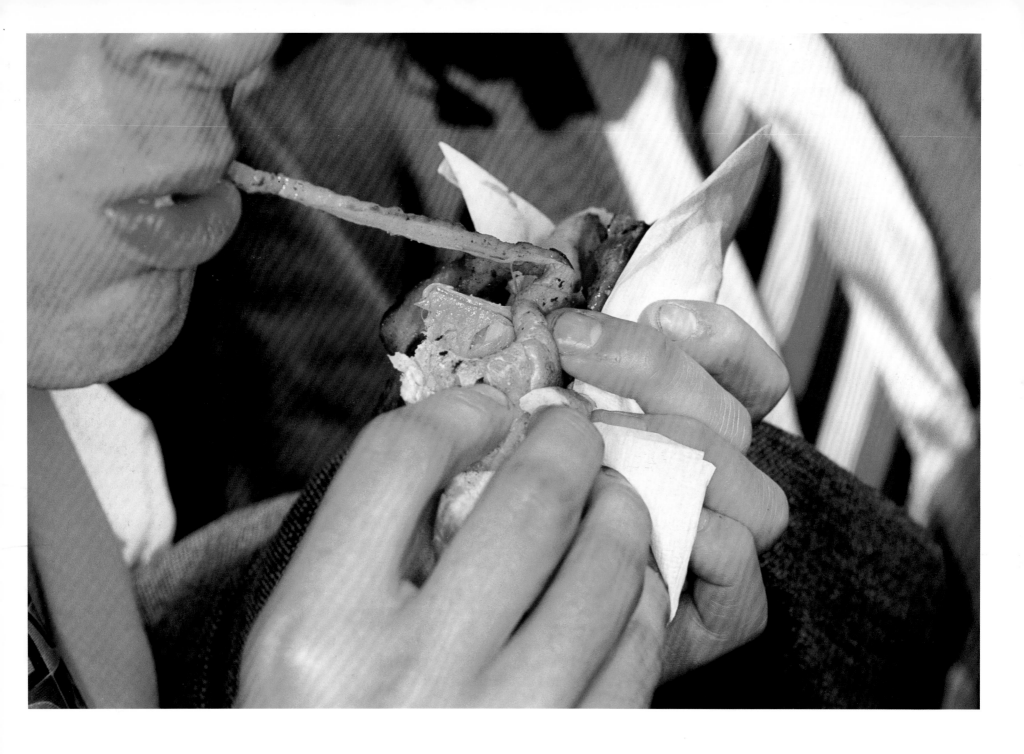

Badminton, Gloucestershire, from 'Think of England', 1996–2000

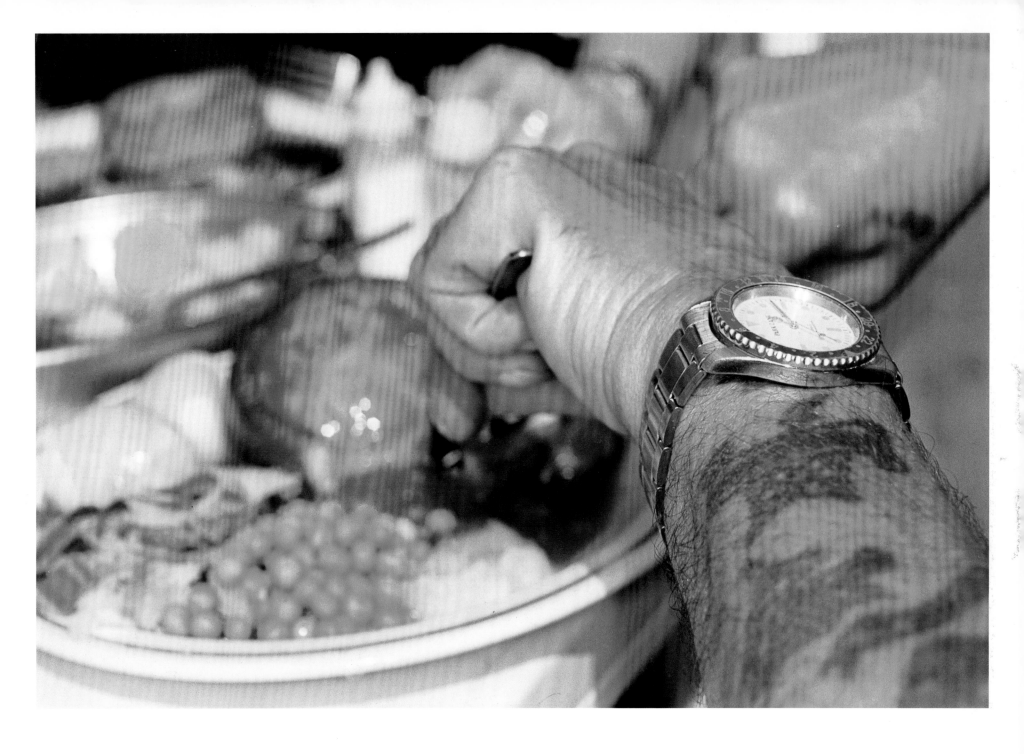

Ascot, Berkshire, from 'Think of England', 1996–2000

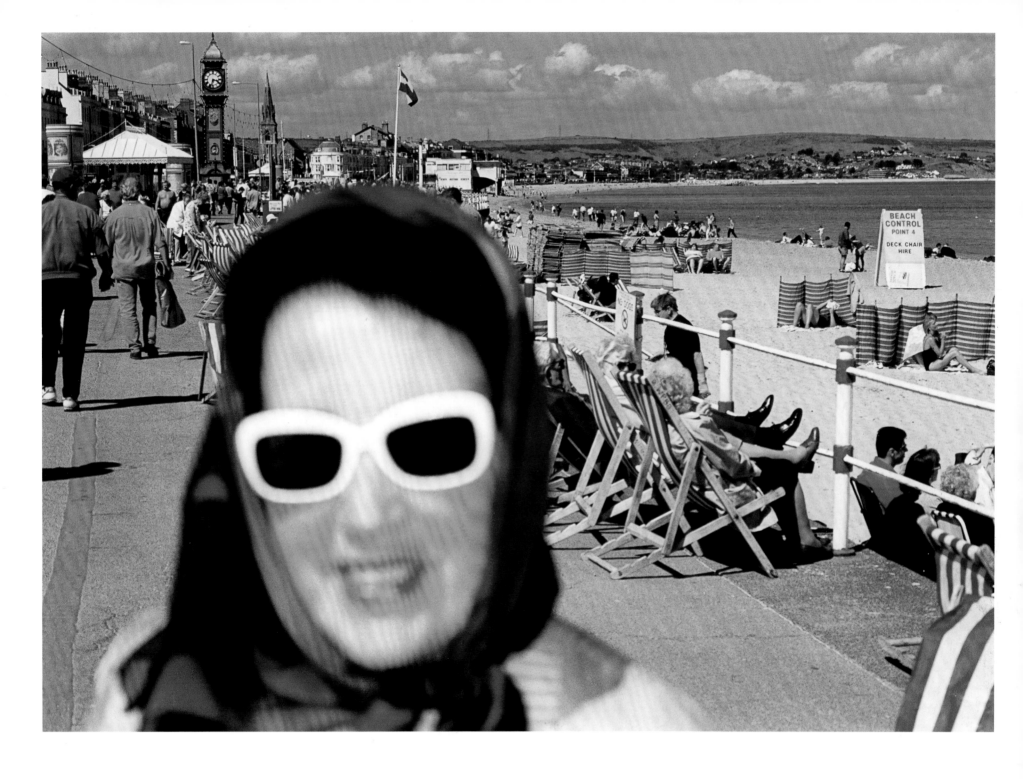

Weymouth, Dorset, from 'Think of England', 1996–2000

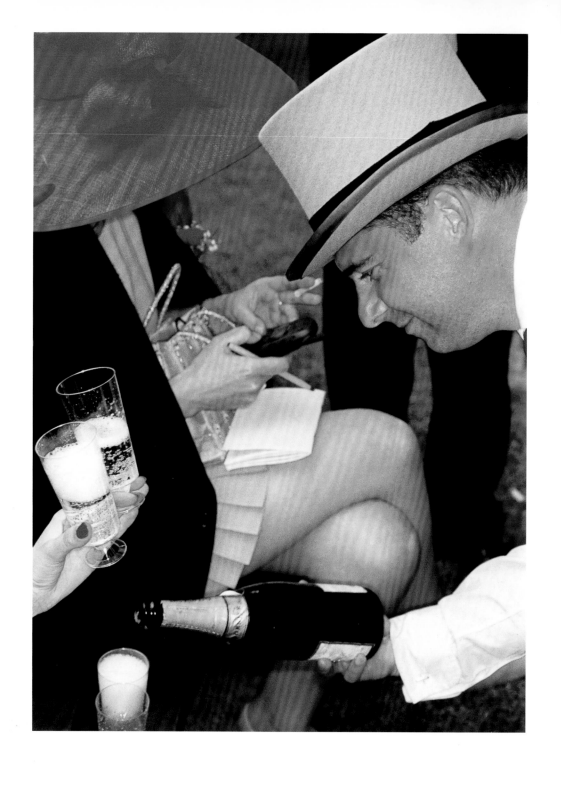

Ascot, Berkshire, from 'Think of England', 1996–2000

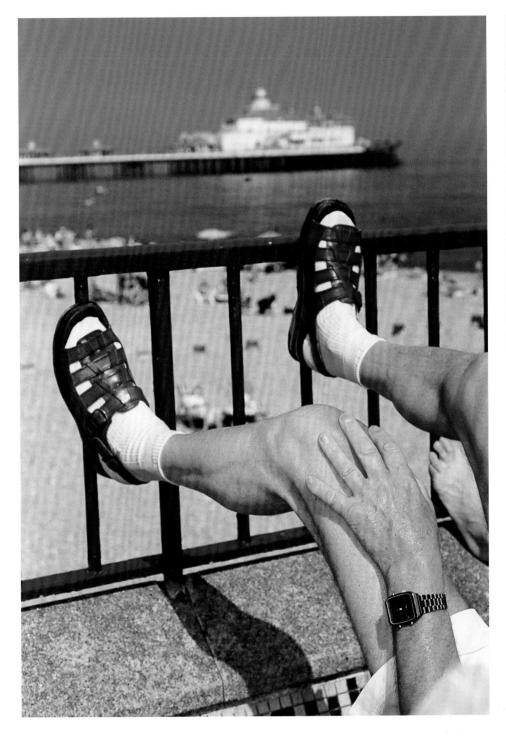

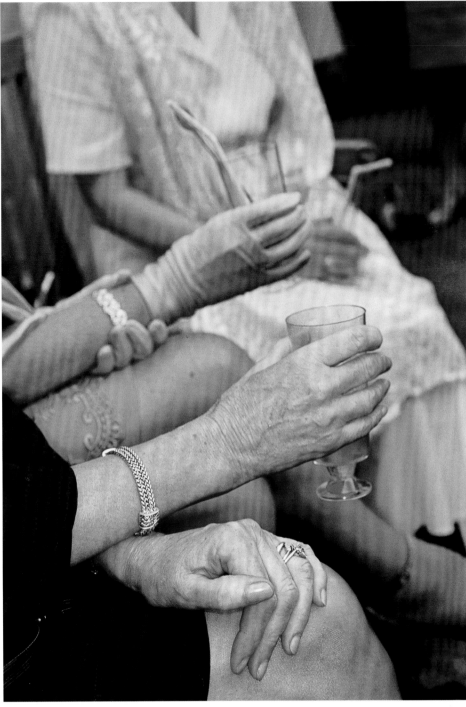

Eastbourne, East Sussex, from 'Think of England', 1996–2000

Ascot, Berkshire, from 'Think of England', 1996–2000

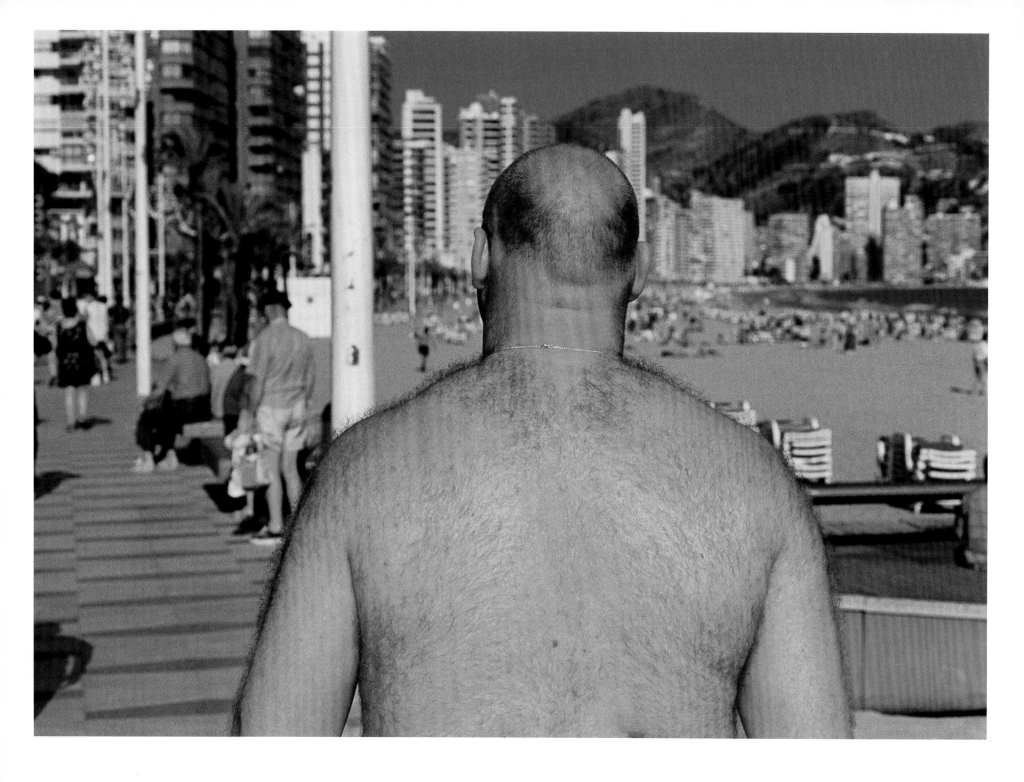

From 'Benidorm', 1997–8

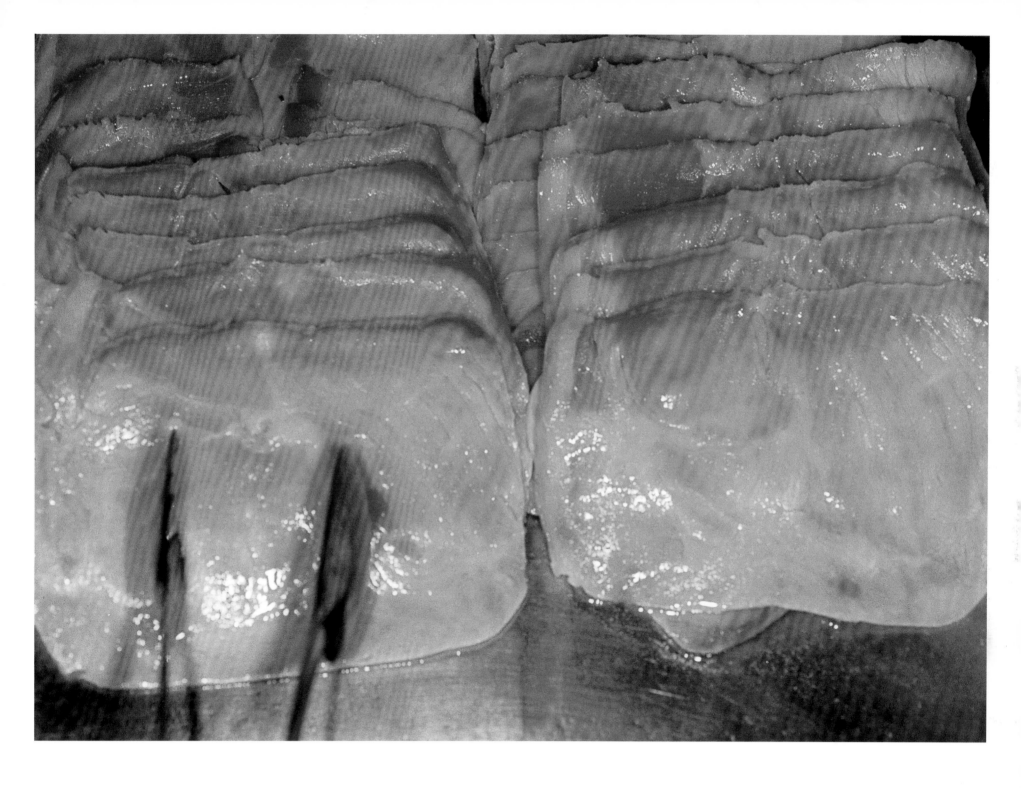

288 Martin Parr

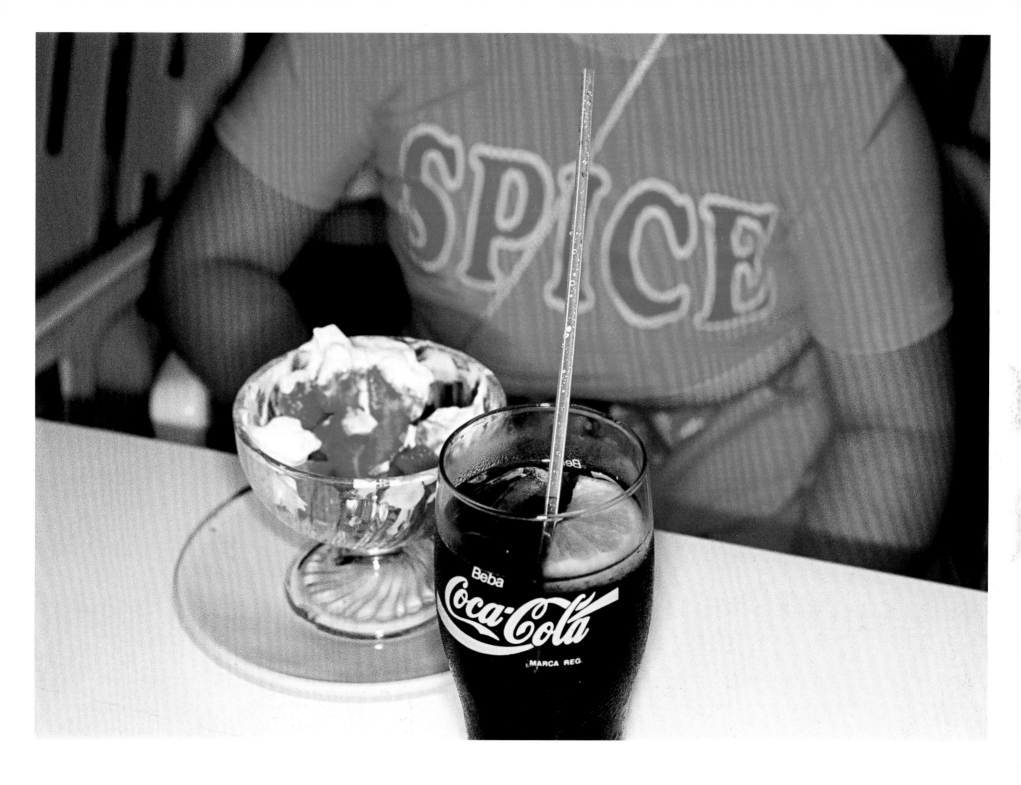

From 'Benidorm', 1997–8

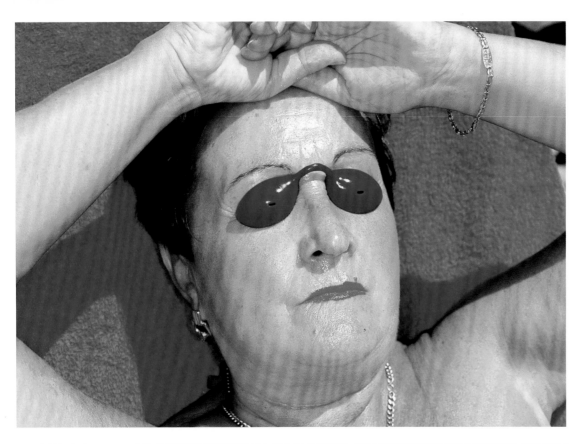

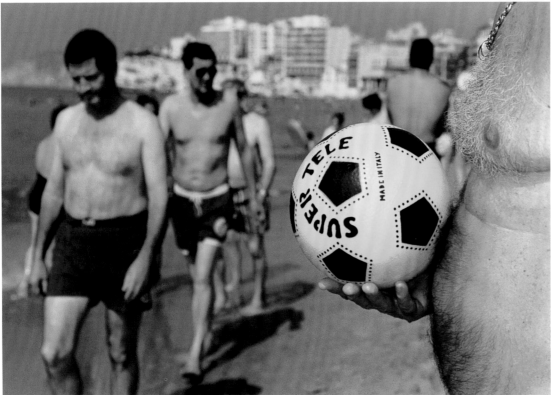

From 'Benidorm', 1997–8

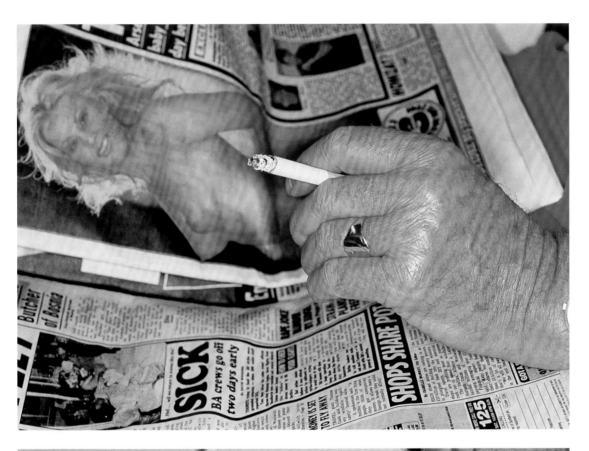

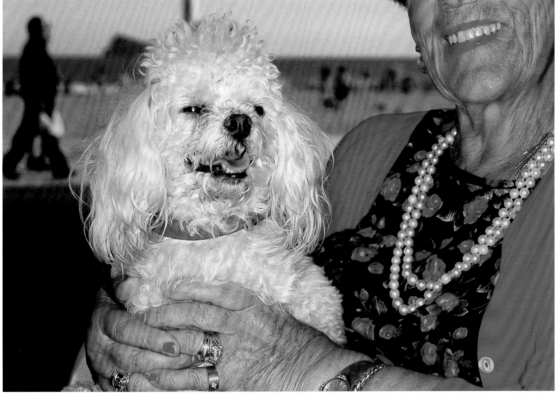

Beaminster, Dorset, 1998

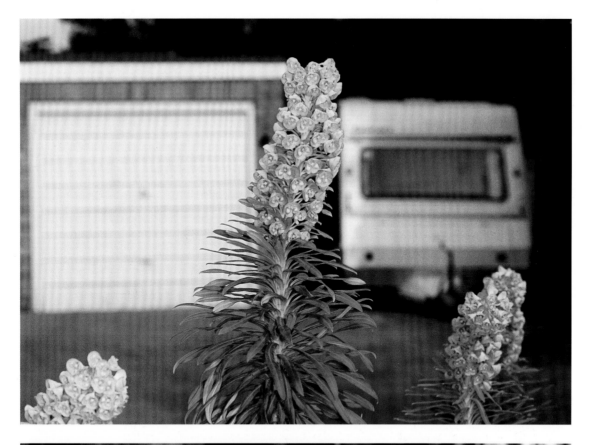

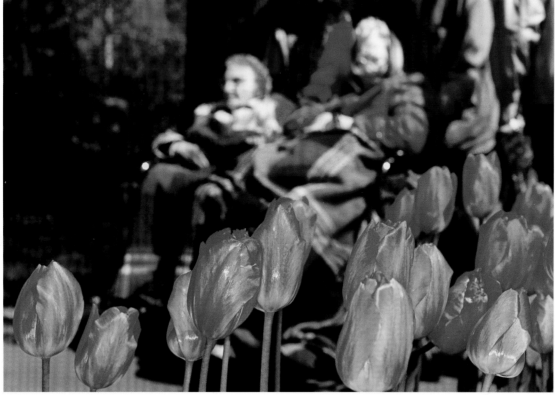

Top: Malvern, Worcestershire, 1998 Bottom: Keukenhof, Netherlands, 1998

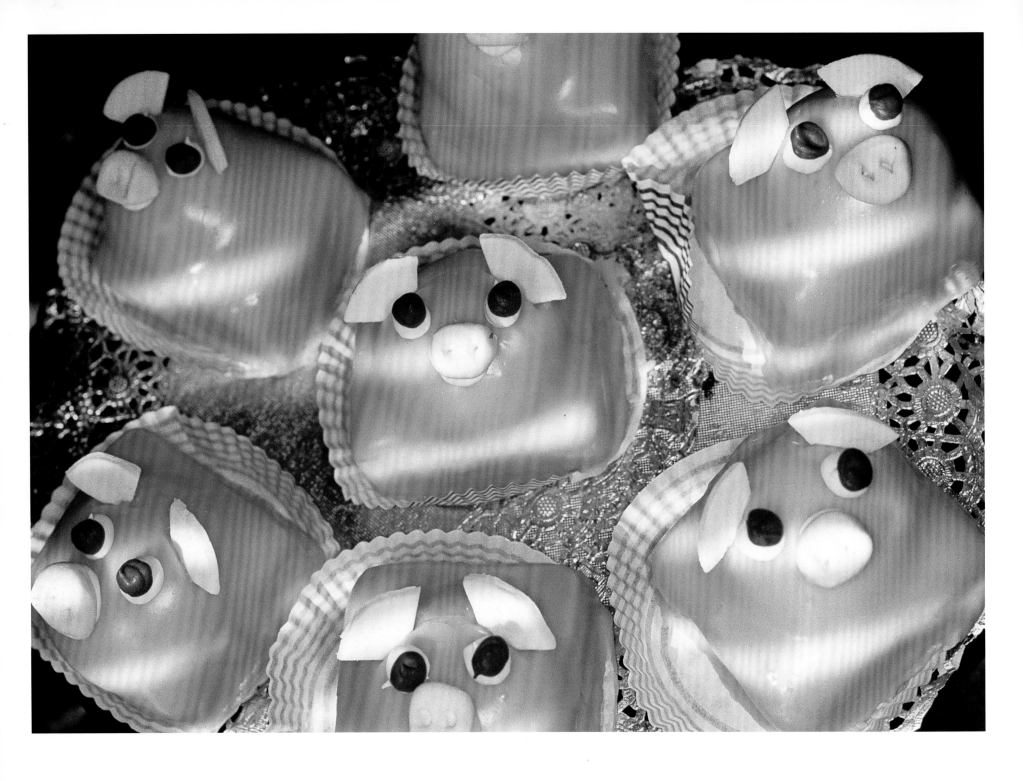

From 'Common Sense', 1995–9

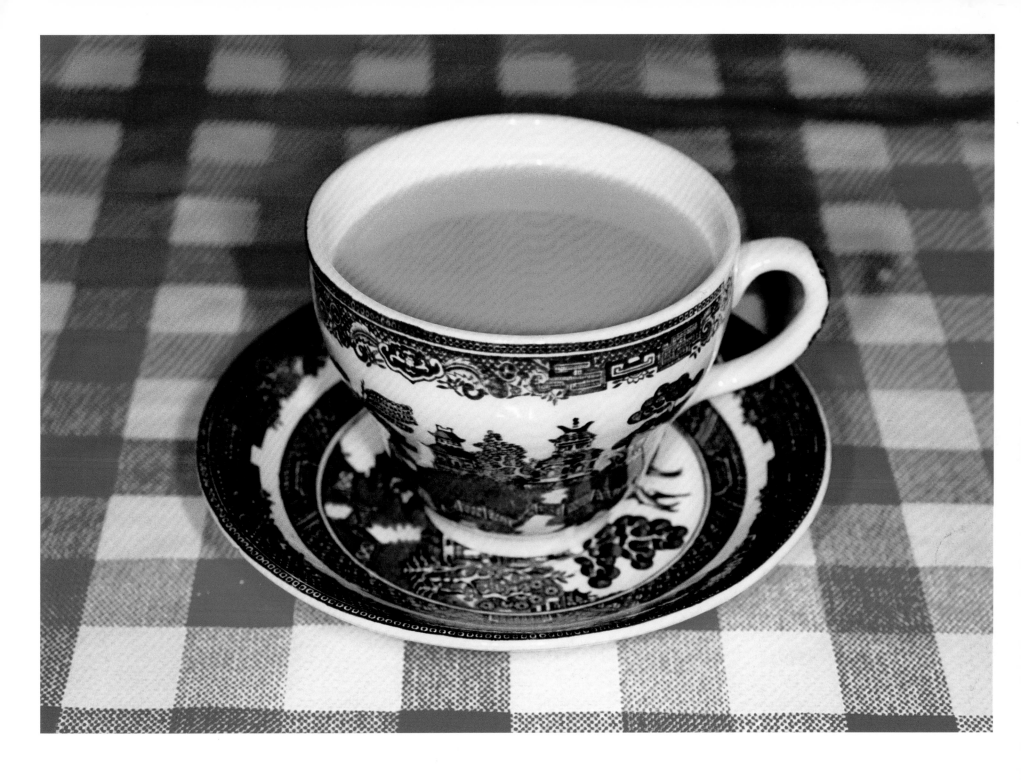

From 'Common Sense', 1995–9

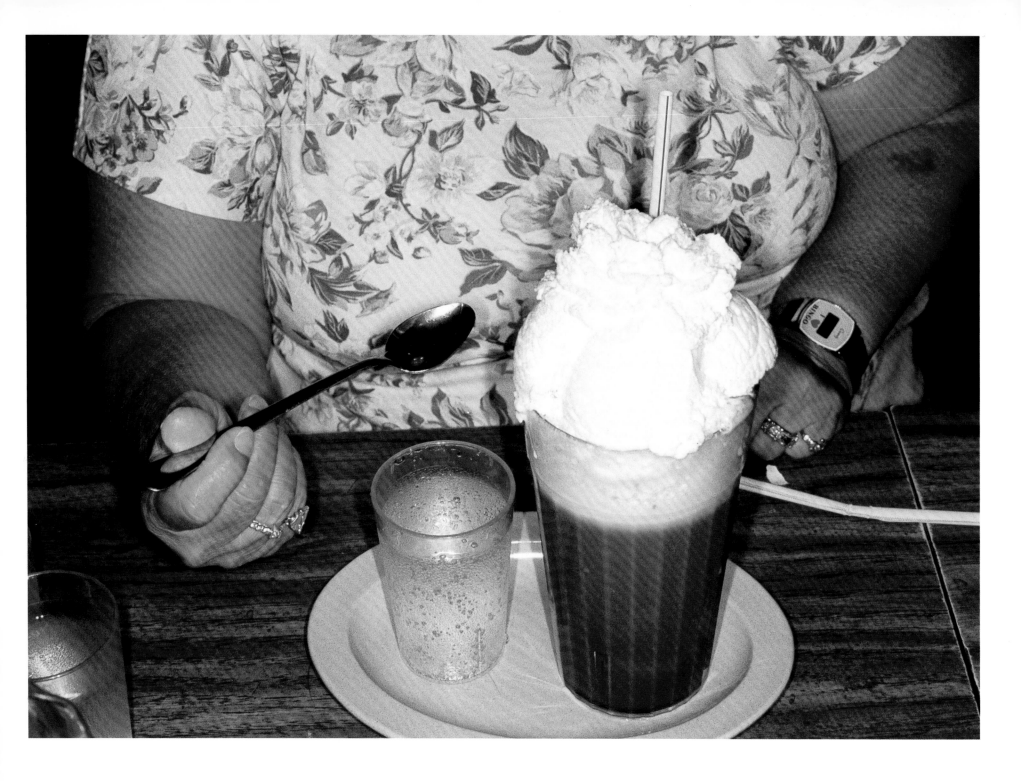

From 'Common Sense', 1995–9

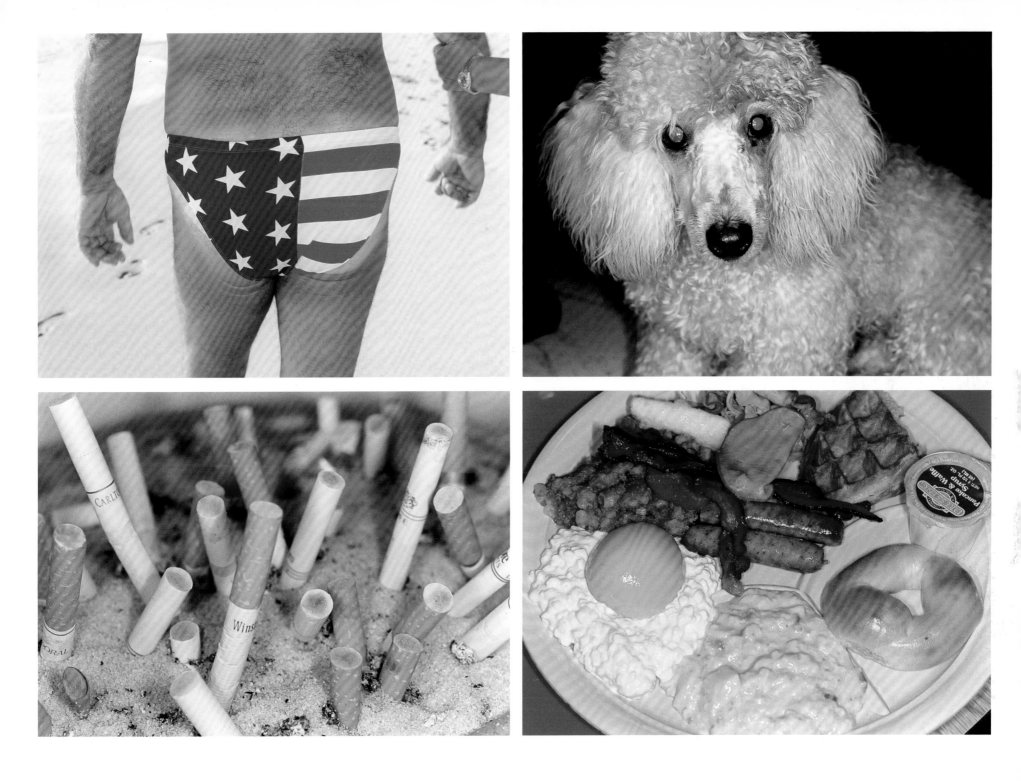

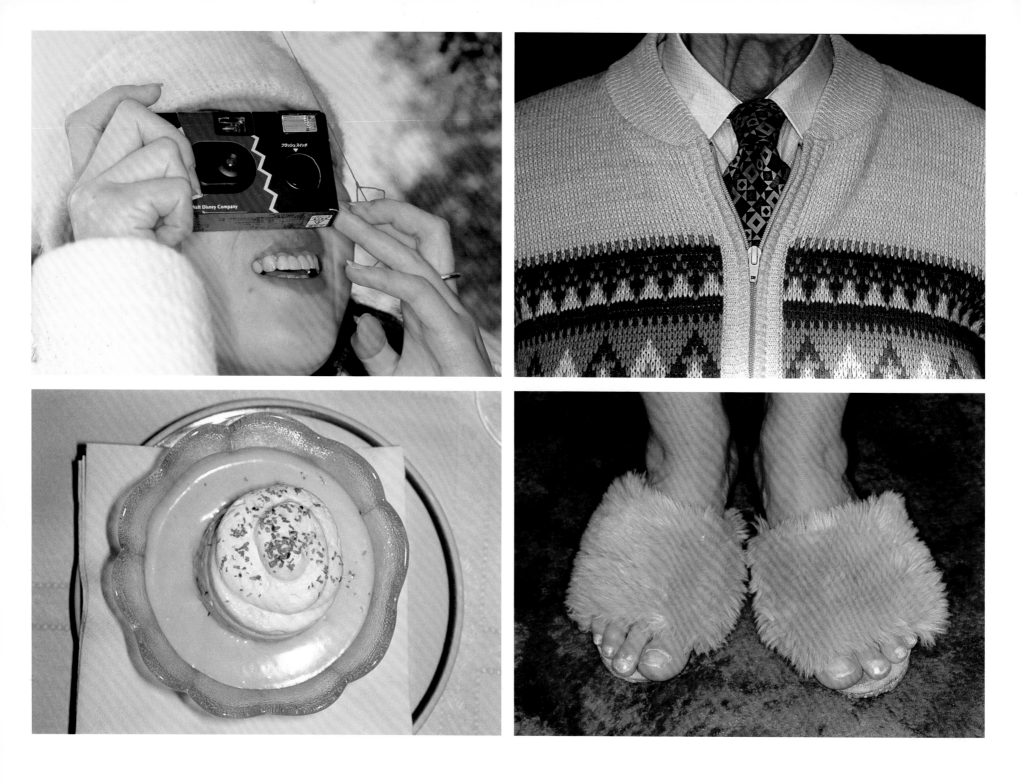

From 'Common Sense', 1995–9

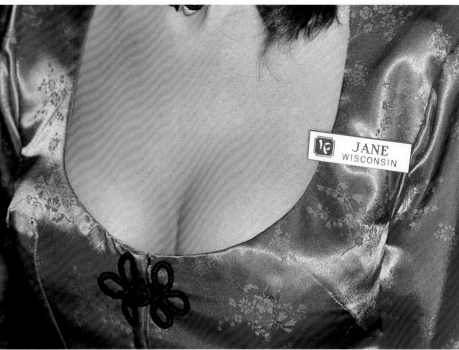
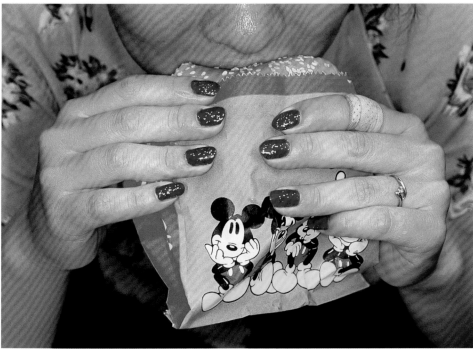
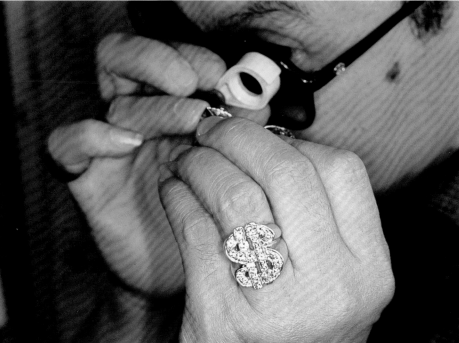

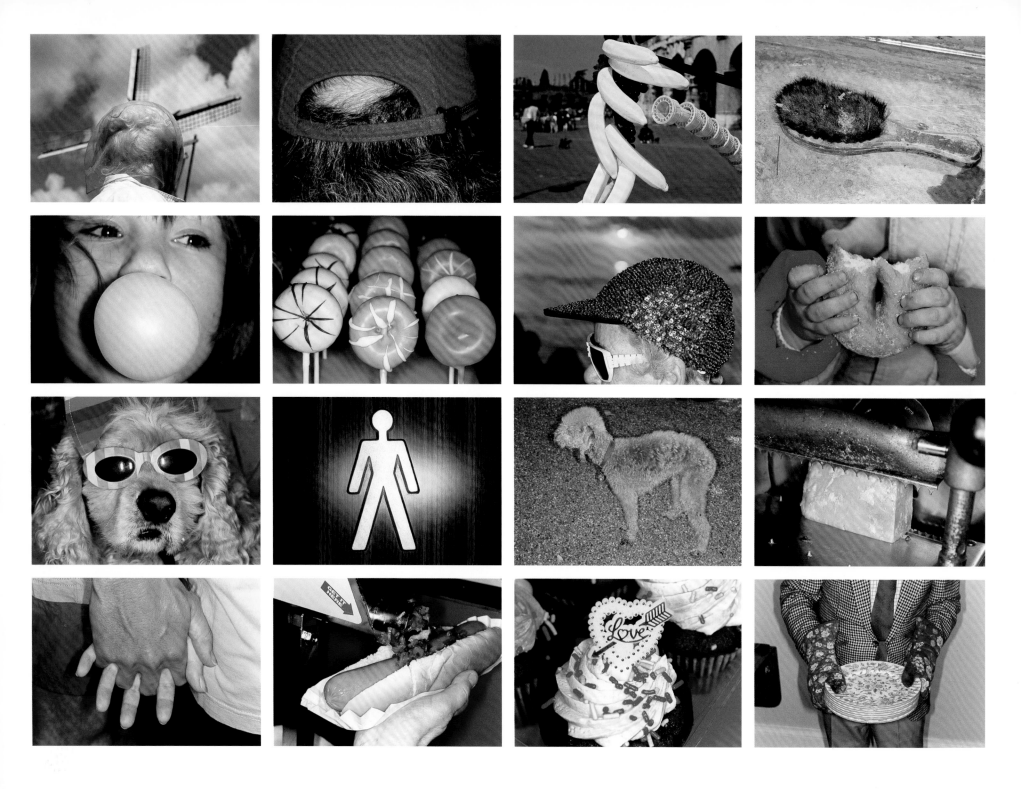

From 'Common Sense', 1995–9

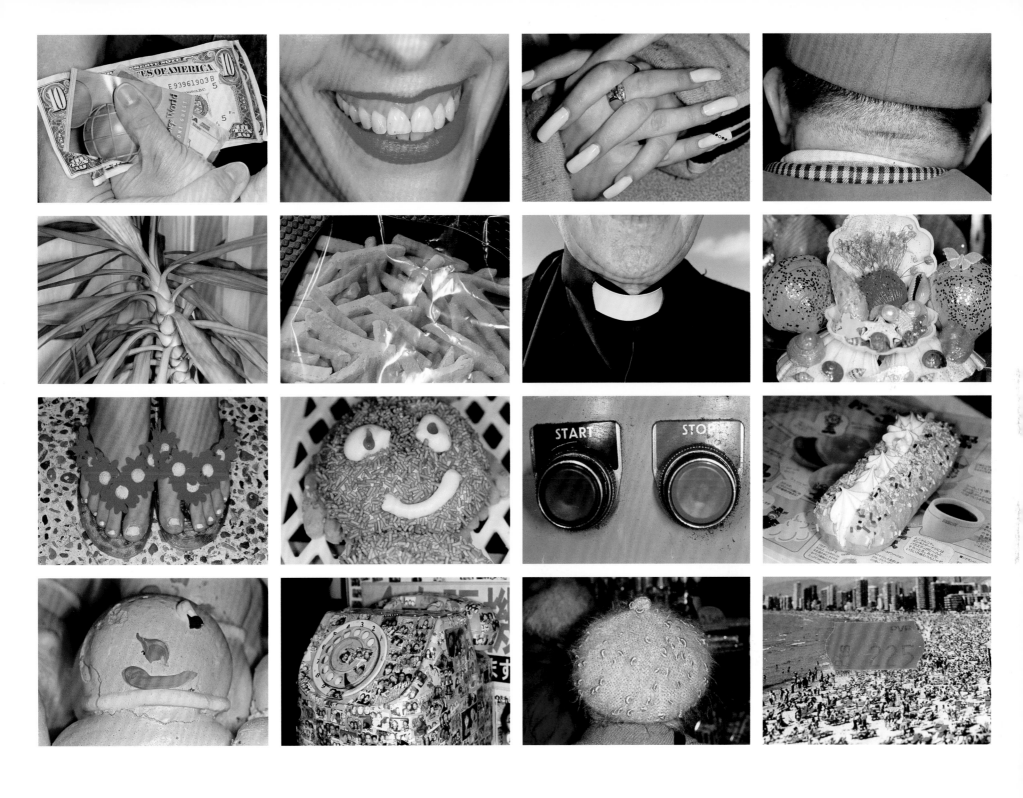

From 'British Food', 1995–6

From 'British Food', 1995–6

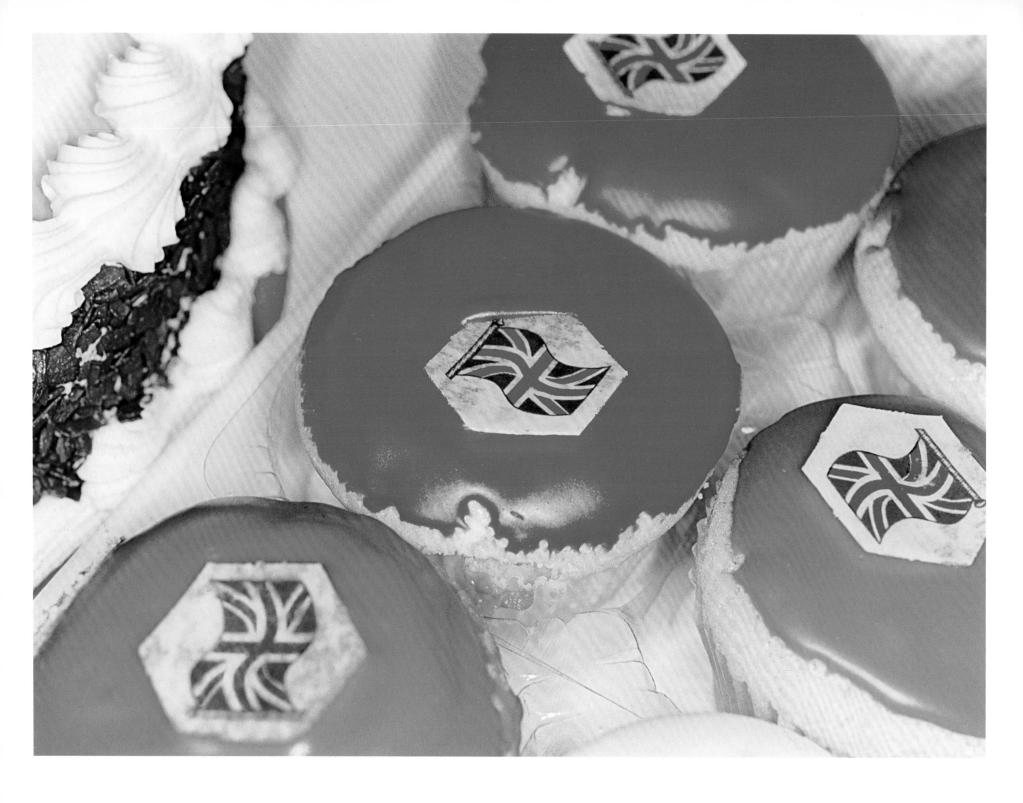

From 'British Food', 1995–6

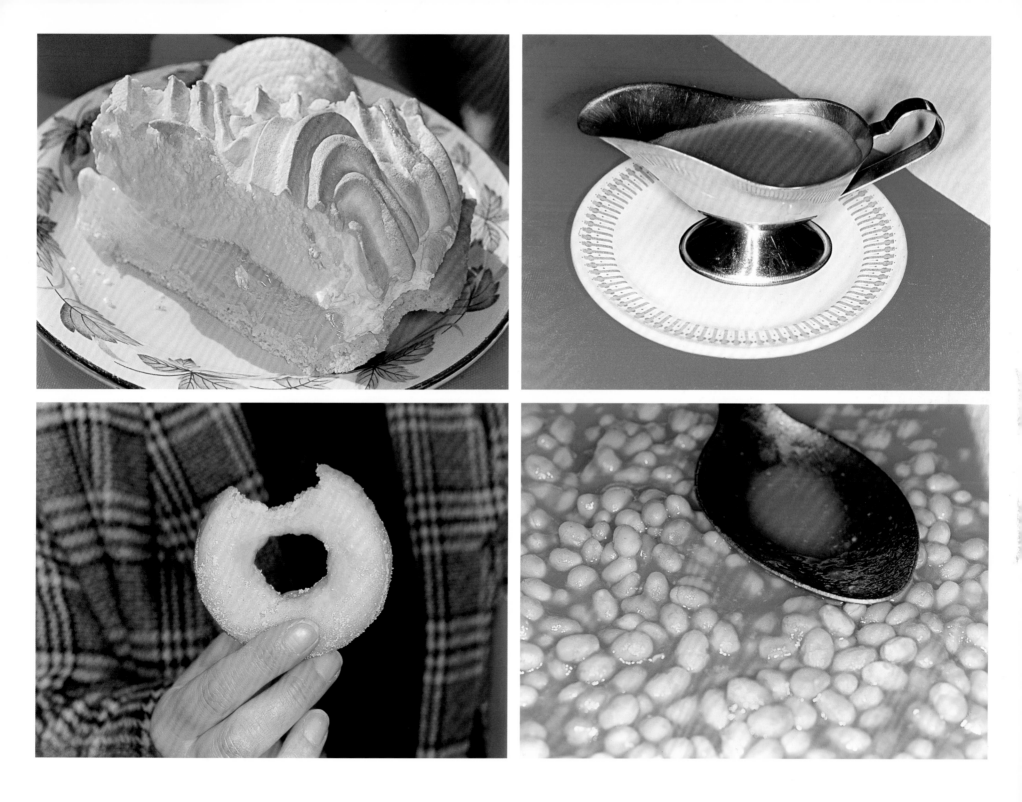

306 Martin Parr

From 'Japonais Endormis', 1998

308 Martin Parr

West Bay, Dorset, 1997

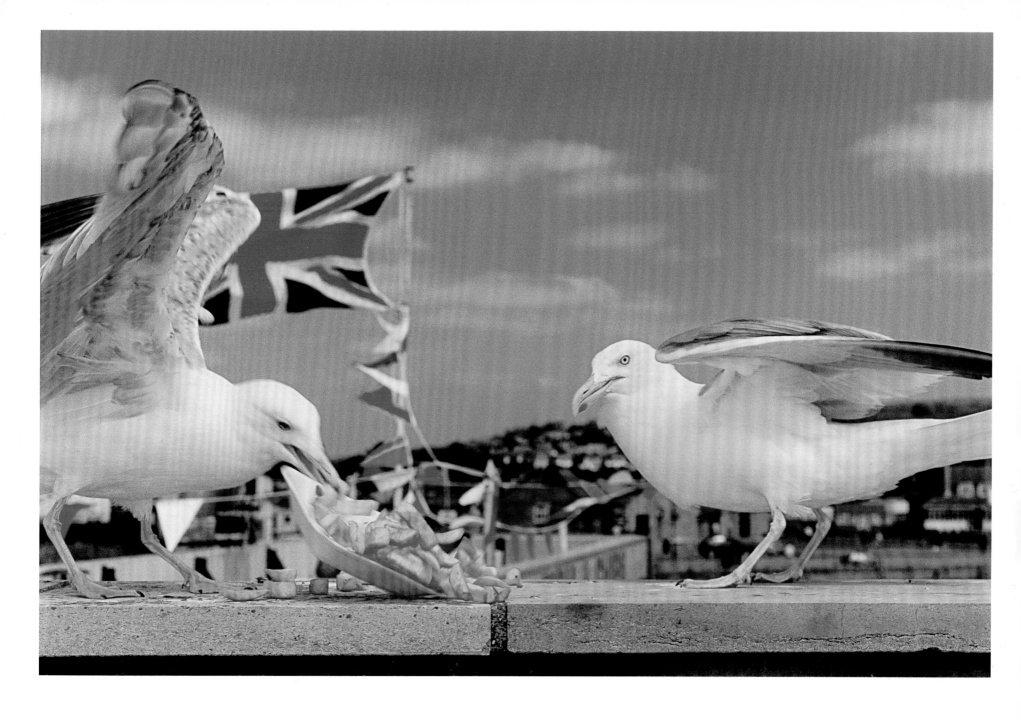

West Bay, Dorset, 1997

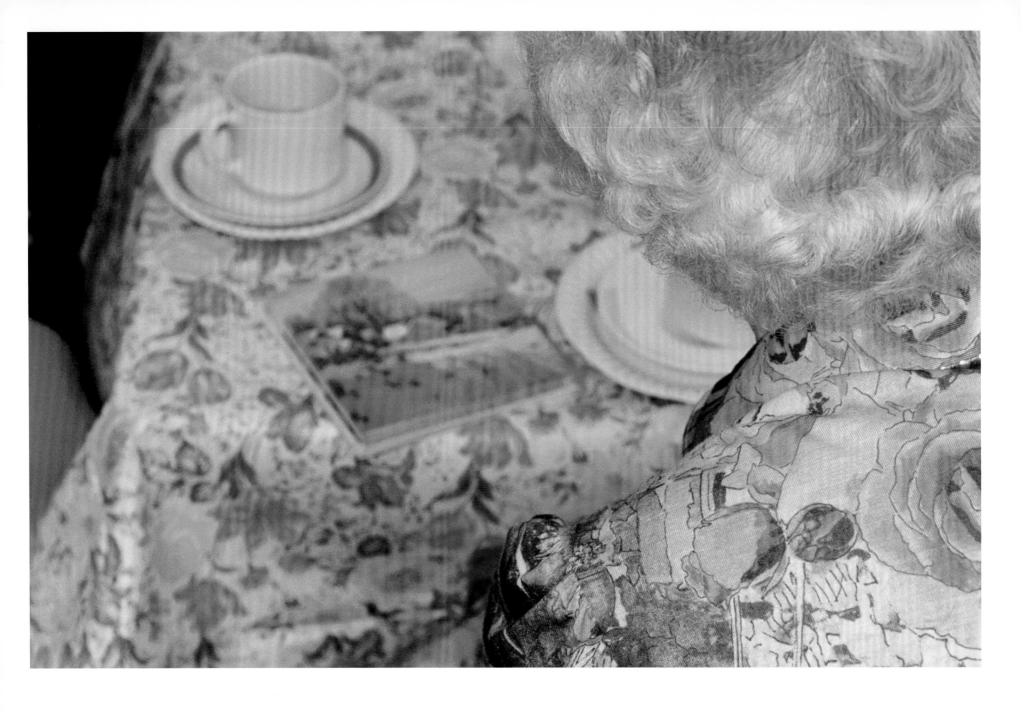

West Bay, Dorset, 1997

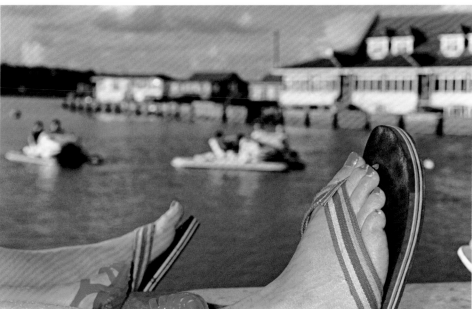
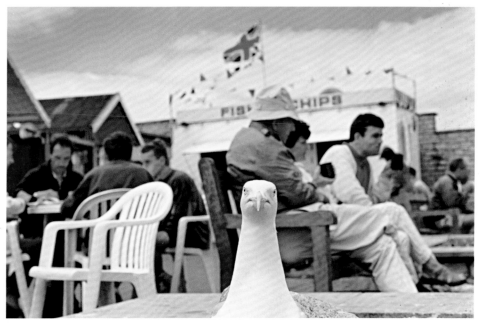

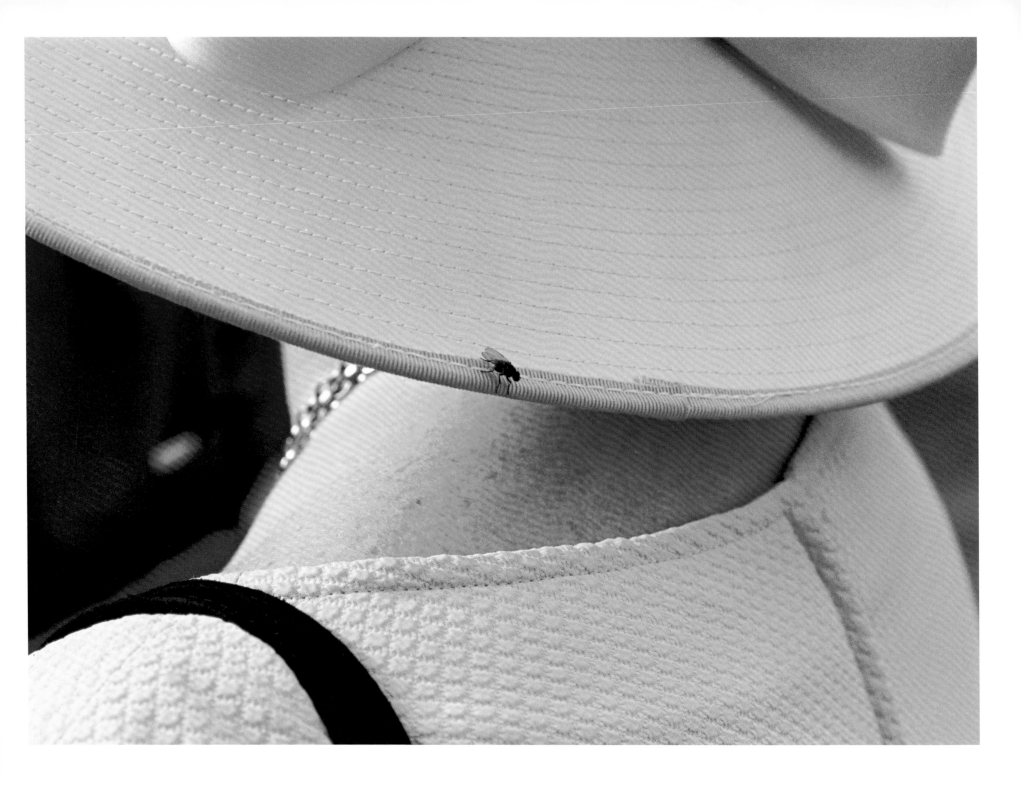

Galway Races, Ireland, 1997–8

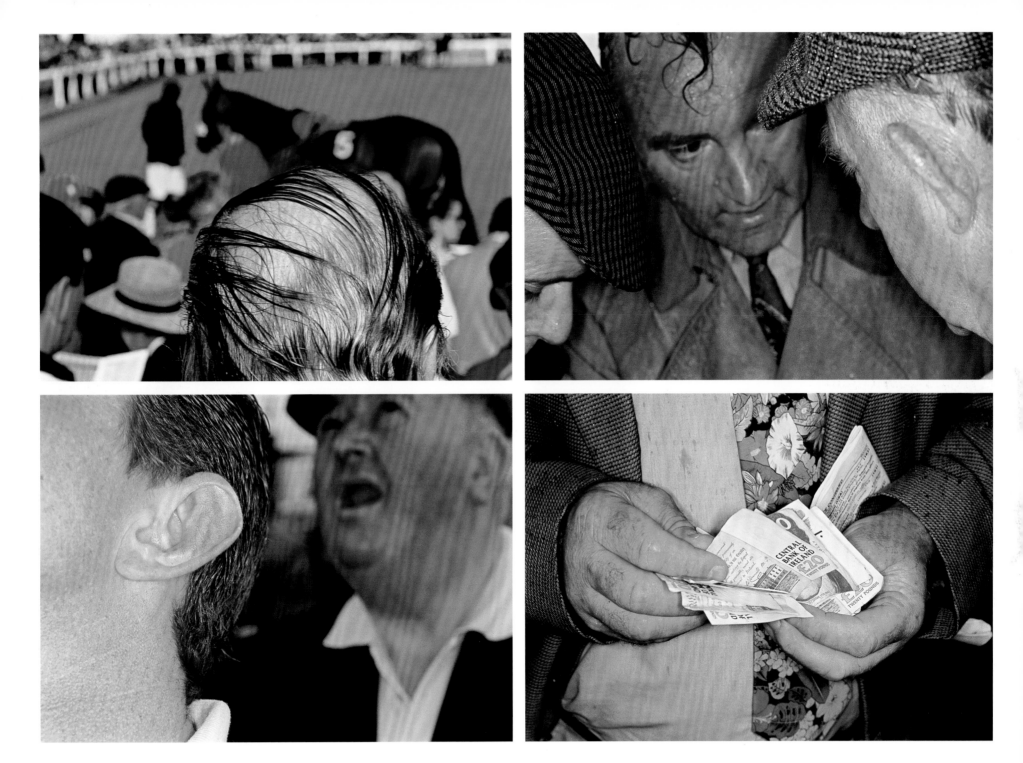

Galway Races, Ireland, 1997–8

Boring, Oregon, 2000

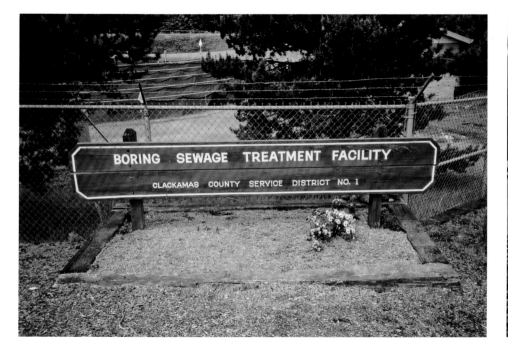

Boring, Oregon, 2000

Boring, Oregon, 2000

Boring, Oregon, 2000

Boring, Oregon, 2000

Boring, Oregon, 2000

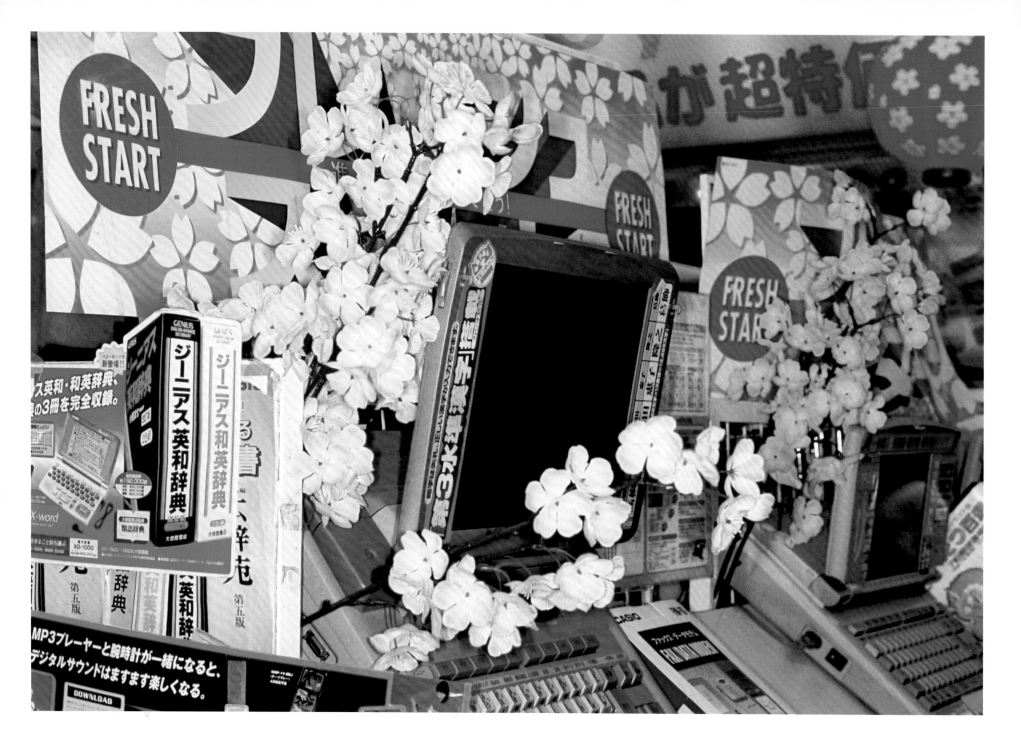

From 'Cherry Blossom Time in Tokyo', 2000

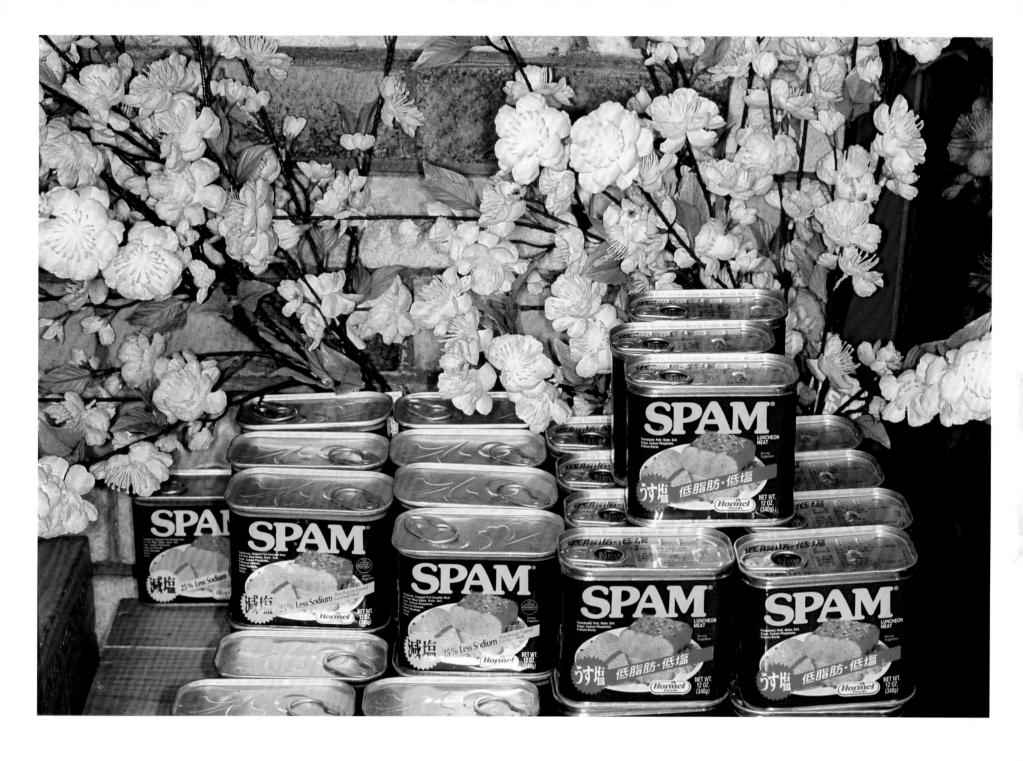

Amsterdam, Netherlands, 2000, from 'Autoportrait'

Amsterdam, Netherlands, 2000, from 'Autoportrait'

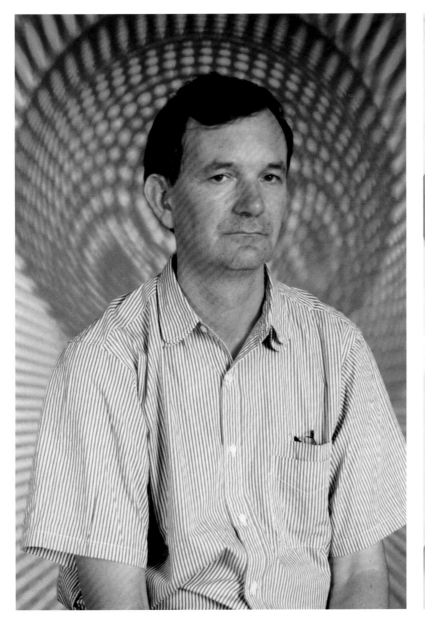

Odessa, Ukraine, 2000, from 'Autoportrait' Havana, Cuba, 2001, from 'Autoportrait'

Braga, Portugal, 2000, from 'Autoportrait'

Odessa, Ukraine, 2000, from 'Autoportrait'

Vienna, Austria, 2000, from 'Autoportrait'

Benidorm, Spain, 1997, from 'Autoportrait'

BOM JESUS - BRAGA

Braga, Portugal, 2000, from 'Autoportrait'

New York, 1998, from 'Autoportrait'

Previous Publications and Exhibitions

Books and catalogues

Langweilige Postkarten
Phaidon Press, London, 2001

Boring Postcards USA
Phaidon Press, London, 2000

Think of England
Phaidon Press, London, 2000

Autoportrait
Dewi Lewis Publishing,
Stockport, 2000

Flowers
(catalogue) Galerie du jour,
Paris, 2000

Happy Days
(CD Rom)
Media Towns, Tokyo, 1999

Benidorm
(catalogue) Sprengel
Museum, Hannover, 1999

Boring Postcards
Phaidon Press, London,
1999

Sguardi gardesani
(catalogue) with John Davies
Edizione Charta, Milan,
1999

Common Sense
Dewi Lewis Publishing,
Stockport, 1999

Flowers
Browns and Trebruk,
London, 1999

Japonais Endormis
(catalogue) Galerie du jour,
Paris, 1998

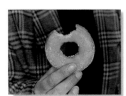

British Food
(catalogue) Galerie du
jour, Paris, 1995

Small World
Dewi Lewis Publishing,
Stockport, 1995

**From A to B – tales
of modern motoring**
BBC Books, London, 1994

Home and Abroad
Jonathan Cape, London,
1993

Bored Couples
(catalogue) Galerie du jour,
Paris, 1993

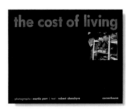

Signs of the Times
Cornerhouse Publications,
Manchester, 1992

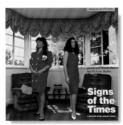

The Cost of Living
Cornerhouse Publications,
Manchester, 1989

One Day Trip
(catalogue) Editions
de la Différence,
Centre Régional
de la Photographie,
Nord-Pas-de-Calais,
1989

**The Actual Boot – the
photographic postcard
boom 1900–1920**
(with Jack Stasiack)
Jolly Editorial/National
Museum of Photography,
Film and Television,
Bradford, 1986

The Last Resort
Promenade Press,
Wallasey, 1986,
Dewi Lewis Publishing,
Stockport, 1998

**A Fair Day –
photographs from
the West of Ireland**
Promenade Press,
Wallasey, 1984

Calderdale Photographs
(catalogue) Calderdale
Museums Service,
Yorkshire, 1983

Artist's books

Bad Weather
Zwemmers, London, 1982

**Cherry Blossom
Time in Tokyo**
edition of 30
Eyestorm, 2001

Souvenir du Maroc
edition of 10
self-published, 2001

Boring Photographs
edition of 12
self-published, 2000

West Bay
edition of 250 (25 with print)
Rocket Gallery, London,
1997

Benidorm
edition of 8
self-published, 1997

Home Sweet Home
Impressions Gallery,
York, 1974

Work printed in following publications

160 ans de photographie: en Nord-Pas-de-Calais. L'Association des conservateurs des musées du Nord-Pas-de-Calais/Actes Sud, Arles, France, 2001

La collection de photographies d'agnès b. Centre national de la photographie, Paris, France, 2000

GMT 2000: a portrait of Britain at the millennium. Harper Collins, London, UK, 2000

Inside Out: underwear and style in the UK. British Council and Black Dog Publishing, London, UK, 2000

Magnum Degrees. Phaidon Press, London, UK, 2000

Photogenic. Scriptum Editions, London, UK, 2000

Photography: a crash course, Dave Yorath. Watson-Guptill Publications, New York, USA, 2000

(un)Fashion, Tibor Kalman. Booth-Clibborn Editions, London, UK, 2000

Unsere Umgangsformen. Falken Verlag, Niedernhausen, Germany, 2000

Up and Down. Vereins- und Westbank AG, Hamburg, Germany, 2000

50 x 50 Tati. Steidl, Göttingen, Germany, 1999

20th Century Photography. Carlton Books, London, UK, 1999

6th International Month of Photography. Hellenic Centre of Photography, Athens, Greece, 1999

Calender 2000. Eddy Speciality Papers, Domtar Inc., Montreal, Canada, 1999

A Century in Photographs: a portrait of Britain 1900–1999. Times Books, London, UK, 1999

Collection NSM Vie: figures libres. Imprimerie Ideale, Geneva, Switzerland, 1999

Food, Design and Culture. Laurence King Publishing, London, UK, 1999

Fotofestival. Naarden, Netherlands, 1999

Géo: vingt photographes autour du monde. En Vues, Paris, France, 1999

Histoires d'oeufs. Editions Ides et Calendes, Neuchâtel, Switzerland, 1999

Into the Light. The Royal Photographic Society, Bath, UK, 1999

Le Journal des galeries photo, No.50. Fnac, Paris, France, 1999

Magnum Photos: press corporate edition. Magnum, Paris, France, 1999

Memorias da Cidade. Braga photography festival, Portugal, 1999

Ritual: Magnum Images. Dah Hua Printing Press, Hong Kong, 1999

La sphère de l'intime. Le Govic à Saint-Herblain, France, 1999

'Together': the Passage Exhibition. Croft Printers and Bookbinders, London, UK, 1999

Vision: 50 years of British creativity, a celebration of art, architecture and design. Thames and Hudson, London, UK, 1999

The Alfred Eisenstaedt Award for Magazine Photography. Life, New York, USA, 1998

La Brava, Elmore Leonard. William Morrow, New York, USA, 1998

Continental Drift. Prestel-Verlag, New York, USA, 1998

Dormir/Sleep. Editions Coromandel, Paris, France, 1998

Israel: 50 years as seen by Magnum photographers. Aperature Foundation, New York, USA, 1998

Powerhouse: UK. Aspen Publishers, New York, USA, 1998

Talking Photography. The Arts Council of England, London, UK, 1998

Americani. Contrasto, Milan, Italy, 1997

Magnum Photos. Photopoche, Editions Nathan, Paris, France, 1997

On the Bright Side of Life. NGBK, Berlin, Germany, 1997

The Photography Book. Phaidon Press, London, UK, 1997

The Photograph, Graham Clarke. Oxford University Press, Oxford, UK, 1997

Voyages Méditerranéens. Alphée, Aubagne, France, 1997

Zurich, Buchs Druck. Zurich, Switzerland, 1997

Begrenzte Grenzenlosigkeit. Neue Gesellschaft für bildende Kunst NGBK, Berlin, Germany, 1996

Encontros da Imagem a Colecca. Fundacao Cupertino de Miranda, Oporto, Portugal, 1996

Paesaggi Magnum Formats. Contrasto, Milan, Italy, 1996

Photos leurres, No.24. Galerie du jour, Paris, France, 1996

Les trois grandes Egyptiennes. Editions Marval, Paris, France, 1996

VI Biennale Internazionale di Fotografia. Skira Editore, Milan, Italy, 1995

Une aventure contemporaine: la photographie 1955–1995. Maison Européenne de la photographie, Paris, France, 1995

Contrejour: vacances de rêves. Contrejour Communication, Paris, France, 1995

Contre l'exclusions: nous nous engageons. Euro RSCG Futurs, Paris, France, 1995

Documentalismo Fotografico Contemporaneo. Xerais, Spain, 1995

Encom Frosda Imagem. Braga photography festival, Portugal, 1995

Internationale Foto-Triennale Esslingen: Close to Life. Hatje Cantz Verlag, Ostfildern, Germany, 1995

Portfolio, No.22. The Arts Council of England, London, UK, 1995

Spectrum Photogalerie 1972–1991. Landeshauptstadt, Hannover, Germany, 1995

A Dream of England. Manchester University Press, Manchester, UK, 1994

Documentary Dilemmas. The British Council, London, UK, 1994

Barbary Coast Revisited. The Heritage Centre, Salford, UK, 1994

Bridging the Years. The Heritage Centre, Salford, UK, 1994

European Photography Awards 1985–1994. Hatje Cantz Verlag, Ostfildern, Germany, 1994

Mesiac Fotografie. Fotograficka Nadacia, Slovensko, Czech Republic, 1994

Portraits d'un portrait. Galerie Gisele Linder, Basel, Switzerland, 1994

La ville et la modernité: la jeune fille dans la ville. Galerie du jour, Paris, France, 1994

A Positive View. Vogue, Condé Nast, London, UK, 1994

A la recherche du père. Editions Paris-Audiovisuel, Paris, France, 1993

Photographs from the Real World. Den Norske Bokklubben, Oslo, Norway, 1993

Photographie d'une collection. Editions Hazan, Paris, France, 1993

Tres de Magnum, No.3. Universidade de Santiago, Spain, 1993

Première photo. Galerie du jour, Paris, France, 1992

Rencontres internationales de la photographie. Maeght Editeur, Paris, France, 1992

Voir la Suisse autrement, Charles-Henri Favrod. Lucerne, Switzerland, 1991

British Photography from the Thatcher Years. The Museum of Modern Art, New York, USA, 1991

A l'est de Magnum 1945–1990. Arthaud, Lausanne, Switzerland, 1990

Encontros da Imagem. Braga photography festival, Portugal, 1990

Heimat. Brandstatter, Vienna, Austria, 1990

Imagina. Almediterranea, Almeria, Spain, 1990

Mai de la photo. Reims, France, 1990

The Past and the Present of Photography. National Museum of Modern Art, Tokyo, Japan, 1990

Plaisir du photographe. Galerie Maeght, Paris, 1990

Rooms. B and R Khatir, Locarno, Switzerland, 1990

Stages. Rencontres internationales de la photographie à Arles, France, 1990

Who's Looking at the Family? Barbican Art Gallery, London, UK, 1990

32 Photography in Art: Portraits. SDU Drukkerij's, Gravenhage, Netherlands, 1989

The Art of Photography 1839–1989. Amilcare Pizzi, Milan, Italy, 1989

Image. Europrint Espoo, Helsinki, Finland, 1989

Le Invenzioni dello Sguardo No.5. Azienda Energetica Municipale, Milan, Italy, 1989

A Special Place. Orchard Books, London, UK, 1989

What is Photography: 150 years of photography. Tlaciarne SNP, Slovakia, 1989

Acquisitions 1982–88. F.R.A.C., Marseille, France, 1988

Selection. Kodak Photo Salon, Tokyo, Japan, 1988

Smart Car promotion book. Zurich, Switzerland, 1998

History of Photography. Bison Books, London, UK, 1987

Inscription and Invention: British photography in the 1980s. The British Council, London, UK, 1987

Mysterious Coincidences. Photographers' Gallery, London, UK, 1987

Realities Revised. Hulton Picture Library, London, UK, 1987

50 Years of Modern Colour Photography 1936–1986. Photokina, Cologne, Germany, 1986

II Fotobienal-Vigo '86. Xunta de Galicia, Spain, 1986

Autoscatto. Editoriale Domus, Milan, Italy, 1986

Connections: Liverpool/Manchester. Jackson Wilson, Leeds, UK, 1986

Foto Amsterdam '86. Stichting, Amsterdam, Netherlands, 1986

Ireland: a week in the life of a nation. Century Hutchinson, London, UK, 1986

The Photographic Art: Pictorial Tradition in Britain and America. Scottish Arts Council/The Herbert Press, UK, 1986

Torino Fotografia '85. Edizioni Panini, Modena, Italy, 1985

Foto Amsterdam '84. Stichting, Amsterdam, Netherlands, 1984

Nuova Fotografia Inglese. Gabriele Mazzotta, Milan, Italy, 1984

A Woman's Place: the changing picture of women in Britain. Penguin Books, London, UK, 1984

Prescot Now and Then. Metropolitan Borough of Knowsley Leisure Services, Knowsley, UK, 1984

The Football Grounds of England and Wales. Willow Books, London, UK, 1983

Fotografia Europea Contemporanea. Jaca Books, Milan, Italy, 1983

Fotografie. Kunstverein Schaffhausen, Schaffhausen, Switzerland, 1983

Internationell Foto Festival Malmö. Tryckeriteknik AB, Malmö, Sweden, 1983

La ville et la modernité: la jeune fille dans la ville. Galerie du jour, Paris, France, 1983

Contemporains en Europe: 21 photographes. Berger-Levrault, Paris, France, 1982

Dumont Foto 4. Helio, Cologne, Germany, 1982

About 70 Photographers. Arts Council of Great Britain, London, UK, 1980

Three Perspectives on Photography. Arts Council of Great Britain, London, UK, 1979

Creative Camera Collections. Coo Press, London, UK, 1978

Memories, Harry Greenwood. Arvon Press, Hebden Bridge, UK, 1977

Selected articles and reviews
(UK unless stated)

'Who Let This Guy in Here', John Bentley Mays. *National Post* (Canada), October 2001

'What a Picture', Tim Power. *Halifax Evening Courier*, 7 April 2001

'England, Sweet England', Ralf Sotscheck. *Die Tageszeitung* (Germany), 21 January 2001

'All Out World: the photographs of Martin Parr', Peter Hamilton. *Art on Paper*, 13 January 2001

'Household Martin', interview by David Land. *Royal Photographic Society Journal*, January 2001

'From Grease to Gloss', John Leland. *New York Times* (USA), 8 November 2000

'Friend or Foe?', Colin Jacobson. *Creative Review*, November, 2000

'Think of a Cliché', Colin Jacobson. *Sunday Tribune* (Ireland), 15 October 2000

'So Near, So Parr', Nigel Atherton. *Amateur Photographer*, 4 October 2000

'Ich bin ein Populist'. *Die Welt* (Germany), 11 September 2000

'The Eyes of Martin Parr', interview with Andrew Billen, *London Evening Standard*, 30 August 2000

'A Vision of Englishness', Steven Pyle. *Daily Telegraph*, 12 August 2000

'Buitenbeentje wordt voortrekker', Jeroen Hendriks. *ZB* (Netherlands), 1 July 2000

'Parr and the Madding Crowd', Eugene Byrne. *Venue* magazine, 1 October 1999

'The Quiet Desperation of the Provincial English', Philip Hensher. *Independent*, 24 September 1999

Interview with Michael Koetzle. *Phototechnik International* (Germany), September 1999

'Reviere der Freizeitgesellschaft', Nicole Busing. *Weser Kurier* (Germany), 31 August 1999

'Life's a Beach', Gerry Badger. *British Journal of Photography*, 18 August 1999

'Benidorm ist über alles', Alexandra Glanz. *Hannoversche Allgemeine Zeitung* (Germany), 14 July 1999

'De Wereld als Soap', Jannetje Koelwijn. *Vrij Nederland* (Netherlands), 10 April 1999

'Martin Parr's Juicy Absurdity', Kim Hastreiter. *Paper* magazine, April 1999

'Kitsch in Synch', Lesley Gillilan. *Independent on Sunday*, 21 March 1999

'Lachen doet pijn', Edie Peters. *de Volkskrant* (Netherlands), 13 March 1999

'Martin Parr', Gaby Wood. *Guardian Weekend*, 6 March 1999

Interview with Richard Pinsent. *The Art Newspaper*, March 1999

'Common Sense', Mark Durden. *Portfolio*, Spring 1999

'A Cold Snap at the Seaside', Lisa Dukes. *Highbury and Islington Express*, 12 June 1998

'Us and Them', William Feaver. *Observer Review*, 26 April 1998
'Working Class Heroes, Martin Parr and Robert Capa'. Don Jacobson, *British Journal of Photography*, 6 April 1998
'Reduced to This', Derek Bishton. *Daily Telegraph*, 14 March 1998
'Ooh La La', Neil Brown. *Frieze* magazine No.42, 1998
'Beside the Seaside', Gerry Badger. *Contemporary Visual Arts* Issue 16, 1997
'25 Welcome Break Service Stations', Graham Evans. *Untitled* magazine, Summer 1994
'Martin Parr', David Lee. *Arts Review*, March 1994
'Ordinary People', Val Williams. *Independent on Sunday*, 4 December 1993
'Sad Hearts at the Supermarket', Boyd Tonkin. *New Statesman and Society*, 6 August 1993
'Up to Parr', Michael Hallett. *British Journal of Photography*, 5 August 1993
'The Tourist in the Picture', Suzanne Moore. *Guardian Weekend*, 17 June 1993
'I'm Buggered Without My Prejudice', David Brittain. *Creative Camera*, June 1993
'Eloge de la vie quotidienne', Michel Guerin. *Le Monde* (France), 13 March 1993
'Martin Parr', Tanya King. *Circa Art Magazine* (Ireland), 3 April 1991
'Old World Images That Are New', Andy Grundberg. *New York Times* (USA), 22 March 1991
'Consumer Packaging for the Middle Classes', William Bishop. *British Journal of Photography*, 8 February 1990
'Comfort and Joy', Bob Chesshyre and Richard Ehrlich. *Sunday Times Magazine*, 19 November 1989
'Colours You Can't Believe', Waldemar Januszczak. *Guardian*, 24 December 1987
'Fotos met georganiseerd thaas zijn mode geworden', Mariette Havermon. *de Volkskrant* (Netherlands), 6 October 1987
'End of the Pier', Robert Morris. *British Journal of Photography*, 15 August 1986
'The Last Resort', David Lee. *Arts Review*, August 1986
'Problematic Renaissance in British Photography', Wendy Watriss. *Spot* magazine (Houston Center for Photography, USA), 1986
'A Fair Day', Val Williams. *Creative Camera*, October 1984
'A Fair Day', Chris Coppock. *Circa Art Magazine* (Ireland), September/October 1984
'A Fair Day', Finton O'Toole. *Magill* magazine (Ireland), July 1984
'Martin Parr in Bad Weather'. Val Williams, *Creative Camera*, October 1982
'Martin Parr', Rob Powell. *British Journal of Photography*, 8 May 1981
'Viewed', Gerry Badger. *British Journal of Photography*, 31 March 1978
'The Face in the Picture'. Paul Barker, *New Society*, 5 January 1978
'On View', Ainslie Ellis. *British Journal of Photography*, 6 September 1974
'The Slanted Mirror', Stewart Scotney. *Art and Artists*, September 1974

Selected solo exhibitions

2001 'Home and Abroad', fOTO Gallery, Sarajevo, Bosnia; Centrar za Kulturu, Mostar, Bosnia; Centrum Edukacyjno Kulturalne Lowicka, Warsaw, Poland

2000 Galerie du jour, Paris, France
'Flowers: public presentation', ABN AMRO, Paris, France
Kulturbeutel, Old Post Office, Berlin, Germany
Galerie du jour, Paris, France
'Japonais Endormis', Kunsthalle, Rotterdam, Netherlands
'Autoportrait', Tom Blau Gallery, London, UK
20/21 Gallery, Essen, Germany
Brandenburgische Kunstsammlungen Cottbus, Cottbus, Germany
arsFutura Galerie, Zurich, Switzerland
Ancien Carmel, Tarbes, France
fOTO Galeria, Sarajevo, Bosnia
International Centre of Culture, Tirana, Albania
'Home and Abroad', Zapovednik, Novgorod, Russia; Fine Art Gallery, Pskov, Russia; Chernyshevsky Museum, Saratov, Russia; State Museum of Fine Art, Samara, Russia; Centre for Contemporary Art, Tirana, Albania; Fotoforum West, Innsbruck, Austria

1999 'Benidorm', Sprengel Museum, Hannover, Germany (catalogue)
'Common Sense', worldwide tour (catalogue): Amsterdams Centrum voor Fotografie, Netherlands; Harvard University, Massachussetts, USA; Ffotogallery, Cardiff, UK; Gallery of Photography, Dublin, Ireland; Rocket Gallery, London, UK; Vox Populi, Le mois de la photo à Montréal, Canada; Janet Borden Gallery, New York, USA; Canadian Museum of Contemporary Photography, Ottawa, Canada; Australian Centre for Photography, Paddington, Australia; Galerie du jour, Paris, France; Tatra Gallery, Poprad, Slovakia; Glasgow Film and Video Workshop, Glasgow, UK; House of Filmmakers, Moscow, Russia; BWX at the Exchange, New Zealand; Hamish McKay Gallery, Wellington, New Zealand; Büro für Fotografie, Stuttgart, Germany; Schaden.com, Cologne, Germany; Camera Austria, Graz, Austria; arsFutura Galerie, Zurich, Switzerland; Bilder Till Salu, Stockholm, Sweden; Galerie Asbaek, Copenhagen, Denmark; Jiri Jaskmanicky Gallery, Prague, Czech Republic; Fondazione Marangoni, Florence, Italy; Institute of Visual Arts, University of Milwaukee, USA; Fotogalleriet, Oslo, Norway; Livingstone Art Museum, Zambia; British Council, Lusaka, Zambia; Richard Heller Gallery, Santa Monica, California, USA; b.Yourself!! Gallery, Tokyo, Japan; agnès b. Aoyama, Tokyo, Japan; agnès b. Shibuya, Tokyo, Japan; agnès b. Sapporo, Japan; agnès b. Osaka, Japan; agnès b. Kyoto, Japan; agnès b. Fukuoka, Japan; Galerie Rodolphe Janssen, Brussels, Belgium; Lopdell House Gallery/Waitakere Centre for the Arts, Auckland, New Zealand; Wetterling Teo Gallery, Singapore; Palazzo delle Esposizioni, Rome, Italy; The British Council, Turin, Italy; The British Council, Bologna, Italy; Galleria Franca Speranza, Milan, Italy; The British Council, Naples, Italy; Son and Kelly Boutique, Singapore
Harley Gallery, Nottingham, UK
La maison de la culture d'Amiens, France
Gallery Jiri Jaskmanicky, Prague, Czech Republic
'Home and Abroad', New Town Hall Gallery, Prague, Czech Republic; J Miron Theatre, Ostrava, Czech Republic; Moravian-Silesian Museum, Opava, Czech Republic; Moravian Gallery, Brno, Czech Republic; Fine Art Museum, Ekaterinburg, Russia; St Peter and Paul Fortress, St Petersburg, Russia

1998 'Ooh La La', National Museum of Photography, Film and Television, Bradford, UK (catalogue)
Galeria Palmira Suso, Lisbon, Portugal
FotoGaleria, Buenos Aires, Argentina

'Japonais Endormis', Gallery du jour, Paris, France (catalogue)
'Home and Abroad', Fotogaleria, Teatro General San Martin, Buenos Aires, Argentina; Centro Cultural Villa Victoria, Mar del Plata, Argentina; Biblioteca Bernardino Rivadavia, Bahia Blanca, Argentina

1997 'West Bay', Rocket Gallery, London, UK (catalogue)
'Souvenirs', The Jerusalem School of Photography, Israel
Shadai Gallery, Tokyo, Japan
'Home and Abroad', Victoria Memorial, Durbar Hall, Calcutta, India; Bangkok Art Centre, Thailand; Hosei Gallery, Tokyo; Instituto Chileno Britanico de Cultura, Santiago, Chile

1996 Janet Borden, New York, USA
Portfolio Gallery, Edinburgh, UK
Fundació 'La Caixa', Palma de Mallorca
'Home and Abroad', Arts Centre, Hong Kong; DRIK Gallery, Dhaka, Bangladesh; British Council Art Gallery, New Delhi, India

1995 'Martin Parr', Galerie du jour, Paris, France
'Small World' and 'From A to B', Centre national de la photographie, Paris, France
'Small World', Photographers' Gallery, London, UK (catalogue)
Provinciaal Museum voor Fotografie, Antwerp, Belgium
'Home and Abroad', Staatliche Galerie Moritzburg, Halle, Germany; Photography Museum, Antwerp, Belgium; Cultural Centre Strombeek, Brussels; Les Chiroux, Liège, Belgium; International Photography Meeting, Plovdiv, Bulgaria; Museum of Modern Art, Sofia, Bulgaria

1994 Curitiba Photo Festival, Curitiba, Brazil
'From A to B', 27 Welcome Break service stations, UK
Galerie Augustus, Berlin, Germany
L'Institut Français de Bucarest, Romania
'Home and Abroad', Peri Centre of Photography, Turku, Finland; Galerie Augustus, Berlin; LFT Gallery, Lodz, Poland

1993 Cambridge Darkroom Gallery, Cambridge, UK
'Home and Abroad', Watershed Gallery, Bristol, UK and international tour 1993–2001 (catalogue)
'Bored Couples', Galerie du jour, Paris, France and tour (catalogue)
'A Year in the Life of Chew Stoke', Chew Stoke Village Hall, Bristol, UK (catalogue)

1992 Kiek in de Kok Gallery, Tallinn, Estonia
'Signs of the Times', Janet Borden Gallery, New York, USA

1991 Galerie Jacques Gordat, Paris, France
Janet Borden Gallery, New York, USA

1989 Spectrum Photogalerie, Hannover, Germany
Photographers' Gallery, London, UK
Fotogallery, Luxembourg
'The Cost of Living', Royal Photographic Society, Bath, UK and tour (catalogue)
'One Day Trip', Musée de Boulogne-sur-Mer, France

1988 Kodak Gallery, Tokyo and Osaka, Japan
Galerie les Pipots, Boulogne-sur-Mer, France

1987 Spending Time, Centre national de la photographie, Paris, France
Art and Research Exchange, Belfast, Northern Ireland, UK
ICP Midtown, New York, USA

1986 Arpa, Bordeaux, France
Oldham Art Gallery, Oldham, UK

Watershed Gallery, Bristol, UK
Amsterdam Manifestation festival, Amsterdam, Netherlands
Fotograficentrum, Stockholm, Netherlands
Festival d'Arles, France
Museum Folkwang, Essen, Germany
'The Last Resort', Serpentine Gallery, London, UK
'Point of Sale', Salford City Museum and Art Gallery, UK

1985 George Eastman House, Rochester, New York, USA
Triskel Arts Centre, Cork, Ireland
Creative Photography Gallery, Dayton, USA

1984 Project Arts Centre, Dublin, Ireland
'A Fair Day', Orchard Gallery, Derry, Ireland and tour
'British Photographic Art', Geology Museum, Beijing, China
Piece Hall Art Gallery, Halifax, UK

1983 Ffotogallery, Cardiff, UK
International Photography Festival, Malmö, Sweden

1982 Uppermill Library, Oldham, UK
'Bad Weather', Photographers' Gallery, London, UK and tour (catalogue)
'Abandoned Morris Minors of the West of Ireland', Albert Street Workshop, Hebden Bridge, UK
'Rural Irish Photographers', Neikrug Gallery, New York, USA (catalogue)

1981 Gallery of Photography, Dublin, Ireland
'The Nonconformists', Camerawork, London, UK

1979 'Martin Parr', Photogallery, St Leonards-on-sea, East Sussex, UK
Smith Art Gallery, Brighouse, UK

1978 'Documentary Martin Parr', Piece Hall Gallery, Halifax, UK
'This is Your Life', South Pennine Information Centre, Hebden Bridge, UK
Fotomania Gallery, Barcelona, Spain

1977 Photographers' Gallery, London, UK

1976 'Beauty Spots', Impressions Gallery, York, UK and tour
'The Chimney Pots Show', North West Arts, Manchester, UK

1974 'Home Sweet Home', Impressions Gallery, York, UK and Arnolfini Gallery, Bristol, UK (catalogue)

Permanent exhibition

West Dorset General Hospital, Dorchester, UK

Selected group exhibitions

2001 'In Bed With Magnum', Great Eastern Hotel, London, UK
Kommunalen Galerie im Leinwandhaus, Frankfurt, Germany
'Magnum Degrees: Our Turning World', Louisiana Museum, Humlebaek, Denmark; Culturgest, Lisbon

2000 'We Are So Happy', Brussels, Belgium
'Israël Magnum', Fnac Ghent, Belgium
'East of Magnum', Union of Mongolian Artists, Ulan Bator, Mongolia; Novosibirsk Picture Gallery, Russia; Dushanbe, Tajikistan (2000–1)
'Portraits de stars', Espâcio de Cultura, Madrid, Spain
'The Misfits', Semana Internacional de Cine de Valladolid, Spain;

Porto, Portugal; Viano do Castelo, Portugal; Fnac Madrid, Spain; Fnac Cannes, France, (2000–1)
'Magnum Paysages', Museo Casa Diego Rivera, Guanajuato, Mexico; Centro de la Imagen, Mexico City; Museo de Arte Contemporaneo de Monterrey, Mexico (2000–1)
'Magnum Degrees: Our Turning World', Bibliothèque nationale de France (Richelieu), Paris; Palazzo del Esposizioni, Rome, Italy; Centro Oberdan, Milan, Italy; Postfuhramt, Berlin, Germany; Kunsthaus, Zurich, Switzerland; Le Botanique, Brussels, Belgium
'Images Beyond the Naked Eye', Munich, Germany
'The Show', Robert Miller Gallery, New York, USA
'Encontros da Imagem', Braga, Portugal
'Capitale jeunesse: première partie', Mairie du 13ème, Paris, France
'Dormir/Sleep', Colette, Paris, France
Mois de la photo, Galerie du jour, Paris, France
'Domestic Bliss', The Rocket Gallery, London, UK
'At Sea', Tate Gallery, Liverpool, UK
Magnum Photos Eyestorm Collection, Great Eastern Hotel, London, UK
Postfuhramt, Berlin, Germany
Galeries Mansart et Mazarine, Paris, France

1999 'Das Bild vom Menschen: 50 Jahre Stern', Museum für Kunst und Gewerbe, Hamburg, Germany
'Des Conflicts Intérieurs', Octeville, France
'Le plus bel âge', Centre photographique, Pontault-Combault, France
'Travaux en cours', Galerie du jour, Paris, France
'Love and Desire', Galleria Photology, Milan, Italy
'Géo a 20 ans', Fnac, St Lazare, Paris, France
'Our Turning World: Magnum Photographers 1989–1999', Barbican Art Gallery, London, UK (catalogue)

1998 'Years Ending in Nine', Museum of Fine Arts, Houston, USA
'Wish You Were Here', Islington Museum, London, UK
'Blind Spot', Soho Traid Fine Arts, New York, USA
'Beauty in Diversity', Piece Hall Art Gallery, Halifax, UK
'Continental Drift', Fruitmarket Gallery, Edinburgh, UK
'No Sex Please, We're British', Shiseido Department Store, Tokyo, Japan
Octagon Galleries, Bath, UK

1997 'Acquired Images '97', Ffotogallery, Cardiff, UK
'Voyages Méditerranéens, Aubagne en vue', Ile des Marronniers, France
'Hope Photographs', The National Art Club, New York, USA
'Wait and See', The Towner Art Gallery, Eastbourne, UK
'Les trois grandes Egyptiennes', Musée de la photographie, à Charleroi, Belgium (catalogue)
'Exposition pour les enfants', Espace la Redoute, Châtellerault, France
'Approaching Documentary', Viewpoint Photography Gallery, Salford, UK
'Zurich', Kunsthaus Zurich, Switzerland (catalogue)
'West Bay', West Bay Harbour Museum, Dorset, UK

1996 L'hôtel de Sully, Paris, France
'C'est arrivé près de chez nous', Galerie Duchamp, Yvetot, France
Nederlands Foto Instituut, Rotterdam, Netherlands
'Profession Reporter', Photoforum, Zurich, Switzerland
Photo Festival, City Art Gallery Hereford, UK

1995 Internationale Foto-Triennale, Esslingen, Germany (catalogue)

1994 European Photography Award 1985–1994, Kultur Zentrum, Bad Homburg, Germany (catalogue)

1993 'Images from the Coalfields', Angela Flowers Gallery, London, UK
Henri Vincenot Prize Five Years Retrospective, Espace Brassens, Dijon, France

'Sobre Santiago, Tres de Magnum', Santiago, Spain (catalogue)
'Photographs from the Real World', Lilliehammer Art Museum, Norway (catalogue)

1992 'Imagina', World Fair, Seville, Spain (catalogue)
'Première photo', Galerie du jour, Paris, France

1991 'Européens', Centre Jean Savidan, Lannion, France
'Voir la Suisse autrement', Fribourg, Switzerland (catalogue)
'British Photography from the Thatcher Years', Museum of Modern Art, New York, USA (catalogue)

1990 'The Past and Present of Photography', Museum of Modern Art, Tokyo, Japan (catalogue)

1989 Foto Biennale, Enschede, Netherlands (catalogue)
'The Art of Photography', Royal Academy, London, UK (catalogue)
'Through the Looking Glass, British Photography 1945–1989', Barbican Centre, London, UK (catalogue)

1988 'A British View', Museum für Gestaltung, Zurich, Switzerland (catalogue)

1987 'Nyvytaiteen: Paul Graham, Martin Parr and Victor Burgin', Tampere Museum, Finland
'Mysterious Coincidences', Photographers' Gallery, London, UK (catalogue)
'Attitudes to Ireland', Orchard Gallery, Derry, Northern Ireland, UK
'Inscriptions and Inventions', British Council touring exhibition (catalogue)

1986 'China, Martin Parr and Jane Bown', Harris Museum and Art Gallery, Preston, UK
Cornerhouse, Manchester, UK
'Connections', Open Eye Gallery, Liverpool, UK
'New Documents', Museum of Contemporary Photography, Chicago, USA
'British Contemporary Photography', Houston FotoFest, USA (catalogue)

1985 'Quelques Anglais', Centre national de la photographie, Paris, France

1982 'Strategies: recent developments in British photography', John Hansard Gallery, Southampton, UK (catalogue)

1981 'Streetshooters', Camerawork, San Francisco, USA
Gallery of Photography, Dublin, Ireland
'New Work in Britain', Photographers' Gallery, London, UK

1980 'Two Ways of Life', Canon Photo Gallery, Amsterdam, Netherlands
'Salford '80 Alternative Exhibition', Manchester Polytechnic, UK

1979 'Three Perspectives on Photography', Hayward Gallery, London, UK (catalogue)

1978 'Art for Society', Whitechapel Art Gallery, London, UK (catalogue)
'Personal Views 1860–1977', British Council touring show
'Albert Street Workshop', Royal Northern College of Music, Manchester, UK

1972 'Butlin's by the Sea' (with Daniel Meadows), Impressions Gallery, York, UK
'Real Britain, 10 from Co-optic', Jordan Gallery, London, UK

1971 Students of Manchester Polytechnic, Kendal Milne department store, Manchester, UK

Index

Author's Acknowledgements

I would like to thank all the people with whom I have had conversations about Martin Parr and British photography over the last two years, including: Brigitte Lardinois, Liz Grogan, Stephen Snoddy, Anna Fox, Gordon MacDonald, Clare Strand, Paul Seawright, Mark Durden, Donigan Cumming, Martha Langford, Daniel Meadows, Martino Marangoni, Roger Ballen, Susan Lipper, Simon Grennan, Greg Hobson, Derek Ridgers, Julian Rodriguez, Adam Broomberg, Oliver Chanarin, Colin Jacobson, Tom Wood, Hannah Starkey, Christine Redmond, Neil Baber, Susie Parr, Brett Rogers, Elaine Constantine, Marco Santucci, Alan Dein, Richard Hollis, Carol Brown, Charlotte Cotton, David Chandler, Stephen Bull, Meredith Williams and Megan Williams. Though they may not have realized it at the time, their comments and opinions have been invaluable in the writing of this text.

The extracts from interviews between Martin Parr and myself are taken from the 1992 interview made for the Oral History of British Photography at the British Library National Sound Archive, and though not directly quoted, much of the information about the progress of British photography from the 1950s to the early 1990s comes from the interviews for this project conducted by myself, and in the case of Daniel Meadows, by Alan Dein.

The Salford project, diary and archive material are stored at the Greater Manchester Archive, Manchester.

I have had full access to Martin Parr's papers and to his memories, and thank him very much for this privilege.

Collections

a selection of objects and ephemera from Martin Parr's collections

Statuettes of John F Kennedy, Yuri Gagarin and Lenin

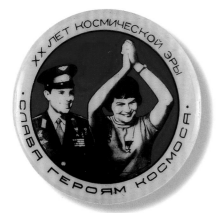
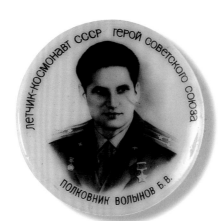
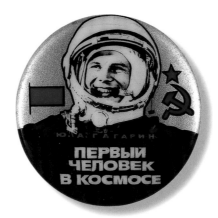

Cosmonaut lapel badges

Miniature televisions

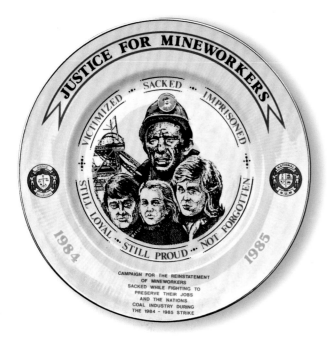

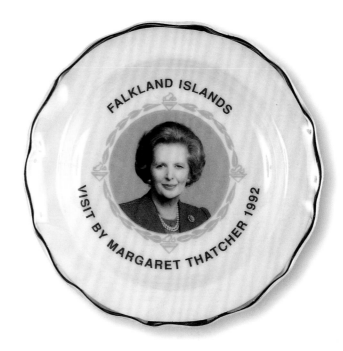

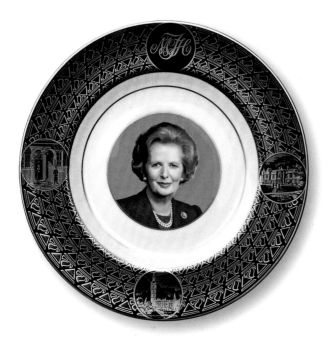

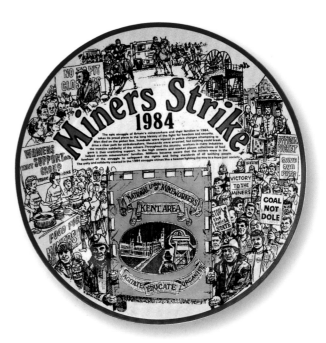

Set of Russian coasters

Assorted ephemera

Space-themed timepieces

Assorted ephemera

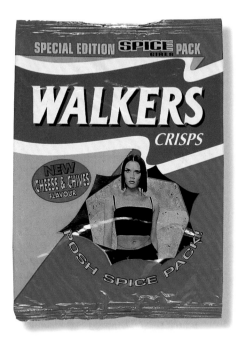

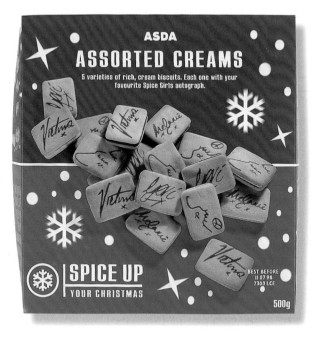

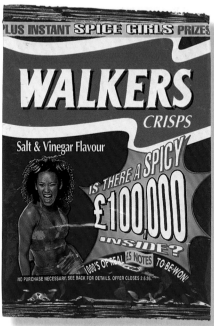

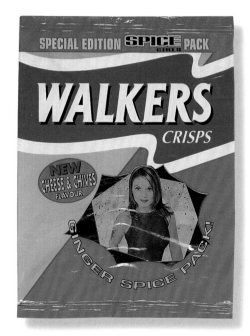

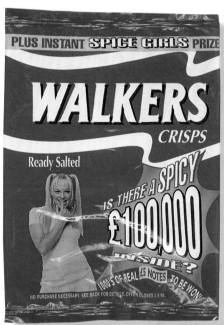

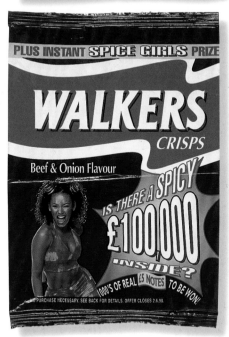

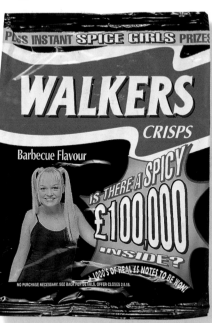

If you count his schooldays, Martin Parr has been a photographer for almost thirty-five years. In that time, he has produced a vast body of work, all of which reflects on the strange conglomeration of people, places and events that make up society. He has chronicled the dying congregation of an obscure Methodist chapel, and the first McDonald's in Russia. He has followed tourists in the Gambia and on a cross-channel shopping spree. He has captured the styles of the 1980s and 1990s, from ruched satin blinds to minimalist art galleries. He has photographed flowers and tea trays, fancy cakes and prize marrows, litter and ladies' hairdressers. He has been, with his camera, to the Leaning Tower of Pisa and the Acropolis in Athens, to school speech days, the Badminton Horse Trials, Galway Races, Eccles Shopping Mall and Las Vegas. Parr has travelled to the places where we feel that we are something a little out of the ordinary, where we dream of being different. He is

a cunning photographer, sidling his way into situations where he shouldn't always be, looking as ordinary as the people he photographs. It has been thirty-five years of photographing ordinary things, and along the way, showing other people, students, younger photographers, editors, curators, how to look at the world in a different way. Without Parr – his energy, his singular way of seeing, his strategy – the landscape of British photography would be much bleaker than it is today. Scratch the surface of Martin Parr and you can still find a train-spotter, a milkbottle collector, an accumulator, someone who operates on an obscure wavelength, pursuing a goal that, in the grand scheme of things, might seem to be a little obtuse.

In Parr's 1998 series of films about Britain; he interviewed teenagers and old people, holidaymakers and suburbanites. They were highly comic films, and Parr's pose was of the innocent. He asked questions that

were so bland that the responses he got were invariably illuminating, sometimes violently pathetic. Very occasionally, the interviewees became interlocutors: 'Who are you then?' shouted a teenage girl, blown along a Newcastle street by a boisterous wind, 'some kind of trainspotter?'